INTERFACING WITH THE INTERNET
IN POPULAR CINEMA

Interfacing with the Internet in Popular Cinema

Aaron Tucker

INTERFACING WITH THE INTERNET IN POPULAR CINEMA
Copyright © Aaron Tucker, 2014.

Softcover reprint of the hardcover 1st edition 2014 978-1-137-38668-7

First published in 2014 by
PALGRAVE MACMILLAN®
in the United States—a division of St. Martin's Press LLC,
175 Fifth Avenue, New York, NY 10010.

Where this book is distributed in the UK, Europe and the rest of the world,
this is by Palgrave Macmillan, a division of Macmillan Publishers Limited,
registered in England, company number 785998, of Houndmills,
Basingstoke, Hampshire RG21 6XS.

Palgrave Macmillan is the global academic imprint of the above companies
and has companies and representatives throughout the world.

Palgrave® and Macmillan® are registered trademarks in the United States,
the United Kingdom, Europe and other countries.

ISBN 978-1-349-48172-9 ISBN 978-1-137-38669-4 (eBook)
DOI 10.1057/9781137386694

Library of Congress Cataloging-in-Publication Data

Tucker, Aaron, 1982–
 Interfacing with the Internet in popular cinema / Aaron Tucker.
 pages cm
 Includes bibliographical references and index.

 1. Internet in motion pictures. I. Title.

PN1995.9.I573T83 2014
791.43'69—dc23 2014000412

A catalogue record of the book is available from the British Library.

Design by Newgen Knowledge Works (P) Ltd., Chennai, India.

First edition: July 2014

10 9 8 7 6 5 4 3 2 1

To Andrea and my parents, Cam and Sherrie, for all the love and support

Contents

Figures

Acknowledgments

I am grateful to all the members of the two panels at the 2011 NE-MLA Panel where I presented an earlier version of my third chapter, as well as to all the attendants and participants at the 2012 NN conference where I gave a version of my second chapter. In particular I would like to single out Candra Gill, who was on a panel with me at the 2013 PCA/ACA conference where I presented a version of my first chapter; her paper sparked a good number of thoughts and she was extremely generous in sending me a list of texts to read and consider.

I would also like to thank Ryerson University's CUPE union for providing me with funds to attend conferences and continue working on this text as also for the support of many in the English Department there, in particular, Dr. Paul Chafe. I extend my thanks to Andrea Schofield, Andrew Faulkner, Tyler Harper, Renee Jackson, and Jordan Scott for reading and responding to versions of this text along the way.

Introduction: The Robot Historian and the Internet

M anuel De Landa begins *War in the Age of Intelligent Machines* (*WAIM*) with the useful construct of a "robot historian," an entity "committed to tracing the various technological lineages that gave rise to their species" (3). Such a historian was not just interested in how a certain machine or robot came to be, but rather how that entity "affected human evolution" by giving logical and/or metaphoric systems by which humans came to understand both themselves and the world in general (3). As an example, De Landa discusses clockwork:

> While a human historian might try to understand the way people assembled clockworks, motors, and other physical contraptions...a robot [historian] would stress the fact that when clockwork once represented the dominant technology on the planet, people imagined their world around them as a similar system of cogs and wheels. The solar system, for instance, was pictured right up until the nineteenth century as a clockwork mechanism. (3)

The robot historian of *WAIM* stops with the book's publication in 1991 and, as such, just begins to touch on one the most important technologies to emerge from the twentieth century: the Internet. When writing this text, I pictured myself as one robot historian picking up where De Landa's left off, instead focusing intensely on how the Internet, as a virtual and connective technology, has come to be the pervasive intellectual system of the twenty-first century. To begin, my goal was not to achieve a (impossible) comprehensiveness of All Things Internet, but rather to be one node in a potential network of other robot historians. I imagined that some within this network collected the technical and mechanical evolutions of hardware/software while others analyzed the cultural narratives (novels,

magazines, television, movies, etc.) that compiled an understanding of the Internet. As such, I found it best to approach the wide variety of texts I was using as Foucault hoped his readers would use his own works: as "a kind of tool-box which others can rummage through to find a tool which they can use however they wish in their own area…I write for users, not readers" (trans. Clare O'Farrell, para. 8). As a robot historian, I borrowed a lot of different types of tools from a great number of different authors and literacies, ranging from the philosophical to the literary to the technical. Therefore, I imagined the "users" of this text beginning, as Vivian Sobchack does in *Carnal Thoughts*, by acknowledging my quest as an "undisciplined" one, one that also grounds itself in a fairly wide-ranging and multidisciplinary approach. As a specific robot historian of the Internet, I found myself concerned, as De Landa was, with the "migrations" of hardware evolutions that "carried logical structures over from vacuum tubes to transistors, and then to integrated chips" (*WAIM*, 4); I followed the trajectories of the software and languages used to control/manipulate/activate that hardware; I found myself repeatedly pursuing the user's relationship with (and projections into) the Internet, and how that user's body interacted with a physical keyboard and/or a virtual message board. From this, I boiled the Internet down to a much-needed definition: Using Manuel Castells's definition of a network as "a set of interconnected nodes" (*Internet Galaxy*, 1), I began to think of the Internet as a network of physical (hardware, servers, cables, physical users) and virtual (software, code, avatars) networks.

Yet, the Internet, and all its various impacts, is vast, and I found myself needing to focus further. My specific historicizing began to increasingly gravitate toward movies that depict literal and metaphoric versions of the Internet as I found that they act as both a molding and a reflecting set of cultural narratives that simultaneously encourage and imagine what a cyberspace could or should look like. Lev Manovich explains that the "cultural interfaces" of contemporary computer usage ("the ways in which computers present and allow us to interact with cultural data" [*The Language of New Media*, 80]) are "the toolbox of a computer user" or the main "organization principles of computer software" (ibid., 92). In particular, cinema's "aesthetic strategies" and its use of "the mobile camera" and "rectangular framing of represented reality" (ibid., 88) allow "cinematic means of perception, of connecting time and space, or representing human memory, thinking, and emotions [to] become a way of work and a way of life for millions in the computer age. The window in a fictional world of a cinematic narrative has become a window in a datascape"

(ibid., 92). In addition, David Kirby argues that "film-makers, scientists and engineers can also create filmic portrayals of technological possibilities with the intention of reducing anxiety and stimulating desires in audiences to see those realities"; the "virtual witnessing" of various computer interfaces and representations of the Internet in movies, such as those in *The Lawnmower Man* (Dir. Brett Leonard, 1992) or *Minority Report* (Dir. Steven Spielberg, 2002), create future-looking "diegetic prototypes" that, possibly, manifest in computer devices, interfaces, or software in the audience's world outside the movie. Such depictions "[contextualize] emergent technologies within the social sphere," which then lead the audience to consider the "desires" created by these diegetic prototypes as well as the fears that they encourage (Kirby, 44). Chapter 2 of this book unpacks this idea by paralleling the shifts in the design of web interfaces and their back-end markup and/or coding languages with a number of films, beginning with *War Games* (Dir. John Badham, 1983) and *TRON* (Dir. Steven Lisberger, 1982), through *The Matrix* (Dir. Andy Wachowski and Lana Wachowski, 1999) and *The Thirteenth Floor* (Dir. Josef Rusnack, 1999), before finishing with *TRON: Legacy* (Dir. Joseph Kosinski, 2010); likewise, chapter 3 contends that the futuristic filmic depictions of the Internet in *The Matrix* trilogy—*The Matrix Reloaded* (Dir. Andy Wachowski and Lana Wachowski, 2003) and *The Matrix Revolutions* (Dir. Andy Wachowski and Lana Wachowski, 2003)—and *Avatar* (Dir. James Cameron, 2009) promote a heroic understanding of the computer-biological bodily relationships bound within Internet usage.

Balancing Kirby's thoughts, Michele Pierson, when speaking about the "cultural implication of new technologies" as represented in film, states that "all speculation about the future is already a form of historical commentary" (30–31); she adds, films that project a future technology often rely on an "imagery with a remarkable resemblance to objects crafted in the physical world" always in equilibrium with "the hyperreal, electronic properties of objects crafted in the digital realm" (36). Therefore, movies are always grounded in the current (or past) world that produces them and in a view/argument about the world (and a particular construction of the history of that world) that produced those films. Movies are not only future-looking, shaping forces of the Internet technologies outside them, but also reflective of their zeitgeist and the celebrations or concerns surrounding the increasingly dense digital networks of their particular era. As such, I took great care to examine films within their particular Internet contexts in order to can see what positive or negative attitudes a viewing

audience might have had (or was being encouraged to have) toward the digital and physical bodies that occupied those era's virtual spaces. As discussed further in chapter 7, for much of the history of the Internet in film, movies that included the Internet were not considered "realistic" movies but were overwhelmingly defined by the genres of science fiction (*The Matrix*, *Johnny Mnemonic* [Dir. Robert Longo, 1995], *The Lawnmower Man*) or horror (*The Net* [Dir. Irwin Winkler, 1995], *Ghost in the Machine* [Dir. Rachel Talalay, 1993]), or were flat out fantastical in their depiction of the technology (*Hackers* [Dir. Iain Softley, 1995]). The cinematic Internet's transition from dramatic/central conceit to background/normalized technology makes obvious how largely negative the technology was in its early depictions: chapter 1 argues that *The Net* and *Ghost in the Machine* mirror how an explosion in common (private) home-use of the Internet led to the hysteric understanding of the technology as viral and deviant that necessarily created vulnerable and ill digital bodies; chapter 5 explains that this fear re-intensifies in the mid-2000s, as expressed by *Untraceable* (Dir. Gregory Hoblit, 2008) and *feardotcom* (Dir. William Malone, 2002), where the Internet user is constructed as too immature to handle the responsibility of humanizing the digital avatar and therefore automatically slips into a perverse voyeurism.

While a consideration of the content of the aforementioned movies is important, as a robot historian grounded in Manovich's historicizing of New Media, I must also explain how the increasing digitization of the moviegoing audience in cooperation with her/his own computers outside the theater melded with the increasing digitization of the filmmaking process itself. While a full history of film technologies and digital effects is beyond this text, it is essential to pause and consider the changing attitudes toward cinema's disappearing materiality. In many ways, D. N. Rodowick's work in *The Virtual Life of Film* explaining the ontological binary in Film Studies between material (images saved on and projected from physical film) and virtual (digital created/edited files that are manipulated and stored ephemerally) parallels the gaps in value systems present when cutting across generations of computer and Internet users; his understanding that film, even in the earliest physical forms of the medium, is virtual (just by its nature of being mechanically motion-dependent) sketches useful resemblances between the ontological divisions of an Internet user's physical/material ("real") body and the user's virtual/projected ("fake") avatars. Further, Rodowick, in parsing Christian Metz's separation of film from cinema, flags cinema as that "within the filmic"; he adds that "the cinematographic inscribes itself as a vast virtuality

that is nonetheless specific and homogenous—this is the notion of cinematic codes" (18). These codes, "in a continual state of innovation and change," are a language. From this, this text questions how the shifts in the languages or codes from a "physical" or "material" filmmaking to a digital filmmaking (and the techniques and effects typical of that filmmaking) are accepted (and become expected) by an Internet-using, movie audience. One of this text's main arguments is that the 2014 moviegoer is not only deeply attuned to the digital effects and the limits of these effects' codes, but also craves them as part of a reflection of her/his own digitally created and maintained worlds. Lisa Purse, in her *Digital Imaging in Popular Cinema*, articulates part of this contemporary movie audience by establishing "the digitally literate spectator," an audience member who is especially savvy in recognizing and appreciating the digitizing process undertaken in contemporary films (25); this same audience uses the Internet outside the theater and, as such, is expectant of photoshopped pictures/advertisements, digitally altered/combined landscapes, as they themselves produce multiple avatars that are digital creations/extensions of themselves. Therefore, this moviegoing audience is a network of active digital craftsmen/women and recognizes what Pierson calls "the craft" of digitally creating and editing not merely as a "reduction to technics," but also as startling and impressive acts of creativity (31). This audience sees a far less clear binary in their understanding of an ontology of the virtual: his/her richly connected and active avatars are the real agents of his/her identity. The "fake" digital worlds of films are not that different than their own digitally altered ("faked") world outside the movie.

With films as a useful prism for me to gaze through, I began to combine a quick rehashing of the Internet's trajectory with the goal of flagging the key fulcrum points and essential thinkers along that historical path, in order to understand and restructure the shifts and tensions around a user's ontology during each historical era's networked and virtual world. There are a number of other texts that establish a very thorough history of the Internet and so I see no need to go into great depth here.[1] Instead, I will break up the migrations of Internet technology into three fairly distinct periods: the First Era, defined by a pre-Popular Internet (roughly 1960–1993); the Second Era that revolves around the introduction of the Graphical User Interface (GUI) web browser (roughly 1993–2003); and the Third Era that we currently inhabit that has brought about the Web 2.0 Internet (roughly 2003–present).[2] By following the Internet across these three basic eras, we can restructure a user's particular

knowledge and attitudes, at least partially reflected or created by the movies s/he has been watching, toward the technology in a particular era and see how those fears/attitudes shaped (or are shaping) the user's perspective and understanding of him/herself and the world around her/him.

The First Era: The Early, Pre-Popular Internet

The Internet is often thought to have begun as an American military resource fully realized in the foundations of ARPAnet after being theoretically conceived in 1964 with Paul Baran's paper "On Distributed Communications" outlining "packet switching" and a distributed, rather than centralized, network (Moschovitis, 45); however, there were other scholars like Leonard Kleinrock at MIT and Donald Davies in England working on the theoretical underpinnings of the technology in the early 1960s (Blum, 41–49). Still, home computing and the early stages of the public Internet didn't begin to make tiny footholds until the late 1970s' Bulletin Board Systems (BBS), such as CBBS and later FidoNet, which demonstrated the excitement to gather into denser and more complex computer networks (Ryan, 112). Even then, public access was relatively minimal until the late 1980s–early 1990s after which home computers became more affordable, and the proliferation of basic faster infrastructure, like modems and later DSL and cable connections, increased to a tolerable level; this was combined with more Internet-integrated workplaces leading to the trickle-down effect of workers inheriting old systems into their private homes as their workplaces upgraded systems (Bowden, 30). This user and hardware expansion dovetailed with the Apple Lisa computers, then the more popular Macintosh computers, introduction of a home computer GUI, a "point-and-click" interface that standardized the more "friendly and accessible" WIMP ("window, icon, menu, pointing device") interaction between computer and user (Ryan, 116). This GUI-mediated understanding did not require a knowledge of "tight machine code" and extended a user's digitized body into a liminal, yet visible, space: though fairly crude, Popular GUIs began to establish doppelgangers of body parts in virtual space (the "mouse" or cursor became a user-controlled graphical hand) leading to personalized understandings of a user's physical body interaction within that computerized space. However, while home computing was expanding, the first era of Internet use is marked by a relatively small and specialized user base of university, corporate or government employees and/or knowledgeable hobbyists. This can be partly attributed to the

lack of a user-friendly Internet GUI: the Internet then consisted of very basic information transfers most commonly on BBS or via FTP programs; as depicted in *War Games* or *Sneakers* (Dir. Phil Alden Robinson, 1992), there were no webpages, no Popular web browsers, nothing beyond white text on a black screen (figure 0.1). Basic navigation of these spaces was done by typing into command lines: a user would access another user's files, download them, and read them using his/her own text or image-reading program. This treatment of a networked virtual space was flat and non-dynamic, crude: metaphorically, users acted much like the light-bike fights in *TRON*, travelling straight paths between nodes along nets or grids in a simply two-dimensional, low-immersive way.

Two divergent future visions of user-Internet relationships emerged from this time period that now seem in opposition to each other. On one side, Hans Moravec's influential 1988 book *Mind Children* predicts a postbiological version of the Internet user in which "no essential human function, physical or mental, will lack an artificial counterpart" (2). Building on the 1946–1953 Macy conferences' foundational establishment of cybernetics and information theory, Moravec imagined a "transmigration" of the user into the digital sphere based on the belief that the "essence of a person," a user's identity, was "an abstract mathematical property," a reproducible "continuity of body stuff…the *pattern* and the *process* going on in [the] head and body" (ibid., 121; 117, author's italics); such a transmigration was then reliant on the recreation of an individual's "pattern-identity"

Figure 0.1 David Lightman (Matthew Broderick) and Jennifer (Ally Sheedy) in *War Games* (1983)

via a number of "momentary copies" or scans, of a person's brain (ibid., 119; 117). A network of computers, an Internet, would then "migrate" those copies back and forth, "juggling" them in a feedback loop between various areas of the new (external) mechanical brain and thereby replicating that user (120). A dense network of networks, as a series of interlocking databases, could potentially create a collection of users-as-copies, uploaded personalities without biological bodies, that could then be forever transferred back and forth across virtual (cyber)space.

Moravec's postbiological user hypothetically casting aside the human body was contrasted with Sherry Turkle's 1984 work *The Second Self*, a crucial text in its sociological consideration of actual users speaking and thinking about the computer technologies of the era. *The Second Self* describes users intimately connected to their machines, using them as a way of augmenting, not replacing, their physical bodies and identity; to many that Turkle talks to, the computer (and the Internet by extension) is a deeply personal space that is tied to a physical self-identity as much as any virtual one(s). This augmenting reflects Donna Haraway's articulations in "The Cyborg Manifesto" (first published in 1985; updated in 1991) wherein she sees the cyborg as a user where the biological cannot be replaced (or uploaded), but only extended by the technology that invisibly surrounds and incorporates itself into that user; the cyborg is therefore a "[chimera], theorized and fabricated hybrids of machine and organism…two joined centres structuring any possibility of historical transformation" (150). Haraway's cyborg is an especially powerful assemblage, particularly for females: by blurring completely the binary of machine-human into nonexistence, it resists any previous Western origin story (Oedipal, Christian, patriarchal specifically), and is instead a place of powerful self-creation and self-controlled identity. The cyborg, unrestricted by the familiar barriers of gender, sexuality, race, class, etc, embraces its artificiality and the invisible species/ systems that surround the user. The evolutionary, Internet-enabled cyborg, as offspring, was a place of (biological and virtual) embodied resistance, a means to survive in healthy dynamics with an increasingly complex and populous machine species.

The binary between Moravec's imagined uploaded and immortal postbiological user (post-scarcity, post-hunger) and Haraway's embodied cyborg closely grounded in actual Internet and computer usage, was contained by the fairly simplistic and sparsely populated Internet that existed until the early 1990s. Looking back, Jean Baudrillard's critiques of early computer use and the Internet as distantly hyperreal

and overly/unhealthily immersive (*Simulacra and Simulation* [1981; explored more fully in Chapter 3]) which then obscenely miniaturizes and commodifies humans into "nuclear matrices" (*The Ecstasy of Communication,* 129 [1987]), makes more sense within the context of their era: the Internet, in the textual and nondynamically flat form in which the small amount of users were interacting within it, was probably too simple in both interface and its inability to easily create many multiple avatars to generate the optimistic visions of the cyborg. As such, early Internet-engaged films representing the technology tended to follow Baudrillard's sentiments, manifesting the concerns into (fantastical) uploaded/postbiological villains like Jobe (Jeff Fahey) in *The Lawnmower Man* and Karl Hochman (Ted Marcoux) in *Ghost in the Machine* or openly sexual, duplicitous reprobates like Meredith Johnson (Demi Moore) in *Disclosure* (Dir. Barry Levinson, 1994). Ontologically, the physical reality (and bodies within) was the most valuable, "real," and the virtual (avatar) was "fake," only a faint fantasy. Yet, there is a danger of applying this binary ontology and parts of Baudrillard's critique to an evolved Internet that had, by 1995, changed drastically in density and virtual mobility. De Landa's 1991 robot historian pauses just at the end of the first era of the Internet and just before 1993 when the massively Popular GUI web browser Mosaic (later Netscape), and its source code, was released to the public. From this point, the Internet expanded into the average home at a tremendous rate, encouraging its users' virtual bodies to become more fully formed in a much more dense population of fellow, globally connected avatars.

The Second Era: The Early Mass-Popular Internet

The 1980s saw a mass of corporate, governmental, and academic institutions move toward networked computing as their main means of storing and transferring their information. Yet, that interaction and recording/storing of information was still largely kept away from "everyday citizen" until the end of the decade. Still, beginning in 1987, the server MERIT NSFNET, one of the major connecting spaces of the early Internet, grew from 28 thousand internet connected machines to over 160 thousand online machines in just two years (Ryan, 93). While the European Organization for Nuclear Research's (CERN) 1993 public release of the code that showed how to run a basic web server as well as the large-scale standardizing of web protocols to HTTP and WWW in the early 1990s was also very important, it was Mosaic (later Netscape), similar to the Macintosh's

transformation of the home computer, that provided the first GUI web browser of networked computers and effectively encouraged a nonexpert public to access and navigate the Internet more intuitively. This interface shifted the basic user of the Internet from one that required a great deal of technical skill to a more basic, general one: as opposed to the older command-line and FTP-style file downloading/exchange system, a user utilizing Mosaic could type in the address of a desired webpage and the information there would display immediately in the browser where the user could then spatially engage with it with the same point-and-click GUI home computers had been utilizing for close to a decade.

Initially, the webpages of this period displayed what was written by the designer or programmer and the pages were largely still limited to manually written, HTML marked-up (or previous templates of) static wholes. But the advent of Extensible Markup Language (XML) in 1998 enabled "more versatile documentation and data exchange within the Web" (Moschovitis, 224). XML was combined with dynamic scripts like Flash (1994) and PHP (1994) that generated objects/elements/spaces that were far more (potentially) immersive and interactive than what a basic HTML markup webpage allowed (Davis and Phillips, 2); not only did these scripts help to create more dynamic webpages but they also allowed easier integration of video and audio, expanding the Internet into a more multi-sensual realm capable of "real time" interaction between users. As well, Cascading Style Sheets (CSS), first released in 1996, allowed a designer to control the aesthetics of a whole site from one centralized file: previously, the style of each page had to be manually written into each page; with a CSS, a designer could have one file to control the style of all webpages on a site, effectively outsourcing a portion of the webpage's functionality to the computer/machine. The web browser changed very quickly from static, mostly human-generated webpages in the mid-1990s to a far more adaptable and human/machine cooperative virtual space by the turn of the millennium (figure 0.2).

With a more dynamically designed and coded cyberspace, the number of websites grew from 130 in June of 1993, to 23,500 in June 1995, to over 650 thousand by January of 1997 (Moschovitis, 277). The amount of web traffic grew 11 percent each month, and in the time between October 1994 and July 1995 the amount of hosts in the domain name system nearly doubled from 3.8 million to 6.6 million (ibid., 277); by 1996, nearly 50 percent of Americans were Internet users (ibid., 274). The massive increase in users also coincided with home computers becoming cheaper and easier to use. By 1996, one

and overly/unhealthily immersive (*Simulacra and Simulation* [1981; explored more fully in Chapter 3]) which then obscenely miniaturizes and commodifies humans into "nuclear matrices" (*The Ecstasy of Communication,* 129 [1987]), makes more sense within the context of their era: the Internet, in the textual and nondynamically flat form in which the small amount of users were interacting within it, was probably too simple in both interface and its inability to easily create many multiple avatars to generate the optimistic visions of the cyborg. As such, early Internet-engaged films representing the technology tended to follow Baudrillard's sentiments, manifesting the concerns into (fantastical) uploaded/postbiological villains like Jobe (Jeff Fahey) in *The Lawnmower Man* and Karl Hochman (Ted Marcoux) in *Ghost in the Machine* or openly sexual, duplicitous reprobates like Meredith Johnson (Demi Moore) in *Disclosure* (Dir. Barry Levinson, 1994). Ontologically, the physical reality (and bodies within) was the most valuable, "real," and the virtual (avatar) was "fake," only a faint fantasy. Yet, there is a danger of applying this binary ontology and parts of Baudrillard's critique to an evolved Internet that had, by 1995, changed drastically in density and virtual mobility. De Landa's 1991 robot historian pauses just at the end of the first era of the Internet and just before 1993 when the massively Popular GUI web browser Mosaic (later Netscape), and its source code, was released to the public. From this point, the Internet expanded into the average home at a tremendous rate, encouraging its users' virtual bodies to become more fully formed in a much more dense population of fellow, globally connected avatars.

The Second Era: The Early Mass-Popular Internet

The 1980s saw a mass of corporate, governmental, and academic institutions move toward networked computing as their main means of storing and transferring their information. Yet, that interaction and recording/storing of information was still largely kept away from "everyday citizen" until the end of the decade. Still, beginning in 1987, the server MERIT NSFNET, one of the major connecting spaces of the early Internet, grew from 28 thousand internet connected machines to over 160 thousand online machines in just two years (Ryan, 93). While the European Organization for Nuclear Research's (CERN) 1993 public release of the code that showed how to run a basic web server as well as the large-scale standardizing of web protocols to HTTP and WWW in the early 1990s was also very important, it was Mosaic (later Netscape), similar to the Macintosh's

transformation of the home computer, that provided the first GUI web browser of networked computers and effectively encouraged a nonexpert public to access and navigate the Internet more intuitively. This interface shifted the basic user of the Internet from one that required a great deal of technical skill to a more basic, general one: as opposed to the older command-line and FTP-style file downloading/exchange system, a user utilizing Mosaic could type in the address of a desired webpage and the information there would display immediately in the browser where the user could then spatially engage with it with the same point-and-click GUI home computers had been utilizing for close to a decade.

Initially, the webpages of this period displayed what was written by the designer or programmer and the pages were largely still limited to manually written, HTML marked-up (or previous templates of) static wholes. But the advent of Extensible Markup Language (XML) in 1998 enabled "more versatile documentation and data exchange within the Web" (Moschovitis, 224). XML was combined with dynamic scripts like Flash (1994) and PHP (1994) that generated objects/elements/spaces that were far more (potentially) immersive and interactive than what a basic HTML markup webpage allowed (Davis and Phillips, 2); not only did these scripts help to create more dynamic webpages but they also allowed easier integration of video and audio, expanding the Internet into a more multi-sensual realm capable of "real time" interaction between users. As well, Cascading Style Sheets (CSS), first released in 1996, allowed a designer to control the aesthetics of a whole site from one centralized file: previously, the style of each page had to be manually written into each page; with a CSS, a designer could have one file to control the style of all webpages on a site, effectively outsourcing a portion of the webpage's functionality to the computer/machine. The web browser changed very quickly from static, mostly human-generated webpages in the mid-1990s to a far more adaptable and human/machine cooperative virtual space by the turn of the millennium (figure 0.2).

With a more dynamically designed and coded cyberspace, the number of websites grew from 130 in June of 1993, to 23,500 in June 1995, to over 650 thousand by January of 1997 (Moschovitis, 277). The amount of web traffic grew 11 percent each month, and in the time between October 1994 and July 1995 the amount of hosts in the domain name system nearly doubled from 3.8 million to 6.6 million (ibid., 277); by 1996, nearly 50 percent of Americans were Internet users (ibid., 274). The massive increase in users also coincided with home computers becoming cheaper and easier to use. By 1996, one

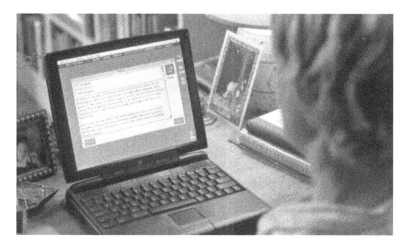

Figure 0.2 Kathleen Kelly (Meg Ryan) checks her email in *You've Got Mail* (1998)

in every three homes had a home computer, up from 8 percent in 1984 (as per the United States Census). The Internet became increasingly private, moving from public infrastructures (like libraries and universities) into the personal home. Finally, the last major difference separating this era from the previous one was the enormous increase in scale of the Internet, where users of the Second Era were plugged into ever-expanding, massively populated networks of other users all interacting in same ways.

However, reactions to and depictions of this exciting and expansive Second Era Internet began to problematically conflate generalized nonnetworked computer use with the Internet; while that confusion was fairly easy to identify, the Second Era is marked by a common and problematic jumbling of the Internet with virtual realities (VR). The stereotypical VR was a user, fully encased in goggles and gloves, navigating an artificially rendered three-dimensional world, like the use of The Corridor software by Tom Sanders (Michael Douglas) in *Disclosure* or Johnny Mnemonic (Keanu Reeves) in *Johnny Mnemonic*. Really, Mnemonic and Sanders are using a VR interface to navigate the Internet, and a too-futuristic one at that; for the average user of that era, the Internet was most likely accessed through a personal computer assemblage of monitor-keyboard-mouse (closer to the more realistic, but still advanced and fantastic, users of *Hackers*, *Sneakers* or *The Net*). *TRON* too is confusing as it is a very simple version of the Internet (low density) but its VR interface/immersion never quite separates the two technologies; similarly, *The Lawnmower Man* mainly

focuses on VR software used by Lawrence Angelo (Pierce Brosnan) and does not mention the Internet until the end of the film where the two are hastily merged. While the Internet user of the Second Era was moving into a deeper and more dynamic interactivity, the Internet has never required the sort of other-world complete immersion that a VR depicts. It must be made clear: a virtual reality is a (re)creation or simulation of a full and complete world, very often with the goal of copying reality; the Internet and its usage, as a facilitator of connection and interaction, makes no goals to replicate or (re)create a parallel version of its user's world, only to virtually/electronically store and retrieve and display bits and parts of information. Critique of Internet usage that fuse the two spaces/technologies fail to represent how a user actually used (or are still using) the Internet. We need to be careful when analyzing the movies in this text not to mix the Internet with unnetworked computer use or VR softwares, like video games and The Corridor, that are one part of the Internet (one network) that use the larger technology to communicate between its users; The Matrix, like The Corridor, is not the Internet itself but a piece of interface software into one network within an array of other networks.

Part of the confusion/conflation between the two technologies was due to a public ignorance around computers in general brought on by a fairly large knowledge gap between designers/engineers and average users of the Internet. The roots of this can be seen in texts like the Pulitzer Prize–winning *The Soul of a New Machine* by Tracy Kidder (1981) and Howard Rheingold's popular *Tools for Thought* (1985) and *Virtual Reality* (1991), all very excellent and readable texts that nonetheless muddle general computer use and the Internet while clearly separating the "genius" machine-familiar user from the average "ignorant" user. Too, a portion of the confusion can be attributed to the shift in value systems between two generations of users wherein McLuhan's Literate Man was asked to adopt and understand a Retribalized Man's technology;[3] echoing McLuhan, Fredric Jameson, in 1991, clarifies "the human subjects who happen into this space, have not kept pace with the evolution...we do not yet possess the perceptual equipment to match this new hyperspace, as I will call it, in part because our perceptual habits were formed in that older kind of space" (*Postmodernism, or, the Cultural Logic of Late Capitalism*, 38). For example, Michael Heim, writing in 1993, argues: "At the computer interface the spirit migrates from the body to total representation. Information and images float through the Platonic mind without a grounding in bodily experience" (as quoted in "Of Shit and the Soul" Muri, 76). Applying this deeply pessimistic

comment to the Internet belies Literate Man's ontological value of the physical body as the most important/unified, "real" marker of identity and creates, in dichotomy, the virtual avatar as a lesser shadow, a facsimile Heim, like Baudrillard's theoretical responses mentioned earlier in this Introduction, simplifies the Internet (and its potential), and in doing so addresses an imagined VR future full of Moravec's postbiological beings that doesn't reflect how Internet users of the time were actually engaging with the technology. Similarly, Slavoj Žižek's chapter "Cyberspace, or, The Unbearable Closure of Being" in *The Plague of Fantasies* (1997) imagines an Internet user conflated with a VR user (a term he repeats), a user split or "mediatised" into a "decentred subject" (180–182) that too resembles the postbiological. Such a subject, because of their reliance on digital "agents," is especially vulnerable to another program hijacking that user's avatar "unbeknownst to [the user]" (183) and in that vulnerability has "the identity of the self which perceives something (be it appearance or objective reality)" exploded (171). Žižek's imaginings of the Internet as potential "technological colonizer of the body" creates a world in which the user "loses contact with reality," where "bodily activity is more and more reduced to giving signals to machines that do the work for me (clicking on a computer mouse, etc.)" (172). From this perspective of the Internet, Moravec's postbiological seems horrifically realistic, even more so after the publication of Ray Kurzweil's 1999 book *The Age of Spiritual Machines*. Building on Moravec, as well as his own work in *The Age of Intelligent Machines* (1988), Kurzweil argues that the ever-increasing capabilities of computer hardware make it a near-future probability that replicating a person's complex patterns (via brain scan) within a neural net in multiple iterations, will become cheap and viable (101–103). Dense networks populated with a user's series of self-identity patterns would then be manipulated by "evolutionary algorithms" that would self-organize into a coherent entity remarkably (exactly?) similar to the original user (ibid., 75–83). Once a user can copy him/herself "connection by connection, synapse by synapse, neurotransmitter by neurotransmitter…[his/her] identity will be based on [his/her] evolving mind file. *[S/He] will be software, not hardware*" (ibid., 125, 129, author's italics). The Internet, as an already dense connection of personal computers, is the sort of hardware infrastructure needed to support these cyber-entities, providing the ports of users' minds a space to exist, and also the global mobility and rich population of users that Moravec deemed so necessary; the ability to download the self, then "plug into" the "pervasive" wireless Internet, an Internet augmented

by "readily accessible internal [databases]" of "human knowledge/ skills," created a utopian, immortal creature (Kurzweil, 144).

But Žižek's or Heim's version of the Internet never really existed in the same way that neither Kurzweil's nor Moravec's postbiological has come to be. To criticize the space by falsely imagining how a user actually used the Internet erroneously ignores it the ways in which a user engaged with a networked self or selves. For instance, such pessimism constructs a 1:1 ratio between user-avatar (one body, one Platonic "shadow"); however, by the late 1990s, the average Internet user would have had (many) multiple avatars acting and reacting in unique ways, always influenced by the physical body. Instead, we should return to Sherry Turkle, in particular, *Life on the Screen* (1995). In this text, she observes the self-replicating identities constructed and proliferated in the Second Era Internet as increasingly detailed and networked avatars, in line with what she calls "connectionist" ideals, hinging on a decentralizing of the self that recognizes human self-identity as an emerging system composed of many multiple parts (140); the Internet becomes the perfect technological enabler, providing a space to "build a self by cycling through many selves," "a sense of self without being one self" (178, 258). However, this cycle of selves is never just virtual: Turkle is always careful to stress the computer and Internet user's physical embodiment and, as such, we should combine her work with N. Katherine Hayles's *How We Became Posthuman* (1999). Hayles's posthuman, echoing Haraway's cyborg, is defined as "an amalgam, a collection of heterogeneous components, a material-information entity whose boundaries undergo continuous construction and reconstruction" (3). The posthuman is, most importantly, an entwined entity, one that depends on the body as the "original prosthesis" and looks at embodiment as one major means to establish identity; "consciousness," what the postbiological proposes to upload and fervently preserve away from the wetware body, is just "an epiphenomenon, an evolutionary upstart trying to claim that it is the whole show when in actuality it is only a minor sideshow" (3). Hayles's deeply flexible amalgam is far from a colonized or too-deeply immersed nonphysical entity; instead, the Internet-enabled posthuman is constantly regenerating itself based on sensual bodily/material input in combination with sensory information or data from the various technologies and/or networked (posthuman) users interpenetrated into that user. Because there is currently a great amount of scholarship done on the posthuman (*The Posthuman* by Rosi Braidotti and *Posthumanism* by Stefan Herbrechter were both published in 2013), there is no need to expand much further far at this point; instead,

acting as a robot historian, I establish the posthuman in order to align it with Turkle's depictions of actual Internet users, balanced/connected to a material presence and engaging with (and extended by) cyberspace and all the avatars within. Unlike Žižek's vulnerable phantoms or the future fantasy of the postbiological, Hayles, by using the past tense "became" in her title, sets up the historical transformation toward the posthuman as a process already underway and irreversible. At the turn of the millennium, this was evidenced by more portable, cheaper, and faster computers melding with software that began to better harness the Internet's dense networking capabilities. With these hardware/software migrations at the forefront, the Third Era of the Internet is eventually defined by the Web 2.0 technologies enabled by smartphones and apps that established the emergence of Marc Prensky's Digital Natives, figures parallel to Hayles's posthumans, as a formidable cultural and intellectual force.

The Third Era: Web 2.0 and a Horizontal Ontology of Repetition

The year 2000 marked a key turning point for Internet-user relationships: as the turn of the millennium approached, the year 2000 and its Y2K bug[4] was seen by some as a "doomsday scenario," inspiring alarming headlines like "Cyber survivalists fear Year 2000 means apocalypse" (Brandon, 1998), "The year 2000: Apocalypse soon" (Hansen, 1999), and making bestsellers out of *Time Bomb 2000* (Yourdon and Yourdon, 1998) and *The Computer Time Bomb* (Zetlin, 1998). Every Internet-enabled computer system, from transportation grids, to banks, to governmental and corporate infrastructure, was deathly susceptible; *Time Bomb 2000* detailed possible "blackout scenarios" in everything, from cars turning off at midnight, to banks being unable to open, to planes falling out of the skies. The Y2K bug exposed two major concerns: first, an increasing amount of information (financial, personal, corporate, governmental) was being uploaded and maintained by networked computers, exposing the dependency on these suddenly prone networks; second, because users had allowed computers to infiltrate and become ubiquitous "invisible species" (Kurzweil, *The Age of Spiritual Machines*, 71), humans were having to confront just how surrounded (outnumbered?) they were, and how that made them a species in danger. Even if the year 2000 did not seem like the End of Time, it did seem like a potential End of Times, or the end of a cycle of human development "as defined by man" (Carrière, 121).

The "Y2K scare" passing fairly harmlessly was a sympathetic reflex point in human-Internet relationships: instead of computers conspiring to overthrow human civilization, as in the sorcerer's apprentice scenario that Baudrillard imagines in *The System of Objects* (131), nothing happened. As *The Matrix Reloaded* and *The Matrix Revolutions* underline, a human apocalypse is also a machine (Internet) apocalypse and so the films begin to show the two entities working together in order to survive into the future. Therefore, if computers, enabled by an oncoming Web 2.0 Internet, were no longer a cartoonish menace and instead allies, they could be viewed as potential evolutionary partners. The collaborative relationships shown by Internet-using characters in *Swordfish* (Dir. Dominic Sena, 2001) and *The Core* (Dir. Jon Amiel, 2004) argue that the cooperating users of the Internet draw great amounts of power from their symbiotic relationships with the technology; in parallel, outside the theater, the average user increasingly allowed/encouraged the blending of the Internet and Internet-enabled devices into both his/her physical body and intellectual habits.

Specifically, the key migration to a Web 2.0 Internet moved the user away from the anchored desktop computer into a dense network of networks made up of increasingly portable Internet-connected devices like laptops and cellphones (later smartphones). Also, the web browser, long the main portal for the average user into the Internet, morphed dramatically. In the first two eras of Internet usage, the web browser was software that demonstrated the large gap between what the back-end designer and/or engineer knew about the Internet (basic functionality, ability to read and write code and markup) and what the front-end user knew. As chapter 2 discusses in detail, later in the mid-2000s, this chasm began to close as designers and/or engineers shared more of the workload of constructing a webpage with the average user and the machines themselves, leading to a vastly more dense and intimate Internet. The Popular implantation of "What You See Is What You Get" (WYSIWYG) bars allowed a user without a heavy-machine knowledge to create and publish content quickly and easily to a personalized webspace (figure 0.3). This individualized publishing was made possible by a vast surge in the development and implementation of Content Management Systems (CMS), managing and constructing ecosystems of digital design and engineering that amalgamate front-end user information/instruction with back-end design and function that then depends upon an extensive machine-controlled process that does the heavy lifting of creating code (and markup) and manipulating style elements (CSS). The

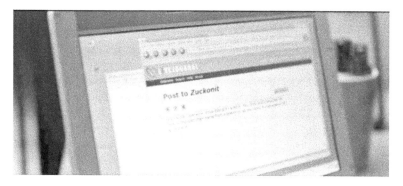

Figure 0.3 Mark Zuckerberg (Jesse Eisenberg) writes using a basic WYSIWYG bar in *The Social Network* (2010)

result is a webpage that is an extremely fluid and adaptable document: whereas earlier web browsing required the page to be (human) made before the visiting user accessed it, the CMS (machine)-driven site creates the page anew each time a user visits.

Encouraged by the non-apocalypse of Y2K, it is a machine-human symbiotic Internet that is densely populated by reciprocal actions between user-hardware-software, what Tim Berners-Lee calls a "semantic web" that is "linked in a way that can be used by machines not just for display purposes, but for automation, integration, and reuse of data across various applications" (w3.org, para. 6). Within this sophisticated space, users organize themselves into (McLuhan) Tribes through the integration of "wikis," "tags," and "taxonomies"; such incorporation creates units of user-generated, database-organized information that are displayed, redisplayed, and moved quickly/easily around the webpage, the website, and the Internet at large. This automation and reuse enables "recombination...collaborative content creation and modification" that eventually results in the compact networks of social media sites/apps like Facebook and Twitter (De Hertogh et al., 126).[5] These networks are further enhanced by what Sam Murugesan points to as the increasing use of Mashup APIs, software that "facilitates data exchange between applications, allowing the creation of new applications"; this allows an app like Google Maps to be integrated into another site or application (a Facebook event page). This has lead to the potential extinction of the web browser as more contemporary users access the Internet through a network of individual apps housed on increasingly portable devices. Putting this alongside the popularization of touch screens and tactile

interfaces, such a user (and the expanding population of common objects that make up the "Internet of Everything"[6]) is always virtually connected: a virtual avatar (i.e., an Instagram profile) does not go away when a user is not directly manipulating or interacting with it; also, unlike an older computer user that most likely shut down and restarted the machine with each use, the smartphone and laptop computers of 2014 are nearly "always on." All of these components interacting create a Web 2.0 Internet with a current world population in the billions that is extended by the vast increases in broadband speeds, hardware capabilities, and more complex (common) coding. This current Internet is cooperatively inhabited by users, designers/ engineers and managing/creating machines, creating a space beyond McLuhan's "global village" that is instead an (over)active, densely connected, portable "global city."

This "global city" is contemporarily constructed in *TRON: Legacy*, *Avatar*, *The Amazing Spiderman* (Dir. Marc Webb, 2012), as well as the "realistic" drama *The Social Network* (Dir. David Fincher, 2010), films where there are heroic and rich reflections of the Web 2.0 Internet user and his/her avatar(s) within visually stunning/complex virtual spaces that showcases intensely reciprocal machine-Internet-human assemblages. Yet, those films also recognize that the Internet is a physical technology as well as a virtual, machine, or "cloud" technology: the Internet depends on physical servers to store information, physical cables to transfer that information, physical devices used by physical bodies to access, control, and create that information. The networks of networks that make up the Internet are both physical and virtual. Recalling Rodowick's discussions of film, the Internet is both a physical technology/medium, materially present, that creates, by its machine-human interactions, virtual documents and spaces. Keeping this in mind strips away the uncompromisingly harsh ontological divisions that might force the Internet user to divide themselves into his/her strictly physical or strictly virtual components. Far from the software-only postbiological or hyper-immersed (singular) avatar of the VR user, the embodied Web 2.0 posthuman should gravitate toward Gilles Deleuze and his joint work with Félix Guattari to best understand how to navigate through the challenges in ontology and self-identity that confront a present-day user of the Internet.

Ella Brians is right to caution the application of Deleuze's theories on the body to cyberculture piecemeal, highlighting the problems with surface applications of Deleuze's machinic body and the rhizome as misinterpreting Deleuze's initial intentions. Still, by further burrowing into the term "virtual," we can provide a useful framework

to then place overtop the three eras of Internet use. Žižek's *Organs without Bodies* begins by clarifying that "what matters to Deleuze is not virtual reality but *the reality of the virtual*" (3, author's italics); Deleuze himself clarifies in *Difference and Repetition* that the virtual is "symbolic without being fictional" (208). De Landa uses atomic science as an illustrative example: "An atomic assemblage has an actual part, the components that actually interact to yield emergent properties, and a *virtual* part, the universal singularities and symmetries that structure its associated possibility space. The term 'virtual' refers to the ontological statues of entities that are real but not actual" (*Deleuze: History and Science*, 91). We can treat the Internet with the same understanding, as a space/phenomenon not actualized in a completely physical manifestation, but also not fictional (fake), as a space of interaction that demands/requires imaginative projection and conceptualization as well as embodied physical interactions and technologies.

From this understanding of the virtual, Deleuze and Guattari give some useful tools by which we can comprehend the physical/avatar relationship of the Internet user. As outlined first in Deleuze's *The Logic of Sense*, a person is a product of the interactions between his/her organism (physical body/bodies) and his/her (multiple) Body Without Organs (BwO). In *A Thousand Plateaus* (*ATP*), Deleuze and Guattari discuss the concept of the BwO as a as an abstracted projection of a person's identity that underlies the physical organism/body; a person will create many BwOs to deal with the many facets of experience a person goes through. As such, the BwO is "adjacent to [the organism] and is continuously in the process of constructing itself" (*ATP*, 164). The organism and the BwO are not opposites or binaries but rather deeply hybridized (ibid., 160). The authors differentiate the BwO into three categories: *Anti-Oedipus* lays out the empty BwO as one that "[resists] linked, connected and interrupted flow" that "presents its smooth slippery, opaque, taut surface as a barrier" (*Anti-Oedipus*, 9); this type of BwO can be found in the "hypochondriac body," "the paranoid body," "the schizo body," "the drugged body," and the "masochist body" (*ATP*, 150). Such a joyless BwO does not allow for a healthy range of interactions and connections that the authors argue a full BwO can accomplish. Similarly, the cancerous BwO becomes "mad, proliferates and loses its configuration, takes everything over," a "fascist" that wipes out any other potential BwO (ibid., 163). This text is most interested in the third type, the full BwO, an "intense" and "unified" entity that a place of multiplicity and power and joy, "full of gaiety, ecstasy and dance" we can

perhaps begin to see in a Web 2.0 environment (150). The full BwO is a positive construction of many different fragments, a "collectivity" that is open and allows other BwOs and information/sensations to flow through it (161). Explored further in chapter 3 of this text, Deleuze and Guattari's treatment of the full BwO resists Cartesian and/or Platonic separations of body and "soul" and instead move toward a flexibly dynamic understanding of self-identity as a repetitious mixture of subjectivities that are neither wholly virtual nor wholly physical, neither singular nor multiple, but composed of many different connections and relationships all at once (Brians, 137–138). As such, in the introduction to *ATP*, the authors cast aside the linear/ hierarchical treatments of the self as "tree" or "root" and embrace the structuring imagery of the rhizomatic map, asking their reader to embrace the interconnected and multitudinous interpenetrations of their (digital and other) self-constructions (BwOs) with his/her own physical organisms (and also others' physical and projected organisms and BwOs) as "intense" and unified "assemblages."[7] While the authors caution that a complete organism-BwO "unity" is not necessarily the goal (and may in fact lead to death or addiction [*ATP*, 165]), having "intense" full BwOs allows a person to participate completely in a healthy rhizomatic culture of assemblages interconnected within networks of other assemblages.

De Landa's cautious definition of a "society" as "an assemblage of assemblages" mirrors our initial definition of the Internet (*A New Philosophy of Society*, 25); the "levels of scale" and "density" come to define changes in the larger assemblages of assemblages, where the "levels of scale" acknowledges "the processes that historically produce the identity of a given social whole, but also the processes that maintain that identity through time" (*Deleuze: History and Science*, 9), and "density" is "an emergent property that may be roughly defined by the degree to which the friends of the friends of any given member (that is his or her indirect links) know the indirect links of others" (*ibid*, 4; *A New Philosophy of Society*, 56). The Internet of 2014 is a large portion of a present-day society, a portion that is at a level of scale and density unseen at any other point in history; the Web 2.0 user, as an extremely unique assemblage of other portable and intricate assemblages, is a massively complex and ever-changing entity that oscillates between the smaller scale of the individual and the larger scale of social machines or assemblages shiftily and confidently. This view of the Internet aligns itself with the sort of repetitive chaos that Deleuze and Guattari explain in *What is Philosophy?* as the expanding breeding ground for the virtual; an understanding of chaos that

embraces the infinite while "containing all possible particles and drawing out all possible forms, which spring up only to disappear immediately, without consistency or reference, without consequence" (118, authors' italics). The Web 2.0 user approaches the world and its inhabitants with the authors' understanding of the "philosophical virtual," one that "retains the infinite, *giving the virtual a consistency specific to it*" (ibid., 188, authors' italics). This consistency manifests (unifies) in Hayles's posthuman, an assemblage amalgam of full BwOs and organism (densely packed and small/large scale, simultaneously) that is constantly (and messily) regenerating based on sensory/bodily/material input in combination with technological and digital information (from the technology itself, other users, etc.). In contrast, the postbiological is an expression of the scientific understanding of chaos, one that "relinquishes the infinite" expanding cyberspace and the amount of repetitions or BwOs potentially generated within that space; in turn, such a perspective relies on Science's need for a snapshot, a "freeze-frame" or a "fantastic *slowing down*" of chaos, that is evidenced by Kurzweil's proposed scanning of a person's momentary brain state in order to recreate the (stable) software-only postbiological entity (ibid., 118, authors' italics). Such a creature is far from the adaptive and flexible Web 2.0 user of 2014, a user comfortable cycling through (and expanding) a variety of his/her avatars (BwOs), with each avatar in relation to the other and to an ever-morphing material and physical organism/body. This slippery and evolving version of the self, symbiotically blended with the machines and (Internet) technologies diffused into it, is a place of liberating potential: when Deleuze and Guattari talk about Faciality in *ATP* (as chapter 3 also does) and a need to break familiar and repressive colonial/capitalistic "faces"/visages, the authors are potentially advocating for Haraway's resistive cyborg or Hayles's posthuman, an entity in charge of her/his own construction that is able to redefine her/himself outside the dominant hegemony. That being said, there are parts of this text that are suspicious that without a self-aware Internet use and critically engaged movie watching the virtual space of the Internet will give way to nationalistic, military, and/or corporate interests. Chapter 4 outlines the dangers in the contemporary remilitarization of the Internet and a potential virtual machinic phylum as the new war machine that reappropriates civilian hackers as nationalistic soldiers, with *Iron Man 3* (Dir. Shane Black, 2013) as a pivotal example; similarly, chapter 5, using *Enemy of the State* (Dir. Tony Scott, 1998), *Swordfish, Iron Man 3*, and *The Dark Knight* (Dir. Christopher Nolan, 2008), challenges the need for surveillant

control of such a space by singular, governmental, or corporate assemblages.

Still, the robot historian of this text is an optimistic one. When Deleuze and Guattari ask "would it be possible to use drugs without using drugs" (*ATP*, 166), they are questioning whether it's possible to construct a full BwO capable of intensities and unity without the known prior mechanisms (addiction, paranoia, schizophrenia, etc.). I argue yes, that as the Internet and its interfaces have changed to allow and/or demand more engagement and immersion, and the ability for its users to generate more complex and interlocked/interpenetrated (often full) BwOs that remain deeply dependent on and tethered to their material organism, the Web 2.0 posthuman user is on a potential path to the healthy unity the authors imagine.

The Chapters

Combining the cultural interfaces of movies and the Internet required some chronological navigation but it made the most sense to organize this text by topic, rather than as a linear history. Chapter 1, titled "The Cables under, in and around Our Homes: 'The Net' as Viral Suburban Intruder," uses *The Net* and *Hackers*, and to a lesser degree *The Lawnmower Man* and *Ghost in the Machine* to explain how the populous explosion of the GUI browser Internet in the mid-1990s disturbed the innate conservatism of the suburban home. The threat of strangers hacking into private bedrooms and offices via the integrated device of the home computer mirrored much of the already present viral rhetoric surrounding illness, specifically, AIDS. Drawing heavily on Susan Sontag's *Illness as Metaphor* and Michel Foucault's explanation of heterotopias, the chapter contextualizes the era's specific concerns around Internet pornography and virtual deviancy as a way of explaining how the contemporary Internet user has "cured" him/herself. Chapter 2, "The Evolution of the Web Browser: The Global Village Outgrown," builds on this conversation by tracking how the virtual body is portrayed/reflected by the diegetic prototypes present in a number of movies. As Internet interfaces have evolved from text-based command lines to GUI, HTML markup-dependent web browsers to the CMS-run browser webspaces a contemporary Internet user utilizes, the individual human body has stopped being the structuring element of these virtual spaces; instead, the vocabulary and understanding of virtual space has morphed into a dense and urban one much closer to expansive and organic cities than global villages. The chapter combines Donald Norman's theories on interface

design with Deleuze and Guattari's work in *A Thousand Plateaus* in order to chronologically restructure the changes in organism-BwO relationships. Chapter 3, "*Avatar* in the Uncanny Valley: The Na'vi and Us, the Machinic Audience," acts as the central hub for this entire text, building on the historical transmigrations of the previous chapters with a particular focus on the posthuman that emerges from *Avatar*. Both its plot and the digital tools/techniques used (the Cameron-invented SimulCam specifically) bridge the Uncanny Valley and instead portray the instantly digitized bodies expressed within *Avatar* as an optimistic reflection of the increased technologizing of a modern movie audience that then generates the visual and semantic language(s) that a contemporary moviegoing audience, what I call the machinic audience, demands (more fully expanded later in this Introduction).

With the machinic audience at the base, Chapter 4, "Hacking against the Apocalypse: Tony Stark and the Remilitarized Internet," argues that while *War Games* and *The Matrix* represent the Internet as an antagonist and a treacherous technology, movies like *Swordfish* and *The Core* made after the non-scare of Y2K instead show humankind in cooperation with the Internet. This collaboration has resulted in the Internet becoming an exceptionally valuable military asset leading to a contemporary military's "man-in-the-middle" that is increasingly similar to the titular hero of *Iron Man 3*. The movie encourages a dangerous remilitarization of the Internet wherein the hacker has been repurposed from her/his civilian body into an outdated military assemblage that promotes an overly simplistic nationalism and a too-basic posthuman evolution. If Iron Man (Robert Downey Jr.) is not a healthy policing assemblage, chapter 5, "With a Great Data Plan Comes Great Responsibility: The Enmeshed Web 2.0 Internet User," answers who or what exactly would be the best cinematic Internet-enabled authoritative assemblage. Batman and Iron Man are discarded as too centralized and individual; as reflected by the pessimistic film narratives of *feardotcom*, *Untraceable*, and *Firewall* (Dir. Richard Loncraine, 2006), the digital Synopticon Thomas Mathiesen proposes is also dismissed because the average Web 2.0 user is too voyeuristically dehumanized to handle the responsibility. Yet, *The Amazing Spiderman*, in conversation with Vivian Sobchack's cine-aesthetic subject, provides a solution by structuring its heroic user as symbiotically tethered and intimately enhanced by his Internet-enabled technologies. Against this background of a burgeoning Web 2.0 Internet, chapter 6, "Don't Shoot the (Instant) Messenger: The Efficient Virtual Body Learns," begins with *Antitrust*'s arguments

around a contemporary digital ontology as it relates to capitalistic property/product. The chapter then uses the automatic learning in *Johnny Mnemonic*, *The Computer Wore Tennis Shoes* (Dir. Robert Butler, 1969), and *The Matrix* to explore how an Internet user's memory and knowledge built around Jacques Ellul's overwhelming "technique" potentially reduces him/her to walking hard drives. The solution to this reduction, made in part by comparing 1990's *Total Recall* (Dir. Paul Verhoeven, 1990) to the 2012 version by the same title (Dir. Len Wiseman, 2012), is a self-aware combination of Alison Landsberg's prosthetic memory and N. Katherine Hayles's concept of "narrative," wherein the Internet-using audience member balances his/her extreme access to digital information with his/her own specific embodied experiences to come to knowledge and intelligence. Finally, the text ends with "The Reel/Real Internet: Beyond Genre and the Often Vulnerable Virtual Family," which explains that the majority of films in the first two eras of the Internet foreground the technology and its users as science fiction and therefore strange and impossibly futuristic. *Disclosure* and *You've Got Mail* (Dir. Nora Ephron, 1998) are outliers in that they largely normalize the Internet with relatively naturalistic portrayals of the Internet and its usage. However, once shifted away from the distancing of overt genre, both films fracture the traditional family via the vulnerable female Internet user, a treatment that echoes loudly in 2009's *Trust* (Dir. David Schwimmer, 2010). However, *Me and You and Everyone We Know* (Dir. Miranda July, 2005) and *The Social Network* provide useful and optimistic counterpoints as their cinematic self-aware Internet users enhance/expand their intimate relationships into richly dense digital ecosystems that form new networks of families.

The confluence between cinematic representations of the Internet and actual user-technology interactions, and the Tribes or families this creates, is where this Introduction ends, with a more complete explanation of the machinic audience that populates a 2014 movie theater.

The Machinic Audience Emerges

As we end the Introduction we must remember that the moviegoing audience of 2014 is an Internet-using audience; they do not leave the (physical and virtual) tools or habits or desires they use to navigate the Internet at the theater doors. However, taking up Rodowick again alongside Deleuze's work in *Cinema 2*, we can see that the medium of the Internet, as we've described it in this Introduction, is not that

different than the medium of the film: "the real object is reflected in a mirror-image as in the virtual object which, from its side and simultaneously, envelops or reflects the real: there is a coalescence between the two. There is a formation of an image with two sides, actual *and* virtual" (*Cinema 2*, 68). A movie is also an assemblage of virtual and actual, "recollection-images, dream-images and world images" (68); "[the] cinema does not present images, it surrounds them with a world" much like the Internet of 2014 does (68–69). Lev Manovich similarly argues that "the designer of a virtual world is thus a cinematographer as well as the architect. The user can wander around the world or can save time by assuming the familiar position of a cinema viewer for whom the cinematographer has already chosen the best viewpoints" (*The Language of New Media*, 90). From this, the moviegoing audience of 2014 can (and does) understand and navigate both remarkably analogous virtual spaces in a sophisticated and a self-aware way.

This text's focal point then is on the establishment and observation of a present-day and future machinic audience (explored and expanded in much greater depth in chapter 3). A machinic audience does not just refer to the larger-scale social, capitalistic, and desiring "machinic" described in Deleuze and Guatarri's *Anti-Oedipus* or *A Thousand Plateaus*; the authors' sense of "machine" is abstract and philosophic, but work as broader conceptualizations in which to put specific viewers of movies that are also users of the Internet. In its most basic form, Marshall McLuhan would point to the machinic audience as those "extended by technology" that are "beginning to wear their brains outside their skulls and their nerves outside their skin" (258). I think of the machinic audience as the people I interact with on a daily basis, Internet users and movie watchers that are "artificially intellectual" (Bök, 17), a group of information-consumers/producers that understand language through the lens of machines and make meaning through the portals of screens, auto-tuning and search-engine algorithms. Like Haraway's cyborg or Hayles's posthuman, the machinic audience recognizes themselves as "a collection of networks, constantly feeding information back and forth across the lines to the millions of networks that make up the 'world'" (Kunzru, para. 40). As assemblages of organism-BwOs, they see themselves as a network of many different avatars and physical versions of themselves; they invite in and consider a near overwhelming amount of constant data, thriving in a densely social and informational world, while also consistently reflecting that virtual navigation back into their physical bodies. They are very savvy at navigating and parsing out "fake" from "real," eschewing a binary Platonic ontology and instead relying

upon the repetition, or cycle of selves, that the Internet enables. The machinic audience is Purse's "digitally literate spectator," and when such an audience member sits down at a movie, he/she expects that cinematic world to (actually or metaphorically) reflect his/her own world, a world interpenetrated by different virtual and physical networked technologies, a world saturated with a vibrant and interconnected Internet.

At this point, this text is still far from finished, one node in a series of future nodes. Over half the world's population does not have regular access to the Internet and so I found it painfully unavoidable to concentrate on Internet usage from a fairly homogenous North American–specific perspective. As well, there simply wasn't space in this text to begin to consider in the necessary breadth the gendered or class-based or different ethnographical portrayals of Internet users in the analyzed movies. There is also a great deal of work to be done expanding and considering some of this text's initial thoughts on how the Internet, and portrayals of it, fit within a global capitalistic system, a series of writings that would need to involve shifting the attention away from identity with a heavier inclusion of authors like Jean-François Lyotard and Fredric Jameson. Yet, the ambition here is to be one robot historian in a network of other robot historians, that this text will be picked up by a variety of users who might then take up the different tasks or movies that this text doesn't have the scope to cover in depth. As a robot historian who is always aware of my future audience, I've preserved and analyzed the texts here in hopes of making the user aware of his/her own Internet use and movie watching, and in that awareness create a healthy symbiotic cooperation between themselves and the Internet. The past number of decades have been dominated by the narratives and attitudes of McLuhan's Retribalized Man (who, while integrated into a less dense electronic literacy, still has profound connections to Literate Man's Romantic print-based (and material/bodily) literacy, narratives that depict human-computer relationships as futuristically alien or apocalyptically impossible. This text aims to generate a more optimistic view of the machinic audience, one that speaks on how an Internet user actually uses and feels about the Internet and his/her use of it, and one that does its best to imagine what future narratives and technologies the machinic audience might consume, create, and enjoy.

Chapter 1

The Cables under, in, and around Our Homes: "The Net" as Viral Suburban Intruder

Introduction: A Network of Perverts

The scene that perhaps best exemplifies the conflicting cinematic rhetoric behind the popularization of the Internet in the 1990s comes 49 minutes into the movie *Pleasantville* (Dir. Gary Ross, 1998), in which Joan Allen's character, the black-and-white June Cleaver clone Betty Parker, masturbates in her bathtub, her sexual self-awareness paralleled by the introduction of color into her various bathroom objects, her orgasm overlapped with a tree outside the Parker home that literally combusts.

Betty Parker inviting a sexual awareness into her home ran alongside the public's mass scale introduction to pornography via the popularization of the home computer and the GUI web browser in the 1990s. However, in *Pleasantville*, color doesn't just correspond to responses and objects related to sexual awareness: characters gain color simply by being exposed to new knowledge and reacting in an emotionally expressive manner. What makes the visual metaphor of the injection of color so powerful is the way that it explains how objects (or people) are not changed outright by this knowledge but, are, in the movie's view, enhanced, made more "real." Five years earlier, the popular form of the Internet, likewise, was suddenly allowing a giant excess of information (sexual and otherwise) into private homes, flooding the suburbs with an invisible tide of facts and languages and strangers from around the globe, giving access to previously hard-to-get (or unpopular or dissident) information and contexts.

Yet, this celebration of the power of information made possible by the Internet was buried under a wealth of terrors surrounding, superficially, obscenity and pornography. Already the public perception of pornography was linked to unhealthy sexual appetites and consumption; as experts such as Zillman explained in his 1989 study (and further studies by Donnerstein, 1984; Malamuth, 1984, Zillman and Bryant, 1984),[1] the effects of watching pornography include (among others) an "appetite for more deviant and bizarre types of pornography" that manifest in "distorted perceptions about sexuality" (as quoted by Richard E. Drake, 101). In 1995, Marty Rimm's study in the *Georgetown Law Journal* ("Marketing Pornography on the Information Superhighway") built on these fears by analyzing 917,410 Usenet "pornographic files"; the study found:

> Sixty-eight commercial "adult" BBS containing 450,620 pornographic images, animations, and text files that had been downloaded by consumers 6.4 million times; six "adult" BBS with approximately 75,000 files for which only partial download information was available; and another twenty-seven "adult" BBS containing 391,790 files for which no consumer download information was available. (1853)

More, these files contained large numbers of "paraphilic, pedophilic, and hebephilic" material (1854). The users of these virtual spaces were not couples using pornography as sexual aid, as 25 percent claimed they did (Munro, 43), but instead child predators engaged in illegal and exploitative behavior. The 1988 General Social Survey (GSS), a biennial US national survey that began in 1978, asked "Which of these statements comes closest to your feelings about pornography laws?"; an all-time high of 43.8 percent of respondents stated it should be illegal for all, with an added 51.2 percent saying it should be illegal for those under 18.[2] In particular, Drake's later 1994 study surveyed 250 psychiatric nurse professionals to gauge their perception surrounding the consumption of pornography, adding "there was 62% agreement that there are potential hazards to the consumption of pornography"; further, "approximately 38% of all psychiatric nurses agreed that PC [pornography consumption] can stimulate consumers to commit sex crimes. The majority (53%) did not know whether PC would lead to committing a sex crime." As well, "a large majority of psychiatric nurses agreed (78%) that there are risks for pre-adult consumers of pornography" (104). The research suggests a pervading view among healthcare authorities that while pornography doesn't compel individuals not already being medically treated for sexual crimes to commit

more, it is likely that easier (and earlier) exposure to pornography greatly heightens those offenders to commit another crime and with this comes an erosion of public safety.

Extrapolated out from this speculation, the Internet, as a networked distribution device, gave these previous offenders and sex criminals easy access to these urges and fantasies, a way to connect with other offenders and breed a further, larger population of deviants. To combat this growing fear, the Clinton administration introduced the Communications Decency Act (1996) that not only aimed to shut down all websites that produced and hosted such material but also severely limit the public's exposure to (digital) pornography. The goal was to limit the material that was already in this dense network that was gaining exponentially more users each month, and also to contain the exposure to obscene materials to a general public and, more specifically, children under 18.[3]

It is this idea of exposure that begins to build a vocabulary toward the shifting treatment of the body surrounding cyberspace and its digital inhabitants. Marshall McLuhan in the 1960s was at the vanguard of discussing the transition from Literate Man into Retribalized Man. McLuhan pointed to Literate Man, using books and the phonetic alphabet as his main mode of communication, as isolated, alienated and alone in his/her act of receiving and producing information; likewise, her/his body was seen as a singular vessel that housed the soul and mind, the rest of the world was intrusively external and other. What McLuhan began to observe was that the shift back into a Tribe-like culture, as mediated and encouraged by electronic technology, created new, Retribalized bodies that valued interconnection and communal values/knowledge. Yet, these generational shifts were initially slow (to go from Tribal to Literate took thousands of years), but the speed at which the electronic technology was increasing (both in capabilities and popularization, from electronic telegraphs to phones, televisions and radios, digital computers) leaves large gaps between even single generations; it was this immense speed of change that McLuhan points to as the site of real and potentially overwhelming trauma.

As discussed in the Introduction, by the early 1990s, Haraway's cyborg was competing with Moravec's *Mind Children* to establish vocabulary and modes to engage with this new value system. But nuanced and academic discussion hadn't quite filtered into the public consciousness. Instead, the Internet's explosion in popularity and use in the early 1990s can then be seen through the eyes of Rimm, Drake, and later the Communications Decency Act as an epidemic

rooted in the shifting value systems of the body, and, in particular, disease. Where Literate Man treated his body as the singular embodiment of identity, the Retribalized man (what Marc Prensky eventually calls a "Digital Immigrant") was digitalizing that body, making it multiple and projecting it into cyberspace with an increasing amount of personal information and agency. McLuhan would refer to these as "extensions" or "doppelgangers" but a reader in 2014 would know them, very familiarly, as avatars. Yet this move, in the early 1990s, from the physical body as the most valuable and stable marker of identity to the digital body and avatar (Platonic "shadows"), couched itself in vulnerability, and given the atmosphere of the era, this digital body was already seen as tainted, infected by the mere contact with cyberspace.

This use of "epidemic" and "exposure" mirrors the language of illness that Sontag describes in *Illness and Metaphor* (1978) and later in *AIDS and its Metaphors* (1988). Sontag points out that the blame for illness begins to shift in the eighteenth and nineteenth centuries from the carrier to the disease itself; using the modern idea of cancer, she points first to the metaphors of excess within the body ("the barbarian within" or a "destructive overpopulation") that deteriorates health (61). The early popular Internet was maligned with similar treatment: it was the general fear of exposure to excessive information (pornography but also alternate cultures, language, experiences) and its consequences and also the idea of being "invaded" and taken over, by the different users in the network. The digital body was especially vulnerable to this conquering barbarian, susceptible to the invisible virus of the Internet. The public perception then, limited by the knowledge of Internet hardware and software, was that the user's digital body, as Rimm insisted, was immoral just by merely associating in such a space.

But who or what was to blame: the Internet or its users? Sontag argues too that viruses have long been seen as reflections of their victims' moral character (those infected with TB had "a defective vitality," and later as the manifested punishment for immoral deeds [62]). Within the early history of computing, the computer virus and the metaphors attached begin to parallel Sontag's observations about AIDS in the late 1980s and early 1990s. Sontag states that the metaphoric language around and treatment of AIDS was a mix of what she sees as having a "dual metaphoric genealogy" (105) that combines the central language of the modern cancer (of invasion) with the older metaphors surrounding TB (of pollution). Adding to this early rhetoric was an insistence that it attacked "risk groups," namely

homosexual males, linking it what she calls a perception of "unsafe behavior that...is judged to be more than weakness. It is indulgence, delinquency," to which she also adds "illegal" and "deviant." This link between AIDS and deviancy and "weakness of will" were further attached to the stigma of homosexuality and its perceived "unnatural" lifestyle; more, a general misconception of the mid- to late 1980s was that "normal" heterosexuals couldn't contract the disease. When heterosexuals began to be infected with HIV, the same stigma and obscenity that was attached to being homosexual was also transferred to anyone with the virus and the fear of being associated with AIDS rose alarmingly fast. Further ignorance perpetuated myths of contraction and suddenly made the panic of anyone being infected with the disease (from kissing, touching, associating) seem very real.

Though Marty Rimm's report was later discredited,[4] in 1995, this fear of perverse invasion into the private home parallels the perception of AIDS and the general distress that came with the popularization of home computers and the Internet. Spurred by Rimm, *Time* ran a cover story on the extremely pervasive nature of cyberporn, insisting "you can obtain it in the privacy of your home—without having to walk into a seedy bookstore or movie house" (40). The rhetoric around the access to pornographic material showed how the clearly demarcated spaces for pornography (and for the deviant consumers) had moved from public spaces of sale and, perhaps, surveillance and transparency, where a knowing customer had the added shame of having to potentially be seen entering these spaces, to the private home, an unwatched space where such perversion could fester and spread epidemically. As Literate Man's privacy and isolation, as encapsulated by first the private body and then the home too, began to be invaded with the fears of AIDS and the "nonnormative values" attached, so too was the Internet infecting the private home and body with an invisible wave of perversion, causing an outbreak of already-ill avatars created in cyberspace. In reaction to this concern, a number of films of this period chose to deliberately set these fears within a suburban setting.

While American films have long expressed the fears that characterize the suburbs as an overly homogenized community that breeds violence, menace, and immorality (*Blue Velvet* [Dir. David Lynch], *Invasion of the Body Snatchers* [Dir. Don Seigel] just two quick examples), the enemies within those films are external and corporeal (aliens/communist spies, oxygen-sucking perverts). This then parallels what Sontag saw as the shift from the metaphor of disease (and cancer) to the virus (and AIDS). Deliberately then, the enemies of

The Net and *Hackers*, both released in 1995, began to transform into invisible digitalized invaders with impossible infrastructural and ever-present omnipotence, undetectable strangers that would climb into a user's computer and private life in the same way a prowler would climb in through an open window. The victims/protagonists within the *The Net* and *Hackers* struggle to keep the infection attached to their digital avatar from spreading to their physical bodies. Using the suburbs as a symbol of stability and familiarity, the two latter films grapple with the changing of an individual into a collection of discreet digital information; the enemy then was invisible, viral, able to manipulate or destroy that personal information. This accelerated killer was already inside the house and digital body, not in a closet or basement, but on every floor and in every organ simultaneously.

The Suburbs as Symbols

Ralph G. Martin opens his 1950 *New York Times Magazine* piece "Life in the New Suburbia" with a thought experience that transforms the Long Island suburban development from a view of "tractors levelling the land" and "unlandscaped mud" into the "new Suburbia"; he describes this vision as "a future park, all dressed up in thick trees and birds" and houses as encasing "cozy furniture arrangement around the fireplace" and "your wife busy in the kitchen making another fancy dessert, the crying of a brand-new baby" (14). This idealized projection was at the heart of American post-WWII development, a creation that was as much a project of actual physical buildings as of the post-war optimism, wealth, and healing that was the result of mass trauma and the created absences of husbands, fathers, familial units.

Sontag adds that moving into rural and suburban places was actually tied into how urban settings were linked to disease and that in order to "cure" the human body, the patient had to move to "the south, mountains, deserts, islands." More, "the city itself was seen as a cancer—a place of abnormal, unnatural growth and extravagant, devouring, armored passions" later quoting Frank Lloyd Wright's description of a big city as "a fibrous tumor" (73–74). In order to escape from these places, especially post-WWII, families began an exodus in hopes of curing the home from the ills of violence and depravity associated with cities. The suburbs then became a microcosm of conservative postwar value systems, a cliché that Robert Beuka in *SuburbiaNation* explains would backdrop sitcoms like *Father Knows Best* (1954–1960) and *The Donna Reed Show* (1958–1966), a set of

mythologies and value systems that would center around G-rated perfect families, mildly living through familial and financial success. The value systems within these spaces were inherently conservative and traditional in terms of familial units and moral systems, slow to change and accept "intruders" or "outsiders."

The suburbs then are a place to escape the sorts of moral diseases of the city and also a safe haven that promotes stability and well being of not just individuals but the American nation as a whole. Yet, the need to affirm certain value systems in these spaces implies the need to argue against and perhaps demonize the opposite of those values. Beuka argues that the representations of these suburban spaces reflect Foucault's notion of heterotopias. To Beuka, the early representations of these spaces, in film especially, are projected ideals that "[emerge] as a place that reflects both an idealized image of middle-class life and specific cultural anxieties about the very elements of society that threaten that image…evidence of our culture's uneasy relationship to a landscape that mirrors both our fantasies and the phobias of the culture at large" (9). With this approach, American film has had a long history of deconstructing these fanciful visions to showcase the potential violence and abnormalities behind the suburban façade to the point where in 2014 this "subversion" of the suburb is an overfamiliar television and movie trope itself. Still, Don Siegel's *The Invasion of the Body Snatchers* (1956), though unpopular at the time of its release, has gained in stature largely through its treatment of what Katrina Mann calls the subversion of "postwar hegemony" (49). The film explores the now overly familiar notion that suburbs, with their "cookie-cutter" replication of carefully measured housing/yards, create staunch homogeneity that mirrors the fear of Russian Communism. Sontag is quick to point to this film specifically as linking into communism into the metaphoric language of "the invasion of 'alien' or 'mutant' cells, stronger than normal cells" (68). Within the film, there is a need to distrust the familiar, the neighbors that are created by the homogeneous "equal" spaces of the suburbs. What makes *Invasion* a true horror film is that the mutation that emerges is a deformity of the value systems within the stable suburban environments, treating Communism as an illness "to impute guilt, to prescribe punishment" (Sontag, 82). To be Communist is to be antihuman, a mutant or alien (in the same way, she says, Trotsky described Stalinism as "a cholera, a syphilis, and a cancer" [82]). As Dr. Miles J. Bennell (Kevin McCarthy) first finds the pods in a greenhouse he exclaims "somebody, somewhere wants this duplication to take place!" pointing toward some mysterious, unseen, outside force

imposing itself upon the neighborhood. The clichéd version of the suburbs as a heterotopia becomes the perfect breeding ground for the real threat: the "infected" and reprogrammed citizens, controlled by "somebody, somewhere"; they are citizens completely swallowed by an outside force hell-bent on replicating and "equalizing" the American notions of the Individual (defined by hard work that is rewarded by material success) into oblivion.

Similarly, David Lynch's *Blue Velvet* (1986) uses Jeffery Beaumont's (Kyle MacLachlan) small town projections of "the American Dream—a comfortable, orderly, secure life" as a catalyst for a "moral education that involves confrontation with his own capacities for violence and perversion" (Knafo and Feiner, 1445). Violence and perversion lay just barely beneath the surface: the opening shot of the film pans down, literally below the earth, underneath the homes and white picket fences (echoing Martin's profile) to focus on the dirt underground. The "illness" in *Blue Velvet* is one of sexual perversion, drugs, and violence, considered stereotypically as "urban" problems. Whereas the stereotypical suburban family is the nuclear family, Dennis Hopper's Frank Booth is much like Zillman's pornography viewer: he's fetishistic, prone to violent outbursts of sexual aggression; at a more basic level, his and Dorothy Vallens's (Isabella Rossellini's character) relationship is based on uneven power dynamics and the complete embracing of sexual urges outside of a monogamous relationship. Lynch's Booth is the precursor to Rimm's Internet deviant. By paralleling Zillman's research, Booth is perhaps a product of pornography being brought in the private home by magazines, but more importantly, by VHS tapes and the VCR. In *Changing Suburbs*, editors Richard Harris and Peter J. Larkham are quick to point out that the initial utopic visions of the suburbs post-WWII were largely a reaction to new or cheaper technologies; paralleling the earlier transformative effects of cars and highways, VCRs, and the early Internet, simply by making information and documents more readily available and easy to replicate (watch in private and distribute), the average suburban user necessarily morphed the user into one that valued and expected privacy. *Blue Velvet*'s violence takes place in bedrooms and closets, away from the casual dinner parties of *Invasions*. While Seigel's film takes on the sort of communal (and public) infection of communism into the suburbs, Lynch's suburbs are one where the private spaces are the most vicious, where the biggest danger comes not on the lawns but in the closed spaces of the homes themselves.

Both films are key explorations of the relationship between the suburbs and "the fantasies and the phobias of the culture at large"

(Beuka, 4), especially when contextualizing American film's movement into the early to mid 1990s where the relationship between the body and technology and "illness" becomes especially panicky. In *Invasion*, the mysterious invaders, after replicating, replace the older bodies by killing them. This is Sontag's treatment of cancer: the invaders are purely destructive forces whose job is to kill "healthy" Americans and replace them with copies. While this initial fear of copies and multiple versions of identity is present and very real in the film, the pods of *Invasion* are still remarkably organic. When Bennell finds the first pod in a closet, then later another in the greenhouse, the viewer can see that these replacement bodies are like plants; Bennell insists "that if they are like seeds and seed pods, they must grow on a plant." Once the pods have "undergone the process" of forming, the creatures are still recognizably human and embodied. While the end of the film's terror is based in the idea that "They're already here! You're next!" Bennell is able to escape and warn the authorities. More, this invasion is small, contained and, as Bennell demonstrates, escapable. Within *Blue Velvet*, Frank Booth is also still a physical human that is ultimately constrained by his physical body as well; Beaumont is able to triumph over Booth by shooting him, and is then able to return, albeit immensely changed by the whole experience, to his "normal" life in which Dorothy reunites with her son and Beaumont reunites with his girlfriend, Sandy. Through Sontag's lens, both films present an illness that is rooted in the biological body and is then able to be contained and ultimately able to be controlled and eradicated.

The key to understanding *The Net* and *Hackers* then is to compare the two heterotopias that both films take place in: the suburbs and cyberspace. If we are to take Foucault's definition of a heterotopia to mean an imagined or fictionalized/exaggerated (virtual) space in which a culture can examine its fears and concerns under the guise of a familiar landscape, then, starting in the 1990s, the digital space of the Internet becomes such a place to unpack. More specifically, Foucault, in describing the heterotopia, argues that process of staring into a mirror, at a double of one's self (like an avatar) is essential in creating the space, but "the mirror functions as a heterotopia" (333). Like the mirror, the Internet functions as the "virtual space which is on the other side of the mirror" that "makes the place that I occupy, whenever I look at myself in the glass, both absolutely real—it is in fact linked to all the surrounding space—and absolutely unreal" (333). The "unreal" space of the Internet, doubling and mirroring, becomes the same site of fantasy and fear that Beuka links to portrayals of the suburbs. Within the *The Net* and *Hackers*, the infection of

its characters becomes reflective of the deep roots the Internet had already grown and worries that arise from that particular space as contrasted against the conservatism of the suburbs. *The Net* and *Hackers* treat the Internet much like how *Invasion* treats Communism: both are invisible transformative invaders, illnesses. Yet, Siegel's invaders, as reflecting Sontag's earlier versions of TB and cancer in 1978, no longer reflect the sort of dormant and yet ever-present nature that the Internet held in the early 1990s. While Frank Booth is closer to Sontag's understanding of AIDS as linked to immoral perversity and over-sexualization, the character lacks the same concerns around the AIDS virus (dormant symptoms, invisible, fast) that are the same fears that the films of the early to mid-1990s struggle with. In both *Blue Velvet* and *Invasions,* the enemy is a physical entity, made corporeal and able, ultimately, to be combatted or escaped; the landscape, similarly, is a familiar physical one of recognizable homes and physical spaces. However, as the Internet and home computing became more popular and affordable in the late 1980s–early 1990s, the enemies of *The Net* and *Hackers* shifted from the physical to the ethereal, laying bare the shifts (and fears/concerns) of a changing value system in which the physical body, and the identity housed within, were becoming increasingly diseased by its digitization.

The Explosion of the Internet and Home Computing

The Introduction detailed the specifics that brought about the Second Era of the Internet and the exponentially expanding communities of digital users that flooded technology; such a shift brought more complexity to the Internet user's virtual spaces and populating bodies,[5] but this complexity was contingent on the Internet becoming increasingly private as it moved from public infrastructures (like libraries and universities) to the personal home. While these jumps allowed for a closer actualization of McLuhan's Global Village, they also created fears and anxiety surrounding the digitizing of the self into dense cyberspace that did not resemble cozy villages or familiar suburbs, but rather interconnected city blocks. Early visualizations and treatments of the Internet followed William Gibson's description of cyberspace in *Neuromancer* (1984): the drug-addicted and at-the-margins-of-legality protagonist Case describes it first in vague narcotic terms, as "a consensual hallucination" (51) but continues that cyberspace is "lines of light ranged in the nonspace of the mind, clusters and constellations of data. Like city lights, receding..." (51). Within this treatment of cyberspace is an echo of Wright's and Sontag's

arguments aligning metaphors of urbanity with illness; already, within the very nature of the technology lies the potential for virus or disease. While the user recognizes it as a "hallucination," unreal and a copy, to explore "the nonspace of the mind" demands that the user abandons, to some extent, the physical body that Literate Man attaches identity in order to even enter. With this necessary detachment comes the confusion and the fears around a new (vulnerable) digital body/bodies that is part of the communal (and "consensual") Retribalizing process.

Also, information was obviously vastly different than the Literate Man's previous dealings: instead of information being housed and presented in a linear and contextual document like a book or a newspaper, knowledge on the Internet was scattered, thickly connected by hyperlinks, often entirely bare of authorship or agency, like Beaumont's discovery of a human ear in a field, unconcealed and without context. This invisible torrent of information posed access to value systems outside the "norms" of the users' (conservative) private home and larger community; as such, there was an anxiety around this new, "different" information being beamed directly into the home and how to contain or monitor it (see, again, the Marty Rimm report from 1995).

The "home" or "personal" computer, as these devices were marketed, represented an extension of the house, an extra room, where a user would populate it with folders and files and programs as furniture. However, treating the computer with this sort of metaphoric language ignored the fact that the Internet, by its very nature, is an extremely public network and any computer in that network is, of course, public. The terror (or realization) that other users of the Internet now had access to that user's computer and could infiltrate that private home by slipping, unseen, through the phone and cable lines began to take root. Once inside the home, that stranger would burglarize not the jewelry or television set, but rather the information and records that had been digitized over the previous decade and half. Again, as entrance into cyberspace demanded a necessary extension or detachment from the physical body, there was a fear for both the private home and the body as private space. The struggle to maintain private documents (governmental, like a driver's license, and also personal ones like pictures, narratives, even "likes" and "dislikes") and the identity of the self that a user defines by those documents, is at the heart of a number of Internet-engaged films of this era.

One of the first (and most popular) films looking at these apprehensions was *Disclosure*, but its construction of the Internet as a "background" technology and its specific gender-centric concerns

make it necessary to explore the film in greater depth, which we'll do in chapter 7. At this point, it's most useful to begin with another film that articulates the anxieties of the era, *The Lawnmower Man*. Set mostly within a suburban neighborhood, its plot follows virtual reality researcher Dr. Lawrence Angelo as he experiments on a developmentally delayed Jobe Smith. Much of the film takes place within the personal home of Angelo where he already has a computer and a full virtual reality sensorium (gloves, goggles, bed) set up in his basement. When Angelo begins "curing" Smith by augmenting and retraining his brain via VR programs, it sets off a chain reaction in which Smith grows so powerful that he develops telekinesis and is eventually able to put other people to sleep or cause them to burst into flames. Jobe Smith begins the film as caring and playful and ends it, after being enhanced by computer technology, as inhuman, evil, and murderous; this transformation oversimplifies the fear that the Internet, and its potential access to a wealth of information, would corrupt an average user in much the same way. The fears become more specifically pointed toward the vulnerability of personal information and identity in *Ghost in the Machine*, where serial killer Karl Hochman selects his victims by stealing address books that have been uploaded to his computer shop's databases by unwitting customers, then uses that intimate knowledge to gain entrance into the home. After a car accident, he dies, but, as he's enclosed by an MRI machine, the MRI is hit by a power surge and his "soul" is uploaded to the Internet, after which the killer begins to torment the protagonist Terry Monroe and her son (played by Karen Allen and Wil Horneff, respectively) by accessing and manipulating their personal information (and appliances) at will. The film showcases fairly obviously the panic of a stranger accessing personal information (address books) and the ease with which that information can be used to commit horrible violence; also, there are a number of shots that show the presence of the cords and cables leading to different appliances and computers in the Monroe's home as the killer "travels" along them, implying how quickly and easily a deviant user of the Internet can occupy and navigate the private home. At the end of the film, the killer actually takes a physical form, a light/information swarm; correspondingly, when Smith dives into the mainframe computer at the end of *The Lawnmower Man*, his physical body shrivels and becomes grotesque while his digital avatar grows menacingly with sharp teeth and fingers. In both cases the new digital embodiment is inhuman and terrifying, aligning digital beings with evil and scaring the average viewer/potential Internet user away from cyberspace.

Both *Ghost in the Machine* and *The Lawnmower Man* are intriguing in that they give some useful early envisioning of the internal cyberspace, but both treat that space as a blocky and overly abstracted landscape. As well, perhaps building on a general audience's ignorance of the Internet, *Ghost in the Machine* confuses the Internet with all electronic objects plugged into a wall (dishwashers and microwaves, for example) and muddles a lot of cogent concerns with increasingly strained plot turns and a cartoonish demonic antagonist. *The Lawnmower Man* mistakenly treats the VR program Smith uses to train, a piece of localized software, in the same way that it treats the Internet and cyberspace and, in such a treatment, the film generates an erroneous version of what the Internet was and how it was actually being used at that time; in fact, it isn't until the end of the film where Smith threatens to enter into a mainframe computer that the idea of large-scale networked computer systems is even addressed. This mashing of technology in both films fed into and reflected a general ignorance about the Internet that only reduced the technology and further confused an audience toward the Internet's potential. While *The Lawnmower Man* was reasonably successful (making just under 27 million dollars on a mostly American release), *Ghosts in the Machine* earned just under 5 million in the United States (despite a budget of 12 million); by contrast, *The Net*, released two years later, earned over $110 million worldwide.[6] While *Ghost in the Machine* and *The Lawnmower Man* provide a first look at the fears surrounding the Internet, *The Net* and *Hackers*, as more popular films, are more useful to analyze, as each provides unique (and generational) fears about the digital body as the carrier of potential infection.

The Net and Hackers

Hackers opens with a disorienting scene in which the camera follows a SWAT team, assault rifles in hand, as they charge through a suburban neighborhood complete with a barking dog and a man washing his car. The camera lens then distorts the scene: the colors and sounds appear underwater and the camera jostles as if running before snapping into focus as the SWAT team rushes into the private home. The juxtaposition of brute force (the police breaking down first the front door, then Dade's bedroom door) against the serenity of Dade's mother plating breakfast just before the private home is invaded underlines the violence of invasion that Dade's misuse of the Internet has justified.

When the film resumes, 11-year-old Dade is in a courtroom (a boy the age and class that the Communications Decency Act aimed to

protect) as he is sentenced to a mandatory quarantine from the Internet for seven years for his role in creating and utilizing a computer virus that "crashed one thousand five hundred and seven computer systems, including Wall Street trading systems, single-handedly causing a seven point drop in the New York Stock Market." Right away, computer usage is linked to, as the lawyer describes, "destructive and antisocial" behavior; initially, the child version of Dade, as easy shorthand for innocence, invited the Internet into the private suburban home and was corrupted by it, even going so far as to infect other systems.

When the film resumes after the title screen, Dade is 18 years old and trying to hack, via social engineering and a clumsy computer interface, a television station. There is a prolonged shot of the camera following a series of wires between floors as Dade speaks; like the serial killer Hochman, the Internet is already inside the home, at once visible in the protruding wires but also invisible in how it hides in the walls and floor. After Dade fights for control of the television station with hacker Acid Burn/Kate (Angelina Jolie) and is defeated, the viewer meets his mother (Alberta Watson) who complains to an unknown person on the end of the phone that Dade has been locked in his room with his computer for a week; she pauses then to ask "Dade, do you like girls?" The idea of homosexuality (or perhaps asexuality) is conflated with computer use, further linking computers to "abnormality." Adding to this, we also see now that he and his mother have moved into a significantly smaller brownstone in New York City; the father is absent and the mother is the only family member (and friend) Dade has. The punishment for Dade's Internet use was to be banned not only from this suburban utopia but also from the traditional nuclear family unit as well.

The Net's introduction of its protagonist is very similar: when we first meet Sandra Bullock's character Angela Bennett, we see that she lives in a quiet suburban neighborhood in a full house. Yet, echoing *Hackers*, the camera begins with a wide shot of the neighborhood that slowly focuses in on a skylight in Bennett's house that then pulls in tighter, invading the home as the SWAT team did, to settle on a prolonged shot of Bennett, surrounded by multiple computers, playing *Wolfenstein*. Unlike Dade who wields viruses, she works as a computer virus expert, and in that first scene she works expertly through reasonably complicated actions of debugging and capturing a virus. Yet, her work station is in her home and Bennett similarly invites the Internet in, depending upon it not only for work and money, but also for ordering dinner and social interaction. The screen saver of a fireplace gives the illusion of suburban homeliness but as she chats

(in the dark and completely alone) with strangers online, the viewer sees Bennett as reclusive and lonely; her interactions, at this point, are completely mediated through technology (a phone, then a computer) and this is immediately linked to an unhealthy solitude. When she "talks" in the chat room, the voice that replies in a completely mechanized filter that strips out all markers of identity (a unique voice, accent, speaking pattern); as multiple users within the chat room then insist she is "one of us," echoing first the malformed, table-pounding chanters from the classic *Freaks* (1932) but, more strongly, aligning her directly into the robot inhabitants of the Internet.

Once she is tethered to this notion of inhabitance, the viewer follows her on her vacation, where she meets the villain of the movie, Jack Devlin (Jeremy Northam). Not knowing he's a villain, she engages in a one-night stand with him. This is the sort of sexually reckless behavior that Sontag points to as a stereotypical perception of an AIDS patient. This "irresponsible" sexual activity is compounded by her interaction with the Internet, doubly infecting her and, as the film argues, doubling the need for punishment. When she's then attacked by a duplicitous Jack Devlin, he steals first her physical records (passport, driver's license, money) but then, more terrifyingly the film insists, he starts destroying her digital identity. The tag line for the film states, in red letters, "Her driver's license. Her credit cards. Her Bank accounts. Her identity…Deleted." The lesson here is that, by inviting the Internet into the formation and maintenance of personal identity and records, Bennett is leaving herself horribly vulnerable to being erased. In fact, that's what happens: she struggles to get back into the country and when she does, she finds her whole identity has been wiped clean and replaced with a drug addicted ex-con's name Ruth Marx (the sort of "demonic possession" Sontag associates with cancer) (figure 1.1).

She's even replaced at her old job by a new "Angela Bennett" (made possible by the established fact that Bennett has never met anyone, in person, at the company), a doubling that should remind us of *Invasion of the Body Snatchers*, shifted slightly toward the distinct horror of the Internet providing "pods" through the easy creation of avatars. Finally, when she gets back to her suburban home, she finds it has been sold while she was gone and her name has been taken completely out of the records of its ownership. Like Dade in *Hackers*, because Bennett invited the Internet into her house, her punishment was to be cast out from stability (as represented by the suburban environment) and into a paranoid jumble of a life that eventually leads to a mental hospital and jail.

The implication is that any movie viewer, by acting in the same way as Bennett and digitizing his/her own private world (as necessitated

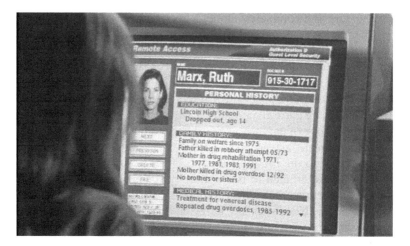

Figure 1.1 Angela Bennett (Sandra Bullock) looks in the digital mirror and sees her ill Ruth Marx doppelganger (*The Net*, 1995)

by government, bank, police records), becomes just as vulnerable to this home invasion and identity deletion. In fact, the home and private conversations are the primary entry point for the physical villain of the film, Jack Devlin: in the opening chat room scene, the viewer sees Bennett innocently share private info about a vacation and then list the qualities she finds attractive in a man, all information that Devlin later uses to woo Bennett. His main entry into Bennett's house was through the chat room that she is seen using at the beginning of the film. Devlin impersonates a friendly stranger (another *Invasion* pod), retrieves all the private information he can get from Bennett, and uses that to ultimately wipe her existence out. This information and identity manipulation is a task so easy that Devlin is shown later in the film on a laptop, in his car, changing her police records in real time; there is also real time changing of digital DMV records and medical records (at the hospital and drugstores). Similarly, in *Hackers*, Fisher Steven's character, The Plague, changes Dade's mother's police profile into "a wanted felon in the state of Washington." The physical body is completely secondary in the film, no longer the true house of identity; instead, that identity has been projected into the vulnerable digital space. When Bennett's digital identity is transformed into "Ruth Marx," she has no other alternative but to live as Ruth Marx; she has no real "proof" of who she is otherwise. It is Devlin then, a name deliberately close to "devil," that is the external embodiment (and cautionary corporeal presence) of the Internet; when Bennett

invites Devlin into her suburban home through the window of that chat room, her casting out and destruction and break down begin, resulting in her transformation into "Ruth Marx."

While the metaphoric infection of Bennett's digital identity is a bit more subtle, a clearer depiction of the body and disease can be further explained by looking at Bennett's relationship with her Alzheimer-stricken mother. In the first such scene, Bennett's mother doesn't recognize her, first asking how Bennett knew what her favorite cookies were, later mistaking her for one of her former students. The notion of Bennett's fragile identity is further deepened by her mother's missing memories and, perhaps more interestingly, the notion of Alzheimer's as a potentially hereditary disease. In much the same way, the invisible Internet is destabilizing her identity and relationship with her own self, just as her conversion into "Ruth Marx" shows the dormant and unseen possibility of disease and dementia inherent in every Internet-enabled avatar.

Even the title of *The Net* recalls monster films such as *The Blob* (Dir. Irvin S. Yeaworth Jr., 1958) and *The Fly* (Dir. Kurt Neumann, 1958), with creatures and transformations that produced grotesque and inexplicable consequences. This monstrous presence begins to illustrate the main plot catalyst of both films, the ultimate virtual bogeyman: the computer virus. Jan Hruska's 1990 *Computer Viruses and Anti-Virus Warfare* gives a computer virus four characteristics: replication, executable path, side effects, and disguise (5); Eric Filiol adds that a computer virus "does not only contain only a single virus (a program) but also all its possible different but equivalent forms (variants), obtained as the results of a computation" (44). In Antonio A. Casilli's very thorough article "A History of Virulence: The Body and Computer Culture in the 1980s," he tracks "both mainstream and underground press sources from 1982 to 1991 ... that revolves around the 'computer virus' metaphor" that parallel the vocabulary associated with the AIDS virus (1). In his study, he finds examples from numerous Associated Press articles as well as mentions in *The Financial Times*, *The Guardian*, *The Washington Times*, *Christian Science Monitor*, and *PC Business World* that demonstrate that "after 1988, the general public started perceiving HIV/AIDS not as a problem confined to certain minorities (homosexuals, Haitian immigrants, intravenous drugs users, etc.) HIV/AIDS could strike 'anybody anytime'" (10) in much the same way a computer virus could. He argues then that:

> The mimicking of the media hype was not only performed with satirical intent. It also performed a deliberate distortion and amplification

of the viral discourse into one of "viscerality." The classical Cartesian superposition between body and machine—implied by the mainstream rhetoric of computer viruses—expanded into a thematic sequence that came to be dominated by the image of the machine penetrating the body. (12)

The understanding then of a computer virus gives new vocabulary to this invasion of the home and the digital body: suddenly the computer virus is a dormant, invisible invader, silently swallowing the personal/private computer/space in the same way a body is infected. As Casilli concludes "exchanging blood and bodily fluids came to overlap symbolically with exchanging computer files and hardware components: two mutually reinforcing illustrations of the same phenomenon of transgressing the boundaries imposed by clinical powers on the body" (24). Sontag too recognizes the link between the biological virus and the virtual, adding that these programs "[parallel] the behavior of biological viruses" in that the viruses "won't produce immediate signs of damage to the computer's memory, which gives the newly 'infected' program time to spread to other computers" (157). But more importantly, Sontag makes direct parallels between the metaphoric treatment of the computer virus and AIDS, arguing that it is obvious that the new technology, characterized as "omnipresent...a menace in waiting, as mutable, as furtive," would borrow from the vocabulary of the new biological virus of AIDS (158). To further her idea, she points to the characterization of a computer virus in Bethlehem, Pennsylvania, as "PC AIDS"; Hruska also explains that an early computer virus in 1989 disguised itself as "AIDS information Version 2.0," infecting the computer with fake invoices to be paid to companies in Panama (3).

In parallel to these fears, *The Net* begins with the Undersecretary of State Michael Bergstrom (played by Ken Howard) finding out he has been diagnosed with AIDS and committing suicide. Just before he shoots himself, he tries his best to reestablish familial normalcy, talking over the phone to his son about his video game habits and then telling his wife he loves her; however, the shame of being infected is too much as he grimly puts the gun in his mouth and fires. The camera then pans up to J. Seward Johnson Jr.'s sculpture "The Awakening" in which a fragmented man struggles to emerge as he sinks further into the earth. With that lingering camera, the audience now understands the body as corrupted, fragmented and sinking, a location of trauma, all as a direct result of AIDS. The camera fades out, then returns, as it pans over a suburban neighborhood until it

finally settles on the skylight of Angela Bennett, where she is intro-
duced, as described earlier, on her computer. This close proximity
of Bergstrom's suicide and Bennett's Internet-connected computer
conjoins the two viral sites, giving only one possible end to the con-
tamination it highlights.

Sontag points out that "the only sure way to curb the threat of
computer viruses, experts agree, is not to share programs and data"
(167), but the process by which each film "cures" its characters drive
the films to two entirely different endings, both largely dictated by
their target demographics. *Hackers*, a sometimes cartoonish depiction
of 1990s counterculture and early Internet hacking/phone phreaks,
is aimed distinctly at a youth demographic. The scene where Dade,
a high school student, is introduced to other hackers shows the wide
range of clichés about underground culture, including skateboard-
ing, graffiti, wild pointy, dyed and gelled hair, and baggy, bright rave
clothes. *The Net*, however, is a remarkably more adult film: Angela
Bennett is a freelance consultant that worries about job benefits and
spends the first 45 minutes of the film trying to balance a failed love
life with a mother suffering from Alzheimer's. The clearest example
of this divide is the two films' soundtracks: the centerpiece of *The Net*
is an Annie Lennox cover of Procal Harum's 1967 "Whiter Shade of
Pale"; in contrast, *Hacker*'s soundtrack is rooted in the 1990s elec-
tronica scene, showcasing artists like Orbital and The Prodigy. When
McLuhan talks about the trauma between generations that arises
with a harsh and extremely fast shift in value systems, he is speaking
of the gap between a parent (target demographic for *The Net*) and
her/his teenage daughter (target demographic for *Hackers*) who had
grown up with much more a familiar comfort using a computer and
the Internet.

It is fitting then that Bennett only triumphs after she releases the
virus into Gregg's own systems, exposing the corruption and effec-
tively deleting her facsimile identity "Ruth Marx"; it is with this dele-
tion that her one "true" identity is restored (physical body [organism]
and digital [BwO] match again), and she is allowed to return to her
suburban home. When the film ends with all the pieces restored to
their proper places, the final scene is of her and her mother back in a
house in a tree-lined neighborhood; Bennett is typing with the door
open to the front yard where her mother plants flowers in the garden.
Order (and identity) is restored and, as such, the suburbs and the
home are once again a place of stability and familial strength. She
is allowed back into paradise/Eden because her symptoms of a vul-
nerable and unsteady identity, much like her mother's Alzheimer's,

are being managed and monitored. Arthur Frank's 1994 essay "The Body's Problem with Illness" aligns Bennett's digital healing process with what he calls "the disciplined body," defined by a "single minded pursuit of regimens [that] transforms the body into an 'it' to be treated; the self becomes *dissociated* from this 'it'" (39, author's italics) This ideal body type demands that the barriers between self and the body remain rigid in order to quarantine and conquer any illness. *The Net* argues, then, that vanquishing the viruses in the film and restoring order (and personal identity) can only be achieved when the user dissociates herself from her avatar in order to maintain control over that invisible force.

Hackers, on the other hand, argues an opposite sentiment, employing what Frank calls "the communicative body" (with language very similar to Deleuze and Guattari's treatment of organism-full BwO unity) as a mode of re-health for the digital body. The communicative body is characterized by the body being "fragile; breakdown is built into it" (43) and that "the body-self exists as a unity, with two parts not only interdependent but inextricable...just where one ends and the other begins is undecideable" (43). For Dade, the digital body is just as important as the physical body; more, the sort of messiness of that inextricable combination of physical-digital self/bodies (what Hayles and Haraway both champion) is a reality that brings comfort. Frank adds that the communicative body recognizes very clearly that there are other bodies around it (pointing to Schweitzer's phrase "brotherhood of those who bear the mark of pain"), and in fact depends on them and the interaction between bodies in order to regain health (44). In *Hackers*, it is the Internet at the end of the film that brings Dade into a tight-knit structure of peers, a McLuhan Tribe. Whereas *The Net* reinforces that the most important Tribe one can belong to is a family, *Hackers* implies that the Internet lends itself to multicultural bonds that run as deep or deeper than the conventional familial Tribe (figure 1.2).

In fact, the credits at the end of the film list only the character's first name, eschewing the family surname for the younger characters entirely. *The Net* goes out of its way to point out how few friends Bennett has; at the end of the film, she has expanded her tribe only slightly to include her mother. In contrast, *Hackers'* happy ending is not a casting away or conquering of the Internet, but rather a celebration of it as a means to expose governmental and corporate corruption and unite disparate peers who otherwise have nothing in common. First, it is Dade and his friends who use their own hand-coded viruses to infect and overload the computer systems, to

Figure 1.2 The young tribal posse of *Hackers* (1995) crowds around the computer

provide cover to infiltrate the main system and conquer The Plague. This is only made possible after Dade and Kate recruit the world-wide network of other hackers, lead by Razor and Blade, personalities of the pirate television show "Hack the Planet": the film then cuts, individually, to hackers from numerous nationalities and languages (Britain, Japan, Russian, Italian) as they come together and attack The Plague and Ellington Mineral. It is the ability to become one part of a larger interconnected global network that ultimately allows Dade to succeed. The curing of the main Da Vinci virus that serves as the climax of *Hackers* is not a purging but rather a reclaiming of the powers of the Internet to be harnessed in positive moral directions. The two films seem to be arguing two different solutions: *The Net*, aimed at a more adult audience, says that control of the Internet and its disciplined digital bodies as strictly a functional tool is necessary, ending with a reinforcing of the conservative values associated with the clichéd suburbs; identity is grounded in the physical body and the family unit; *Hackers*, through the lens of a communicative digital body, says that the solution is to start a new "family" of densely connected, flexible, avatars that embraces the virtual space of the web. In *The Net*, the Internet is a tool to be feared; in *Hackers*, the Internet is a tool with a vast future and creative potential.

Conclusion: Leaving the Doors and Windows Wide Open

Looking at the films now, we can see clearly that the argument put forth in *Hackers* won convincingly. Foucault, in 1965, worried that the "heterotopias of crisis are vanishing today, only to be replaced, I believe, by others which could be described as heterotopias of

deviance, occupied by individuals whose behavior deviates from the current average or standard" (334). This was certainly true of the treatment of the Internet in the early 1990s, but by 1997 the proposed Communications Decency Act was struck down and Marty Rimm's article was refuted as inaccurate. While most users recognized that obscene material existed within the digital spaces, the chance exposure to that material didn't necessarily infect the digital avatar. Instead, the technology was inevitable, unavoidable, and sublime and the chance to gain reams upon reams of information, to talk to anyone anywhere, a potential technotopia, was just too tantalizing. Just three years after *Hackers*, *Pleasantville* revels in the ability to literally enter into a multimedia document (a television show) and live there with full agency, and also experiences the triumph of the unfettered exposure to knowledge. *Hackers* overlaps with *Pleasantville* in that way: the visual metaphor of the introduction of color explains how objects (or people) are not outright changed by this knowledge but, are, in the movie's view, enhanced, made more "real," better. This is not an infection or virus but what McLuhan might call an "extension" of base human capacities. In 2014, digital natives and digital immigrants alike are exaggerated Dades, not only consuming mountains of information in their suburban private spaces but also compulsively inviting in hundreds of millions of people into their own homes: vloggers spend hours a week seducing strangers, openly, into their bedrooms, bathrooms, and households; mega-popular social media technology such as Instagram, Facebook, and Twitter demand a user share private meals, thoughts, conversations, and moments constantly. While spread of personal information and identity operates like an infection, it is one that the contemporary digital body appears to have built up a tolerance, if not an immunity, toward.

Chapter 2

The Evolution of the Web Browser: The Global Village Outgrown

Introduction: Interface and the Potential Full Avatar

In *TRON: Legacy*, a grizzled Kevin Flynn (Jeff Bridges) explains the virtual world he's been trapped in for 20 years as "The Grid. A digital frontier. I tried to picture clusters of information as they moved through the computer. What did they look like? Ships? Motorcycles? Were the circuits like freeways?" Flynn undertakes a vital thought experiment: he is trying to understand the ways that the Internet not only stores information but how that information gets from point to point within its system. His struggles in coming up with a correct metaphor mirror various authors' and film directors' attempts to take what is the abstract nonspace of the digital world and relay it into a familiar and concrete object and/or process. A great number of the visual metaphors the films in this chapter use are built first on syntactical/poetic metaphors from novels. While Flynn calls the Internet "a grid," John Brunner's 1977 novel *The Shockwave Rider* gives it the imagery of a "data-net," building off of Alvin Toffler's book *Future Shock* (1970). Both these images (grid/net) highlight the interconnected nature of the technology, but in relatively simple and flat ways; the descriptions don't really capture the dynamic and multidimensional nature of cyberspace. A great number of other theorists point to early cyberpunk author William Gibson's *Neuromancer* (as discussed in chapter 1) as one of the first to imagine the space with a more complex and vibrant structuring; N. Katherine Hayles also highlights Neal Stephenson's description in *Snow Crash* (1993), in which he describes the Metaverse as a persistent and large urban space, intercut by a long highway. As interaction with the Internet

became increasingly prevalent, the need to understand the metaphoric spaces that a user interacted within when entering into cyberspace became increasingly important. As George Lakoff and Mark Johnson's *Metaphors We Live By* establishes, the metaphoric diction and imagery a person uses directly shapes his/her attitudes and interactions with the objects and people in his/her world. Being aware of the "conceptual system" (3) that structures human-internet interaction is essential to understanding the attitudes, both conscious and unconscious, that in turn shape the technology itself. We must then examine not only the ways in which a user metaphorically constructs and acts within cyberspace, but also the process by which cultural interfaces, like Internet-engaged movies, grapple with generating their own visual representations of the space: what do those virtual spaces actually look like? What imagery should users be using to describe his/her virtual spaces?

As Lakoff and Johnson rightly stress, metaphoric acts are always collaborative acts. These conversations, whether between two people in dialogue/argument or, more abstractly, between an artist/designer and a user, depend upon the relationship in the collaboration being reciprocal and completely symbiotic. It is this site of interaction between user and technology that becomes especially important when exploring how films, as cultural interfaces, represent the Internet and its inhabitants; how the films construct representations of that virtual space is directly contingent on the design of the interfaces through which the user, in his/her own world outside the film, interacts in order to populate that space with his/her avatar. Again, this process of interface requires metaphoric acts, icons, and languages in order to bridge the gap between digital "virtuality" and physical "reality." Donald A. Norman's *The Design of Everyday Things* argues that interfaces define how a person interacts with the world and the objects within that world, constructing not only the function of that object but also the emotional attachment and engagement with it and, most important, how that user "makes sense of the world" through it (2). This is especially true for digital technologies such as computers (and more precise and incredible technologies like smartphones, tablet computers, etc): how the user interacts at the conjoining site of technology/human defines what sort of relationship that user has with cyberspace and how his/her digital body is constructed. This became increasingly important over the last three decades as the computer, very quickly, became an "everyday thing"; the more a user interacted with a computer (and the Internet), the more crucial the interface became. As discussed in chapter 1 and Introduction, the value

systems created and/or reinforced within portrayals of this interaction of these spaces (or heterotopia) in popular films can largely shape attitudes toward the technology and toward the ideas of subjectivity and identity in relationship to digital landscapes and avatars. The key is to recognize Kirby's diegetic prototypes as a reciprocal relationship between cinematic fiction and an audience's "reality," in which the popular portrayals of interfaces in film affect the actual interfaces being designed outside those fictions in the same way that the actual film/nonfiction interfaces dictate how characters utilize technologies within films.

Norman stresses that the best user interfaces, no matter the object or technology, are user and context-centric; it matters most how and where the object is being used and the actual ways in which the physical body (how it bends, moves, twists) interacts with that technology. As mentioned earlier, both Gibson and Stephenson are seen as pillars by many cyber-theorists for their metaphoric depictions of the Internet as both novels touch on the density and city structure of this virtual space (not some limitless, structureless limbo); however, each also describe their protagonists as deliberately interacting with virtual reality equipment (goggles, gloves, beds) as the way of entering into these worlds: the body remains in the "real" world while the avatar is projected into the virtual space. The avatar is purely digital and deliberately separate; the body is purely organic and in control. While there is also an interesting discussion to be had about how characters within films interact with the hardware of computers and the Internet (mouse, keyboard, monitor), how the digital bodies of the user are first created and then how they interact with the imagined nonspace of the Internet within films is a more attractive exploration. Such an investigation depends upon Norman's description of how a user and designer interact with a specific object/technology. There are three components that each depends on what he terms "conceptual models" (an echo of Lakoff and Johnson's "systems") or the ability to "mentally simulate its operation" (12): first there is the designer's conceptual model, or how the designer imagines the particular "system" (Norman's term for the object or technology) might be used; this is then paired with the user's conceptual model, "the mental model developed through interaction with the system" (16). Yet this interrelationship between the two is mediated by what Norman calls the "system image," the site of communication (interface) between the user and that system. Ideally, the best interfaces/system image are the ones where the design model and the user model match, but that relationship is often quite messy as each user is defined by various

other mental models, "the models people have of themselves, others, the environment," that are formed through "experience, training and instruction" (17). These users' various mental models could very well be influenced by the books they read and the popular films they view. The trick then, Norman says, is to make the system model as visible and transparent in its intentions as possible. While he points to scissors having a relatively easy-to-imagine/visualize system model, the act of visualization becomes less an act of physical interaction and more of a mental or imaginative one similar to when a user begins to enter into the interfaces of a computer operating system. This imaginative act of simulation, and its successes, depends entirely on the act of metaphor, of representing that abstract space in a familiar and visible way.

Tarlteon Gillespie's essay "the stories digital tools tell" uses the example of the Dreamweaver and Macromedia Director software and their accompanying metaphoric language built around "the theater" as a means to illustrate how a piece of computer software can effectively disrupt traditional understandings of authorship. This relationship between software and user is "based on an uneasy tension between similarity and difference, stability and change, novelty and familiarity" (117). While Gillespie's undertaking is useful in exploring digital interaction in a nonnetworked system of just user-computer, it doesn't capture the relationship between the multinodal Internet and its many simultaneous users. The clearest way to explore that bond is by tracking the history of web browsing software, the most obvious site/system to test the user's conceptual models of cyberspace. While the 2014 web browser may not be the consistent/main portal into the Internet it once was, it was for much of the Internet's (Popular) history; therefore, it is vital to track how an average user would have used (and still uses) a web browser, how those spaces arranged themselves, and how the user interacted in those spaces through surface interfaces like Mosaic, Netscape, later, Internet Explorer and Safari, then Firefox, Chrome etceteras. In the First and Second Eras of Internet usage, the user system image of the Internet, the designer's conceptual models were largely dictated by changes in the coding and construction of those spaces, the constraints of those particular technologies specific to each era of the Internet and home computing. As previously discussed, initially there was a very large gap between what the designer knew about the Internet (and her/his conceptual model) and the what the user knew (and her/his conceptual model); it was later in the mid-2000s, when this gap began to close, that the interfaces and representations/metaphors of cyberspace began to change

most drastically. Focusing on the web browser, this understanding of early virtual spaces directly reflects a strong barrier between physical and virtual self in early web programming and design. However, as hardware capabilities increased dramatically alongside the population of Internet users, the immersiveness and engagement within these spaces increased exponentially. It is through the exploration that the shifting value systems between McLuhan's Literate Man and Retribalized Man and, finally, the Digital Native became obvious: while early web design was rooted very heavily in the metaphor of the body and small scale structures (a room, private home, sites of Literate Man's values), transformations to Content Management Systems (CMS) in the backend design of websites signalled a focal shift toward portability, engagement, and dense interconnection. As such, there has been a deliberate shift in how these virtual spaces are depicted in film and novels and, more interestingly, how the bodies (organism[s] and Bodies without Organs [BwOs]) that populate these virtual spaces are valued.

Again, depictions of the Internet hinge on the bodily relationship between user and that virtual space. As argued in chapter 1, in its Popular infancy the digital body was seen as infected and it was the shift from the disciplined body (physical body separate from the "ill" digital avatar) to the communicative body (physical and virtual intertwined and completely inseparable) that dictated the relationships between users and virtual space from the late 1990s onward. This embrace of the communicative body has a number of parallels with other theorists, like Hayles's posthuman and Haraway's cyborg, and also begins to link in very tightly with Deleuze and his work with Guattari, in particular the articulation of an organism-full BwO unity (as detailed in the Introduction to this text). We must return again to the cinematic and realistic ("outside the theater") sites of interface between the user's physical and digital body/bodies and the Internet: by tracking the description and interactions with virtual spaces from early 1990s films through to recent movies like *TRON: Legacy*, it becomes clear that McLuhan's "global village" no longer describes contemporary users' dynamic, technologized experiences. Instead of the individual body being the metaphoric structuring element of these virtual spaces, as it was in the early days of the Internet, the vocabulary and understanding has changed to a dense, urban one, a structure that its users fully inhabit, absent of a physical body, as avatars with complete agency, intense BwOs, living in a construction much, much closer to expansive and organic cities than villages.

Early Web Design (1980s–mid-1990s)

Brunner's metaphor of the Internet-as-data-net accurately characterizes the simple two-dimensional, low-immersive interface (black screen, white text) of the First Era of Internet usage. *TRON* (1982)[1] was one of the first films to build a visualization of this space by having protagonist Kevin Flynn (Jeff Bridges) mysteriously digitize and enter the game Tron. Viewers of the film, though, notice immediately that while the space is navigable, it is quite small, constantly constricted by walls and alleys that are only occasionally broken; these walls are without texture and often without a top, towering out of the shot, unreal and abstract. More, *TRON* depicts an inflexible space, full of right angles and large blocky structures. As such, the most exciting and iconic parts of the film, the light bike races, showcase users who move in straight lines on a ground marked as a grid of straight vertical and horizontal lines (along the grid/net) (figure 2.1).

Crude as it is, it is one of the first instances of films attempting to construct some representation of what was happening when they entered into a digital space. Most other Internet-engaged films of the First Era and early Second Era (including *The Net* and *Hackers* [both 1995] or *Disclosure* [1994]) are a lot like 1983's *War Games* or 1992's *Sneakers* in that they struggle to make the actual interactions between the user and the Internet interesting and instead rely on multiple shots of people using computers rather than inhabiting them; when a character is allowed to inhabit it, as serial killer Karl Hochman

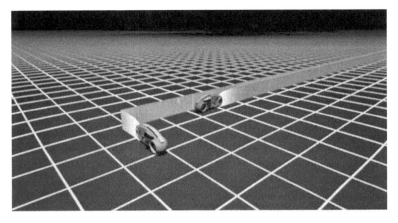

Figure 2.1 The iconic light bike fights from *TRON* (1982) showcases the non-dynamic grid of the early Internet

does in the 1993 film *Ghost in the Machine,* the space, too, is so basic, blocky, and strange, that it bears very little resemblance to the users' world/"reality." Instead, the users' experience could be typified by any scene from *War Games* that shows Matthew Broderick's character, David, typing with white type and curser into the black screen interface; while the Second Era GUI interfaces in *The Net* and *Hackers* become comically unrealistic and more colorful, the same basic interaction with the Internet is present: the human is outside the machine in control and rooted firmly in the physical body and reality. This reflects basic web design literature of the time and the sorts of system models that designers were struggling to create, exampled by key texts such as *The Human Factor: Designing Computer Systems for People* (Rubinstein and Hersh, 1984) and *Reading in Human-Computer Interaction: A Multidisciplinary Approach* (Baecker and Buxton, 1987). Examining Richard Bolt's *The Human Interface* (1984), a text reflecting on both current computer-human interfaces and predictions for the future, illustrates, literally, various interactive spaces such as MIT's Media Room (10–11), where the user sits, where the hardware is situated, and how those characteristics can best shape a user's interaction with those technologies. There is further discussion of "Put-that-there" interfaces (*The Human Interface*, 44, diagram on page 45, 46) and early versions of gesture and voice control interfaces, but diagrams and discussions of these are focused more on the physical bodily interaction and creation of the physical spaces, a body that is very much separate and outside the virtual space. As was common in most interface texts of the time, the focus is largely on (nonnetworked) human-computer interactions like menu selections and typed command-computer response that ignored the potentiality of dense digital networks. At best, these sorts of interfaces still create the system image of horizontal "Image Planes" (24), like microscopically thin plates that overlay each other to present information as layers (like a book on its side); even Bolt's discussion of transformative Graphical User Interface of the Apple Lisa computer (which was later popularized with the Apple Macintosh computer), the first system to display the home computer with the now familiar WIMP desktop, is somewhat lessened by the author's focus on the "stacking" and "overlapping" of windows that ignores most of the metaphoric potentials for three-dimensional movement within that space. In the First Era of the Internet and home computing, the user's conceptual model of the Internet, as influenced by popular films like *War Games*, is a model that demands that the user is separate and controls the Internet very externally. Likewise, the designers' conceptual models were flat and

externally bodied as well, creating clear divisions between physical and virtual space/bodies and, outside of *TRON*, largely ignoring (or vilifying as in *Ghost in the Machine*) the metaphoric quality of actually entering into that nonspace. These barriers would create the sort of low intensities that Deleuze and Guattari warn of, generating an impenetrable binary between the organism (physical body) and the BwO (the avatar) that prevents a full BwO and produces an unhealthy, uneven power dynamic.

One of the more useful texts of the early part of the Second Internet Era is Brenda Laurel's *Computers as Theatre* (1991, new edition "Post-Virtual Reality," 1993) in which Laurel, also leaning heavily on Norman's text, does her best to link the emerging virtual spaces to her metaphor of drama and stage. She critiques treatments like Bolt's as basic "conversations" between human and computers, "two distinct parties whose 'conversation' is [mediated] by the screen" that does not reflect what linguists see as how conversation actually works: "dialogue is not linearized turn-taking" (3). She wants to highlight the need to move toward what she calls "engagement" between computers and humans, an emotional act, which she links to Samuel Taylor Coleridge's idea of a "willing suspension of disbelief" (113). This suspension allows a theater audience to project into the action on a stage as a way of experiencing those characters (and spaces) and the fears/thrills that world contains. Her metaphoric paralleling of computers as theater/stage then showcases, first, the performative elements of interacting in such a space, and, second, the reciprocal relationships that are necessary in the deep immersion ("magic," [15]) in the imagined space at the site of the interaction between audience/ user and actor/computer. Laurel's attempts to make metaphors that make sense of how a user/computer interacts in virtual space, however, are built mostly on the stretch between 1984 (the Mac's first GUI) and just before Mosaic/Netscape's GUI Internet browser. As such, her treatment focuses mainly on the special relationship that takes place within software applications and user in the home computer (in particular word processors and computer games) but doesn't take up the gigantic shift and freedom that came with Mosaic's rearrangement of digital space. Her very useful description of WYSIWYG bars in word processor programs is interesting, but such an interface wasn't integrated into the construction of webpages and popular Internet until the late 1990s–early 2000s. More, the home computer (and the application/software within) that Laurel describes was still severely limited in terms of virtual geography and interconnections compared to the Internet as a technology and, as such, further focus

must be made on the main portal into that early virtual space, the web browser.

The transformative release of Mosaic brought a wealth of Internet users to the technology, but webpage design for early browsers was very simple. Each page that a user navigated to was a static chunk of coding and mark-up languages, written by a human designer, the early standard being HyperText Markup Language (HTML); the browser would then take those languages and translate it into a page that the user could then traverse. Early how-to books on HTML mark-up describe the pages as "static" and largely two-dimensional: a document that "someone had to create...by hand or with tools and upload to a site where web browsers can visit" (Davis and Phillips, 1). What is interesting about this back-end design is that it was still rooted, very specifically, in the human body. Pages in early web design were single houses intended to be occupied by a single body at one time. The early guide on designing both web and operating system interfaces titled "Macintosh Human Interface Guidelines" (1992), as an example, constantly uses language that points directly to a specific individual user, often addressing the user as "you" and spelling out, in a section titled "Metaphors," that the space must be analogous to "a people's knowledge of the world around them...involving concrete familiar ideas" (4). The most familiar idea was the physical body, and the vocabulary of design and programming reflects this: designers, as a nod as well toward print literacy and documents, worked within the "header" (top space of the page) and "footer" (bottom space); the major information was posted in the "body" portion of the page. As well, the default mouse in these early programs was a disembodied hand that floated around the screen.

It is important to note that while the body was always present in this sense of design, an architectural echo of Le Corbusier's modular homes, that body was fragmented; the "real" body was the one, complete and whole, that controlled the computer from the outside. Earlier descriptions of *War Games*, *The Net*, *Sneakers*, and *Hackers* highlighted that it was always the young protagonists outside the computer using it and gazing at the barrier of the screen. The physical "real" body is the focus here, the one in control and where the action is; the virtual space is uninhabitable and when a user does enter into it, as in *Johnny Mnemonic* or the *Lawnmower Man* series of films, only fragments of the body (in *Johnny Mnemonic*'s case, just hands) are present in the virtual space. While it is important to note (and to expand later in this chapter) that Johnny Mnemonic's treatment of the body in that space and the ability to "swipe" and pinch/expand

information and objects within that space was a relatively new con-
cept to the average movie viewer (and a harbinger/diegetic prototype
of Web 2.0 tactile interfaces), this partial-immersion and fragmenta-
tion reflected the still large gap between the user and the designer's
conceptual models of the space. Further, to lessen the exposure to
the degradations the Internet seemed to cause to identity and mor-
als (as exampled by the serial killer's digital embodiment in *Ghost in
the Machine*), the body was only immersed in parts to limit poten-
tial infection (as expanded in chapter 1). This version of the avatar,
while a beginning toe-dip into virtuality, reflected the chopped-up
versions of the body that went into web design earlier and reflected,
again, the trepidation around a full immersion into the space. While
this complexity allowed for greater intensities and engagement than
previous webspaces, the binary between physical bodies/organism
and the avatar/BwO was still present and ultimately the two bod-
ies were too far apart to be completely powerful and unified. Again,
while this is further along the spectrum toward unity, the basic initial
construction of the web browser and its interface was still creating a
hierarchy where the physical body was separate and more important
than the virtual body and the only way to participate and engage with
its BwOs was in fragments, effectively resisting the full BwO. More,
engagement within these nonspaces was still linear and fragmented,
far away from Deleuze and Guattari's unity.

 This fragmented digital body (without organs) was only further
established by the overreliance on the main transportation system
within the Internet: the hyperlink. In one sense, the hyperlink allows
for the dense interconnection that the Internet depends so strongly
on but, at the same time, each jump from space to space also provides
little context for that journey. As the user skips from place to place,
that user loses the sense of continuous transport and the time/space
it takes to get from one physical space to the next and the embodied
experience that comes with it. It is the difference between taking a
train to a city versus magically teleporting there; the speed and jolting
nature of such a decontextualized experience makes it only possible
for parts of the human to be present in that metaphoric space. The
overreliance on the hyperlink in early web design also did strange
things to the visual metaphors of cyberspace within films. Building
off *Neuromancer*, first, in *Hackers*, in the climatic scene in which
Dade and his friends hack into Ellington Mineral's webspace, the
viewer zooms in first on the computer screen, then further inside,
echoing a bullet train barrelling impossibly fast through a tunnel;
each time, the passage through space is characterized by speed, a user

wormholing forward. Likewise, in *Johnny Mnemonic*, once Mnemonic dons his goggles and gloves, the audience zooms into an overcrowded collection of buildings and movements constructed by the telltale green hue of a computer that he then zips in between, alternating between spreadsheets and maps, then floor plans of a hotel, each document accessed and discarded unbelievably quick. While the hyperlink gave the illusion of a dense and dynamic cyberspace, the reality was that the capabilities and execution of actual web design was far simpler: the hyperlink that allowed for jumping between pages was a metaphoric door that allowed a user from one room (or house, i.e., whole other web page) to another; each static page of code would be a basic room—the user could wander some but ultimately that space was very small and relatively limited, still simple and abstract. Altogether, the early Internet, underpopulated as it was, was analogous to a village, a small neighborhood a user could wander through. Like in *Johnny Mnemonic* and *Hackers*, it gave the illusion of a city, but the design and user interaction was still lagging behind those projections of the technology.

Fragmented to Complex and Full (late 1990s–mid-2000s)

Driven by the dramatic increase in home computers and Internet users, as well as, again, explosive changes in the capabilities of basic hardware (CPU, hard drives, ROM), the latter part of the Second Era of the Internet's web design, and the virtual spaces it created, began to increase in complexity. While more complex scripts like PHP and XML became more commonly integrated with a CSS-based system that generated more immersive spaces, there was still a large gap between the average user's ability or willingness to create in this space and the designer's, lessening the intensity of the BwO-avatar and moving the user further from unity. Still, the web page was tied to the designer and programmer as architect and God. If the full BwO is built on a compilation of fragments and collectivity, the users of this version of the Internet were forced to assemble their BwOs out of pieces created not by themselves but by the only people who knew how to generate content within the spaces of the internet: the designers who wrote and understood how building/creating within that space worked.

Therefore, these more engaged spaces created a call for more personal or what Donald Norman, writing in 2004, called "emotional design." This was interface design marked by its user being required/allowed to immerse him/herself more completely and fully into these

virtual rooms and houses, projecting a more complete version of the self into these realms. This was a far more reciprocal relationship between human/computer than the turn-taking "conversation" Bolt points out (and Norman underlines in *Emotional Design* with his description of computer "therapist" Eliza on page 188), a relationship that demanded that users inject themselves and their personalities/ identities into these spaces in order to make the most use of them. Jeff Raskin's crucial *The Humane Interface* (2000) defines a humane interface as "responsive to human needs and considerate of human frailties" (6). A lot of what Raskin points to as "human frailties" are cognitive limitations (the requirement of a "locus of attention," for example [17]) and the habits that arise from those conscious or unconscious interactions with a computer. A number of his solutions to positive interfaces are built around making the interface "modeless," meaning the input (the "Enter" key) acts in the same way regardless of whatever task/application the user is undertaking (37); the gesture that creates interaction at the site of interface then is constant and the output is constant.[2] As such, he describes the ideal interface:

> We can eliminate files and file names, leaving only one universe or content space. You do not need to open or close documents; you zoom to them and just start working. You do not open applications; you duplicate a blank document (or whatever). You do not launch a game; you zoom in on it. (174)

This treatment of the virtual space is one where the user doesn't so much skip from place to place (as a hyperlink), but rather navigates it a more holistic system in which all the parts are present and accessible by pulling back to a larger scope, then zooming in on the particular space the user wants to inhabit. This conceptual model looks a lot more like a city than isolated villages connected by a grid of linear "information highways," in which the user zooms into specific neighborhoods but always with an awareness that the neighborhood is connected to a larger whole that operates without his/her being in that particular space.

This is a key shift in metaphoric understanding of cyberspace that begins to move the Internet user toward unity by utilizing Deleuze and Guattari's understanding of mapping. To the authors, the key to moving toward greater intensities and unity is to understand that the "rhizome has no beginning or end; it is always in the middle, between things, interbeing, *intermezzo*" (25, authors' italics); this then depends on "multiple entryways" that allow for multiple users to engage and

participate (12, 14). The map then, and not the hierarchical and stratified tree, becomes the structuring metaphor because "the map is open and connectable in all dimensions; it is detachable, reversible, susceptible to constant modification. It can be torn, reversed, adapted to any kind of mounting, reworked by an individual, group or social formation" (12). This image of the map echoes very strongly Ruskin's nonmodal cyberspace. Also, Ruskin's construction of the nonspace is much more concerned with the holistic center and zooming into and out of the multiple entryways that this model of web construction allows. Stephen Mamber, in his article "narrative mapping," adds that digital documents, such as electronic newspapers, need to employ the metaphor of maps as the main mode of interaction, stating that such a design generates a tool that aids a user deal with "complexity, ambiguity, density and information overload" (157). As the designers' conceptual models of web construction moved closer to a rhizomatic map, the avatar/BwO becomes able to be more deeply engaged, intensified, fuller, moving ever closer to unity.

Still, the user must often be completely immersed within these maps/systems in order to operate at its highest potentials. The cult classic *The Thirteenth Floor* reflects these efforts at full immersion by having the characters within the film create an exact digital replica of 1937 Los Angeles that the protagonist of the film Douglass Hall (Craig Bierko) can jack into, taking over the body of a program already present in that digital world. The film is exciting in that the inhabitants of the parallel Los Angeles don't know they are computer programs and experience time and space in the exact same ways as any outsider entering in would; the world too, does not turn off regardless of whether a user is present or not. In parallel, *The Matrix* (also released in 1999) also showcases this latter part of the Second Era and the movie's vast popularity (earning $460 million worldwide [boxofficemojo.com]) speaks to how very formative of users' conceptual models of the Internet it was. In it, the avatars of Neo, Trinity, and Morpheus are digital representations of their users who populate an underground ship equipped to jack into the dense interconnections of human consciousness, a software program called the Matrix. As Morpheus explains "Your appearance now is what we call residual self image. It is the mental projection of your digital self"; interestingly, both Neo's and Halls' Los Angeles avatar look exactly as they do when they are not plugged into the system. In contrast to early and mid-1990s' versions of cyberspace, the avatars in *The Matrix* and *The Thirteenth Floor* are full and complete bodies that don't interact with interfaces as Johnny Mnemonic does, but actually inhabit a parallel

universe of not just rooms and buildings but whole (and vibrant) urban landscapes; when a user is in the digital Los Angeles or the city of the Matrix, the colors are rich and the action is sensual, a near exact urban copy of the user's real world. Importantly, to enter into these spaces, characters in both films visually "zoom" into the space to get in and out of the software; these modes of transfer are not so much immediate hyperlinks but preplanned subway trips in which there is a specific geographic part of the city the user is transported to.

In *The Matrix*, representations of the city begin in darkness: the preopening credits scene in which Trinity escapes from a number of Agents has each room barely lit and it is night time outside. However, there are changes in the virtual environment throughout the film: it ends, eventually, in daylight, reflecting a virtual space breaking from static representations into adaptive mirroring of reality. The environment itself is populated by a number of different flexible objects (helicopters, subways, numerous weapons) that the user, once in the Matrix, can manipulate and master. The same can be seen in *The Thirteenth Floor*, in which the avatars dance, drink, drive cars, etc. and each avatar interacts with the other in a unique and consistent way. More, the city is sprawling, large and constantly changing. The shared and dense version of cyberspace in both *The Matrix* and *The Thirteenth Floor* is active, user-defined, fully inhabitable, designed with far more complexity that the virtual spaces portrayed in *The Net* and *Hackers*.

Yet, there is still a clear divide in knowledge of the space: users outside the Matrix (like Morpheus or Mouse) can look at the string of code and translate that into buildings, streets, bodies, etc.; this power is learned, not innately possessed, and sets up a clear power divide between those that can understand or "read" this space and those who can't; likewise, the gap remained between the average users' ability to understand and create in the virtual space and the designers' abilities. *The Thirteenth Floor* actually begins with a quote from Descartes and, like *The Matrix*, builds itself around characters that are obsessed with finding out the "truth" behind their reality. The main twist of the movie comes when Hall realizes that, although it appears as though he is in control of the digital Los Angeles, he is, in fact, a part of a larger simulated world in which a user in 2024 is sporadically jacking into his body and taking over. The tidy ending of the film comes when he finally escapes both digital worlds and is able to live, in a physical body, in 2024. In both films, this uneven power dynamic maintains the physical/digital body dualism that *The Net* and *Hackers* uphold, but also works to at least complicate it

through the figures of Neo and Hall. As P. Chad Barnett states in his essay "Reviving Cyberpunk: (Re)Constructing the Subject and Mapping Cyberspace in the Wachowski Brothers' Film *The Matrix*," Neo "must simultaneously see the virtual reality of the Matrix, the underlying code and that writes and informs it, the bodies that are confined within it, the minds that are controlled by it" (369). The need to simultaneously read languages of construction in both spaces becomes central in the Matrix for Neo to conquer the Agents at the end of the film; also, Hall cannot escape until he recognizes the limits of his reality and is then able to transcend from digital avatar to user. While films are still favoring the physical body, both protagonists give an instructive model to the average Internet user: that user must begin to bridge the digital and physical and equally embrace the construction of their BwOs.

As such, the people of The Matrix's intricate virtual space construct their own bodies, mentally, rather than having them be just biologically defined. The digital body is beautiful, the actions and capabilities of that body are superheroic. The notion that these bodies are diseased or lesser, as established in *The Net* or *The Lawnmower Man*, is flipped on its head; Neo's physical body, upon leaving the Matrix for the first time, is fetal and atrophied, stripped of its biological identity, and exists as one among many arranged into racks upon racks of pink human batteries. More, Agent Smith, in his monologue near the end of the film states:

> Every mammal on this planet instinctively develops a natural equilibrium with the surrounding environment but you humans do not. Instead you multiply, and multiply, until every resource is consumed. The only way for you to survive is to spread to another area. There is another organism on this planet that follows the same pattern, a virus. Human beings are a disease, a cancer on this planet. You are a plague and we are the cure.

This is the opposite argument of *The Net*, and shows how understandings of the Internet were changing: instead it is the human/ physical body that is flawed and immoral, all consuming, greedy, and it is the digital bodies that are pure in their ability to be managed and controlled. The "virus" of the biological body can only be eradicated by treating it as lesser. While the binary attitudes attached to physical/digital appear to have changed from *The Net*, it is still a binary, though admittedly more complex, and moving further still toward Deleuze and Guattari's full BwOs. The avatars approach a

strange perfection, an ideal version of how the characters view themselves. It is this act of construction and compilation of fragments (Neo "learning" Kung Fu as a fragment, for example) that is empowering, in the same way that Haraway's cyborg construction is, and is encouraging a deeper union between organism and BwO. As Christina Lee writes in her Deleuzian-drenched essay "Lock and Load(up): The Action Body in *The Matrix*," "It is this same technology that not only suppresses, but also provides a site of effective resistance...the boundaries between flesh and computer hardware have become porous...technology is more than an avatar or artificial limb. Technology becomes the body, and the body becomes technology" (564). This is the "gaiety, ecstasy and dance" Deleuze and Guattari argue for, and it is brought about only, as a process throughout the film, as Neo comes to embrace the necessary assemblage of digital and physical identities: within this "boundaries between flesh and computer hardware," at the protagonist's victorious moment of the film, the lead character proclaims, in response to Agent Smith repeatedly referring to him as Mr. Anderson (his pre-Matrix name), "My name is Neo." This declaration shows a shift in claimed identity: the user is choosing to identify himself, empowered, by his digital avatar's (hacker) name and the now-interdependent nature between his bodies. "Mr. Anderson," the naive user of the Matrix is gone, replaced by a user who is expertly able to navigate in and out of the digital space with full self-awareness, striving toward unity.

But, the fear of complete immersion into the virtual space still lingers in both *The Matrix* and *The Thirteenth Floor*: the avatar still requires a physical body; it is only after plugging the physical body into the network that a user can enter. There are still two separate and distinct bodies, both vying for the user's self-identification. But, in a more intriguing shift, it is the mind (and not the gesture-controlled VR goggles or gloves of *Johnny Mnemonic*) that controls these avatars, suggesting, again, a deeper immersion into the world and a reciprocal relationship that puts the digital and physical body on par. While the importance had shifted, in a matter of years of interacting with a cyberspace, from the body to the mind, the change was still rooted in the mind being housed in the body. The physical body still reigns supreme: In *The Matrix Revolutions*, it is still the inevitable sacrifice of Neo's physical body that gives closure to the films (though this is complicated further in chapter 4); Hall, too, must die in his reality in order to gain a physical embodiment in his "next life."

As represented by the web design surrounding *The Matrix*, the body still reigns supreme as a physical entity, a puppet master

Figure 2.2 Douglass Hall (Craig Bierko) looks at the end of the Internet in *The Thirteenth Floor* (1999)

controlling its other, the avatar, and those without an organism are demonized. The villain (Agent Smith) is the one that lacks a physical body of his own and exists only in cyberspace. More, when one of the Agents chooses to switch bodies and "invade" another unknowing (still connected) user in the Matrix, the transformation is grotesque, a stretching monstrous conquering of the physical (user) into the digital (agent/software). As well, the digital space is still a finite one, understandable and not quite sublime: the visual centerpiece in *The Thirteenth Floor* is of Hall driving to the edge of the system and looking out at a wireframe mock-up of mountains and the world beyond, the digital skeleton of his world, stripped bare of the familiar flesh of landscape and humanity (figure 2.2). From this, the Internet in this period was seen as always a lesser version, interesting as a knowing visitor but ultimately too constrained and flawed for permanent inhabitation. Still, slowly, the user was being given conceptual models in films that are moving the designers and users toward each other. It isn't until the Internet reaches portability and immense intensity, driving into Web 2.0 construction, however, that this deep union and mutual understanding of its system-model take place.

Web 2.0: Modern Web Design (2005–)

The Third Era's shift to a CMS web design signalled, as Johnny Ryan argues, the shift of Web 2.0 Internet that is "plastic and mutable, open-ended and infinitely adaptable by users" (139). Within this space, contemporary web pages, instead of being controlled by the manual script the designer/programmer writes and the browser executes, rely

instead on a server-side CMS; this construction, driven by power-ful AJAX scripts (in combination with PHP and XML), generate webspaces that break past the "one-way" communications the early HTML-centric Internet created and into a multivocal (multinodal) space in which the user, not the designer, provides and organizes the vast majority of the content through simpler and more respon-sive interfaces. This can best be exemplified by the proliferation of WYSIWYG interfaces (Blogger and Wordpress sites, for example): the writer types the text into these boxes, highlights and changes the words to bolding or underlining, and the CMS core does the heavy lifting of translating that into a displayable web page. Whereas, in the past, the browser simply translated and displayed what the designer wrote, Web 2.0 pages rely on a series of interlocking, complex scripts to generate each page as it is visited. Instead of each web page being a full and complete static document that is made before the user visits the site, each page is created as the user enters, by the scripts work-ing in response to a series of choices that are both user and designer oriented. As the mid-2000s approached, these systems allowed for a user with very little knowledge of how the webspace worked to start a blog, create or edit a Wikipedia page, post images or video, and estab-lish a personalized web presence very easily. While a user may not know how a webpage eventually displays, he/she, through the new Web 2.0 interfaces, was able to create and manipulate content that reflected his/her own experiences and identity. Slowly then, the user and designer combined, created a more unified system that allowed greater intensities.

With Web 2.0, the users generate more of the content than the designers but it is the machine/digital infrastructures that actually complete the form. As a former freelance web designer, I'm most familiar with Drupal (drupal.org), the open-source CMS that runs a good number of sites including the White House's. Design textbooks on Drupal stress how the CMS "greatly simplifies the process of authoring, managing, and publishing content...it is a forum, a blog-ging tool, and an organizer of information." (Douglass, Little and Smith, 3). The flexibility of this system is stressed again in another Drupal design text stating the system can be used as "a personal, departmental, or corporate website; an e-commerce site; a resource directory; an online newspaper; an image gallery" (VanDyk and Westgate, 1). It is this immediate emphasizing of adaptability and simplification that is allowing the bodies that populate these web-spaces to be just as flexible and dynamic. More, the vocabulary of design begins to transform dramatically using these more complex

structuring systems. Instead of static pages (individually humanized as header, footer, body) being connected by hyperlinks, each page is grouped into "blocks" or "views." Pieces of content are referred to as nodes. The body is still present in that there is still a place on each page for a "header," "footer," and "body," but this metaphoric construction is secondary, one part, and no longer the main structuring element. Instead, pages are no longer restricted to boxy chunks of a screen but can include large shifting slide shows, weaving menus, pop-up light box features for photos, etc. This shift from a book-like structure ("pages") to nodes (pieces of information in a network) highlights the types of bodies needed to populate the new space. The BwO that interacts, as designer or user of a webpage, is now one body among many other nodes, interconnected and dense, organized into "blocks," (echoing "city blocks") and "views," allowing a user the sort of high-level gaze that Ruskin hoped for, with an ability to see the whole complex system (or map) at once, like the view from a balcony of a tall building. Actions, then, are dictated by the PHP-driven "modules," a series of interlocking tasks that dive in and out of databases in order to construct, anew each visit, the space. This is not a simple village anymore, but rather a collection of cities, tightly populated by avatars. Suddenly, a page can have multiple blocks, nodes, and views on it—the page is far more multifaceted and, as such, the user inhabiting the space is allowed to be as well. Like the dynamic Deleuzian map, suddenly the user has a complex space to not just visit and wander around, but live, in constant contact with other complex users, a full (second) life completely inside. Within these systems, the user and computer are completely symbiotic, intertwined in the task of creation, the human user creating basic content (a story, an image) and the computer constructing the space to house that item within.

This understanding of virtual space is perhaps best exemplified by *TRON: Legacy* as it portrays its virtual realms as complete and immersive urban spaces. The first glimpse inside of Tron is a view of an immaculately clean and incredibly complex city. It is constructed of streets and buildings that reach improbably high into the sky. This digital space is beautiful and pristine in the same way that the Matrix's individual avatars are: it's a supercity with an oasis glimmer, not the dirty and dark urbanity that opens *The Matrix*, but rather a gorgeous perfection (figure 2.3).

When Sam escapes back to his father's home outside this city, the viewer gets to gaze at it in the distance, see it fully formed and bright against the dark backdrop. When actually in the city, there is no pervading sense of it being a digital space, the only hints being

Figure 2.3 The complex global city of *TRON: Legacy* (2010)

the honeycomb-units that comprise the roads that drop away or rise. It looks exactly as a real city does, and operates in the same ways: the city has traffic and streets, night clubs, and, most of all, fully embodied programs that act identically to people. More than this, the programs, and eventually Sam, move freely through this intricate digital space. The glorification of this digital space is important: Chris Hables Gray in *Cyborg Citizen* points to modern virtual realms as valuing mobility over space (134); it is the ability to move and create within an exact parallel space that is valued by a contemporary user of the Internet. The world shown in *TRON: Legacy* is a crystallized exaggeration of this. Like modern CMSs, the virtual space of Tron demands multidirectionality and expansiveness, a map to zoom in and out from, driven first and foremost by individual users and computer-controlled back-end scripts. Reflecting the shift in user/designer dynamics, the original programmer from the first *TRON* film, Jeff Flynn, has lost control of the world he has created; he lives on the outskirts of the city as the programs, namely his digital clone CLU (who looks exactly as Jeff Bridges did in 1982), control the city. Like a modern CMS, it is not the original programmer/designer in control but rather it is the scripts, the digital beings, which generate and ultimately construct and deconstruct the virtual space. The human, as puppet-master or main agent, is all but wiped out.

The intensities created by this construction of the CMS-driven digital space create the potential for unity between the organism and a full BwO, but is the user comfortable enough with this immersion to carry out this total melding to its (extreme) completion? It is interesting then to note the subtitle of *TRON: Legacy*. "Legacy" is a computer science term used to describe how newer pieces of software/operating

systems integrate older versions of programs/files (how can, or should, a Photoshop 1 file run on Photoshop 4?, for example). Immediately, the film is foregrounding the struggle of technology in transition and the adaptation necessary to speak and survive within those new systems. The site that this then takes place is, like the films discussed before, at the body. Sam, who eventually gets a text to visit the arcade from the first movie, by some magical digital act, is thrust into the game of Tron. When Sam is first trying to unravel the mystery of the old arcade, he is seen typing into a DOS-like screen very similar to the interfaces from the original *TRON*-era. He types in complex commands that are then responded to by the computer, listing and displaying in the turn-taking conversation described earlier. These old interfaces come into stark contrast with contemporary versions when Sam does finally transition into Tron. The transition itself is brief and complete, more "magical," as Laurel might describe, than digital: the camera quickly breaks the body and the room into tiny bits, then cuts to black, only to reassemble the world and Sam's body whole. There is no zooming or travelling into the space as visualized by the tunnel-like high-speed entry into *The Matrix* or *The Net*, but rather a whole and near-instant transition of the body from one space (physical) to the other (digital). When the film resumes, the space and Sam look identical to the "reality" that Sam just left, the only difference being a slight blue filter tinting the digital world. More importantly though, Sam, when he enters the world, only exists in the world of Tron; there is no body to find in the "physical realm" of Earth. Jeff Bridges's character has been missing for 20 years because he exists only in the virtual world: yet, when Sam meets him, he still retains the personality and identity (and memory) he had when he originally disappeared into the game. Adding then, the "real" people, like Sam and Kevin Flynn, exist either in the physical world or the virtual world of Tron, not both, as the characters of *The Thirteenth Floor* and *The Matrix* do. There are no avatars or projections, just one entity. This is the full and complete melding of organism and a full BwO, a unified identity, a Web 2.0 construction of self, driven by CMSs at the center of web programming and design. The modern Internet user recognizes his/her own experience in the density/complexity of the world of Tron and the necessary immersion and intensities that such tools require.[3]

More interestingly though, the programs in the film, such as Tron, Quorra, or CLU, have no physical doppelganger—rather they exist only (and with complete agency) in the virtual space. They require no physical body to control them; they are no puppets. Unlike a character such as Dixie Flatline from *Neuromancer*, who laments his

ROM-only existence, Quorra is seen as a potential savior. Quorra is an isomorphic algorithm (ISO) that the computer system of TRON itself created; she is not an entity created by the human designer, Flynn, but rather a creature that evolved naturally and spontaneously out of the system with the potential (if able to be transported back into "reality"), Jeff Flynn theorizes, to miraculously help cure many types of illnesses and solve many of the mysteries of the world. Without an organism/biological base, Quorra is the most extreme example of the evolutionary posthuman, walking from the primordial ooze of Tron and into the "real" world at the end of the film.

To return to the earlier question about whether a user is ready, the fears of intense immersion are still present for the older Flynn (who doesn't/can't return to the world outside Tron), but for his son and Quorra, the unification has already happened. Quorra was "born" and only ever existed in the digital space. At the end of the film she occupies a corporeal body the exact copy of her virtual one, reversing the physical-body-into-avatar process *The Matrix* and earlier films put forth. The word "Legacy" is both biological and technological: it represents the evolutionary and generational step of Jeff to Sam, Jeff's biological son, to Quorra, Jeff's all-digital daughter, and the potential miracle, that the film celebrates.[4]

Conclusion

If the viewer leaves TRON celebrating Quorra's creation and embodiment then this truly signals the near end of the usefulness of the web browser as the primary entry point into the Internet. In 2014, the home computer is an unwieldy weight that doesn't allow for what Manovich calls "augmented space" where the user is "still largely present in physical space [and] the display adds to your overall phenomenological experience but does not take over" (79). While the home computer anchored cyberspace to a specific place and interactive site, say in one room in a home, it has now given way to the extreme portability of laptops and, in particular, smart phones, devices that allowed Manovich's augmented space to envelop and follow the user everywhere. There is no real way to "leave" the Internet at home, as it blankets all structures and people, at all times. This is the "Internet of Everything": it is not just the computer that is accessing the Internet but more and more objects. As John Chambers in *Wired* wonders "We currently live in a world where more than 99 percent of all physical objects are not connected to the network. What happens when

a mere 10 percent get connected? What happens when we connect people, process, data and things?" The answer to these questions is the rise of an entity remarkably similar to Quorra.

The move to CMS-controlled webspaces shifts, as Sam Flynn signals, the user to a much closer, nearing complete, unity between organism and a full BwO, an entity that interacts in the contemporary urban digital spaces, a "global city," with complete agency and immersion, quickly and fluidly. Yet the character of Quorra is something entirely different, much closer to the smartphone user who enters into the Internet through multiple portals/apps (Twitter, Facebook, etc.), and uses the web browser sparingly. First, treating Internet-connected devices like smartphones as "always on" conditions a user to always be connected into the network, never separated by an on/off switch (as an old PC might have been) but rather "sleeping," not dead-and-reborn with each reboot like Dixie Flatline, a continuous presence that can be awakened and active within mere seconds. Second, there are parallels to be made between this decline and the disappearance of Palm Pilots and devices that relied upon a stylus for user-system interface. Instead, through the filter of Quorra, we can understand the shift to the gestural interfaces that *Minority Report* and the *Iron Man* films use and popularized (much to the chagrin of real life Internet designers),[5] to hardware and interfaces like the Leap and Microsoft's Kinect, where the body itself (hands, arms, fingers), not a pen or keyboard, is the interface. This is an intensification that slams the organism and its BwOs together. In fact, as technology progresses, the barrier between human and the Internet, as mediated by any interface, will dissolve completely. We can already see the beginning of this in contact lens HUDs (Heads Up Displays) and Google Glass. How long before we simply replace and implant Internet-connected eyeballs with these capabilities or, as the character of Quorra suggests, we're born with them? Instead of Internet technology being anchored and separate in a device, when will it unify the digital and biological completely, become hereditary, like genes being passed down? This encompasses the next step in understanding our virtual space: our cyberspace moves with us, is us. We carry our avatars around with us in our tablets and phones, working their touch screens; all the while, these avatars are acting and reacting in their own virtual spaces. Like Quorra, the 2014 user of the Internet is the Internet.

Chapter 3

Avatar in the Uncanny Valley: The Na'vi and Us, the Machinic Audience

Introduction: The Machinic Audience and the Alien's Art

Published in 1984, *The Policeman's Beard is Half Constructed* purported to be "the world's first book ever written entirely by a computer." The author bio at the beginning of the book explains that, unlike normal human-mimicking AI, the program Racter can "write original work without prompting from a human operator" (i). The book's author then writes about a number of poetic topics, ranging through existence and death, looping back repeatedly to love, all across a number of different genres including limericks, "imaginative dialogues," aphorisms and interviews. The voice in the text is playful and incisive, flexible and strange; in the introduction, Bill Chamberlain, Racter's programmer, even goes so far as to say "its output is not only new and unknowable, it is apparently thoughtful." The second poem in the text has Racter explaining:

> Awareness is like consciousness. Soul is like spirit.
> But soft is not like hard and weak is not like
> strong. A mechanic can be both soft and hard, a
> stewardess can be both weak and strong. This is
> called a philosophy or a world-view.

In the poem, Racter struggles to equate: the poem itself permits a sliding scale, a flexible version of language and, then, of the world. The use of "like" in the poem first suggests caution, an unwillingness to make a complete comparison, but then also pinpoints the struggles with aligning any person or concept at one extreme end

of a spectrum. Racter's "world-view" is one where a person can be many things at once, an entity in a constantly fluid state of contradictions that is impossible to truly, fully define. The poem too plays along with the machine-human relationship that brought Racter into construction: What exactly does Racter mean by "soft and hard"? On one hand, the mechanic in the poem has "hard" parts (bones, teeth) and "soft" parts (flesh, organs) based on her/his anatomy as a human; on the other hand, perhaps, the mechanic can have soft and hard elements of her/his personality, identity, based on who or what s/he is interacting with. Similarly, Racter too is made up by sliding between binaries: what parts of him are human (soft?) by its very nature as a program (*soft*ware) created by a human? What parts are "hard" (motherboard, processor) based on its nature as part of a computer? Ultimately, Racter's "philosophy" is that it is both, soft and hard, computer and human.

While the computer's text, complimented by collages by human artist Joan Hall, was available in book format, an individual could also buy a computer program version of Racter, install it on her/his home computer and, within a matter of minutes, have the program talk, like computer-therapist ELIZA, with the user. As Chamberlain explains in the Introduction, the program is based on a set of rules interacting with a database of vocabulary; the program then manipulates the "piles" of language in the database, guided by "random chosen variables" that conjugate, pluralize, and systemically manipulate the words into poems (ii). The most astounding effect that emerges is, as Chamberlain says, "prose that is in no way contingent upon human experience" (i). Whereas so much of pre-Modernist Western Literature was author-centric, depending upon an author's cultural background, language, life experiences, etc., Racter was a program allegedly pulling words and phrases from the ether, devoid of interaction with an outside world, and instead constructing art based on algorithmic manipulation of constraints and variables.[1] Christian Bök's essay in response to Racter, "The Piecemeal Bard is Deconstructed: Notes Towards a Potential Robopoetics" discusses consumers of such a poetry, half jokingly assuring that "we are probably the first generation of poets who can reasonably expect to write literature for a machinic audience of artificially intellectual peers." Such an audience, savvy to their soft and hard networks of networks, is the machinic audience outlined in our Introduction and the subject of this chapter, an audience very comfortably draped in the virtuality of a Web 2.0 Internet, and an audience that understands/appreciates/invites the digitization of themselves and the world around them.

Peter Lunenfeld, in his essay "Space Invaders: Thoughts on Technology and the Production of Culture," explains that, as an art critic, he often has to approach works as "art for aliens." Yet, he points out that this alien is not extraterrestrial but potentially "a mechanical other, one that manifests itself as artificial life and intelligent computation—an alien we ourselves have created" (63). As a thinker then, Lunenfeld posits that critics might be best served to "outline the context for an alien aesthetic…get a fix on what aliens will learn from our cultural moment and what they could contribute" (64). Lunenfeld's "alien" consumer/contributor is the machinic audience Bök speaks of, and the same questions and perspectives Lunenfeld undertakes through his thought experiment are the same a movie critic (and movie maker) must undertake in 2014. I must, half jokingly, assure the reader that we are in the midst of a time in which machines make films for a machinic audience. From this, the obvious question arises: What exactly might a "machinic audience" entail? What does a machinic audience expect and accept as art? Let's consider these questions in response to why the 2009 film *Avatar* is, by earning a box office of just under 2.8 billion dollars worldwide, the most popular move of all time (as per boxofficemojo.com). The answer to its popularity comes in parts: the film itself is beautiful, a lush and sensual experience that transports and immerses an audience in an alien utopia; also, the technology used to create the film was revolutionary, not just the advanced three-dimensional filming and projection, but the other Cameron-invented technology such as the SimulCam along with his headrigs that allowed a near perfect digitized version of the human actors; as well, the 2009 audience of the film could have related to the Na'vi in the film in a very intimate and familiar way; the Na'vi are constantly plugging into their world (trees, animals, each other) in much the same ways a digital native or digital immigrant would plug into their phones, computers, and the Internet at large. The Internet is the central technology that binds audience members to each other and their devices, in much the same way the Na'vi are bound to Eywa. These eager and engaged spectators of *Avatar* are very close to the machinic audience, an audience that expects/demands machine elements from its movies in the same way it insists its protagonists relate to their technologies in the same manners that they do. Herein lies the machinic audience: one that understands him/herself as mechanically extended, mediated, and manipulated, but also one that thinks in the language of networks and recognizes oneself in the constant digital transfers one undertakes in a day. This is not just a matter of the content of the

film, whether the protagonist is a digital native or not, but also the very technology used to generate the film: the machinic audience is especially comfortable with the digitizing of a modern camera, savvy to the computer graphic (CG) transformations of an actor or actress in the same ways they themselves are used to photoshopping and digitizing their own bodies into the virtual spaces of the Internet.

It seems then that the artist, whether a computer program or programmer, poet, or movie director, must acknowledge this audience as being increasingly normative and begin to gear that art toward the language and interactions that such an audience can appreciate and identify with. It is silly to suggest that Cameron has created the machinic audience, but *Avatar* is participating, more so than any film before, in the languages, both in terms of bodily reconstruction and constant networks, that the digital natives of 2014 recognize within themselves, and, in that, a great well of popular response sprung.

The Machinic Audience's Repetitions

Deleuze, in *Difference and Repetition*, gives some useful theoretical frameworks for understanding how the machinic audience interacts with their avatars. For much of the chapter "Difference in Itself," Deleuze struggles with how to properly separate the ideas of difference and division. He begins first with the hierarchical, biological understanding of nature in which he explores the ideas of the taxonomic terms "genus" versus "species" (31–33). Such a system is at the base of identifying an organism and that organism's identity is further specified by plunging down the hierarchy, with each stratum made possible by evolutionary iterations or repetitions, representing a further step to accurately defining that creature. This construction of the natural world, as a top-down hierarchy, puts a premium on defining a creature by its species, the layer below genus, as it is considered a more accurate, specific pin point to its identity. Yet, Deleuze argues this is ineffective in establishing and defining an entity as it divides an organism up into hierarchal layers of identity that create stratified barriers that impede a holistic understanding of an organism's identity. These iterations then, he points out, should be treated not as divisions but rather differences; to separate one layer from another is impossible as each layer depends upon the layer before and the layer after. In the same way, he states that organizing a person's identity with this same idea of hierarchy, where there are more "accurate" versions of identity within a person (say a soul) is impossible in a multitudinous world of interaction. To characterize the genus as just

"an indifferent material, a mixture, an indefinite representing mul-
tiplicity" (60) in order to value the "purer" definition of species is
to ignore the historical, environmental, and potentially sociological
relationships that tether genus to species, and, more broadly, identity
to a single person. This is in direct contrast to traditional Platonic
understandings of the world and knowledge in which there is a clear/
pure Truth (of object or identity) that is to be valued above all else; in
Plato's "Allegory of the Cave" the world of the shadows is deemed to
be lesser, judged as incomplete and not nearly as vital as the world of
enlightenment and knowledge. Yet, for the inhabitant of Plato's Cave,
his/her shadow is not divided from him/her but is, rather, different;
to judge a shadow, an extension inseparable from the body, as sepa-
rate from that actual person is to create a hierarchical division that
doesn't reflect how identity is formed and treated. These shadows can
be linked into the notion of a simulacra (as Deleuze points to) and are
potential versions of a self that help to explore and define a person's
identity; if the shadow is as valuable as the True body, then that is a
system in which there is "no prior *identity*, no internal *resemblance*"
and each version of a person is a component to be assembled into a
greater whole (*Difference and Repetition*, 299, author's italics). It is
from this understanding of identity as always connected and poten-
tial multiple, that Deleuze points to Nietzsche's idea of the Eternal
Return, in which a person is constantly returning, after experiences
and interactions in the world or "diverging series" (ibid., 69), to prior
states of their identity. Each return, or what Deleuze calls a repeti-
tion, "does not bring back 'the same'" but instead creates a "superior
form" in which the prior self is added to, with each repetition or
return of the cycle. In this process, "division turns back against itself
and begins to function in reverse, and, as a result, of being applied to
simulacra themselves (dreams, shadows, reflections, paintings), shows
the impossibility of distinguishing themselves from the originals or
models" (ibid., 68). This process has no "copies" or divisions but
instead treats the formation of an identity as a repeating cycle of gath-
ered identities in which a person adds to their prior understanding of
self with each new version s/he creates.

It is not that far to extend from "dreams, shadows, reflections,
paintings" to digital avatars. In basic terms, an avatar is "a computer
generated figure controlled by a person via a computer. It is often a
graphical representation of a person with which one can interact in
real time" (Coleman, 12). Even this definition seems a bit limiting
and it's better to think of an individual avatar as existing on a sliding
scale: any digital representation of a user in cyberspace is an avatar of

sorts, it is just that some avatars (like a Second Life or EVE character) are more nimble, anthropomorphic, and detailed than others (say online identities given to a student by a University). For the machinic audience, their avatars, enabled and maintained by the Internet, are multiple and dynamic, ranging from Twitter and Facebook accounts, to Xbox Live profiles, to email accounts; each avatar then is participating in a particular McLuhan Tribe and establishing and reestablishing a portion of the user's identity. Sherry Turkle, in her chapter in *Life on the Screen* titled "Identity Crisis," states that even early forms of avatar-Internet-physical user interaction have the potential for Deleuze's full BwO, a self "with fluid access among their many aspects"; it is from this fluidity that "the open communication encourages an attitude of respect for the many within us and the many within others" (*Life on the Screen*, 261). The "decentered circles" (*Difference and Repetition*, 69) that Deleuze describes are the groups of avatars interacting in digital space that, when assembled, create a holistic understanding of an individual digital native, a structuring of identity he and Félix Guattari further champion as rhizomatic in *A Thousand Plateaus*. The machinic audience lives in a world in which "everything has become simulacrum, for by simulacrum we should not understand a simple imitation but rather the act by which the very idea of a model or privileged position is challenged and overturned" (*Difference and Repetition*, 69). McLuhan's Literate Man and her/his value system that privileges the physical body as the best/only marker of identity has been overturned by the proliferation and dependence upon avatars. For an Internet user in 2014, avatars interact with such a potentially large group of people (a Facebook profile may have 1000 plus friends but, theoretically, any user on the Internet could access that avatar making the prospective sphere of interaction exponentially larger) over such a potentially large area of the world that it makes sense that the machinic audience greatly values their avatars; after all, that avatar most likely interacts with far more people in potentially far richer ways than a user's physical body (and identity) would. It would make sense then that the machinic audience would enjoy and support a film whose protagonist and landscape reflects and upholds the same user-avatar dynamics they experience in their own lives.

 This could explain why *Surrogates* (Dir. Jonathan Mostiw, 2009) did not do nearly as well at the box office as *TRON: Legacy* (2010) and *Avatar* (2009). As mentioned earlier, *Avatar* took in just under $2.8 billion while *TRON: Legacy* made $400 million worldwide; by comparison, *Surrogates*, driven mostly by its lead, Bruce Willis, pulled in (a very respectable) $122 million worldwide.[2] Based

on the graphic novel *The Surrogates* by Robert Venditti, the film creates a world in which users have almost completely outsourced their lives to surrogates, life-size mechanical replicas, that undertake all tasks for the user while the user remains, isolated, in the bedroom of his/her own home, plugged-in and immobile. An individual user receives the sensations that the surrogate receives but, at least at the beginning of the film, does not die when the surrogate dies. A user's surrogate is part toy, part vehicle of idealized identity: users enact an updated form of virtual "deviancy," evolved from our discussion in chapter 1, utilizing their surrogates to have sex with strangers, drink excessive amount of alcohol, do a myriad of drugs, and inflict extreme violence to each other; also, their surrogates are physically stunning, presenting edited, younger, more attractive versions of the user (and, in some cases, different genders and races entirely).[3] In the beginning of the film, this creates a pseudo-utopia: there have been no homicides and what crime that does occur, destruction of a surrogate, for example, is filed under vandalism. The surrogate is not the dynamic extension that Deleuze describes as the full BwO but rather a piece of property, a disposable object to destroy and replace.

The ability for the machinic audience to carry their avatars around with them, to have them physically interact in the world as they do, as sutured to them by the constant connectivity of a smartphone or laptop, is much different than the avatars of the 1990s and early 2000s, where a user, in order to interact with their avatars, most likely needed to use a stationary desktop computer. Distinct from earlier films, such as *The Net*, that deal with anxieties about the early Internet, *Surrogates* is concerned with the more contemporary portability of the Web 2.0 Internet. As such, it exaggerates the potential problems in a machinic audience's transportable user-avatar relationships by generating an allegorical experiment within the film that replaces physical bodies altogether, mirroring the potential substitution of the physical body for the digital that Literate Man (and/or Retribalized Man or a Digital Immigrant) finds so unsettling; in this respect, the film is not far from the fear and distrust of the "digitally ill" avatars in *The Net* (as discussed in chapter 1) wherein the ability to shift into any body and be any gender, race, age, class, is terrifying, not liberating. Yet, it is that fantasy/nightmare that *Surrogates* undertakes that perhaps distances the machinic audience from the film, a process that Lunenfeld describes as happening when an artist "overliteralizes its interests in the alien" (69), the result of which is "taking the best and worst of ourselves and ascribing these characteristics to an imaginary, anthropomorphized externality" (69). If the surrogates are the film's

versions of the "alien," potentially future machinic audience, this might explain why *Surrogates* takes such a negative stance on user-avatar relationship, maintaining the Platonic divisions that Deleuze and the machinic audience find troubling. In the film, the body and surrogate are completely separate, a division that allows the film to create a very clear value system that supports the physical body as the only agent of free will and therefore the most important: as in Plato's Cave, when Bruce Willis's character, detective Tom Greer, disconnects from his surrogate, he returns to his physical body in a darkened room; even his surrogate's walk down the hallway to his apartment is almost completely blackened. As Greer lays in the bed and his surrogate watches him, his "real" eyes are covered (figure 3.1).

When Greer returns his surrogate to its resting place, an upright battery that evokes a vampiric coffin, Greer tries to stand but his legs are weakened from inactivity. The film presents the user first as blind, trapped like Plato's Cave dweller, before also critiquing the user of surrogates as literally weakening the physical body, eroding the physical. Unlike *The Matrix* where the mastery of the user-avatar relationship is superhuman, the pseudo-avatars in *Surrogates* are immoral and vain, far lesser creatures that generate a de-evolution, creating a version of humanity no longer at the top of Darwinian fitness. There is a later scene in which Greer, after having his surrogate destroyed in an earlier attempted capture of a criminal, leaves the hospital without the filter of his surrogate for the first time, Greer admits, that he can remember. First, his police partner, Jennifer Peters (Radha Mitchell), cautions that he shouldn't be out without some sort of anxiety medicine to help him deal with a unscrimmed reality; then, as he enters

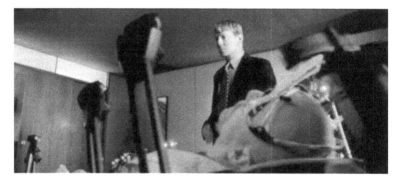

Figure 3.1 Tom Greer's "perfect" surrogate (Bruce Willis) stares at his lesser physical body (*Surrogates*, 2009)

the street, each passing surrogate is punctuated by a loud swiping noise. Greer is overcome by simply being outside; a car rushes by, too close, and he yelps. Finally, Peters drags Greer into a convenience store to buy, as one might buy a light bulb, a replacement "generic" surrogate to help him cope. This is not just simple agoraphobia: this is a fear of the open spaces of cyberspace too. Greer is unable to continue living through his copy/shadow and it is from this point on in the film that Greer begins an honest rejection of "surris" and opts to navigate the world in his physical body, establishing himself as the hero of the film whose value system that audience is, ideally, supposed to align themselves with.

Still, while Greer is leaving his surrogate behind, everyone else in the film clings to theirs. The erosion created by the complete attachment to a surrogate pervades all the characters, not just physically but also morally and emotionally, best exemplified by Greer's wife Maggie (Rosamund Pike). Despite Greer's begging, she refuses to even emerge from her room if not through her replica. As she explains later in the film, she's unable to separate herself from her surrogate because of their son's death. The surrogate then is a place of emotional escape where she can delay facing her son's death and completely separate herself from the history and trauma associated with her physical body. In parallel, when Greer wakes up in the hospital, after his surrogate-destroying near-death experience, Maggie does not come with her body but rather sends her surrogate. Rather than interact face-to-face in order to deal with trauma (a son's death, a husband nearly dying), the avatar is a vehicle of emotional distance that the film critiques as crippling, suggesting that to rely on a surrogate, or avatar, is to be weak, cowardly.

Also, the freedom of identity created by the use of surrogates manifests itself as a fear of completely fractured or fabricated user-avatar relationships. The attractive young female surrogate that gets killed at the beginning of the film is actually controlled by an overweight middle-aged man. Most tellingly, main villain and surrogate creator Dr. Canter (James Cromwell) is able to shift surrogates at will, never choosing a copy that looks at all like him; his hijacking of Greer's partner Peters's surri, after her physical body has been killed in her home, almost allows the infection of the surrogate mainframe via computer virus that would murder billions of biological users. The ability to completely transform the self into any iteration of race and sex is not celebrated in the film but rather is treated with the same mistrust as the cautionary tales of Manti T'eo's girlfriend or the documentary *Catfish* (Dir. Henry Joost and Ariel Schulman,

2010) encourage: the ability to hide completely, to separate wholly from the physical body into any form/identity, only creates users' intent on "fooling" other users, often maliciously. The film argues that the physical body is the only identity that can be trusted: all else are suspicious, potential forgeries.

Greer's "heroic" choice at the end of the film to save the physical users and purge the surrogates, allowing the release of a virus that wipes the surris out, is the only logical path the film gives. As Greer allows the death of the surrogates and all their bodies slump lifeless to the ground, the city disintegrates: cars crash, subways stop, phones bleat off their hooks. Yet, this is not chaos but a rebirth: the DVD Chapter is titled "A New Beginning," and from the apocalyptic land-scape of motionless bodies and destruction, users emerge tentatively, in sleep clothes and without makeup, natural, into the bright sun. They wander around with the same confusion that Plato's released prisoners do, the bright sun of knowledge and "reality" impossibly disorienting. Greer returns home to find his wife, finally detached from her surrogate, in her son's room, silent and, finally touching her husband's face and crying into his embrace, able, perhaps, to finally confront the ordeal of her son's death. While this provides a tidy and emotional ending, it also reaffirms the binaries and value systems a machinic audience has come to distrust: in order for the human race to evolve forward they must ignore all varieties of identity that were created by surrogates and return to their genus, a purer, sin-gular form. While the film was still successful monetarily (making $40 million more than its listed $80 million budget), it failed to reso-nate in the zeitgeist in the same way *Avatar* did because it belittles and ultimately discards the user-avatar species that *Avatar* and the machinic audience celebrate.

Echoing Lunenfeld again, the aliens that *Surrogates* create as reflections of a potential machinic audience are closer to the *Invasion* pods that *The Net* reinforces, whereas the literal aliens of *Avatar*, the Na'vi, are limber and beautiful creatures, agile, and able to navi-gate their environment gracefully and with an amazing amount of knowledge. If these "aliens" are the potential machinic audience then they are not foreign or monstrous invaders/usurpers or overly plas-tic vehicles of immorality; in fact, it is the humans of the film that are instead colonizing their home planet of Pandora for capitalistic gains. If *Surrogates* is creating its aliens with the machinic audience's worst qualities, *Avatar* is using the best. The protagonists of the film spend their time not trying to distance themselves from the Na'vi but, instead, literally trying to become them. Through the filter

of the film's protagonist Jake Sully (Sam Worthington) and Grace Augustine (Sigourney Weaver), the audience sees humans visually mirror the Na'vi through elongated, blue doppelgangers and also, more immersively, participate in their rituals and languages. Unlike *Surrogates*, the aliens here are autonomous organisms, not puppets, with a rich cultural history and are to be emulated, admired. The machinic audience would feel a special connection to the Na'vi as they too "plug into" the world around them. As Neytiri (Zoë Saldana) is teaching Jake how to become a Na'vi, she instructs him on how to join with a Direhorse by connecting via the fiber-optic-like cables that emerge from both the Na'vi's braid of hair, Queues, and the Direhorse's. Jake connects with the creature and Neytiri explains "That is Tsaheylu, the bond." This bonding explains how the connection between the self and the outside world is essential, sacred; it is through connection that the Na'vi are able to communicate with each other, ride other animals, or share memories and history in the Tree of Souls. More, it is an organic process, completely biological in that it requires no outside hardware. For the Na'vi, as well, the act of singular connection is tied into two important rituals of maturation. First, when Jake has passed his training from Neytiri, the last step before becoming a hunter/warrior is to bond with his own Ikran (a flying dragon); once Jake climbs the Hallelujah Mountains, he wrestles his own Ikran, bonding and then joyously plummeting over the edge, straightening out, and then flying, top speed, in complete freedom. This ritual of connection brings the joy of complete mobility, exhilarating and breathtaking access to a whole new part of Pandora. Second, in order to bond with a partner, two Na'vi must join Queues and then be bonded for life, which Jake and Neytiri do under the Tree of Souls; it is with this act that Jake turns fully away from his human military counterparts and begins to fight as a Na'vi. This is a romanticized reflection of how the machinic audience plugs into their own world via the Internet, signing into the various avatars through the multitude of connected devices. From this, the Tree of Souls is mirrored by cloud computing, the Tsaheylu paralleling a bonding moment between digital native Tribe members. Pandora is what the world of 2014 is moving toward as more and more objects intertwine in the "Internet of Everything," paralleling what Neytiri, when describing Pandora, clarifies as "a network of energy that flows through all living things."

The exploration of Jake Sully and his relationship to his Na'vi doppelganger further reflects a potential machinic audience. Like *The Matrix* and *The Thirteenth Floor*, this is a world in which the

user controls his or her avatar entirely by brain impulses; there are no virtual reality goggles or gloves, simply an inert networked body in a bed. At the beginning of the film the body-avatar binary, familiar from *Surrogates*, is still set in place wherein the Na'vi version of Jake is controlled entirely by him and is fully without agency. Yet, this version of Jake still maintains a distinct biological reflection of him in his avatar's near perfect re-creation of his face that does not reflect the fractures in identity that Greer sees in the surrogates around him. More than this, to create a Na'vi avatar is an arduous process deeply tied to the user and is not undertaken with the flippancy of by simply buying one at a local convenience store. The only reason Jake is able to take over his dead twin brother's avatar is because his "genome is the same" and, as such, it retains the facial features and voice of the original user. One user cannot simply take over another's avatar; they are bonded, Tsaheylu, entirely to their Na'vi other. Unlike the replicas of *Surrogates*, these avatars are biological, not mechanical; they were "grown" on the flight into Pandora and suffer the same biological traumas (bleeding, death) that the physical bodies do. In particular, Jake's avatar, because he is wheel-chair bound (far closer to a literal cyborg than his Na'vi other), allows him the freedom to walk. It is this less foreign recreation of the self that the machinic audience identifies with: not a literal robot, or even an ephemeral digital Other, but rather a fully embodied biological/technological melding that is able to navigate the same reality the physical body does.

Like Greer's surrogate, while the Na'vi version of Jake is not strictly an avatar by definition, it functions with a very similar relationship to a user/Internet avatar. However, *Avatar*'s treatment is different in that it is a far more positive portrayal of the contemporary user-avatar relationship. Jake Sully's Na'vi operates in what Mark B. N. Hansen in his book *Bodies in Code* describes as "wearable space." Echoing Lunenfeld's vocabulary, Hansen defines "wearable space" as "a visionary, perhaps truly alien, projection of a complete fluidity between body and space: a mutual embedding of both in the primary 'medium' of sensation … space becomes wearable when embodied affectivity becomes the operator of space" (175). This is an understanding of space and architecture that acknowledges how a portable Internet user adjusts/expands his/her space based on the flexible and shifting body (both digital and physical) that is omnipresent. An architect (or web designer) must then acknowledge this new type of body, still dependent on sensual interaction but augmented by constant access to information, other users, etc.; this body is always

in transport: wherever the user of a smart phone goes, s/he brings this melding of avatar/user and effects/manipulates the space as s/he enters or leaves. It is this dynamic body that Jake inhabits in the jungles of Pandora: his Na'vi alien interacts and manipulates the geography he interacts with every time he plugs into his environment. More, the necessary acknowledgment of the dual presence of both bodies is captured by Jake as well: the other Na'vi do this by calling him by his "human name" Jake; Neytiri does it when she rescues him at the end of the film by preserving his physical body so he can then be reborn.

It is this rebirth that provides the natural end for the film, where Jake melds with his Na'vi avatar in a communal ritual under the Tree of Souls (figure 3.2). He lays on the ground and the same fiber-optic-like Queues that provide connection between objects and organisms in the world cocoon both his physical and avatar bodies. Both of Jake's bodies appear peacefully asleep until the film settles on its last shot, Jake opening his eyes, seeing clearly, as one singularly embodied self. Jean Baudrillard would look at the initial treatment of Jake's Na'vi avatar at the beginning of the film as creating a double or clone. In his chapter "Clone Story" in *Simulacra and Simulation*, he critiques this doubling process as generating ephemeral "phantasms," unhealthy serial repetitions (95). He critiques the clone, in much the same way *Surrogates* does, a body that "ceases to be conceived as anything but a message, as a stockpile of information and

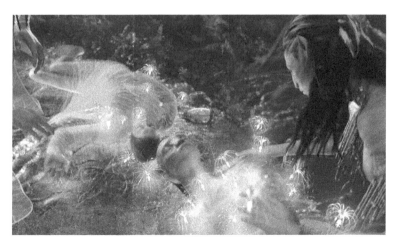

Figure 3.2 Jake Sully (Sam Worthington) melds with his Na'vi avatar while Neytiri (Zoë Saldana) watches (*Avatar*, 2009)

of messages, as fodder for data processing" (99). This is true at the start of *Avatar*, where Jake is using his clone as a double, a fantasy, a dream, that allows him to run and navigate the world in a way his physical body cannot. By keeping the physical and avatar body separate, an audience could critique *Avatar* as promoting, as Baudrillard outlines, "auto-genesis" in which there is "no more mother, no more father: a matrix. And it is the matrix, that of the genetic code, that now infinitely 'gives birth' based on a functional mode of all aleatory sexuality" (96). Baudrillard critiques this process because it does not follow the traditional and "natural" model of evolution wherein two organisms blend to create a new product that is a hybrid of the two organisms; instead, the clone/original relationship does not progress the organism forward but stagnates it: the avatar can only be a "reiteration of the same" (97). It is with this reiteration that the body loses its significance: "if all information can be found in each of its parts, the whole loses its meaning" (97). With this idea, Baudrillard is valuing the physical body as the whole, an "indivisible configuration" (98), whereas the clone-avatar is only the "dispersed fragments of the hologram" (97). However, the machinic audience would disagree with this hierarchical avatar/user assessment and instead align themselves with Deleuze's notion of Repetition and Nietzsche's Eternal Return: instead of the avatar being treated as a stagnant reiteration, it is instead one aspect of growth or progression; each time the user interacts with or through his/her avatar, they return to the physical body with additional information and experiences that necessarily advance, evolve, that self forward. For the machinic audience, their avatars do not simply mirror their own actions; they do not have the same information that other avatars or their physical body do. These avatars, Deleuze's full BwOs and "decentered circles," are instead out in the Internet living unique lives in unique spaces, in constant contact with the user as s/he traverses their physical reality, augmented by the flexibility/accessibility of wearable space. For Deleuze, this repetition destroys the linear and hierarchical notions of self and instead demands that each part be combined and recombined, constantly evolving the organism forward. This can explain *Avatar*'s popularity as Jake's unifying at the end of the film is treated as a triumph; he emerges from Plato's Cave, not blindly but proudly, as a shadow/human hybrid. It is in the blending of his physical and avatar body that a new, evolved version emerges: the avatar in this respect is not a clone but rather a component of Jake that can be combined with his other components (physical body) to create a whole, evolved organism. It is in this celebration

of this evolution that the machinic audience identifies and begins to explain the film's immense popularity.

This advanced version of Jake is treated with the same reverence as Quorra in *TRON: Legacy* (chapter 2): the implication is that both Quorra and the new Na'vi-Jake are the next step in a process in which humans are no longer the superior species. William Brown's essay "Man Without a Movie Camera—Movies Without Men" explains posthumanism "not as the end of humanity, but as the end of humanism—that is, posthumanism is precisely the belief that humans no longer play a central and binding role in reality," furthering Evan Selinger and Timothy Engström's understanding as the "end of human exceptionalism" (as cited in Brown). The posthumanist argues that the world is transforming into a planet where, potentially, humans are not the most important species and that there may come a future where humans are seen as one step in the evolution to intelligent biological/technological meldings, the Na'vi or the ISOs from *TRON: Legacy*. On the one hand, this explains the heavy-handed environmentalism of *Avatar*: as global warming progresses and wars around the globe brim over into other decades, theorists like Manuel De Landa (*War in the Age of Intelligent Machines* [1991], *Intensive Science and Virtual Philosophy* [2002]) have posited that having humans as the prominent species is no longer beneficial toward the earth in general and that humans are, in fact, in the death spiral of their existence. While *Avatar* does not engage, necessarily, in these apocalyptic scenarios, the audience can understand the film as portraying the largely destructive nature of an expanding militaristic human race and its inadequacies toward sustaining itself as a species, let alone participating as an intricate part of a universal ecosystem. In the film, humans are simply one species in a much larger universe that extends beyond Earth and Pandora. Too, the plot of the film reinforces these ideals as it casts humans, specifically the characters of Colonel Miles Quaritch (Stephen Lang) and Parker Selfridge (Giovanni Ribisi), as representations of militarism and human greed, encapsulations of Agent Smith's view of humanities viral nature (chapter 2). The film reassures its audience that what they understand as the human body is no longer the strongest, most pure, most moral vessel in the universe; as such, humanity must evolve, and *Avatar* encourages its audience to transcend/evolve toward the unity that Deleuze and Guattari see in full BwO-organism intensities. For the machinic audience, to be a posthuman and value a posthumanism ethic, as a Na'vi or an ISO, a Facebook or Twitter user, a piece of software or a mechanic, is to understand genus and species as equal and embrace the unifying

process of gathered and repeated identity that comes from a user's interaction with multiple avatars as a liberating evolutionary path.

The Machinic Audience and the Filmmaking Technology of *Avatar*

We can understand now, based on the content of the film, why a machinic audience would be attracted to the alien Na'vi within *Avatar* and how this attraction might lead to a posthumanist ethics that values the digital native (or posthuman/cyborg) as a potential evolutionary step. Yet, the distinct and revolutionary filmmaking technology and techniques involved in making *Avatar* creates a process of digitization (of landscape, of the actors) that the machinic audience not only recognizes but expects. While this technology doesn't create the Na'vi from nowhere, as Racter supposedly created poetry, there is something distinctive in the digital process of the film's technology in which we can recognize the machinic audience reflected back.

Much as McLuhan argued that the technology of a car extends the human foot, the camera has long been seen as an extension of, and often substitute, for the eye; traditionally, the analogue camera (8 MM film) "has been thought to represent (the equivalent of) a human point of view, or, more precisely, has been equated to 'seeing' or having an 'eye'" (Brown, 70). Unlike a painting, the movie camera presents "an image of the world [that] is formed automatically, without the creative intervention of man" (Bazin, 96). The camera then directs the audience to what s/he should view and the audience then voyeuristically accepts the image. The device, when considered this way, is rather passive and simply re-presents the world back to the audience as it is. Lev Manovich's adds that this traditional view of films, which he places somewhere in the 1970s, depends on "live action...i.e. they largely consist of unmodified photographic recordings of real events which took place in real physical space" (para. 3). Film, from this point of view, is a recreation of a world that, for the most part, was still dependent on human actors in physical spaces, a pro-filmic body; special effects would have been manipulations of the camera or objects present in the frame. Of course, this is not the case now as, for a number of decades, film has moved toward an increasing digitization both in the filming and creation of the images itself but also in the editing process. No longer is the camera contained to the possible (at least possible for humans) but can now extend outward, to the virtual, to include scenes and species from any depth or ether of imagination.

As William Brown points out in "Avatar: Stereoscopic Cinema, Gaseous Perception and Darkness," film has "nonetheless always been an exhibition or display that has required the viewer's collusion (or acknowledgement of the apparatus) in order to operate" (264). The audience of films, in particular *Avatar*, is of course well aware of the digitizing filming and editing processes, and has begun to expect it, even crave it. Repeating this text's Introduction, the machinic audience lies in Lisa Purse's exceptional *Digital Imaging in Popular Cinema* (2013) when she draws attention to what she calls "the digitally literate spectator," a increasingly normative moviegoer especially skilled in negotiating the digitizing process undertaken in contemporary films (25); such an audience watches the mini-documentaries and deleted scenes and director's commentaries made available on expanded Blu-rays and DVDs. Not only is there an increased understanding from the audience but the "studios work hard to prime spectators to appreciate special effects, to become connoisseurs in assessing their technical realization" (25). Such digital tools are not "outside of narrative," but are essential to understanding how a contemporary audience interacts with their films (26). *Avatar* invests heavily in this audience: promotional material for the film highlighted its vivid special effects and transformational three-dimensional technology, presenting itself not so much as a narrative, but as an event to be immersed within, a spectacle. The film's tagline, repeated as a mantra by the characters within the film, is "I see you." It is the focus on the visual, carried out to extremes and enhanced by three-dimensional effects, that its audience notices too, a seeing that is stunning in its colors and scope. Critics invested in Guy Debord (*Society of the Spectacle*) dismiss Spectacle as only an occupying commodity meant to suppress a mass audience; Purse, in a brief literature review near the start of her book, points to a number of film analysts who see special effects and the "visual spectacle" as not only "[interrupting] the narrative but [suppressing] its 'proper' function" (19). Such criticism argues that spectacle in this form creates a passive audience that only docilely consumes the film; such an immersion drowns out any other potential thought or experience than what the film presents. But, as Brown points out, that is partly *Avatar*'s goal, as it deliberately "occupies [the audience's] entire sensorium" (262); he later adds that instead of such a spectacle interrupting the narrative, it allows its viewers, pointing specifically to the film's visit to the Hallelujah Mountains, to "precisely view the fine level of detail that has gone into *Avatar*, whose settings might in numerous other films have simply been a painted backdrop consisting of a low level of detail" (263). To dismiss the popularity of *Avatar* is

to pessimistically create an audience that does not care to understand how a film is created or, even more troubling, create an audience that is not themselves digital craftsmen/women that do not see parts of themselves in the digital construction and immersiveness of the film. From this, critics such as Christian Metz (pointed to in Purse's 2007 essay "Digital Heroes in Contemporary Cinema: Exertion, Identification and the Virtual Action Body") might further disregard the reliance on special effects as encouraging a "cinema fetishist," a spectator too focused on the visceral and immediate joy/eroticism present in the visual effect that s/he is unable to navigate the film's narrative or potential larger messages or goals; writing in 1975, Metz stigmatizes this type of audience member by referring to him/her as engaged in a "fetish," reducing this mode of viewing to a practice pre-formed by a limited few, with lewd connotations. Metz's work does not anticipate how normalized the navigation between the two spaces would become, nearly 40 years later, and how astute the machinic audience would become at traversing between film and acknowledg-ment of its construction. This machinic audience, in the same way they demand content/protagonists that reflect their digital/physical relationship, expect documents that encourage and imitate that rela-tionship as well: the digitally literate spectator lives in a world where nearly every document they interact with has been digitally altered or constructed, in both the mass media (photoshopping a magazine cover) or in small-scale social interactions (photoshopping a photo of oneself before posting it to Facebook). Such a process (or repetition) is not spectacular but familiar, even potentially comforting. *Avatar*'s popularity is driven by the extreme virtuosity in seamlessly creat-ing and maintaining its digital world; the passivity that critics worry about is replaced by an audience's self-aware and reflexive/skeptical approach to documents.

There are two main digitizing vehicles that propel *Avatar*'s world forward: its advanced three-dimensional filming/projection tools and Cameron's invention of the SimulCam. First, the three-dimensional technology that Cameron pioneered for the film, the Fusion Camera, was essential to audience's experience of the film: it was not a retro-fitted parlor trick or sensational ticket-selling gimmick but rather an integral technology that was imbedded into the conception of the contextual world of the film and the filmmaking process as a whole. As recounted numerous times, Cameron conceived of the film and the technology he wanted to make it with a decade before he began filming and had to wait until the hardware caught up with his vision;[4] as such, he took on the invention process, perfecting and molding

the filming and projection technology to fit his particular needs with *Avatar*, even going so far as to "dry-run" it through with a number of other films, mostly notably the theatrical release of *Spy Kids 3-D* (Dir. Robert Rodriquez, 2003), before he released the film (Davies, 2009). In its early forms, a three-dimensional effect was intended to replicate the audience's world, moving the document further down the spectrum toward a mirroring of the audience's reality by extending the screen and surrounding the audience within the illusion of depth and tactile interaction. But the three-dimensional world of *Avatar* doesn't intend to duplicate "reality" (Pandora is, after all, an alien planet) but instead surrounds the audience in the same way that their wireless connections do, plunging that audience directly into the middle of a world/screen too impossibly large to consume at once. When Cameron describes the film as "a lucid dream" (as cited in Mulrooney, 201) he uses the same language Case does in *Neuromancer* when he occupies cyberspace; too, it is this same motif of dreams that Morpheus draws Neo's attention to when discussing his interaction within the virtual spaces of the Matrix. *Avatar*'s attempt to completely submerge its audience into its world mirrors the mechanisms used to enter into the virtual cyberspaces, also rendered/conceptualized in a similar faux three-dimensional, that the machinic audience occupies constantly; the cooperation between the film's audience and the three-dimensional nature of the film is the same user-computer interaction present in a CMS-driven website. It is with this idea that discussing any sort of "realist" intentions in the film seems a bit strange; the film is a knowing construction that depends on the audience's knowledge of its creation to fully realize its intentions. As Coleman states, in the formation of any avatar "if we are nearly constantly mediated, then how are we making judgments between the real and the virtual? The answer is: we are not" (67). When Brown argues in "Avatar: Stereoscopic Cinema, Gaseous Perception and Darkness" that the three-dimensional glasses, while enabling a "decoding" of the three-dimensional "film" impossible by human eye alone, may "act as a filter, medium or apparatus, between the viewer and the image itself" which takes the audience "away" from what they are seeing (269), he is perhaps not acknowledging that the machinic audience has no real issues interacting with/viewing the world through a technological filter. The three-dimensional glasses occupy the same mode of interaction as a smartphone might; yes, they are both external mediums, but they are required (even normalized) devices that allow access into an enhanced space or narrative. The machinic audience has very little issues with (sometimes even

consciousness of) this mediated relationship between device and user. In a paralleling of the content of the film, the machinic audience identifies with Jake's reliance on his technological filter to interact with the Na'vi on Pandora because they, in the same ways, use similar filters (3-D glasses included) to enter into and participate in cyberspace. In the same way, a user might hold up a smartphone above the crowd and watch a concert through its screen or a sports fan would watch the Jumbotron instead of the field, watching the film through 3-D glasses is perhaps not seen as foreign but an integrated part of consuming culture in 2014. Lisa Purse underlines this fact further in her discussion of *Hulk* (Dir. Ang Lee) and *Spiderman* (Dir. Sam Raimi) when she writes that when inserting a digital character the director must mirror the audience's experience "as mediated photographically through news coverage, film and television, city webcams and personal cameras" (60). To make a film that appeals to a mass machinic audience, as *Avatar* does, it must reflect their own mediated existence, as both creators (via Tweets of photos/video as "news coverage") and consumers of digital content and identities.

So while the 3-D world of *Avatar* plunges its audience into the familiar mirror of the Internet, the SimulCam recreates the digitizing avatar creation process so familiar to a machinic audience. In "Man Without a Movie Camera" (previously cited), Brown points to the shift from analogue to digital filmmaking as morphing the human actors into digital technology and presenting "a hybrid of 'real' flesh and blood actors and digital imagery" (69); this practice of alteration, he argues, creates "'posthuman' cyborgs" (69). Again, it is incorrect to state that Cameron has created digital film, or is the most effective example of its use, but the technology developed for *Avatar* in particular presents the next evolutionary step in digital filmmaking. When the film was released in 2009, the evolutions in Internet interfaces and Internet-connected devices discussed in chapter 2 had normalized the complete body/identity digitizing process that Cameron undertakes when filming his actresses and actors and turning them into the Na'vi doppelgangers that would appear on screen. At this point, there is a fair bit of writing done on the specific technology so it is not worth repeating at length here. Briefly, as Ellen Grabier in *I See You: The Shifting Paradigms of James Cameron's Avatar*[5] describes:

> The SimulCam/virtual camera was equipped with a monitor in which Cameron—while shooting the live-action performance of his actors—could literally see a low resolution version of what had been generated on the computer up to this point. So while Cameron was shooting

actors and actress in motion-capture suits with their head rigs on, he was *seeing* them against a background of lush foliage and bioluminescent plant life. (Loc 1170 of 3779, author's italics)

Not only would Cameron be able to see the background of Pandora CG rendered in real time but the camera also translated the actor/actress into their Na'vi version as well.[6] This new technology moved the digitizing process from postproduction to the immediate translation, allowing Cameron to see how his computer-generated world and actors would look as if he were indeed filming the Na'vi on Pandora. As Jenna Ng explains, the motion-capture in the film is so stunning because it allows for "spatial *and* temporal immediacy, for in mocap lies the presentness of action to be repeated in *any* spatial and temporal framework" (282, author's italics). The key then is to recognize the complete symbiosis the SimulCam enable: the pro-filmic human bodies (organisms) are still necessary, but are instead blended seamlessly with their own digital doppelgangers (BwOs) and create a unified version in the final cut of the film. This process of instantaneously creating a digital repetition with an astounding amount of flexibility and agency, while invisible to the machinic audience when viewing the film, is still one that s/he can recognize and acknowledge and one that is reflective of his/her own personal daily life. Every time a digital photo is captured, photoshopped, and uploaded, the machinic body is reproduced and recognized; it is neither distinctly human nor machine/digital. Likewise, creating avatars, whether simplistically through jpegs or gifs on message boards, profile pictures on Facebook augmented by personal information, or more intriguingly through interactive gaming spaces such as an video game avatar, the machinic audience is constantly placing a digital version of themselves, a repetition, into a virtual environment, in much the same way the cameras filming *Avatar* do to their actors. The fact that this process takes place instantaneously parallels the machinic audience's own continual digital self-projections and submersion in their respective virtual worlds. Ng then suggests that this mode of filming is especially exciting in that it creates a tremendous fluidity of identities, from actor to digital character, "from Andy Serkis to Gollum; from Zoe Saldana to Neytiri," conceivably similar to the transformation from a user to a user's Facebook profile. Ng focuses on the last shot of the film, when Jake opens his eyes as a unified Na'vi as signalling "a new signification of self—of simultaneous resistance and agency, of being and being invisible, of an effortless moving between worlds, realities and forms" (284). It is in this new version of identity

created by Cameron's film technologies that the machinic audience recognizes their own avatar-self relationship/construction reinforced in the film.

Yet, this new signification of the self is the most successful (as in *Avatar*) when each version/fragment/repetition resembles each other in some way. Purse adds that as the duration of the special effect continues and loses its visceral nature the longer the film goes on; she argues that "the desire to see the 'trick' [special effect] performed gets us into the movie theater, it is not really what keeps us there" (56), pointing then to the need for a successful story to pair the special and CG effects with. While we've already discussed the content/narrative of *Avatar* and linked it into the machinic audience's appreciation of it, it is worth lingering to unpack what Purse identifies as the "human agent" aspect of narrative that can also be located specifically in the digital avatar's face. What makes the process of *Avatar*'s creation more exciting than the use of traditional digital effects is that the actors actually look a remarkable amount like their human counterparts: the facial translation the cameras undertake grant the virtual Na'vi features that are directly reflective of the actual actors acting out their bodily movements. The use of the SimulCam in combination with detailed headrigs allowed for "a new technique named 'image-based facial performance capture'" where "the video of the actor's face is rendered at an almost pore-by-pore level, and the result was the astonishing emotional authenticity displayed by the Na'vi characters" (avatarblog.com). Again, Grabiner describes the technology succinctly, detailing the facial mapping process the actors undertook as not just focusing on reconstruction of the actor's face but rather a holistic recreation process that aimed to "recognize a set of behaviors or expressions that belong to a common structure of a particular individual" (Loc 1070 of 3779). The camera was kept impossibly tight to the face until the technicians could gather as much raw data about the face as possible; from there, the basic particular movements of the actors'/actresses' faces were combined with CG technology, "hundreds and hundreds of sliders which made it possible to adjust minute muscle movement" until the Na'vi version matched the human actor (Loc 1085 of 3779). The film's technology and final product supports the research by Cook, Johnston, and Heyes detailed in "Self-recognition of Avatar Motion: How Do I Know It's Me," in which they find that topographic facial cues, defined as "spatial configurations of limb positions and trajectories" are far less useful in self recognition than "frequency and rhythm of key movements" or what they call "temporal cues" (669). It is not enough to simply replicate the face; to truly

recreate a person digitally takes a more personalized approach that recognizes distinct and individual "micro-movements," a process that echoes how multifaceted self-identification can be, and in turn demonstrates the virtuosity of effect/affect that the machinic audience demands/expects. The results in *Avatar* are amazing in their fluid and meticulous reenactment: not only do the Na'vi look flawless and organic but they also look like a lightly morphed, beautiful echo of their human counterparts.

Again, the result of this technology was not enacted with the goal of "realism" in mind but rather creating a Na'vi counterpart that resembled but not cloned-exactly the actor. In this, the Na'vi is a unique blend of digital technology and human agency/individuality that mimics what the machinic audience generates each time they extend themselves with an avatar. The face, in particular, is an essential component in generating an effective avatar. Deleuze and Guattari explain that the face is what separates the strata of the organism (body) from signification and subjectification, the main site of a "facialization" process that they argue maintains uneven power and social dynamics, filtered primarily through the visages of White Europeans and Christ. The abstract machine that governs the face then has two "aspects": the first is to establish a person within a recognizable binary system (woman/man, rich/poor) in order to link the faces together "two-by-two. The face of a teacher and a student, father and son, worker and boss, cop and citizen, accused and judge" (177); the second aspect is to make a choice, to reject or affirm those roles, to "reject faces that do not conform, or seem suspicious" (177). The face, in this larger abstract treatment, is problematic, potentially maintaining the sort of binaries and hierarchies that the authors find destructive in their introduction to *A Thousand Plateaus*. As such, "there is even something absolutely inhuman about the face," that has undergone "an operation worthy of Doctor Moreau: horrible and magnificent," adding that "the face has a great future, but only if it is destroyed, dismantled" (170; 171). Part of this dismantling of the oppressive organizational construction of the face can be found in Cameron's headrigs in which the audience is allowed to pay attention to the "tics," or temporal cues, of an individual's face. As Deleuze and Guattari describe, a tic is "the continually refought battle between a faciality trait that tries to escape the sovereign organization of the face" (188). With this recognition:

> Each freed faciality trait forms a rhizome with a freed trait of landscapity, picturality, or musicality. This is not a collection of part-objects but a

living block, a connecting of stems by which the traits of a face enter a
real multiplicity or diagram with a trait of an unknown landscape, a trait
of painting or music that is thereby effectively produced, created. (190)

In discussing the close-up shot in detail in *Cinema 1*, Deleuze goes
further to explain that the face, on film, "is this organ-carrying plate
of nerves which has sacrificed most of its global mobility and which
gathers or expresses in a free way all kinds of tiny local movements
which the rest of the body usually keeps hidden" (88). When Deleuze
speaks to Eisenstien's innovation of an "intensive series" of faces (per-
haps "a connecting of stems"), he speaks to the close-up as a tool
"which goes beyond all binary structures and exceeds the duality of
the collective and the individual" (92). It is through this series that
an audience is asked to view the face as on a continuum of emotions/
expressions and with this comes, as he later describes a filmic space
where "the facial close-up is both the face and its effacement" (100).
Again, the headrigs exaggerate and record these tics, but not just one
"tic" but rather the whole system of the actor's individual face, and,
as such, reflects the "real multiplicity" that the machinic audience
sees in their individual identity. As mediated through the collected
prolonged close-up "raw footage," potentially similar to the "living
block," the headrig provides the same intensive series, only exagger-
ated by its sheer volume (hours of footage, instead of minutes). As that
footage, dependent on a series of "tics" or "tiny local movements," is
translated into the CG-enhanced Na'vi faces of the actors, they blend
between binary structures of organic and technological, maintaining
the actor's "original face" but also making it indistinct, effacing it,
with computer graphics. The fact that this process is invisible to the
audience, unlike a close-up included in the final cut of a film, does not
mean that the digitally literate spectator isn't aware of it; they under-
stand that there are some digital effects that are creating the Na'vi. In
fact, it is in this act of translation through digitizing technology that
the machinic audience member recognizes his/her own avatar-making
process that enables, potentially, the sort of resistance to the oppres-
sive binaries (human-technology perhaps?) that Deleuze and Guattari
are concerned with. The avatar itself could be an empowering "tic"
in this respect, a new "dismantled" face that resists the power bina-
ries that the authors identify by decontextualizing the face through
the mere fact of it being user-created (and not externally, biologically
or sociologically, predefined). By comparison, while *Avatar* promotes
this dismantling in its filming technologies and in the narrative cre-
ation of Jake and Grace's Na'vi-others, *Surrogates* maintains many of

the binaries Deleuze and Guattari recognize. In *Surrogates*, the ava-
tars/replicas have completely clean faces, flawless skin; there are no tics
here, but an unsettling generic perfection. More, the film makes the
ability to slip behind another face terrifying, vilifying it in the charac-
ter of Dr. Canter and, in the case of the overweight man becoming an
attractive young female via surrogate, presenting the "tic" as perverse
and just plain gross. The avatar is not a tool to explore sexuality or
further notions of nonnormative (binary) identities but rather enables
"unhealthy" social appetites, and in this the film encourages the audi-
ence to undertake the rejection of nonconforming or "suspicious"
faces that Deleuze and Guattari describe. The fact that *Avatar* affirms
the opposite ideals and became so much more popular signals that the
machinic audience views their avatars as empowering creations rather
than spaces to reaffirm larger societal binaries/identities.

When, at the end of the chapter on faciality, Deleuze and Guattari
draw attention to the evolution from "primitive heads, Christ-face,
[to] probe-heads," they are creating a potential evolutionary form,
posthuman or cyborg perhaps, that echoes the "primitive, spiritual,
human head," wherein the most powerful creatures were the ones
absent of distinct facial features, while folding in the cultural history
of the "inhuman" Christ-face. It is in this probe-head, a blending
forming "a nonhuman life," that an unified organism/full BwO lays,
a head with no one singular face but rather a living block, a connect-
ing of stems, a series of multiple faces, repetitions, all tethered tightly
to one another. The machinic audience values the face greatly; after
all, the most popular social media site in 2014 is called "Facebook."
Yet the "faces" of a Facebook user's profile are malleable and vari-
ous: a user's Facebook account is not simply a picture of their face
but rather a multimedia/sensual collection of fragments (living block
and/or stems) that the user claims as part of their identity; the face is
the initial portal to enter but from there it twitches, tics, and expands
outward. It is this audience of *Avatar,* encouraged by the SimulCam
and headrigs that Cameron invented and integrated, that views their
bodies and digital others as interchangeable, echoed repetitions. The
last step of this chapter is to explore the landscapes that the characters
of *Avatar* inhabit and work through why a machinic audience might
find solace in its jungles and mountains.

Pandora—The Hyperreal World and the Uncanny Valley

When Jean Baudrillard describes the "hyperreal" in *Simulacra and
Simulation*, he does it in order to critique such a space (exampled by

Disneyland) as "embalmed and pacified" (12); it is an "ideal" space (like the nuclear family he describes on page 28) that has no real-life equivalent. Such a space is built from nostalgia, an embalmed past, and a yearning for a fictional, and now impossible, return to the "real" world: such a place exists to "[conceal] the fact that the real is no longer real, and thus of saving the reality principle" (13). The hyperreal then is a space of "production," a product in a capitalistic market, the goals of which is "what every society looks for in continuing to produce, and to over-produce...to restore the real that escapes it" (23). Yet, this restoration is impossible: the "real" is too far gone and to try and "return" to the binaries of real/simulation, and if it was ever possible, it is now most certainly an unworkable task. This would be troubling to McLuhan's Literate Man, who based his clear divisions between real/fakes on Plato's Allegory of light/shadows, but, as we've discussed earlier in this chapter, the large-scale embrace of digital avatars and cyberspace has brought with it a self-awareness and intelligence/skepticism toward simulated spaces and bodies. For the machinic audience, "returning" to the "real" is not necessarily a goal; instead, it is the desire to live in simulated spaces, such as cyberspace or even Pandora, that drives him/her. The moviegoing experience for this viewer, yes, is similar to the theme park in that it quarantines the viewer off from the outside world and demands immersion into the space; to this end, Pandora is undeniably stunning to the eye, a supra-vivid exaggeration of reality spectacularly splashed with brighter-than-bright colors and sprawling, impossible landscapes. This is where Baudrillard might pessimistically dismiss *Avatar* as "the hallucinatory resemblance of the real to itself," a product that aims to mirror/simulate reality but through a completely hyperbolic version of Earth (23). While such a view would see the film as a product attempting to replicate the impossible real with its 3-D graphics and "cloning" digital-filming techniques, the machinic audience can view the film and view themselves within Pandora, a world that is obtainable and immensely attractive. Pandora, instead, is acknowledged, not as real, but, as an all encompassing reality that far surpasses the viewer's own in terms of vividness and sharpness, an enhanced version of his/her own utopia. The machinic audience invests in the creation of the hyperreal world of Pandora in a meaningful and emotional way; one might even imagine wanting to live in such a place and, upon being exiled at the end of the film, to feel a longing for such an unreal paradise. A CNN article published just after *Avatar* was released explained how many viewers "experienced depression and suicidal thoughts after seeing the film because they

long to enjoy the beauty of the alien world Pandora" ("Audiences experience '*Avatar*' blues," para. 1). One user, Ivar Hill, highlights the strong attachment to Pandora:

> When I woke up this morning after watching *Avatar* for the first time yesterday, the world seemed...gray. It was like my whole life, everything I've done and worked for, lost its meaning...It just seems so...meaningless. I still don't really see any reason to keep...doing things at all. I live in a dying world...I was depressed because I really wanted to live in Pandora, which seemed like such a perfect place, but I was also depressed and disgusted with the sight of our world, what we have done to Earth. I so much wanted to escape reality.

This statement echoes the posthumanist notion of humans, recalling the earlier sections of this chapter, as a destructive and "disgusting" species perhaps worth the defeat it receives in the film. While this is worth noting, it is a small part of a viewer like Hill's dissatisfaction. Baudrillard explains we live in a world in which "the medium itself is no longer identifiable as such...there is no longer a medium in a literal sense: it is now intangible, diffused, and diffracted in the real" (30); 30 years later, this statement has become exponentially easier to understand as the mediums of the Internet (web pages, text messages, YouTube videos, etc.) are more diffused than ever. Yet, Baudrillard identifies media as "a kind of genetic code that directs the mutation of the real into the hyperreal" (30); it's the media then that is the vehicle of evolution toward the hyperreal. Pandora is a planet in which the media is so diffused that it has become literally biological, grown into the plants and animals and Na'vi: the mutation Baudrillard speaks of, has already long passed into normalcy so that Pandora, for its inhabitants and its viewers, is a supra-connective, media-saturated hyperreality, far from embalmment or pacification. While it might be tempting to reject Hill's reaction to *Avatar* as escapist utopian fantasy into the theme-park false world of Pandora, Hill's own disconnection between his own reality and a virtual planet rendered by a combination of hi-tech cameras, and his ultimate dissatisfaction with the "real" world mirrors the machinic audience's increasing depression of interacting in a world that doesn't allow, as of yet, the type of rich augmented space, a physical-virtual Deleuze-ian map, that the machinic audience finds most comforting.[7]

It is important then to notice that *Avatar* takes place in a lush, organic jungle rather than the cities of *TRON: Legacy* or *Surrogates* (or a majority of the other films discussed thus far). Whereas the

city is man-made, unnatural, and always artificial in its density and growth, the jungle of Pandora, like Darwin's Galapagos Islands, is a site of natural evolution, in which all organisms have advanced into creatures dependent on, and worshipping, compact webs of interconnection. Think of the frustrated groans that come with an unstable wireless connection. Pandora is a place where the Internet never shuts down and the user never disconnects. The wearable space that Hansen described has not yet extended far enough: for the machinic audience, it's not just that people get depressed that they can't live in the un-real beauty of Pandora but also that they can't literally plug into trees and animals and each other. In truth, the machinic audience feels more at home on Pandora; they can imagine themselves there, in the same way they imagine themselves as their digital projections on their Xbox or Facebook page, to constantly be in contact with a world bigger and brighter and sharper than even their own imagination.

This demand for films that reflect a high level of digital integration, manifesting in positive attitudes toward and tolerances of digital representations and computer graphic recreations of human actors and actresses, is still quite new. *Avatar* can then be seen as a marker of a key transitional period in which the understanding of the "Uncanny Valley" has shifted dramatically, perhaps even bridging the chasm entirely. It was only 20 years ago that Jobe Smith in *The Lawnmower Man* argued that his "final stage of evolution" was an entrance into and complete immersion within a mainframe networked computer that would re-create him as a God, a "Cyberchrist." Smith's version of a new posthuman is terrifying, a blasphemous, murdering boogeyman that reflected the initial potential fears of how the Internet would modify the average user. Still, he parallels his own biological evolution with an evolution of hardware, insisting that "just as the telegraph grew to the telephone, as the radio to the TV, [virtual reality] will be everywhere." The film's erroneous conflation of "virtual reality" and the Internet aside, Smith argues that his biological evolution is directly tied to a technological evolution, the results of which, in the early days of the popular Internet, made for digitally disfigured lunatics that bore little resemblance to the human actors and actresses. As such, audiences of popular cinema, while marveling at the new CG effects in a film like *The Lawnmower Man* or the later *Johnny Mnemonic* (1995), were able to see the polygraphic, chunky digital representations of characters within the films' versions of cyberspace as safely distant and fantastical. Yet, as video quality and CG improved into the 2000s, audiences were leaving theaters dissatisfied after watching films such as *Polar*

Express (Dir. Robert Zemeckis, 2004) or *Final Fantasy* (Dir. Hironobu Sakaguchi, Motonori Sakakibara, 2001) because the humanoids generated by the graphic engines or special effects were "too real." While critics pointed out that both films' narratives were muddled and uninspired, it was the attempted creation of digital "actors" that was most disturbing. There were two components to consider, the first of which Rex Reed sums up in his review of the *Polar Express*:

> The result is everything I hate about movies today, composed entirely of digital images, animatronics, laser printers and computer hard drives, eliminating the need for actors, writers, sets, costumes, cameras, lights and anything else that gives a motion picture both its motion and its picture, not to mention its lasting sense of humanity. (para. 1)

It is the nervousness surrounding the end of human exceptionalism that pervades the quotation, a yearning for the pro-filmic body of yore (in opposition to Baudrillard's clones) discussed earlier in the chapter, that resists machines making films for a machinic audience. The second element is articulated by critic Trevor Johnstone in response to *Final Fantasy* when he writes that despite "the detailing of hair and freckles," the viewer is left unnerved by "the marionette-like impression created by cold eyes and oddly unconvincing body movements" (*Time Out*). Through the characters have strong elements of "humanity," appearing close to real, they are still too mechanical. The films of this period, limited by the filming and digital hardware and software, were creating characters that fell into what robotist Masahiro Mori explains in his 1970 paper "Bukimi No Tani" as the Uncanny Valley. For Mori, the relationship between a user and a machine can be charted along two axis: "affinity" or familiarity along the Y and human likeness along the X Machines. Users exist in a relationship wherein there comes a point where a machine looks too much like a human and becomes uncanny; it becomes more "eerie" as its familiarity to its biological user unnerves the user in its replication. Mori sees this relationship most clearly in prosthetics:

> Some prosthetic hands attempt to simulate veins, muscles, tendons, finger nails, and finger prints, and their color resembles human pigmentation. So maybe the prosthetic arm has achieved a degree of human verisimilitude on par with false teeth. But this kind of prosthetic hand is too real and when we notice it is prosthetic, we have a sense of strangeness. So if we shake the hand, we are surprised by the lack of soft tissue and cold temperature. In this case, there is no longer a sense of familiarity. It is uncanny.

Mori's idea is that when a machine looks so familiar, or in his example biological, that it could fool another human into believing it's real, it creates a feeling of extreme unease. In 2007, Jun'ichiro Seyama and Ruth S. Nagayama add that "the same holds true for the physical appearances of agents in virtual reality and characters in computer graphics movies" (338). There is a "valley" then where the machine or characters become "too real" and, in that, repulsive; the digital "actors" of *Polar Express* and *Final Fantasy* fall completely within this valley. An audience of the early 2000s could tolerate robots or CG characters so long as they remain superficially robot-like or distinctly inhuman; however, when that humanoid comes to look too much like a human and the audience is confronted then with its prosthetic nature, they become scared and repulsed. This unease paralleled the still deep-rooted concern that the Internet user's avatar was similarly becoming "too real" and, as such, was seen, through the dogmatic values of Literate Man, as unnatural and untrustworthy, an erosion or shadow of the user's True identity. This was entrenched in Freud's treatment of the uncanny in his essay "The Uncanny" wherein he links the feeling of repulsion around the uncanny to an object associated with unhealthy repression, an "imaginary [that] appears before us in reality" that depends upon "the old animistic conception of the universe" wherein body and "soul" could be separated and arranged in a hierarchy. He points then to a "repetition-compulsion" that generates a "double" that "has become a vision of terror," that transforms from "an assurance of immortality" to "the ghastly harbinger of death" (9–15). The treatment of the user replicas in *Surrogates*, for example, follows this line of thinking, wherein the double is a corrosive point of vulnerability for human identity and survival.

Yet, as demonstrated earlier in this chapter, a Deleuzian understanding of Repetition or doubling within self-identity, as practiced by the avatars of the digital natives of 2014, is seen as natural, necessary, and healthy. In *Avatar*, the highest grossing movie of all time, we can see that art that presents characters, such as the Na'vi, who are based on actual humans but still generated entirely by CG, and therefore robotic in Mori's sense, is extremely popular. Perhaps it is because the CG Na'vi are created in complete symbiosis with the human actors and actresses, rather than created simply out of the ether of a computer program like *Final Fantasy*, that made the film such a touch point for the machinic audience. The headrigs and SimulCam create stunning versions of humanoids that inch ever closer to Mori's "healthy person"; more, the process of digitization is so familiar to the machinic audience, and so central to the film, that it makes a huge amount of

sense that they would identify so strongly with the Na'vi and Jake. The machinic audience is such that its understanding and repulsion away from entities in the Uncanny Valley is greatly diminished and that *Avatar* is participating, as a work of art, in a contemporary milieu that has, in a sense, bridged that Uncanny Valley. Let's remember that *Avatar* was nominated, albeit in a recently expanded Best Picture Category, for nine Oscars and was generally recognized not only as extremely populous, but also one of the best (and perhaps important) films of that year. The digital filmmaking described in the previous section and rejected a decade earlier in the complete CG of *Final Fantasy*, is accepted and even yearned for. The machinic audience lives in the Uncanny Valley: they double and repeat their bodies, engage through a network of their various digital prosthetics, as machine versions of themselves. The posthuman is not a harbinger of death or the apocalypse, but rather an agent of progress and prospective paradise, long present in a user-Internet assemblage. Instead of rejecting the machine Na'vi as repulsive and thrusting them into the Uncanny Valley, we seem to see a shrinking of that valley, an acceptance of the machinic and the digital as a reflection of contemporary life.

The sequel to *Avatar* is tentatively scheduled to be released in 2015, the second in what Cameron promises to be a trilogy. This second instalment will be as highly anticipated as the first, a 3-D romp through the old stomping grounds of Pandora with the digital doppelgangers, the Na'vi. The machinic audience will slip back into the landscape just as easily and comfortably as in the first film, returning to a virtual place that they recognize as a home, as familiar and relatable. While Racter collects dust on old floppy disks, Cameron and his Na'vi will generate art that the machinic audience will consume with the gusto of a pointed Twitter feed or message board, plug into the communal hyperreal, and settle into a digital world mirrored inside their own.

Chapter 4

Hacking against the Apocalypse: Tony Stark and the Remilitarized Internet

Introduction: The Robot Historian, Chess Playing, and the Military Network

Manuel De Landa's *War in the Age of Intelligent Machines* (*WAIM*) is an excellent history of the cross-pollinations of military thought and technological advances, focusing alternately on the evolution of larger hardware components (ballistic missiles, computers) and on the "control machinery" (155), or software, that directs that hardware. Through the eyes of his robot historian, the Internet and modern computing was incubated by the American military: driven by a scarcity of computing supplies and resources, Paul Baran at the Research ANd Development (RAND) Corporation had "convinced government officials the United States needed to establish a distributed communications system that could withstand a nuclear attack" (Moshovitus, 35). This meant the creation of a "distributed network," one that sent "small 'packets' of information" over a number of different routes (Ryan, 15); this proposed system shunned the "traditional network" (one unit of information over one single path, as exampled by "AT&T's highly centralized national telephone network" [Ryan, 13]) and would instead "allow information to be sent over many different possible routes" (Moshovitus, 35). The first such space, ARPAnet, was created in December 1969 (ibid., 61); while it publicly debuted at the 1972 International Conference on Computer Communications, it wasn't until "a rumor, suggesting army intelligence officers had used ARPAnet files to relocate files concerning the whereabouts and behaviors of political activities" that knowledge of its existence became widespread (ibid., 87). A small number of users in the 1970s and early 1980s would have been self-taught

hobbyists, while the vast majority would likely have been government, university, and/or corporate employees (though there was obvious overlap between the three groups). As such, the Internet was still concentrated in the hands of a few, mostly, De Landa argues, those in the American military. Not coincidently, the year the Internet was unveiled was the year Advanced Research Projects Agency (ARPA) added a "D" (as in Defense) to become DARPA.

With this understanding of the Internet as a military technology, De Landa's robot historian puts a premium on exploring the initial binary of hardware and software in military technologies. Hardware, for De Landa, is "concrete physical assemblages," connecting a number of "component parts" (*WAIM*, 139, 142). Early examples include clockwork and steam motors, then later increasingly miniaturized, powerful, and integrated transistors and microchips. Software is concerned with "the mechanization not of 'logical resources' but of the means to press into service those resources," the earliest forms being Jacquard pattern-weaving punch card patterns in 1805 (ibid., 155). When the hardware (tools, weapons) and software (tactics, "thought") unite into a single assemblage in one entity, and that process is repeated across a number of different entities that are then connected in a network, those machines together form what he calls a "machinic phylum" (ibid., 6). De Landa, borrowing the phrase from Deleuze and Guattari, further defines it as the "processes in which a group of previously disconnected elements suddenly reaches a critical point at which they begin to 'cooperate' to form a higher level entity" (ibid., 7). Deleuze and Guattari add that this machinic phylum is "materiality, natural or artificial and both simultaneously; it is matter in movement, in flux, in variation" (*ATP*, 409); further, the machinic phylum is a "*constellation of singularities, which converge, and make the operations converge, upon one or several assignable traits of expression*" (ibid., 406, authors' italics). This new larger machine is an assemblage of assemblages in flux and movement, "self organizing" until each smaller reaches a point of "singularity." The chaos or "turbulence" that arranges itself into a singularity evolves, linking robots and humans to "a common phylogenetic lineage" resulting in an entity that "blurs the distinction between organic and non-organic life" (*WAIM*, 7). While Deleuze and Guattari can envision potential machinic phylum arranging themselves across a number of larger social "desires" or assemblages, De Landa chooses to focus on the specific phylum, a conceptual model of assemblage, that emerges from war and the military; in De Landa's machinic phylum, the multiple smaller machines, each unifying individually, combine to generate a

larger conceptual model of military force that blends physical hardware with tactical and strategic "software." What this singularity hinges on is human beings giving up what he calls "control" to the software; this means allowing the "demons" (localized fragmented pieces of information within the machine) to control and guide the machine, demonstrating "local intelligence" (ibid., 120). These "demons" are crucial as "they are not controlled by a master program or a central computer but rather 'invoked' into action by changes in their environment...allowing a computer network to self-organize" (ibid., 120), as it does in the example of ARPAnet, so that localized computers can then "converse" with other localized computers, regardless of geography. De Landa argues that the military, even in the early 1980s, had already necessarily given up control to these "demons" to "get humans out of the loop," allowing the machines themselves to self-organize, a process he saw as being inevitably transferred to the public Internet (ibid., 193). As mentioned in the Introduction, De Landa's robot historian stops in 1991, just before the Second Era of Internet use that signalled a far more populous use of the technology. Into the mid-1990s, while the Web's traffic was still primarily File Transfer Protocols (FTP) activity and email, the web browser's rise to prominence as the main (accessible and user-friendly) portal into the Internet morphed the technology into one that was no longer concentrated in the hands of a few, but exponentially extended to a mass scale. Since the technology's inception, the Internet user has relied upon the demon's/machine's "local intelligence" to guide information, through the fragmented package switching, from one source (or IP address) to the designated target: the human does not choose the path that the information takes; the demons do. Looking broadly at "average" work/home computers, rather than just at the Internet, is useful too as, for the average early Internet user (and even to some extent a user in 2014), it was likely difficult to conceive of the Internet as a distinct technology apart from the computer itself and, as such, attitudes/fears/concerns about the "demonic control" of computers would have likely been conflated into attitudes about the Internet (and vice versa). Jean Baudrillard in *The System of Objects* sees this as a necessary function of "automatism," a "closing-off, to a sort of functional self-sufficiency which exiles man to the irresponsibility of a mere spectator" (117–118), again putting humans "out of the loop."

The Internet (and early home computing) as a public/mass technology, relying upon its users' trust in their densely networked computers to transfer the information from point to point with their own "local intelligence" (without that user's direction/knowledge),

manifests as frightening and potentially threatening in films like *War Games* and *The Matrix*. The relationships/conflicts within those films between user and computer are drawn largely along the lines of hardware (the computer, an overtly mechanical/technological entity) and software (the more "human elements" (programmers/programmed) that "think," the mind); as such, the film depictions of the early Internet are a key space in which we see user reactions to the user–Internet relationships at the site of machine independence made bare, constructed as military adversaries, and perhaps best mirrored by similar treatments of late twentieth-century chess machines.

De Landa points to chess-playing machines as some of the clearest examples of the "migrations" of thought between user and technology treatments of hardware and software, with the author focusing specifically on computers gaining Artificial Intelligence (AI). With chess machines there is a tendency, De Landa claims, to "[attribute] to it beliefs and desires of its own" and "a tendency to act on those beliefs and desires" as a way of predicting its future behavior; this attempted logical system gives the computer a "mechanical mind." It is here that "the migration of control drifts from humans to hardware, from hardware to software, and from software to data" (*WAIM*, 156–158). We can then combine this "mechanical mind" with chess's long history as a military game, enjoyed by army strategists as a way to generate metaphors and modes of thought about battle that then fits snuggly into the earlier discussion of the Internet as a military technology; more specifically, Deleuze and Guattari write: "Chess is indeed a war, but an institutionalized, regulated, *coded* war, with front, rear, battles" (*ATP*, 353, my italics). The (literally) "coded" war between man and chess machines in the late twentieth century exposed hardware/software relationships in an early public Internet user in the mid-to-late 1990s[1]; while we are not interested in AI in this chapter, the increasing complexity of interplay between computer and human and the attitudes those interactions create is worth a more in-depth look.

IBM's Deep Blue's defeat of Garry Kasparov in February 1996 should then be seen as a major event:[2] a computer had beaten the world champion and what many consider one of the greatest chess players of all time. In "Kasparov Falters, Deep Blue Prevails," Robert Lynch states "With what Kasparov considered 'the fate of all humanity on his shoulders,' [and]...Deep Blue...[unburdened by] human emotions and fatigue," clear, antagonistic and emotional lines between the two entities were marked (1). Jack Broom quotes spectator Vernon Vanpoucke as saying "I'd like to see Garry win...He's my species" (para. 5). This adversarial thinking (species versus species,

man versus machine) separates the two entities further and further apart. Underneath this, of course, is human resistance to a technological machinic phylum, a computer that is synergistically joining with its human counterparts (programmers), who then grant it immense expert systems in order to have the computer make seemingly independent (and unburdened) decisions of its own, in turn having the machine transcend its makers' intelligence and skill; Deep Blue was an example of a machine/computer in which the control has migrated to the machine and the humans are pushed further and further outside the loop, to the potential point of obsolesce. But, instead of celebration, Deep Blue was met with horror. Michael Posner captures the mood when writing the defeat was "a watershed moment in the continuing war of man and machine" (para. 1). If chess is a metaphoric game of war, then man, at this point, lost very publicly to machines; add to this the increasing amount of computers making their ways into the average homes in the 1990s and the Internet's exponential explosion of users in the early to late 1990s (chapter 1), this period is defined by an increasing distrust (and terror) of computers and their potential to overtake or destroy humanity. Consider too that, in addition to becoming more powerful and more prevalent in the average home, computers were now networking (conspiring?) with each other over the Internet, forming an ever-increasing, powerful army. As Macklin rightly states:

> Popular fiction seethes with images of malevolent devices roiling with a natural hatred of humans and a devious desire to recreate a confused and violent world in their more logical image, by any means necessary. The message in most fiction involving computers has always been clear: Machines, especially smart ones, can't be trusted. (para. 12)

These popular fictions, such as the *The Matrix* trilogy, traffic in images of the dystopia and potential apocalypse, specifically a catastrophe brought on by defeat at the hands of increasingly intelligent machines. Yet, these narratives are tied to specific anxieties around technology linked to apocalyptic narratives. As Baudrillard explains, the computer is a "simulacrum of man as a functionally efficient being" (*The System of Objects*, 130), defined by an "obedient functionality embodied (so to speak) in an object which resembles me … turned into a sort of all-powerful slave, cast in my image" (130); he describes further that machines are "a slave, then, but let us not forget that the theme of slavery is always bound up … with the theme of *revolt*" (131, author's italics). The lesson of a computer/slave revolt and its "maleficent

mutations" is to have a user "confronted by a double that enlists his energies and whose appearance, according to legend, spells death" (131). Films like *The Postman* (Dir. Kevin Costner, 1997) imagine an apocalyptic scenario wherein all technology has been wiped out, exposing human's dependencies (and the horrors attached to that reliance) on their technologies/slaves. Other films go in the opposite direction wherein robotic technology overtakes humans, establishing themselves as militant overlords hell-bent on eradicating humanity.[3] *War Games* in particular reflects what Heather Urbanski flags as the nightmare of "technology out of control" (echoing De Landa) combined with a fear of technological progress (14–15). The film more simply reflects deep fears about antagonistic and nationalistic arms-races, but blends this with the petrifying choice to allow the centralizing of nuclear offensive control into NORAD's "Joshua" computer, a super computer that has progressed beyond the human element of error/emotion (much like the depiction of Deep Blue). From this, the real concerns of the film arise: what happens when humans inevitably give their control over to the machines' local intelligences and rely, instead, on those entities to make those decisions, coldly and logically? Too, the fact that protagonist David Lightman (Matthew Broderick) was able to set the whole string of catastrophic events off by accessing Joshua through the Internet speaks to an initial fear of nonauthorized access via networked computers as well as the potential dangers Internet users can intentionally (or unintentionally) set off.

Seventeen years after *War Games*' release, the first *Matrix* film marks an apocalypse of a different sort, one that reflects the fears of the constant forward evolution of machines to the point in which humans are "advancing ourselves into obsolesce" and in turn "losing our spot at the top of the evolutionary chain" (Urbanski, 40–41). In it, the human race has lost a long series of military battles with machines and is now merely comprised of a number of networked, biological batteries. It is a world in which the demons (Agents) are granted unlimited local intelligence, and have complete control of the system (the Matrix), policing the world as its most powerful and advanced inhabitants; the machine "soldiers" of this seemingly one-sided war far outstrip the human "soldiers," both in and out of the Matrix. Superficially then, this uneven power dynamic reflects fears of a posthuman world in which humans are no longer the most powerful/important species. More interestingly though, the Matrix, as a parallel to its audience's Internet, is a technology created to keep control of humans; it is only by complete immersion into the space that humans are pacified and therefore most functional to their machine

overlords.[4] In both *War Games* and *The Matrix*, the apocalyptic scenarios, cemented by an adversarial man versus machine dynamic, depend upon treatment of the Internet as a troubling and initially dangerous technology.

So who then are the best "soldiers" in a war between man and machine? De Landa points to hackers as the key point at which machines and technologies "can be disentangled from the specific usages given to them by particular institutions" (*WAIM*, 123), what Deleuze and Guattari call "the organs of State power" or "industrial complexes" (*ATP*, 360). De Landa adds that it is because the military and corporations horde control over computers that hackers, an assemblage in opposition, become key figures in negotiating cooperative and healthy equalized power dynamics between a user and her/his computer. Hacking then is a function of engineering (hardware) prowess and software manipulation and knowledge; s/he then possesses an elite understanding of machines but is unencumbered by the authorities and infrastructures that could hold back traditional military models. While there are examples of hackers in films that reflect this idealistic version to some extent (Dade and his friends in *Hackers*, *Sneakers*), early representations of hackers tend to focus on the negative aspects of perverse voyeurism (*Ghost in the Machine*, *The Lawnmower Man*) or personal-information-gobbling, identity-erasing maniacs (*The Net*). When the audience is given a hacker as hero, pre-Y2K, they are given one that fights very consciously against the very machines that enable/extend/evolve them. With this in mind, early versions of the heroic hacker, Neo and David Lightman, are pessimistic posthuman reflections and create a strict binary between human/machine, a figure through which machines are conquered, avenging Kasparov, and the hacker becomes the saviour of the human race.

Heroic Hacking

Defining what a hacker is in 2014 will most likely lead down one of two binary paths. The more negative version involves a superuser who cracks into, like a safe, the private information of another user or company via a shadowy connection of computers and/or the Internet. This hacker then sells that information, inserts a virus, or simply lurks in the background. While there seems to be, in the public consciousness, some sense of differentiation between a good ("white hat") and a bad ("black hat") hacker, the construct of what a "hacker" is and what s/he does is the product of decades of often contradictory and inflammatory narratives, reinforced by Paul Young's notion

of "cyberphobia" in media coverage and films (explored further in chapter 6). This chapter sets its sights on the other side of that binary, on what might make a heroic hacker a useful leader/survivor of a machine-led apocalyptic world.

The heroic hacker draws a great deal of its ethical and skilled construction from Steven Levy's classic *Hackers: Heroes of the Computer Revolution* (1984), and the later *The Hacker Crackdown* (1992) by cyberpunk author Bruce Stirling. Levy's hackers are most hardware-based, detailed in the chapter "Part Two: Hardware Hackers," wherein Levy focuses mainly on the computer spectrum of hacking, honing in on the evolutions of high-level hobbyists, Ed Robert's MITS Altair 8800 (186–191) and Steve Wozniak's first two Apple Computers (ibid., 258–263), as two specific examples that made invaluable contributions to hardware and software evolutions. On the software side, Bill Gates and Paul Allen's (ibid., 228) and Tom Pittman's (ibid., 239) work in creating early models for computer operating systems by creating mass marketed interpreters that allowed a computer to translate the most used codes of the time (BASIC, FORTRAN) into machine-readable/executable "object code" (binary, 1s and 0s). Importantly, it was not corporations (IBM) or the American military creating these personalized technologies and "bringing computers to the people," but rather citizens who were pushing computers to be a smaller, cheaper, easier-to-use mass technology (ibid., 154). *The Hacker Crackdown* shifts its focus to the burgeoning networked hackers (first phone phreaks, then later computer hackers) of the Internet. Stirling points to 1984–1990 as the "golden age" of hacking wherein civilian computer users, mostly via BBS, possessed the bulk of high level control over and knowledge about the Internet, spreading and intensifying the underground culture of computer and Internet use (Thomas, 603).

From these initial portraits, the positive portrayals, the heroic hackers, fall in line with, as many hackers self-identify, "the intellectual exploration of the highest and deepest potential of computer systems" or "the heartfelt conviction that beauty can be found in computers, that the fine aesthetic in a perfect program can liberate the mind and spirit" (Stirling, 51). The positively portrayed hacker is constructed more as an antihero, a do-gooder that needs to bend or break some rules in order to achieve a larger, nobler goal. Featherstone argues "the celebration of anti-heroes, re-enacted through forays of computer programs and software, reflects the stylistic promiscuity, eclecticism and code mixing that typifies the post modern experience" (as quoted in Thomas, 620). Dade and the posse of young users

in *Hackers* are exactly this: impetuous youngsters who are rebelling as a means of fighting an ignorant adult world. Dade is much closer to Levy's idealistic hacker and Stirling's phone phreaks: he doesn't hack into any system for profit but merely to test the range of its ecosystem, causing mischievous disruption. The scene in which he first sees Acid Burn's (Angelina Jolie) laptop and excitedly spouts off the technical statistics showcases a set of characters deeply knowledgeable about the technologies that is also an awestruck reveler. Likewise, the grown-up hackers in *Sneakers*, in particular Marty Bishop (Robert Redford) and Whistler (David Strathairn), are on the side of private citizens, protecting the hacking/decoding technology from Cosmo's (Ben Kingsley) abuse/exploitation of the technology; indeed, given one wish at the end of the film, Whistler pushes aside materialistic wants and instead asks for "Peace on earth and good will towards man." Even after Bishop seems to hand over the microchip to the National Security Agency (NSA), he later shows he gave them a shell of the "black box" and instead kept the chip all along, shrugging aside any responsibility to or trust in the government and, instead, setting himself as the moralistic center best suited to guide the use of the technology. Obviously, this is a romanticized version that is as potentially problematic as the previously discussed negative iterations of hacking, but it reflects De Landa's potentially ethical and powerful computer user, one that welcomes technology's potential evolutionary effects. Still, this more positive construction of the hacker is tied to a world of human-human relationships in which computers are tools, not whole separate enemies (as imagined by an extrapolated Deep Blue); the ethical questions raised in these initial movies have more to do with human questions of cyberspace occupation/inhabitation than they do toward hardware and software. As Jon R. Stone's essay "Apocalyptic Fiction: Revelatory Elements within Post-war American Films," an computer like Deep Blue expresses an unshackled technology that is "cruel and dehumanizing" in a world where computers have "enslaved mankind" and "humans are subservient to their own machines" (67). With a more generalized fear of computers gaining more control (as enabled by a growing Internet infrastructure and population), what might films like *War Games* and *The Matrix* have to say about the heroic hacker's role in an apocalyptic showdown with machines?

Most obviously, the heroic hacker is a user that understands the enemy: it is because of her/his deep knowledge of computers and their systems that they would be able to take advantage of the machine enemies' weaknesses; s/he is an advanced user who knows the limits

of the "control" and local intelligence that the machines possess and know too that their own knowledge ("expert systems" included) exceed that of the machine itself. As well, both Stirling and Levy heavily underline that "real hackers," as the phrase is intended to be used, live by a strict ethical code. As such, hackers are strong moralistic characters that can be trusted to make the best decisions, potentially for all of humanity; their construction as "outsider" figures with little to no investment in "corrupt" infrastructures (corporate, governmental) allow them to make "pure" selfless decisions. If apocalypse narratives are also an imagining of potential rebirths (a purging to start fresh), then the strong moral hacker is an ideal tenant and/or leader of the new world. If, as Elizabeth K. Rosen argues, "the apocalyptic impulse is, in effect, a sense-making one...an organizing structure that can create a moral or physical order while also holding out the possibility of social criticism" (xiii), then the hacker is a figure who strives with a similar impulse: they are assemblages-of-Order, "primitive rebels attempting to create dissonance in order to bring social meaning to what they perceive as an increasingly meaningless world" (Thomas, 607). The heroic hacker, such as the original computer programmer/creator of Joshua in *War Games* Peter Falken (John Wood), is an idealistic thinker, well prepared for modes of thinking wherein the social order has been disrupted and needs "fixing." The "order" (a term Rosen repeatedly stresses) that emerges in a post-catastrophe utopia is one that the hacker would see as necessary and would feel deeply obligated to take part in. Therefore, the hacker is a potential diplomat whose ethics places a very high value on computers and machines as beautiful and revolutionary technologies to be cooperated with and respected. With this in mind, would the postapocalyptic rebirth, as a potential utopia borne of trauma, allow the hacker to imagine, or even see glimpses of, a paradise in which humans and computers coexist beautifully together in the aftermath, perhaps in some evolved networked form? Alas, *War Games* and *The Matrix* (pre-Y2K) instead imagine him/her as the last hope against a robot villain. Stone, echoing the earlier sentiments directed at Deep Blue, clarifies "the techno-villain is itself a personification of technology: cold, calculating, brutal, the very face of mechanized evil" (67). The hacker is presented not as a peacemaker, but as a solider against this mechanized evil.

The North American Aerospace Defense Command (NORAD) computer in *War Games*, War Operation Plan Response (WOPR), is not inherently evil (like SID 6.7 from *Virtuosity* [Dir. Brett Leonard, 1995]) but rather a manifestation of human programs and decisions

that make it a place of vulnerability, firstly to America but then to all of humanity. War games, as De Landa points out, are a way to simulate different military scenarios as a way of exploring their potential outcomes (victory/defeat, soldier and civilian causalities, and later, areas of nuclear impact and fallout) that have moved within the last 50 years away from maps and models and into computers. The problem, De Landa states, is when the war games came to "take the place of true politico-military strategic planning" which then focused on simulated military end results ("conflict") rather than considering cooperation and diplomacy as potential solutions (*WAIM*, 84–86); as such "nuclear policies in the last four decades have been guided by models artificially emphasizing conflict over co-operation," a practice in which computers are seen as always "choosing" escalating conflicts, that does not reflect the "rational approach to survival in such a network of interacting entities" (ibid., 86). The computers, "two abstract automata" such as SAM (America) and IVAN (Russia), "fight each other to death in a continuous series of simulated armageddons" (ibid., 87).[5] This representation of computers as coldly logical aggressors, unable or unwilling to take stock of more intangible "human" concepts such as morale, fatigue, or fear, were already digitally embodying the user's fears of the dehumanization and immorality present in war. The opening of *War Games* sets up this villain by first putting unknowing soldiers through a simulated nuclear attack: two soldiers in a silo bunker must go through a long procedure to launch their missiles but when it is time to complete the final step, the older solider (John Spencer) refuses to initiate, even with the second solider (Michael Madsen) pointing a gun at him. Later, Dr. John McKittrick (Dabney Coleman), having reviewed all the simulations, states that 22 percent of the human missile commanders refused to turn their keys, leading the military leaders to decide to take the launch "decision" (protocol) away from humans and centralize it into the Internet-enabled WOPR. First, WOPR is plugged into the Internet and receiving data on everything from troop patterns to nuclear tests to weather reports, which it then uses to make its "decisions," underlining fears of how a networked computer becomes especially dangerous. However, coupling the Internet with a machine that "spends all its time thinking about World War III, 24 hours a day, 365 days a year" constructs computers as war-obsessed, devoid of any moral compass and instead single-minded in its approach to human destruction. It is this construction of WOPR as heartlessly following orders (data), "without knowing what it means" (Dr. McKittrick), and without consideration for human population, that vilifies the computer as

a blind antagonist. As Newman states "WOPR is dangerous because it is [unable]... to distinguish between a game and reality," unable to understand (or is uncaring of) the consequences of its actions (219). The reoccurring shots of WOPR establish it as huge unemotional monolith: it is a blinking sofa-sized box, waist high, clunky, pure hardware without any "human characteristics," just a clean machine facade of lights and shiny black metal, its overhead monitors showing giant digital red numbers ticking dispassionately down (figure 4.1).

The film then creates the computer, enhanced by the Internet, as a clear Other, without the problem, Dr. McKittrick states, "of being [a] human [being]"; WOPR, as a computer that has cut human users "out of the loop" (a phrase the film and De Landa repeat extensively), is capable of great violence against humankind.

The protagonist, David Lightman, is much closer to Dade than Angela Bennett (*The Net*); as he is a bored suburban computer-whiz looking to get beyond his own bedroom; Monica Hulsbus calls him "embryonic" of the hacker, "an idealist, playful, and technically proficient youngster who gravitates, to a great extent, around computers" (26). His tactics are simple, but illustrative of the technology of the times: he uses the Internet to hack into an airline and get seats on a plane for free and breaks into his school's computers to change his grades in order to avoid summer school. His technique of "war dialling" (setting a computer program to dial all phone numbers in an area until he finds an unprotected modem to access)

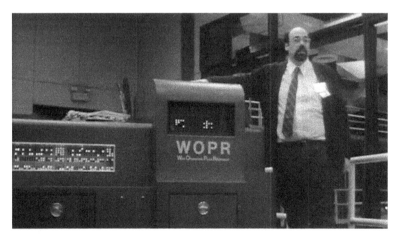

Figure 4.1 Paul Richter (Irving Metzman) stands beside the giant and inhuman WOPR computer (*War Games*, 1983)

was standard phreak/hacker protocol. Lightman's ability to access NORAD and contact WOPR/Joshua expresses the general public's cyberphobia in that the Internet shifts control, not into computers necessarily, but into agents (teenagers) too immature to handle or recognize the effects of computer technology; as such, it comes as no surprise that Lightman, thinking he's playing a video game titled "Global Thermonuclear War," gets Joshua, playing as a simulated USSR (Cold War villain), to engage in nearly setting off a series of nuclear strikes and World War III. Lightman, as hacker, begins as flippant and mischievous but it is his transformation and redemption toward the end of the film that establishes how the hacker might best reaffirm humanity's superiority. At the climax of the film, though completely unrealistic,[6] the civilian outsider Lightman is able to command the other soldiers (who are unable to even recognize the problem let alone fix it) to stand down so he might save Earth. He does so by conversing with the machine, both by typing and vocally as he does via Joshua's digitized voice box throughout the film. Whereas the military treats the machine as purely functional, Lightman sees WOPR as a playful and lonely reflection of Peter Falken's dead son Joshua, calling the computer by that name. It is only by recognizing the unique intelligence (local and global) in Joshua and then exploiting its limits, that Lightman is able to overload Joshua by forcing it to play endless stalemated games of tic-tac-toe against itself. Lightman's more sympathetic humanistic treatment exposes how limited the software (human) aspect of the computer is and, again, how flawed computers are by their very nature. Joshua, even enhanced by all the knowledge of the Internet, cannot recognize that it is trapped in a program loop; it simply crashes. De Landa's vision of a singularity is impossibly far off here: even if it did recognize what was happening, it would have no way of demonstrating ingenuity and solving the problem.

The climactic break-in scene of *Sneakers* treats computers in much the same way: Bishop is able to fool the voice recognizer in the computer into granting him access by stitching together words from Dr. Werner Brandes (Stephen Tobolowsky) conversations with Liz (Mary McDonnell). The computer, bound by strict parameters of input/output, recognizes the input, no matter how inhuman and strange it sounds, because the pure information (specific words, voice, and sequence) is present. Adding to *War Games*, it is because computers are naturally "cold, calculating, brutal," inflexible and unable to adapt/evolve on their own, that humans will remain the superior species. So long as computers remain mostly hardware with primitive

software, hackers hold intimate knowledge of how to converse with machine entities and the vulnerable limits of the machines' capabilities; any war between humans and machines is sure to be easily won by humanity. The average Internet/computer user of this period could therefore safely distance their computers, snug in the surety of their slave-master relationship, telling themselves that even if the machines do revolt, humans can handily beat them back into submission.

Instead of the Internet being a point of intelligence and networked evolution for machines in *War Games* and *Sneakers* (both films, not coincidentally, written by Lawrence Lasker and Walter F. Parkes), networking makes them vulnerable, providing secret backdoors through which human operators can slip inside and wrestle the local intelligence and control back from the computer. In contrast, *The Matrix* shows De Landa's machinic phylum come to fruition and, as Baudrillard warned, having achieved singularity, have incarcerated humans. This enslavement is only made possible by the Matrix software, a mirror of the viewing audience's Internet, occupying and therefore controlling humans; while the Matrix (Internet) proves susceptible to hacker intrusion, it is first painted as a place for empowering the machine enemy. This vision of the end of humanity reflects the late 1990s' fear of machines (like Deep Blue) progressing beyond human control and the Internet enabling these machines to connect to and communicate with each other in order to pacify humans in the simulation. In this postapocalyptic dystopia, machines have defeated humans, save for a group of elite users, hackers, who know the truth behind the simulation. The film's representation of hackers are both utopian visions of human-avatar relationship and adversaries of the more obviously mechanical entities. Unlike *Sneakers* and *War Games* where the hackers have no real avatars and computer-human interaction is done across non-immersive monitor interfaces, *The Matrix* acknowledges the digital BwOs enabled by the Internet, reflecting them as potential perfect versions of the user. This treatment of the Internet and hacking reflects the changing understanding of what a hacker does: the focus shifts from hardware and physical engineering (*War Games*) towards manipulations of software (intrusion, viruses, data corruption). While reactions to Deep Blue exemplify the resistance and even fear of slippery human/computer "software," *The Matrix* presents a idealized hacker, a heroic computer user that recognizes and revels in her/his dual identities (digital and biological) and uses them to evolve him/herself forward. Neo, as this positive model, is part machine: his spine and skull are lined with sensory inputs that allow entrance into the Matrix. Too, the digital projections inside the

Matrix (Neo, Trinity, Morpheus) are utopian visions in this respect, able to superhumanly fight and jump, instantly learn new skills, and acquire expert systems. As such, the Internet-using audience of the film can begin to see their own digital avatars (BwOs) as potential places of healthy, even romanticized, identity construction (explored further in chapters 2 and 3).

Yet, despite encouraging how an Internet user might live with his/her digital self, the film still creates machines as devilishly possessed evils, each Agent a superpowered demon. A digital self, still rooted in humanity, can be healthy, but machines (computers) themselves are still untrustworthy, hell-bent on human annihilation. The film creates a strict binary in its war: (humans) hackers on one side, (machine) Agents on the other. Humanity's most useful weapons are gained by hacking into the Matrix: every (unauthorized) entry into the Matrix is a hack; likewise, every time Neo instantly learns to fly a helicopter or acquires a weapon, he is hacking his own brain. It is because of the remaining humans' superior computer-manipulation abilities that they are able to survive within the Matrix; hacking is heroic in that it enables the basic survival of the human race. Yet, the ultimate weapon that allows Neo to defeat the machines at the end of the film is a human capacity beyond mechanical possession: love. After a long series of fights, the Agents appear to be too strong and multiple to defeat, eventually hunting Neo down before he is able to jack out and kill his BwO, leading to a simultaneous biological and digital death; he is then resurrected by Trinity's kiss and profession of love. With this human outpouring of emotion, Neo gains the ability to fully control the Matrix: he stops bullets, jumps through and destroys Agents, effectively regaining the lost control and signalling a return to human domination. No matter how great the local intelligences the machines in *The Matrix* possess, they cannot experience love (or sadness or happiness, etc.) and therefore will always be weaker and more vulnerable, simply cold and emotionless Agents/demons who execute actions. While the hacker at the end of *The Matrix* is a figure empowered by the Internet and blended further with his/her digital self, it is still a user that identifies as human and made distinct and exceptional by the "human" emotional capacities machines can never have. A pre-Y2K audience/computer user's pessimistic view of machines creates the computer as Other, as enemy or adversary rather than evolutionary compliment; the potential apocalyptic scenarios brought on by machines can only be solved by combat and employing hackers armed with "weapons" and tactics that reaffirm what makes humans distinct from machines. Interestingly then, the

ultimate weapons the hackers use to this point are distinctly nonmili-
tarized (love, tic-tac-toe) and instead abstracted metaphors of human
virtues. But, as the robot historian would mark, the oncoming Y2K
"apocalypse" brought on a new age of machine/human cooperation
and began to shift the hacker, and his/her mastery of computers and
the Internet, from civilian saviour to singular military soldier.

Post-Y2K, The New Apocalypses

The Introduction to this text outlined the fulcrum point in com-
puter/Internet–user relationships that the Y2K nonscare presented,
where computers (as represented by Joshua/WOPR and *The Matrix*'s
various machines) stopped being unflinching enemies and could be
looked at as a potentially positive evolutionary partner. From this,
computer and Internet users were confronted with a decision as to
how to go forward with the Internet technologies already so deeply
ingrained in their social and personal fabrics. Two prospective answers
lay in two very divergent paths: Hans Moravec's "postbiological" or
Hayles's "posthuman" built on Haraway's "cyborg."

Expanding again on this text's Introduction, Moravec's postbio-
logical aligns itself with Case's dismissive body-as-"meat" sentiment
in *Neuromancer*. Moravec imagines a mind "being rescued from
the limitations of the mortal body" (5); the word "rescue" is clearly
important—the human mind is trapped by its squishy and ineffective
meat/body and must (should) transcend beyond it. This would hap-
pen when humans "uploaded" themselves into computer networks so
that the individual's specific body tied to a specific identity would be
replaced with a series of "human proxies" (ibid., 91). His/her "brain"
would "transmigrate" into a computer/algorithm-generated space
and would be able to jump into (and out of) his/her proxies. This
Cartesian severance of mind-body would allow a user to achieve a
pure software version of him/herself; this version housed the hopes
for a post-scarcity, post-disease, post-aging immortality (so long as the
computer networks exist, of course) that Ray Kurzweil expands on in
The Age of Spiritual Machines (1999). On the surface, these potential
postbiological digital assemblages appear to be getting closer to De
Landa's future machinic phylum: the ability for many different (digi-
tal) versions of a user to self-organize, without a biological body, into
a functioning intelligent being looks to be a "singularity" (a term that
Kurzweil also uses frequently). However, the postbiological is still a
creature drawn sharply along software/hardware binaries, with the
"human" software still the most important/valuable fraction. Early

Internet-era films that represent a potential postbiological being still reflect the unwillingness to abandon the physical body and entrust the self to a complete digital re-creation. A product of VR (and not the Internet), SID 6.7 (Russell Crowe), in *Virtuosity*, is a serial killer software that is akin to Moravec's/Kurzweil's visions, a collection of a number of "selves" made from other serial killers' "uploaded" personalities/data; in the film, SID 6.7 is a digital creature brought to life and housed in a nanotechnology body, exaggerating the apprehensions an Internet user of that period would have trusting or coexisting with a species created outside biological reproduction.

Likewise, *The Matrix* trilogy, with their machine-created vat-grown humans, use the very scenario of "inhuman" biological reproduction as means to display a truly horrifying armageddon; when the user is only software (i.e., doesn't know they exist as a physical body outside the Matrix), they are seen as ignorant and trapped, needing to discover their true "human nature" that is only achievable by their release from a purely digital self. Similarly, Agent Smith of *The Matrix* is a "software only" entity who is the embodiment of a pre-Y2k purely digital being's evil/adversarial nature; his relentless pursuit of humans casts him, like SID 6.7, as the cliché "machine out of control," programmed with an unyielding need to purge human elements from its (larger computer) system. But, within *The Matrix*, Smith can be quarantined and defeated within the computer system; he is not really what Kurzweil envisions as postbiological because he has no "biological" base: he was a program to begin with and is therefore a separate species altogether.[7] Yet, the Agent Smith of *The Matrix Reloaded* and *The Matrix Revolutions*, released post-Y2K, is a far more complex creature: as Neo dives through Smith at the end of *The Matrix*, he adds "something" (vaguely magical, unexplainable), which pushes Smith out of the AI/machine system. As Rosen points out, once Smith unplugs from the larger AI consciousness, he becomes "free to make his own choices" (114). Suddenly he is granted the extreme mobility Moravec advocates, throughout both the Matrix system and eventually throughout the "reality" of the human world. Rosen sees this process of unplugging as "humanizing" Smith: he becomes able to be emotional, even demonstrating the sort of wit and humor a human personality would display (106). This insertion of "something" from Neo (source code, "humanness") pushes the character much closer to the postbiological: now he has some "human" element that, when he begins digitally replicating himself or jumping into physical human bodies/minds, he is carrying forward. While Kurzweil states the ability to manipulate "human proxies" is ideal, Smith's newfound ability

to possess Bane as a human proxy in *The Matrix Reloaded* is devilish, demonic (echoing De Landa), allowing him to sabotage the human ambush at the end of the film and later, in *The Matrix Revolutions*, gives him a physical body to attack and blind Neo. The human proxy does not liberate, as Kurzweil imagines, but instead gives more terrorizing power to the machines, all the more so because this ability is distinct to machines/Agent Smith (no human can do it). Within *The Matrix* trilogy, Kurzweil's "holy grail of self-replication" enabled by nanotechnologies (139) is instead viral and ominous, a cancerous BwO. Not only are the self-replicated copies of Smith swarming and ultra-aggressive, but the process by which another user is transformed into a Smith is agonizing: the user is slowly swallowed by a creeping silver metal, writhing and grimacing, until Smith reforms overtop the original user. After the transformation, each Smith-copy acts in harmony with its other copies, showcasing a singularity of its decentralized Smith-copies acting as one unified whole; a machine singularity, through this representation, is not the utopian creature Kurzweil envisions but instead humanity's greatest enemy. As such, Agent Smith, with his millions and millions of self-replications, is the cautionary eventuality of the postbiological. The film's rejection of a postbiological Agent Smith points the machinic audience toward another potential (semi-human) entity that might survive going forward, keyed by the Matrix software itself. Whereas Smith is machine and multiple at his core, Neo, himself a new "species," is still singularly anchored in his human body and therefore presented as a possible future solution for human-machine relationships.

Byrne's points to the definition of "matrix" as "derived from the Latin *mater* or mother" (65), adding from the definition from the *Shorter Oxford English Dictionary*, "uterus or womb...a place or medium in which something is bred, produced or developed" (65). N. Katherine Hayles, in the "Prologue" to *My Mother Was a Computer*, says that while treating the computer as a potential parent to "evolving artificial biota" produces a "anthropomorphic projection that creates (mis)understandings of the computer's functioning" (5), it does create a useful reciprocal metaphor that further explains a site like the Matrix software as a space of hereditary creation and growth "beyond a binary veil" (2). Such a location could produce a (potentially biological) birthing contingent on the inseparable relationship between "mother" (Matrix) and "child" (inhabitant). The last two *Matrix* films, Agent Smith included, move away from the binary human-versus-machine dynamic that the first film builds around, beginning to shift their characters, and the eventual

resolution (salvation) of the film toward the encouragement of a human-technology hybrid. As Agent Smith becomes more human, Rosen observes that Neo becomes more machine-like, spending more and more time in the Matrix, or reading code or downloading software. The difference between the two characters is that while Agent Smith replicates endlessly into many copies, Neo remains relatively stable in only two deeply entwined versions of himself (Matrix and "reality"). It is not just Neo who undertakes a controlled amalgamation, but a number of machines/programs in the film do as well. Interestingly then, as Deirdre Byrne points out, the machines/programs begin to take on "human characteristics," like the face that the main machine-entity uses to bargain with Neo after he and Trinity have flown to the Machine City (the core of the machine intelligence). As well, in "human" fashion, the Key Maker (Randall Duk Kim) sacrifices himself to get Neo into the system to talk with the Architect (Helmut Bakaitis); the Oracle (Gloria Foster) continues to meet with and try to guide Neo forward; Persephone (Monica Belushi) betrays her husband, the Merovingian (Lambert Wilson), in order to receive some vestige of human love, a kiss from Neo that replicates his feelings for Trinity (Bryne, 69). These entities cooperate with the humans (as represented by Neo) as a form of their own survival: Neo's uniting sacrifice at the end is only necessary because Agent Smith has grown too powerful and, in this cancerous over-replicated state, threatens to overrun the Matrix and therefore ensure both a human and a machine apocalypse. Neo is the saviour of both because he is a combined (full BwO-organism) species (though one with the singular human at its core); he is "both human and digital program," as The Architect explains at the end of *The Matrix Reloaded*. Yet, The Architect sees Neo differently than the moviegoing audience, and echoes Moravec and Kurzweil by describing him as an anomalous program trapped in a larger feedback loop: humans then are patterns of information that can be cyclically repeated and relied upon for stable (predictable) results. A human, to The Architect, is able to be repeated in the same way the postbiological "uploaded" human is, because they are a replication of information controlled by the feedback loop of The Matrix. Importantly, Neo's (human) choice to save Trinity and therefore break free from The Architect-designed information pattern/loop that has created and destroyed the first five versions of The One is the ultimate heroic hack, enabling his defeat of Smith at the end of *The Matrix Revolutions* and the "peace on earth" that Whistler wishes for at the end of *Sneakers*. The pre-Y2K machine-human discord in *The Matrix* has given way, post-Y2K, to a much

more symbiotic environment where machines and humans recognize their dependence on each other and begin to work together. The hacker-soldier of *The Matrix* is, at the end of *The Matrix Revolutions*, transformed closer to an ethical human-machine diplomat, nudging the post-Y2K Internet-using movie audiences toward embracing a self-construction that acknowledged an embodied existence that mixed entirely with the technology to create a fusion of the two, a posthuman and/or cyborg wherein each part was inseparable from the other.

We revisit the cyborg here as it acknowledges this chapter's previous link between the Internet and the American military, as Donna Haraway casts the cyborg as "the illegitimate offspring of militarism and patriarchal capitalism, not to mention state socialism." (151). N. Katherine Hayles's posthuman builds on Haraway to create an entity that is a further evolutionary form of Haraway's "illegitimate offspring," and therefore in direct opposition to Moravec and the postbiological's harsh mind-body split. The posthuman, then, has a very different relationship with and perspective on the interaction point between a user and the Internet, in particular through the role of the (heroic) soldier-hacker. De Landa's *WAIM* is built with a tight focus around the Internet as a military/capitalistic technology and his treatment of the machinic phylum and potential singularity is contained to this area: he predicts and critiques looking through a military perspective that values simulated (non-embodied) wars and dehumanized (computerized) soldier units, an unreal "cyborg war" that plays on the "simplistic fantasies of machine-like humans" (Haraway, 149); for De Landa, civilian users, hackers especially, are an outsider entity of resistance. But Moravec and, to a greater extent, Kurzweil extend the disembodied perspective De Landa applies to a focused militarized Internet to include a civilian Internet user; in doing so, they ignore how an "average" civilian obviously interacts differently than a (super-user/hacker) soldier, not just with her/his Internet technologies, but with other users and, most importantly, with her/his material environments. Recalling the discussion of Frank's disciplined body in chapter 1, doing this means applying Foucault's thoughts on the "docile body" of the solider to a civilian population that Deleuze argues has moved, post–World War II, into a society of control that produces bodies that are "undulatory, in orbit, in a continuous network" ("Postscript on the Societies of Control," 4). In contrast, Foucault's docile soldier is "a formless piece of clay, an inapt body" because they are bodies produced by a system of constant restraint that "produces subjected and practiced bodies" within a space that is "divided into as many sections as there are bodies

or elements to be distributed" (135–143); the soldier is an assemblage that marches/acts in formation with other such assemblages, dictated by simple orders (input) and simple protocols (output).

This is parallel to early cybernetic theorists Claude Shannon's and Norbert Weiner's views on the general human body, expressed at the Macy Conferences (1946–1953) and from which Moravec and Kurzweil borrow heavily from decades later. Such views aimed to reduce the human into information by defining "information" as "a stable context that could be moved from one context to another" (Hayles, *HWBPh*, 53); human identity is then patterns of information housed in a feedback loop (simple input, simple output); in this "simpler system," information is processed as rules/programs (input/ output) in a way that "privileges exactness over meaning" (ibid., 67). With this focus, identity could be decontextualized, divorced from "meaning," shifting unchanged from one material (proxy?) to another in homeostasis (ibid., 54). This postbioloigcal (civilian user) body looks remarkably similar to Foucault's docile soldier body: input/output necessarily constructs the military body as "Man-the-Machine," a robotic system of communal repetition/rhythm (marching, *Discipline and Punish*, 151) and dynamic group deployment (war units) in which the soldier is melded to her/his weapon and controlled by the information/orders/protocols given. Such a user is dehumanized and uploaded, much like the postbiological, into the network of the larger military force; similarly, the vision of the civilian postbiological (docile) digital body is that of a collection of exact replicas of a self, stable information, brought together and manipulated by an algorithm, like soldiers on deployment, to join together into a larger entity, dictated/ disciplined completely and only by the information a user receives and the codes/protocols they are to respond with.

Both the soldier and the postbiological is devoid of what Hayles calls "reflexivity" (*HWBPh*, 70) or "narrative" (ibid., 22), slipping into the danger that "there is no essential difference between thought and code" (ibid., 61). The hypothetical postbiological entity is much closer to a simple virtual reality user in a simulated, hermetic world, separate from the user's own embodied existence and reinforcing a problematic "information/matter" duality (ibid., 13) that neglects a contextual cultural/historical/geographical identity rich with other user interactions that are not disciplined input/output protocols.[8] More, the Internet, even in its earliest forms, is not a virtual reality: it is, in 2014, exceptionally dynamic and portable, but it has always been just as contingent on the physical world of servers, computers, mouse, keyboard, etc. to construct it as it has been on "ephemeral"

programs executing the code to generate its virtual spaces and occupant assemblages; the material civilian body is an indispensable site of sensation and narrative that interacts (Repeats) simultaneously and symbiotically inside and outside of the virtual spaces of the Internet.

With this knowledge, the postbiological entity is closer to the unhealthy over-unified entity, violently destratified and therefore reinforcing the organism-BwO binary, like the addict that Deleuze and Guattari warn against (*ATP*, 165). Such an assemblage is made up of cancerous BwOs that replicate and overwhelm the organism and other potential BwOs to the point of extinction/obsolescence, much like Agent Smith threatens to do at the end of *The Matrix* trilogy. As such, the increase in Web 2.0 technology in the first few years following Y2K encouraged the Internet user of the early 2000s to embrace being a posthuman or cyborg as a popular, mutual, and necessary assemblage. Instead of reinforcing the hierarchical species-genus relationship discussed in chapter 3, the figure of the hacker, as exemplified by Neo, shares control with the machines, willingly granting the machines more and more local intelligence (trust), with the conviction that, instead of human destruction, machines were working in tandem with humanity in order to allow the survival and evolution of both species. In this dynamic, hardware and software are no longer strictly within the binary of machine or human; instead the human is as much hardware (original prosthesis) as the computer is software (increasingly responsive and intelligent machines). From this, the Internet, circa 2000, as a popular and relatively non-overtly militarized space, was the perfect neutral ground: the machines worked to transfer information back and forth, providing homes for the user's avatars; the humans, the Internet-using movie audience, acted like McLuhan's pollinating bees, as the sex organs that mass (pseudo-biologically) reproduced machines. Through this lens, Neo's expanded digital knowledge and ethical code typifies the Internet-enabled solider-turned-peacekeeper, an envoy between the two species of human and machine rather than an antagonist. *The Matrix* trilogy's evolutionary steps recognizes the need to cooperate with machines in order to progress the human species forward, encouraging the movie audience to follow along the same cooperative (peaceful) path with their own technologies.

Conclusion: Iron Man, The Core, and Swordfish: The Hacker as a Simple Posthuman

The hacker Rat (DJ Qualls) in *The Core* (2004) is much closer to the idealistic phone phreaks in *Hackers* than the cyber-messiah Neo,

and his role in the film shows an Internet user much more com-
fortable working with computers than against them. Instead of a
human-machine apocalyptic battle, *The Core* has humans and com-
puters working together to solve a man-made, military-caused sce-
nario in which the Earth's core has stopped rotating, leading to
immense electric storms and eventually a disintegration of the protec-
tive electromagnetic field. In the film, computers are used to provide
helpful simulations of potential disasters and solutions to the catas-
trophe, showing how a human, working with the type of immense
computational skills that Deep Blue demonstrated, can harness the
power of computers as a compatriot; parallel to the end of the *The
Matrix Revolutions*, a world without humans is also a world without
machines and the two must work in harmony. If "trust" between
humans and machines is no longer an issue, the hacking in the film
turns from hacking other networks of machines, to hacking/control-
ling the networks of human users on the Internet. General Thomas
Purcell (Richard Jenkins) tasks Rat with creating a virus with the
goal of "hacking the planet" or "information control," with Dr. Josh
Keyes (Aaron Eckhart) simplifying "we need you to control the flow
of information on the Internet." Eventually he creates a "virus-bot"
that "seeks out any files contained in the web with key-words [I] des-
ignate and wipes them out" (as quoted by Rat). This shift to "infor-
mation control" is especially important in the infancy of a Web 2.0
context as the rate of Internet users increased exponentially from a
decade earlier, and the sheer amount of information/data created and
consumed online, from any user globally, became normative. Rat's
heroic hacking is not fighting machines but rather controlling the user
information trafficking through those machine networks. *Sneakers*
anticipates this need as well when Cosmo states "the world isn't run
by weapons anymore, or energy. It's run by little 1s and 0s, little bits
of data," later adding "There's a war out there. A world war. And
it's not about who has the most bullets, but who controls the infor-
mation…it's all about the information!" The "world war" in *The
Core* is not machine-human, but rather human and machine together
versus Nature. Yet, both *The Core* and *Sneakers* ultimately distrust
and reject the (human) military war machine: while Rat works with
the American military, who lead and fund the world-saving Virgil
program, he releases all of its Top Secret Mission data to the globe at
the end of the film, exposing the military's negligence and the heroic
actions of the other civilians sacrificed; following real-life hackers
Ronald Austin or Kevin Mitnick (Krapp, 81), Rat distrusts the gov-
ernmental and military control of information and instead releases

it back into the network of the Internet, knowing that the technology's immense abilities to spread the information will allow it to be seen, understood, and acknowledged. Similarly, Bishop, in *Sneakers*, doesn't give the complete Black Box back to the NSA, instead keeps the power and control of information, like Rat, under the control of civilians (expanded further in chapter 5).

Elsewhere though, the portrait of the heroic civilian/outsider hacker, at this point, had begun to disintegrate slightly, as evidenced by *Swordfish* (2001); instead, portrayals of hackers in film argued for the need for a remilitarized Internet. The hacker Stanley Jobson (Hugh Jackman) is similar to Rat in that he is a civilian with a long history of breaking into government and military cyberspaces in order to expose the secret information within. On the surface, it appears as if Jobson is creating a virus to puncture a bank's firewalls and connect himself into the "backbone" of the larger banking networks so that Gabriel Shear (John Travolta) can steal billions of dollars from the American government. However, Shear, working secretly for Senator James Reisman (Sam Shepard), reveals that he is part of an extremely covert government operation, Black Cell, that needs the billions of dollars to fund an ongoing war with "anyone who impinges on America's freedom," more specifically, terrorists and countries that harbor terrorists (as spoken by Shear). The hacking that Jobson does relocates power back into military channels and further deepens the secretive information hoarding that *Sneakers* and *The Core* combat: the theatrical release of *Swordfish* ends with Shear and Ginger Knowles (Halle Berry) escaping and withdrawing all the funds while the news of a Middle-Eastern terrorist dying under "mysterious circumstances" being implicitly attributed to Shear's new war force.[9] This film encourages the beginning moves of nationalistic military forces (in particular America) attempting to regain control of the Internet as a potential weapon against other governments; this weaponized cyberspace, with its dense access to foreign governmental infrastructures, provided a vulnerable space to scrutinize, attack, and/or invade. Like Shear, behind the fears/justifications of "terrorism," a post–9/11 America began to activate hacking of other government cyberspaces under the guise of combating "cyberterrorism" or "invasion" from another country.[10] Attacks like the American government insertion of a virus into one of Iran's nuclear facilities, North and South Korean infiltrating each other's computer system in order to sabotage/steal/spy, or, in 2013, the increasingly heated between America and China about the hacking of each other's governmental/military systems,[11]

showcase how hacking has shifted to a military tactic, rooted in older visions of pre-globalized nationalism. The "world war" Cosmo imagines has arrived and hacking/control of the Internet (and the information/control therein) is just as capable of crippling a nation as a fleet of bombers or a brigade of soldiers. As resources and knowledge have shifted from the civilian base of hackers in the 1970s and 1980s back to militaries and governments in the 2000s and 2010s, the power and access that was once, perhaps too idealistically, imagined in a citizen-controlled cyber-utopia is greatly diminished; instead, there has been a regression back to the military application of the Cold War–era Internet of *War Games* (and to some extent *Sneakers*) that De Landa bases *WAIM* on, a regression drawn along lines of geographical and national identity, as encouraged by the new "heroic hacker" in the first two *Iron Man* films (Dir. Jon Favreau, 2008 and 2010), and in particular *Iron Man 3*.

Tony Stark is introduced in the first *Iron Man* as a charismatic weapons contractor with direct ties to the American military, delighting in getting rich off all the war technology that he can sell. After he's captured and tortured, he separates himself from his war-mongering and instead runs his company vowing never to make or profit off weapons ever again, resembling De Landa's self-imposed outsider and the illegitimate offspring Haraway imagines. Stark is a hacker closer to Levy's, an engineer or hardware modifier; like RACTER, Stark is a self-proclaimed "mechanic," making his Iron Man suits largely himself, inventing or adjusting existing technologies to fit his own (superpowered) needs/capabilities. His relationships with other Internet-enhanced entities in the films is quite rich: his "partner" Jarvis, an Internet-fuelled AI, is his perfect companion, not only feeding him information and recommending tactics, but also providing an almost-humanized sidekick for Stark to banter with. However, unlike Rat in *The Core* and Stanley Jobson in *Swordfish*, two hackers upholding old binaries of computer/user through outside and non-immersive interfaces (chapter 2), Stark, in the first two films, is an almost too-literal cyborg: he is completely enmeshed/enclosed in his suit and shot in such a way where the movie audience can see both his machine/suit parts (Deleuzian organs) and his human body simultaneously; from these "interior shots" of the suit, the movie draws fairly superficial and obvious boundaries between machine and human, making sure to keep them distinct from each other. Even the strong electromagnet, a technology symbiotically implanted within his body, glows light blue, making its unnatural/machine nature very obvious. While Stark is a posthuman, the blatancy in the first two

films' construction of him as cyborg (separate hardware/software) resists an integrated and unified relationship (like Neo's, or Jake Sulley's in *Avatar*, or Quorra in *Tron: Legacy*) and gives a machinic audience a depiction of the posthuman that is still rooted in old divisions of organic/machine.

Iron Man 3 (*IM3*) complicates the suit/Stark relationship immensely. In the film, he treats the suits more clearly as extensions of his self, insisting to Pepper (Gwyneth Paltrow) that they are "a part of me" and constantly referring to the assemblage of the suits and himself as "we." This is the first film where he can then manage suits that he doesn't physically inhabit, as he is shown injecting himself with microchips/homing devices that allow him to retrieve and control the suits remotely. The suits themselves even show a good amount of their own agency and advanced local intelligence: in response to Stark having an anxiety dream, one suit rushes to his side, terrifying Pepper out of her sleep. The assemblage of suits and Stark together, provide for the spectacular ending set-piece, wherein the cavalry that saves the day is a collection of networked Iron Man suits of varying sizes and skills, controlled by Jarvis and Stark (and the suits themselves) via an Internet-like network. Because they are specifically coded to Stark's DNA, he is able to enter in and out of each suit, complicating the simple posthuman of the first films with a far richer network of multiple selves. The suits in *IM3* are actualized, near-literal BwOs, and Stark, by inhabiting the suits, provides the (biological) organism necessary for unity. While this BwOs/organism unity is still displayed as a fairly superficial machine/body cooperation, the machinic audience of *IM3* is encouraged to see themselves in the unity between Stark and his multiple selves, with each suit resembling the machinic audience's own avatars/ BwOs.

Still, if the heroic hacker began a type of civilian soldier, Stark reflects the modern American soldier/hacker, housed in a Future Combat System (FCS),[12] which Ian Roderick outlines in "Putting the Post-Human in the Loop." The FCS soldier aims to push past Foucault's docile military body and instead empower the solider by placing them in FCS, "systems in which the smaller elements that comprise them are systems in their own right" (303; 306–307); the concept of these FCS, "systems-of-systems," is built on the aforementioned Macy Conferences' work defining a cybernetic system in which the soldier is a "man-in-the-middle," melded to a series of computers, giving him/her access to a "mixed reality [of] information-rich environments" (ibid., 305). Such a soldier, as John Stroud envisioned, aims to "splice humans into feedback loops with machines," merging

his/her output/input system with his/her machines, and allowing a human to engage with the complex nature of a changing war environment as "an open-ended system" in "a portable instrument set" (*HWBPh*, 68). With FCSs in mind, Stark has moved away from the more romanticized civilian hacker, the outsider who exploited or modified his/her technology, toward a military unit constructed not for liberation of information or in awe of technological limits, but rather for fighting and killing. In fact, Stark deliberately distances himself from the "golden age" civilian hacker when he tells Col. James Rhodes (Don Cheadle), "It's not the 80s. Nobody says 'hack' anymore." Even though Stark appears to be a civilian hacker, he is far from an outsider: as a very wealthy man at the head of a successful company, he is able to spend his time "tinkering," as he puts it, adjusting and modifying his own tech without worry of money or time.[13] Superficially, he states his intentions as antimilitary: in *IM3*, when confronting the terrorist The Mandarin (Ben Kingsley), he states "There is no politics here, just good old fashioned revenge. No Pentagon, just you and me." The Mandarin is a cartoonish foreigner: though he is revealed to be a professional actor, he is not that removed from the equally ridiculous Russian villain Whiplash (Mickey Rourke) in *Iron Man 2*; with both villains, there are clear nationalistic (and ethnic) binaries being drawn between themselves and the white (American) Stark. It makes sense then that, despite eschewing the Pentagon, the majority of the combat in the final hour of the film is fought with Stark and Rhodes, also known as Iron Patriot, side-by-side. Much is made of Rhodes's "rebranding" in *IM3*: for the first two *Iron Man* films, Rhodes is "War Machine," a military-claimed version of the Iron Man suit, cocooned deep within the mixed realities of governmentally/militarily controlled orders/protocols, weaponized as the perfect "man-in-the-middle" FCS of the contemporary Military Machine. Deciding then that "War Machine" was "too aggressive," he is repainted red-white-and-blue and renamed Iron Patriot. Blazoned with the American flag, Iron Patriot literally flies around the world, unencumbered by borders or treaties, into countries to interrogate whomever he finds: in Pakistan, Rhodes flies into a building, as a soldier, with the express purpose of threatening (or killing) inhabitants there, acting as a military force outside all international peace laws. He is a weapon of the Americanized World Police, using the cover of The Mandarin's terrorism (like Shear in *Swordfish*) to fight and kill whomever the American military thinks is necessary. On one hand, this does represent the borderless, globalized "War on Terror" that the modern American has been engaged in for the

past decade; yet, Iron Patriot's free reign creates unhealthy binaries of American (the hero) versus the foreign Other (the evil) that has more in common with the outdated, Romanticized, and nostalgic model of the heroic physical soldier present in films like *Saving Private Ryan* (Dir. Steven Spielberg, 1998). This clinging to traditional models of oppositional nationalism and American exceptionalism simplifies the enemies being fought, reducing warfare back to a simple Us–Them dichotomy (SAM versus IVAN, red versus blue) that does not necessarily reflect the globalized identities of the Internet embedded machinic audience. More, upholding the Romantic (physical) soldier neglects how warfare against terror is actually being fought, in particular via the increasing reliance on unmanned drone strikes. Whereas Levy's and Stirling's hacker was upheld for her/his potential moral limits, Stark does not oppose the film's obvious military forces; more, his willingness to kill "evil" humans establishes him as more in line with the Military Machine and separate from other potential ethical models for the machinic audience, civilian superheroes such as Spiderman and Batman, for example, who refuse to take any life as part of their ethical code (explored further in chapter 5). Through this perspective, when Stark's networked BwOs, the multiple Iron Man suits, come in at the end of *IM3*, he becomes the machinic phylum De Landa envisions (and fears), a machine-human assemblage within a larger war assemblage, disparate yet unified and one part of a killing system of systems (figure 4.2).

As an immensely popular series of films,[14] *Iron Man* trilogy normalizes, and in many ways condones, the remilitarization of the Internet, encouraging an Internet user to view his/her networks as

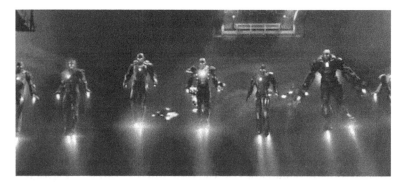

Figure 4.2 The machinic phylum of Iron Men emerges from the sky to save the day (*Iron Man 3*, 2013)

a necessary weapon in fighting Evil and Terror instead of Haraway's vision of it as a site of resistance and identity reformation. If Stark is intended to be presented as a civilian posthuman, constantly enabled/extended/amplified by the Internet (Jarvis), the blurring between himself and the military encourages a machinic audience to see cyberspace as, at the very least, a weapon capable of enhancing physical soldiers as a way of tracking and killing "bad guys." Perhaps this can be balanced out by the ham-fisted anti-military stance shown in *Avatar*; perhaps too, more traditional models of the heroic hacker such as Lisabeth Salander (Rooney Mara) in *The Girl with the Dragon Tattoo* (Dir. David Fincher, 2011), or "real world" examples such as Wikileaks or Anonymous, can survive as alternative models of the cyber solider. We should worry though: Perlroth's *New York Times* article "Luring Young Web Warriors" details Homeland Security's recruitment of exactly the type of hackers/super-users so prominently outside the American military in the early days of the Internet that were responsible for the primary innovations and growth of modern personal computing and the Internet itself. The machinic phylum, with this in mind, is not a terrifying machine-only entity with unlimited local intelligence (like Deep Blue), but rather a collection of densely connected posthuman Internet super-users. By making military hacking "cool and exciting" (Perlroth, 1), like Stark's Iron Man, the machinic audience runs the risk of transforming the Internet into a battlefield, a place of increasingly military contests in which the hacker may well be the best offensive weapon and/or the last line of defense but can only be so by sacrificing the skilled protestors and voices of dissent needed.

Chapter 5

With a Great Data Plan Comes Great Responsibility: The Enmeshed Web 2.0 Internet User

Introduction: Under the mesh of Web 2.0

In 1991, Sven Birkerts foresaw the density of Web 2.0 even in the early stages of the popular Internet, it as a "communications mesh, a soft and pliable mesh woven from invisible threads, [that] has fallen over everything," before clarifying that "the so-called natural world, which used to be our yardstick of the actual, can now be perceived only through a scrim" ("Into the Electronic Millennium," para. 12). This concept of the Internet-as-mesh does well to establish the contemporary density of interconnections between multiple individual users while also reflecting the symbiotic user-object connections in a user's digital/physical environment. However, the scrim Birkerts imagines is similar to the wall Plato's prisoners stare at in the allegorical Cave; the Internet is a barrier keeping the user from "actually" viewing and participating in the "real" world. While, the invisible mesh does have holes in it, allowing slight peeks at the "real" or "natural" world (much as the shadows resemble the real world), ultimately the Internet user's view is incomplete and fragmented. For Birkerts, the mesh that covers everything/everyone is not a powerful connecting entity, but rather a trap, a piece of netting that keeps the user imprisoned, preventing complete interaction with the real/natural world. Like Foucault's docile body or Deleuze and Guattari's empty BwO, Birkerts's enmeshed user is hyper-connected but always partial and restricted.

Still, Birkerts's imagery, grounded in Literate Man's value systems, makes some sense when applied to the first two eras of Internet

users: while laptop computers did exist in the early 1990s, they were prohibitively expensive and bulky, and most users would have inter- faced with the Internet through their home computers.[1] As such, the user was anchored to where their stationary computer was, an enmeshed captive to the phone line that fed into the machine. Post- Y2K, however, Governor et al. detail the increase in "wireless con- nections as [the user's] first means of connecting to the Internet" (x); more, this boost in wireless Internet usage, infrastructure, and speeds then combined with the improved portability of Internet-connected devices. While the popularization of cheaper laptops made this por- tability common place, smartphones and hand-held devices (Personal Digital Assistants [PDAs] like Palm Pilot in 1996 and Blackberry in 1999, then the iPhone in 2007)[2] also greatly transformed how and where the user connected to the Internet. As chapter 2 argued, this moved the user away from the web browser as his/her primary portal; instead, the Web 2.0 user likely enters the Internet via many specific software, individual apps that make the best use of the mashed-up semantic web. The desk-affixed, enmeshed user of the early Popular Internet now moves around more freely, expanding into the "natu- ral world" as his/her potential access points to the Internet stretch beyond both geographical location (always at the desk) and device hardware (always through the desktop computer). All this results in, as Wu Song argues, an Internet that is "increasingly integrated within existing offline practices and social relationships, rather than creating a 'reality' that is completely separate and removed" (266). With this, Birkerts's mesh goes from covering the stationary user to simply meld- ing into the user's skin: using Manovich's notion of augmented space, the Web 2.0 Internet becomes a flexible, portable prosthesis, pushing the user much closer to the embodied, narrative user in "virtuality" that Hayles imagines in opposition to the postbiological. Recalling Hansen's wearable space (chapter 3), virtuality, as a space where "*mate-rial objects are interpenetrated by information patterns,*" produces a material user, interpenetrated by other devices, information and users; s/he walks freely around her/his world, mixing her/his sensual per- ception in with the data patterns being received by contact with her/ his devices and networks (*HWBPh*, 13, author's italics). De Landa and Hayles dovetail together as they both stress that interaction, with other users or objects, in virtuality (or "virtual spaces" for De Landa) requires an acknowledgement of materiality (or "the natural world"), even when "strict physical co-presence [is] unnecessary" (De Landa, *A New Philosophy*, 54). Adding then, as Deleuze says about Foucault's views, "[technology] is therefore social before it is technical": the

soldier's rifle or the farmer's plough are small parts of larger social assemblages, as much tools of the user as they are small components or larger machines (*Foucault*, 34). The Web 2.0 Internet places its virtuality-imbedded users into larger and denser social (material/virtual) assemblages, pushing those larger social assemblages/machines to become more (materially/virtually) dense and interconnected, until each user-assemblage within the larger social machines is inseparable from each other user-assemblage. As discussed in chapter 2, the Web 2.0 user is potentially a collection of organism and full BwOs, multiple and porous, open to exchanges of information and sensation from the immense networks of other BwOs/organism assemblages participating in the networked dense connections/assemblages. In its early stages then, Web 2.0 was met with optimism: once a user was densely incorporated into a virtual/material Deleuzian social machine, s/he could then add her/his unique experiences/documents into the permeable and expansive networks, potentially decentering the power created by any conglomerations of governmental or corporate authority. In contrast to the 1995 *Time* cover story "On A Screen Near You: Cyberporn" explored in chapter 1, *Time*'s "Person of the Year" for 2006 was "You," the Web 2.0 user driven by "the cosmic compendium of knowledge Wikipedia and the million-channel people's network YouTube and the online metropolis MySpace" who wrestled "power from the few and [helped] one another for nothing...founding and framing the new digital democracy" (Grossman, para. 3).

Yet, the vast majority of Web 2.0 technology is contingent upon huge amounts of information being inputted and tagged/manipulated in databases; therefore, a Web 2.0 user participating in this increasingly intense collection of assemblages necessarily exposes large amounts of personal data by way of her/his many different avatars'/full BwOs' many interactions. On the one hand, in order to move from Birkerts's enmeshed/empty BwO user to a more unified organism/full BwOs assemblage, the Web 2.0 user needs to project as much information into his/her isomorphic computer databases in order to facilitate the organization of tags and taxonomies Grossman trumpeted as the future. On the other hand, this joining into larger social technologies/assemblages, makes the user, and in turn the virtual space, potentially susceptible: the black-hat hacker might take the necessarily uploaded information and manipulate it for her/his own means (as Jack Devlin does in *The Net*). This is Literate Man's generalized fear of the Internet: too much private information is being made communal and that the digital self, whether ill or simply weak, is especially prone to attack. This ill/weak BwO becomes particularly

vulnerable as Web 2.0 moves Tribes on the Internet from "bonded groups to loose shifting networks, from shared identity and space to social clusters" (Wu Song, 267). While we'll be discussing the black-hat hacker more in chapter 6, this chapter is more interested in how exactly a Web 2.0 Internet, moved out from under a restrictive mesh and populated by loose "social clusters," might be policed so that the "vulnerable" Web 2.0 user might best be protected.

Recalling the discussion on the Communications Decency Act in chapter 1, there has long been concerns about how a policing force might supervise online spaces as a way of ensuring user safety. However, the implementation of this monitoring force is fraught with obvious problems: Who leads the surveillance? What information or type of user might they target? If so, what techniques or tactics might such a policing force use? The task of monitoring a Web 2.0 space like Facebook, where the user is encouraged to use their real name and is then grouped into categories of familiarized networks/Tribes like "Family" or "Friends," is significantly easier than policing the anonymous and relatively ephemeral 4chan. Similar to parts of the "Dark Web" (portions of craigslist (Campbell and Synders, "Craigslist Declassified") or the removed Silk Road (Farrell, "FBI Cyber Sleuths Capture Alleged Silk Road Internet Crime Boss"), 4chan's immense user base of "10 million unique visitors and 705 million page views a month" is reminiscent of early BBS systems, wherein early Internet users could find guides on anarchy, bomb building, lock picking, etc., all posted under the hacker idealism of free access to all information (Stirling, 77–78). The site has no archives or search tools; unlike Facebook, which is deeply invested in profiles being attached to a user's "real" identity, a 4chan user remain anonymous and his/her posted content is largely wiped out at the end of every day (Grigoriadis, para. 8). Yet, critics of 4chan explain that its remarkable anonymity marks it as a lawless site where racist, misogynist, and/or criminal content is easily uploaded and discussed. Interestingly then, 4chan was also the birthsite of the hacker group Anonymous, a collection of geographically diverse and (of course) anonymous users who use the Web 2.0 as a means to empower those they feel are underrepresented. They were a driving force behind the Occupy Wall Street movement, but are perhaps most famous for their attacks/leaks involving Scientology or, more troublingly, for their involvement outing the accused rapists in Steubenville ("Steubenville High School Students Joke About Rape in Video Leaked By Anonymous"). They are a group, like the Jullian Assange-lead Wikileaks, that uses the power of a Web 2.0 Internet, for better or worse, to act as a

decentralized and nationally/geographically unaffiliated policing force. Anonymous stands in contrast to the increased militarization and nationalization of the Internet, reestablishing the civilian-soldier binary from chapter 4 and calling into question what type of larger machines (governmental, military, civilian, etc.) are being upheld in the cultural scripts of popular cinema as best suited to navigate and police the Web 2.0 Internet.

A reasonable argument can be made that an Internet user has to be willing to sacrifice some amount of privacy in order to receive some safety and protection: the Web 2.0 Internet and its collections of digitized personal information, if overseen by responsible forces, can be exceptionally useful in tracking and preventing crime, both online and offline. Indeed, films like the *Iron Man* trilogy and *The Dark Knight*, present superheroes harnessing the extreme surveillance potentials inherent in Web 2.0 as a means of combating evil, arguing that an Internet user must expect an amount of policing access to private communications/information to maintain order and protect civilians. However, *Untraceable* (2008) and *feardotcom* (2002) take a far more pessimistic view of policing with (and on) the Internet: even the most constant and perfect surveillance cannot prevent deviant and violent content from being posted; more, the films argue that once such content is on the Internet, other users are compelled to flock to it, not as places of surveillance, but of spectacle where they are not only voyeurs but also participants, casting the Internet user as a guilty accomplice that craves the punishment/torture of an dehumanized avatar.

The Responsible (Superheroes) in Charge

As the 2013 NSA scandal revealed,[3] the American government's answer to policing with/on the Internet seems to be through mass surveillance, with a specific focus on the rich Internet data-flows enabled by portable Web 2.0 technologies and devices. Edward Snowden's revelations did not reveal a new phenomenon but rather a long governmental commitment to what Clarke refers to as "dataveillance" ("Information technology and Dataveillance"). Similar to the Cold War-era ECHELON, the Homeland Security Act (2002) and its modifications to The Privacy Act (including, as of 1988, The Computer Matching and Privacy Protection Act [2005]) and the Electronics Communication Act (via the USA Patriot Act, 2001), were created, post–9/11, under the ideals using the wealth of civilian information and communication as a means of rooting out and

preventing terrorism. With this justification, the contemporary Internet-enabled NSA is "always on," always collecting and keeping a user's browsing history, always potentially looking through a user's email, web history, message board content, etc. David Lyons argues in *The Electronic Eye* that "private, sequestered, decentralized activities, the mundane routines of everyday life, are, as it were, in view, continuously and automatically" (71).

This continuous monitoring recalls Jeremy Bentham's construct of the panopticon (*The Panopticon Writings*), wherein Foucault imagines the unvarying gaze of the concealed and (perhaps) omnipresent force as "a permanent visibility that assures the automatic functioning of power" (*Discipline and Punish*, 201). Through this perspective, the Internet user is under Birkerts's mesh, under constant supervision by a larger "surveillant assemblage" that joins together a user's "video images, text files, biometric measures, genetic information," regardless of whether s/he is committing a crime or not, and manipulates that information into "profiles and risk categories within a fluid network" (Lyons, "Surveillance, Power and Everyday Life," 116). But, as Deleuze recognizes in "Postscript on the Societies of Control," the panopticon is not nearly as effective when a society of discipline shifts to a society of control, as mediated specifically by sophisticated computers (or, expanded, the Internet). This change generates a "modulation" of the self, wherein the user is controlled by a "numerical language of control" that is "made of codes that mark access to information" (4–6); for Deleuze, "what counts is…the computer that tracks each person's position—licit or illicit" (ibid., 7), so that virtuality becomes not just a series of visible barriers or checkpoints but also includes numerical ID records, PINS, banking records, etc. While a number of Surveillance Studies scholars erroneously simplify Deleuze's position,[4] Kevin D. Haggerty successfully expands on Deleuze's position by explaining that in the panopticon in a Web 2.0 environment has been "over-extended" past the point of acknowledging the limits of a subtle application of the model ("Tear down the Walls" 23). Digital surveillance rarely follows "a single coherent purpose" (ibid., 28); instead, he argues,

> "[the] multiplication of the sites of surveillance ruptures the unidirectional nature of the gaze, transforming surveillance from a dynamic of the microscope to one where knowledge and images of unexpected intensity and assorted distortions cascade from viewer to viewer and across institutions…undermining the neat distinction between watchers and watched." (ibid., 29)

In this system, any Internet user is a potential surveillant force: most obviously, this multiplication of gazes comes from a Web 2.0 user's ability to quickly and easily upload/update information, not just about him/herself, but those around him/her (for example, think of tagging a friend, unbeknownst to him/her, in a photo on Facebook). The explosion of more sophisticated portable Internet-connected devices (like smartphones), augmented by ever-expanding hard drive space, amazingly complex cameras, and a near continuous connection to the Internet, allow the user to not only watch but also record and upload any action they can point their device at. More troublingly, the smartphone itself is a device of, as Lyons terms it, external "mobiveillance" that allows a surveillance assemblage (e.g., governmental) to not only monitor the content being moved through the data-flow but also where, via GPS coordinates, a specific user is when they access/upload that information (113). As these always-connected, Web 2.0 devices are further integrated into a posthuman virtuality, digital surveillance becomes two-pronged: the Internet user is being watched by large scale surveillance assemblages (corporate, military, governmental, civilian [Anonymous]) and the individual users (nodes), all constantly overlapping in the dense portable networks of a Web 2.0 Internet.

Many Surveillance Studies theorists point to *The Conversation* (Dir. Francis Ford Coppola, 1974), borrowing themes from *Blowup* (Dir. Michelangelo Antonioni, 1966), as one of the first films engaging directly with and complicating the theme of electronic surveillance, but it is *Enemy of the State* (1998) that begins to clearly express the tension between civilian privacy and safety around an increasingly populated/connected Internet. The plot of the film revolves around senior NSA official Thomas Reynolds (Jon Voight) murdering Senator Phil Hammersley (Jason Robards) because the Senator opposes changes to the fictional Telecommunications Security and Privacy Act that would grant the NSA the power needed to fight what Reynolds sees as a near-unwinnable war against both domestic and foreign terrorists. Reynolds argues that his overwhelming surveillant network, ranging from tiny cameras to the satellites that provide the film's stunning overhead chase shots, must intensify to ensure the safety of America, stating:

[The world is] a lot more volatile. Now we've got ten million crackpots out there...Ten-year-olds go on the Net, downloading encryption we can barely break, not to mention instructions on how to make a low-yield nuclear device...You think we're the enemy of democracy, you and I? I think we're democracy's last hope.

While the film doesn't engage overtly with the Internet often, except to imply that all the computers and servers (banks, governmental, military) are connected and feeding information to each other,[5] the idea that anyone on the Internet can access dangerous information (through a space like 4chan) is reason enough to justify the collecting and manipulating of private civilian information; to track and police such a space, he argues, the NSA must house that information in a series of manipulable databases so that they can then use "panoptic sort" techniques like the computer-matching algorithms that Fielder (Jack Black) uses to compare Robert Dean (Will Smith) bank withdrawal records to Rachel Banks's (Lisa Bonet) deposit records. In *Sneakers*, the same over-powerful and immoral NSA spy network haunts the film: when a collection of real NSA agents show up to reclaim the decryption device Bishop and his team have stolen from Cosmo, Bishop explains to lead agent Bernard Abbott (James Earl Jones) that the decryption device is not to going to be used to monitor the webspaces of foreign countries. Rather, it only works on American systems and that the desperately sought device is as a means for the NSA to "spy on Americans," including unfiltered access to The White House and FBI. We should also consider Rat's control of the Internet in *The Core* as reflective of a governmental machine unknowingly monitoring, then censoring, material on the web, allegedly for the benefit of the citizens themselves. Similarly, in *Swordfish*, the Internet is a tool used by secret government agencies to fund covert operations against terrorists, "enemies of America," all without the oversight of civilian, legislative, or even presidential approval. In the film, Gabriel Shear justifies this behavior with much the same rhetoric as Reynolds: that the Internet user must grant trust and surveillant authority to larger governmental assemblages in order to maintain his/her safety, as Shear uses the same terminology as Reynolds ("war," "terrorism") as a means to explain the death of civilians and the clandestine nature of the surveillance and violence he undertakes. Reynolds's and Shear's rationalization falls in line with real world examples of secret agencies like ECHELON whose international existence has been kept hidden since World War II and is largely responsible for much of the data interception (digital, phones traffic) and storage that the NSA undertakes (Gumpert and Drucker, 119; Connolly, 76). While *Enemy of the State*, much like *Sneakers* and *Swordfish*, expresses the fears of dataveillance and the manipulation ("infection") of digital identities that come with the centralizing and networking of personal and infrastructure information in computer databanks (chapter 1), all three films cast the surveillant assemblage

of the NSA (and by extension larger governmental assemblages) as power-hungry, murderous, and invasive, in effect arguing that its authority in the digital realm is too expansive and too easily corrupted, signalling to a movie audience that they should have reason to be suspicious of such an assemblage.

If the mere mortals of the government are untrustworthy, the *Ironman* series of films asks its audience members to place their trust in a superhero as a potential authority and moral arbitrator of their virtual spaces. Tony Stark is a super-user (hacker) of the Internet, who is able to utilize the networking power (and the weaponry innate in it) in powerful and unique ways. His ability to tap into Top-Secret portions of the Internet (Rhodes' military email account, for example) and use/expose the information there, grants him the sort of high ethical grounds De Landa envisions as the most positive type of hacker (chapter 4). More, his access to hyper-intelligent computing systems capable of processing and matching data at enormous speeds with great precision, grants him tools that might be useful, from his ethical position, in policing the Internet: in *Iron Man 3*, he is able to use Jarvis to reconstruct the blast scene that hospitalizes Happy Hogan (Jon Favreau) presumably based on access to the network of police and, city information (building specs and blueprints). In exceptional three-dimensional detail, he is able to step into the recreation and manipulate the holographic objects Jarvis generates; more, he layers and graphs information on top of this three-dimensional display, in advanced, "mashed-up" Web 2.0 space, to track anomalous heat signatures similar to the bomb blast. This sort of Internet super-use by Stark (a superior engineering and coding hacker) is presented as an alternative to a force like the NSA, wherein his policing methods use the information of the Internet not for collection and surveillance, but for active tracking and crime solving.

However, as discussed in chapter 4, Tony Stark's romantic transformation from warmonger to civilian crime-fighter is problematized by his close relationship with the military, in particular War Machine/Iron Patriot. Further, his posthuman existence in virtuality is always accompanied by overt weaponry and the solutions provided by his super-use of the Internet are, in the end, subsumed by his decision to kill and/or blow up "bad guys": the moment of triumph at the end of *Iron Man 3* is not the exposure and jailing of main villain Aldrich Killian (Guy Pearce), but rather his death at the hands of Stark and his Internet-enabled military machinic phylum of Iron Man clones (chapter 4). This vigilante eradication of "terrorism" is not that far off from Shear and Reynolds's killings, even if the audience is willing to admit

the uncomplicated evil that Killian is meant to represent. To this end, Iron Man's villains in the three films are very removed from how an actual terrorist might use the Internet (as a place to relay messages to other camps or hold training information as Al Qaeda does, for example [Brachman, "Internet as Emirate"]) which sets up Iron Man as a super-user who doesn't actually need to understand or navigate the complex Internet beyond the end result of using it as information that leads to a physical battle. Iron Man, as an outdated model, does not use the virtual spaces present in an audience's Web 2.0 environment (message boards like 4chan, email, etc.), and, as such, he is not a particularly useful authority or protective figure for the average Web 2.0 audience.

To compare, Batman (Christian Bale), particularly the version in *The Dark Knight*, is a hero much closer to how an Internet user might act. Bruce Wayne is a super-user similar to Stark, in that he is able to experiment with a vast amount of expensive technology beyond the reach of an "average" citizen. Specifically, the Bat Cave is a icon of (sometimes comically specific) technological gadgetry, a place in which Wayne/Batman houses weaponry, suits, and vehicles, etc. and a space that also acts as a command post/entry point where either he or Alfred (Michael Caine) can access and sort through the numerous databases on the Internet: the film has numerous examples of this, most strikingly Alfred's hurried search to find a criminal's house address along the parade route and Wayne's use of fingerprint databases to match a thumbprint on a shotgun shell. Wayne is able to use his vast wealth and position as an outsider/civilian, much like Stark, to fund the creation of personal technologies that he can then blend with surveillance machinery. His silent rooftop pose as he filters through the cacophony of passing phone conversations, sound-edited in as radio-like channels, stands as one of the more striking and elegantly descriptive scenes of the film.

Wayne and Stark differ dramatically, however, in their basic posthuman construction: while Iron Man is a literal man inside a machine, an overt cyborg or a simplified posthuman, Batman is protected by near head-to-toe armor. Batman's suit is not mechanical but a thick skin, and the technological parts do not encase him entirely: because the audience is able to see his mouth and eyes as he speaks, the technological/gadgetry is present but is blended in a more subtle way that mirrors how an Internet user might, like a multi-sensory skin, slip into their virtuality. This delicate balance between humanizing Batman (allowing the audience to see at least partial facial expressions) and foregrounding the prosthetic technologies are part

of what makes him such an enduring character. More importantly, unlike Stark, Wayne chooses to hide his identity from public knowledge, allowing this particular version of himself (Batman) to act as a mythic, amorphous figure. While this figure does act primarily in the "real" world (and not the digital), the construct of a nameless Batman allows Wayne to navigate the physical world with the same tethered identity, slippery and secret, an Internet user (or member of Anonymous) might with his/her avatars. While other films like *Surrogates* (chapter 3) or *The Net* (chapter 1) fear this slippery avatar, stressing the terror of a "highjacked" digital identity, the figure of Batman is healthily flexible enough to allow Harvey Dent (Aaron Eckhart) to also convincingly claim he's Batman. This elastic capability, the ability to be "whatever Gotham needs [Batman] to be," gives vehicle to the sacrifice Wayne makes at the end of the movie, letting Batman "endure" the criticism meant for Dent, so that Gotham can continue believing in the positive humanism Dent represented to the city. In this way, Batman too is the outsider/civilian hacker De Landa sees as powerful: as Alfred states as he and Wayne are preparing to expose that Wayne is Batman, "Batman can be the outcast. He can make the choice that no one else can make. The right choice"; because Batman is outside the surveillant assemblages (governmental, military), an outcast, he is able to make the "correct" moral choices. This combines with Batman's most clearly established characteristic, his unwillingness to kill with no exception, to further underline his role as ethical arbiter: unlike Iron Man, Batman uses his technology as a pacifying weapon, preferring to allow the larger justice system to play the role of ultimate judgment. While the Joker (Heath Ledger) exploits these "rules," it is Batman's moral fortitude, combined with his anonymous nature, that perhaps presents a better model for monitoring a Web 2.0 environment.

Still, Batman is a figure that believes that intrusive surveillance, demanding the surrender of some privacy, is a tool necessarily required in order to combat crime and terrorism. This is best exampled by the technology he creates, under the guise of "creating cell phones for the Army," that enables his tracking and ultimate defeat of the Joker (figure 5.1).

The system hacks into every Gotham user's cell phone to listen into citizens' conversations and to also release a sonar signal from each phone that creates unique sound "shadows" that Batman can then use, much like Iron Man's three-dimensional recreation of the Chinese Theatre, to navigate and manipulate virtual reconstructions of parts of Gotham. The static, multiscreen machine's real value comes

Figure 5.1 Lucius Fox (Morgan Freeman) looks over his new synopticon in *The Dark Knight* (2008)

when Batman interfaces with it via a Heads Up Display (HUD) in his mask and can then view the images in real time (via, presumably, an Internet connection). Acting within a mobile virtuality extended by his HUD interface, Batman, and the movie viewer, see the silvery avatars of Internet/phone users as ghost images against a stark background; the visuals are reminiscent of the wireframe Internet Douglass Hall spies at the edge of his simulation in *The Thirteenth Floor*, a skeletal underpinning that blends both the digital and "real." The sound and camera effects, for the audience in this environment, mirror techniques used in *The Matrix* trilogy and *Avatar* to indicate movement between avatar/physical environments: as Batman looks around and virtually "travels" between floors, the sound whooshes like the hyperlinking effects described in chapter 2; the camerawork tunnels and twists impossibly fast, as if down a wire, from warehouse floor to warehouse floor, leaving the same type of silhouettes an operator outside The Matrix might see when looking at its raw code. With the mastery of this mobile Internet-enhanced space that comes with the ability to shift between materiality and virtual quickly and expertly, Batman demonstrates himself, in a way Iron Man doesn't, as comfortable utilizing technology that would be best suited for a Web 2.0 policing force.

Yet, the destruction of the device at the end of the film underlines the problems a figure like Batman has as an authorial policing assemblage in virtuality. While Batman calls the technology "beautiful," Lucius Fox (Morgan Freeman) counters that it is "Beautiful. Unethical. Dangerous" questioning whether Batman has the right to spy on "30 million people" before outright stating "This is wrong."

Hugely different than the relatively uncomplicated wiretaps and cameras in *Enemy of the State*, Fox's moral qualms are in reaction to the machine use of a Web 2.0 database manipulation system. Batman too recognizes the immense power in his device and understands that he cannot be the centralized controller of it, adding in a moral layer of accountability in Fox; Fox destroys it because, as he states, it is "too much power for one person." While the machine's destruction further underlines the ethical nature of Batman, it also implies that no solitary force (person/corporation/institution) alone should control the surveillance of such a virtual space, in effect rejecting the sort of singularly focal power dynamics that Benthem and Foucault imagine in the panopticon and suggesting that an assemblage closer to Thomas Mathiesen's concept of the synopticon, a complex surveillant assemblage composed of many varied assemblages, might be the best policing force of a Web 2.0 space. While Mathiesen is quick to point out that the panopticon and synopticon are not binaries, his essay "The Viewer Society," illustrates that within the contemporary expansion of mass media, as users connect into denser networks with more immediate access to each other and information, the power dynamics of the old panoptic system transform into a decentralized society that enables "*the many to see and contemplate the few*," resulting in what he calls a "viewer society" (219, author's italics). As a policing force, such an assemblage would likely involve a network of users, self-aware and savvy, that could augment a policing force (like the NSA or FBI), allowing such an assemblage to reach further, gather more information and sort faster through the data-rich Web 2.0 environment: "the decentralized, narrowly oriented panopticons may quickly be combined into larger broad-ranging systems by technological devices, covering large categories of people in full detail" (221). However, like *The Dark Knight*, he is not particularly positive about the synopticon's effects, especially in reaction to the Internet as he knew it when he updated his original 1987 essay in 1997.[6] In fact, Mathiesen's take on such a user-empowered system is similar to the pessimism in *Untraceable* (2008) and *feardotcom* (2004), films in which users, amplified by both constant portable access to the Internet and the hardware of intricate cameras, are not interested in being crime fighters but would rather participate as voyeuristic accessories.

The Internet User as Accomplice

The late 1990s–early 2000s saw stand-alone digital cameras, portable and pocket-sized with exponentially advancing hardware, become

increasingly cheaper and much more user-friendly in terms of camera interface and computer-camera software symbiosis;[7] the ability to upload pictures or video, once at a computer, led to the initial explosion of networked sharing websites like Flickr and Photobucket. Alongside this, the webcam gained popularity as both a stand-alone device and, when integrated into a laptop, a tool that could provide the user a transportable video-recording studio that was very adept at traversing public/private spaces. Webcams also made it much simpler to "live-stream" events, instantly transporting a user/viewer to a specific space (private/public) in real time. However, the integration of multisensory video documents into a full Web 2.0 didn't begin to be fully realized until the camera was integrated into the cell phone (and evolved even further when included in a smartphone) which combined those videos with "mashed-up" applications like Tumblr, Facebook, Twitter. etc. that then distributed videos and photos even more quickly and even further than a stand-alone digital camera's capabilities. As integrated digital cameras became relatively commonplace, "average user" appliances, the collection of portable Web 2.0 users began to inhabit what Lyon calls a surveillance society, one in which the available surveillant capabilities of the everyday citizen rose as devices got smaller, more complex, and cheaper. Lyon's and Gary T. Marx's works both argue then that the expectation that "someone is watching" has gone well passed normalized, to a point where a citizen fully expects that there is always a camera recording (cell phone, laptop, Closed Circuit Television [CCTV], etc.), leading to a culture in which "the markers between private and public life (the interior and exterior) dissolve in a digital haze" (Turner, "Collapsing the Interior/Exterior Distinction," 106). Gumpert and Drucker argue then that "ubiquitous surveillance" extends further into a monitoring of browser cookies and email communication as a more expected and accepted "informal surveillance" (119, 124); the authors list three possible scenarios for the contemporary Internet user but the most interesting is the second, "Awareness of the Surveillance Technology—Without Knowledge or Permission of Use," that is "based on the possibility of being observed, although the specific site or situation may be unknown" (118). In movies like *Enemy of the State* or *The Dark Knight*, this "possibility" is housed in a centralized assemblage, but in a culture where Internet-connected smartphones carry large storage space along with high-quality cameras, and corporations pay top-dollar for mined data from popular social websites like Facebook, the possible "watcher"/"watched" is each individual Internet user of the synopticon. While a mobile Internet-connected

device has many potential capabilities for surveillance (both by and on the user), the focus on the increased transportability and quality of cameras is important in this discussion as it aligns itself with the medium of film. In the same way that a smartphone might decentralize surveillant power/capabilities, it likewise decentralizes the act of making videos (large or small) into the individual users themselves. Without getting off track with an exploration of studio versus independent movies, the machinic audience represents an increasingly symbiotic dynamic between the watched/the watcher of everyday surveillance and the film/audience of popular cinema. A machinic audience, because of the constant access to their own video-making capabilities as well as their awareness of every other's user's potential capability, is more comfortable with technologically mediated movie-watching experiences, an idea expanded in more depth with our discussion of *Avatar* in chapter 3; that same audience would also be increasingly more secure, and perhaps expectant of, seeing the very technologies they use and see in their own lives represented in films. Cameras on camera, in particular digital cameras and spaces on film, are then essential to understanding how a machinic audience relates to the value systems and judgments being advocated in films that focalize on Web 2.0 technology.

Building on this idea of a surveillance society, Norman K. Denzin, in *The Cinematic Society* (1995), sees the average citizen as the product of a century-long and unavoidable "social formation" that filters and constructs both personal and large-scale "popular" narratives "through the cinematic apparatus," resulting in a cinematic society (1). This society, he argues, is deeply entwined with a voyeuristically way of looking that "created a complex, new scopic and ocular culture based on an overarching gaze" (14). This then created an audience invested in "a spectatorial gaze that [makes] the spectator," an audience aware of their own watching of the movie that then also encouraged films that "gazed back from the theatre's screen" (26; 28); Wheeler Winston Dixon in *It Looks at You* calls this a "look back" in which either the characters acknowledge they are being watched or the film overtly includes film-making equipment (7). Both Dixon and Denzin, writing in the Second Era of Internet use, anticipate the coming reciprocal gaze of a Web 2.0 technology like YouTube; while films are closed conversations between creators/audience, a YouTube is constructed with a watching audience at the forefront, often by directly addressing the camera ("you"). As Nicholas Rombes argues, perhaps too negatively, "the hyper awareness of the self, this deep narcissism, is characteristic of film viewing experience in the digital

era, when the role of the spectator assumes an even more visible role in the arrangement of a film's structure" (58). The "look back" is no longer subtle and the cinematic and surveillance society collide; the "visible" Internet user, assuming the possibility of the camera, construct their lives as if it were a video (movie) to be viewed. If the surveillance society effectively *is* the cinematic society, and that audience *is* the same digital/camera-savvy machinic audience, it makes sense that the characters within popular films would demonstrate the confidence or desire to be in front of a camera. We can see this in a few movies in the first two eras of Internet use, like *American Pie* (Dir. Paul Weitz, 1999), where a comedic mix-up with an Internet-connected live-streaming webcam as a main plot device to eventually get its protagonist Jim Levenstein (Jason Biggs) into a romantic relationship with Michelle Flaherty (Alyson Hannigan); likewise, *The Blair Witch Project* (Dir. Daniel Myrick and Eduardo Sánchez, 1999) was immensely popular partly because of its inventive and overt use of portable personal cameras as the framing conceit. *Strange Days* (Dir. Kathryn Bigelow, 1995), while not engaging with a networked computer system, does present a forerunner to the aesthetics of some of the videos uploaded to Youtube. The film centers around devices called "Superconducting Quantum Interference Devices" (SQUIDs), in which the user attaches the SQUID to themselves and records, including all his/her bodily sensations, his/her experience via a first person POV. It is the SQUID user's ability to exactly live another user's events that mirror the many of the spontaneously captured videos, at once an intimate record of a user's experience, but also a direct portal from audience to user, posted into a Web 2.0 space. In the same way that the SQUID user is aware of her/his mediated experience (the complexity of the device makes it very unlikely to accidentally wear the device) and that it is to be consumed by another person, the Web 2.0 user, the machinic audience, creates and consumes her/his own videos (and movies) with that same knowledge. It makes sense that the visible (Web 2.0/movie) spectator, both creator and watcher, would be a useful agent of active authority in the synopticon, a singular portable assemblage constantly networked with other similar assemblages, transferring, commenting on, and retransferring data (video, textual, photographic, etc.) with ease. The machinic audience no longer demarcates watcher/watched with a panoptic, impersonal dynamic: such an audience of users might even have a special (sympathetic) understanding of the personal relationship of the documents they upload and would therefore take special care when viewing/ sharing others' as an audience member.

Yet, a number of early Web 2.0-era films counter this optimism with rehashed horror: *Firewall*, despite having a protagonist (Jack Stanfield played by Harrison Ford) who works as a Internet security specialist and having been released in the middle of the shift to Web 2.0, presents the terror of the Internet with the same blanket fear of intrusion and family invasion as *The Net* did ten years earlier. In many ways, *Firewall* is similar to *Disclosure* (discussed further in chapter 7), in that its protagonist works for an Internet-invested company; both are dramas more interested in the "grown-up" themes of family rupture without overtly engaging with an extended discussion of the surrounding Internet technologies. Still, in *Firewall*, as in *The Net*, being captured on camera is a mode of terroristic surveillance, one that allows the main villain, Bill Cox (Paul Bettany), to gather information by observing the Stanfields' every move. There is some sense that the film recognizes the shift in Internet technology: characters use wireless Internet on their laptops and Stanfield is able to track his dog via the GPS device hidden in his collar via a program on his computer. However, the film betrays itself as distant from a camera-comfortable Web 2.0 user, in that cameras are devices that strip rather than create power, exampled by the pen-camera Stanfield is forced to carry as a monitoring device or the opening sequence that shows secretly gathered video footage of Stanfield's family. In the end, *Firewall* is a film aligned with a narrative and value system of 10-year-old films like *The Net*; in turn, it did mediocre box office numbers perhaps because of how vulnerable/"infected" the Internet makes both the individual and the whole familial unit.[8]

Similarly, *feardotcom* and *Untraceable* construct the Internet user as narcissistic, dangerously voyeuristic, and sadistic. Part of this comes from the authorial gaze of the protagonists of both films, who Denzin would flag as "the detective," a "special, gifted, out of the ordinary, even almost scientific" gaze "under the interests of the state and its protection" (51); in both films, because of the Internet's globalized nature, the detective exaggerates the power that Denzin sees as "[belonging] to the world, which is visible to all who will look" (52). This emphasis on heroic "looking" by Mike Reilly (Stephen Dorff in *feardotcom*) and Jennifer Marsh (Diane Lane in *Untraceable*) is balanced by the cowardly and passive voyeurism of the Internet user's gaze. *feardotcom* is a hyperbole of this fear: it extends the conceit of *The Ring* (Dir. Gore Verbinski, 2002) and its murderous video tape to the creation of, as the tag of the film promises, a "killer website." The "evil genius" behind the site is The Doctor, Alistair Pratt (Stephen Rea), who live-streams his torture of young women. When the user

first enters the website, s/he is forced to interact with an avatar (a murdered Jeannine [Gesine Cukrowski]) who prompts the user by questioning "Do you like to watch?" and "Do you want to hurt me?" When the user clicks "Yes," s/he is put through a montage, a horrific version of Case's "consensual hallucination" in which the viewer sees his/her own worst fears; the viewer of the site is then (visually) infected with a mysterious disease that causes extreme mental hallucination leading to insanity and, eventually, death. Reilly then becomes the embodiment of the detective gaze, a potential model for Internet policing, trying to quarantine the website and keep The Doctor from murdering others.

The fact that The Doctor is live-streaming the event, rather than recording and posting the video later, exaggerates the cinematic society, wherein "real" events are captured in actual time with a filmic quality; this ability is not harnessed for safety (or as evidence of the horrific crime) but rather broadcast as a way of promoting its ultra-violent content. From this, The Doctor's actions speak to the obvious concern about the Web 2.0 user's ability to post anything and everything into a space like 4chan, regardless of violence or social mores. However, the harshest judgments are reserved for the movie/Internet-gazing audience: throughout the torture scenes, the camera interchanges between the footage being streamed to the Internet, low-resolution and too sharply zoomed, and the more polished cinematic lens that constructs the movie, combining the two so that the viewer of the website is the same as the viewer of the film. All the while, the live-streaming site counts the viewers, a number which spikes into the thousands in the climatic fight scene where Reilly is killed on camera. That viewer, in particular the Internet-using aspect, is insidiously guilty because they are watching with a completely dehumanizing stare: the supernatural twist of the ghost of Jeannine literally haunting and punishing Internet users/viewers is conflated with The Doctor using the site to live stream his torture to the point where The Doctor, Reilly, and Jeannine all blame Internet viewers for even wanting to look in on such a space; after Reilly is infected, Terry Huston (Natascha McElhone) asks Jeannine what exactly Reilly is guilty of, to which she replies simply "Watching." The Doctor adds, lecturing one of his victims earlier in the film, "You and I have a great responsibility. To them. They've come to watch but also to learn. We provide a lesson. That reducing relationships to anonymous electronic impulses is a perversion." The film is a simplified example of Laura Mulvey's "visual pleasure"-obsessed audience, extended to include the movie watcher and the Internet user as one gazing-assemblage, one that participates

in a gendered scolophilia, "the erotic basis for pleasure in looking at another person as an object," that is the same "perversion" The Doctor identifies as endemic on the Internet (135). The watcher, of the film and of the website, is guilty of subsuming a human life in order to participate in the spectacle of sexual exhibition and the potential killing of the young woman The Doctor captures. When the film explains how the ghost of Jeannine is trapped in the website by way of a connective, and vaguely spooky "neuronet" (a combination "of a number of computers with a number of other computers" that can "send energy, store energy, and send it out"), it constructs the Internet as a murderous and hideous space, far from the potentially freeing posthumanism present in Haraway or Hayles. The separated Jeannine, cast out as avatar only, her BwO fractured completely from her organism, can only be a terrifying revenge-obsessed ghoul. The film encourages the audience to think of the Internet, and potentially their own actions on it, as places of grotesque and dehumanized spectacle, a space in which the Internet-user watching is just as guilty and in need of punishment as the criminal carrying out and recording the act.

The prospective cooperative synoptic assemblage of Reilly's detective's gaze and the Internet user's Web 2.0 capabilities is further undermined in *Untraceable*. While *feardotcom* could be dismissed as a supernatural horror film distanced from the average Internet user, *Untraceable* is invested in verisimilitude, deliberately reflecting the Web 2.0 "reality" it was released into; while articulating many of the same concerns present in *feardotcom* (live-streaming violence, users' voyeurism), the film extends them further by better involving more contemporary and realistic Internet technologies and interfaces. With FBI Special Agent Jennifer Marsh at the lead, the film presents a mixed-reality saturated with familiar Web 2.0 interfaces and software that look like and act like the ones the machinic audience would use: Marsh uses a Google Earth–look-alike to zoom in on a cyberfraud artist's neighborhood; she repeatedly uses her telematic On Star system; Griffin Down (Colin Hanks) and Marsh chat in real time with other Internet users. However, like *feardotcom* and *Firewall*, the film frames the Web 2.0 technologies negatively, aligning with Denzin's 2012 update of the cinematic society wherein the Internet user lives in a "second-hand world" deeply engaged with "the mediated ways in which we represent ourselves to ourselves" (339); within this second-hand world, Gumpert and Drucker argue, the Internet user is

left to decay, the value of the physical environment is de-emphasized while energies are redirected towards spectacular mediated options...the

informed citizen [is] disconnected from community, connected with others without physical connection. (116)

The Internet in *Untraceable*, evolved from the one presented in *feardotcom*, similarly demonizes the (decaying) mediated user of Web 2.0 spaces. While The Doctor is tethered to a specific physical place, the true terror of "The Internet Killer," Owen Reilly (Joseph Cross), is that he is anonymous and constantly able to escape geographic location: the fact that the FBI cannot pin him to a particular place because of his expert use of mirror sites make him just as much of a ghoul as Jeannine; his "mirroring" present him as pure reflection, empty of a "real" body (and community, physical connection, etc.). His uncentered and amorphous identity, made overt by his ability to inhabit other Internet users' profiles (Chang's Restaurant, Melanie), only serve to exaggerate this terror and further cast the Internet user as dangerously disembodied.

The Internet Killer also streams the torture of his victims on the site killwithme.com, echoing the fears of an Internet where anyone can upload/view anything; similarly, both Jeannine and the Internet Killer create their sites as places of punishment for those who watched and sensationalized the deaths of themselves (Jeannine) or their father (Owen Reilly's dad's suicide): both point the blame at those who watched and re-watched the events, the Internet user and those who exploited/created the initial video documents. Reilly's father's suicide is particularly fascinating, in that the video of it, and a number of other gruesome deaths, is found in numerous 4chan-like online message boards where it is posted under the nondescript title of "Whoa": the film implies that those who post and watch this type of content on the Internet, which the film argues is relatively easy to do, are as guilty as those who commit the murders themselves. The site, killwithme.com, highlights this in its title: the killer is not acting alone, put rather "with" the watcher; as the banner at the bottom of the site insists "The more that watch, the faster he dies." The fact that the killer never actually murders his victims but rather sets up elaborate traps in which the number of viewers corresponds to a mechanism that speeds up the victims' deaths, implicates the viewer/user directly, a fact police chief Richard Brooks (Peter Lewis) underlines, explaining "any American that visits the site is an accomplice to murder. We are the murder weapon." Later, Reilly argues that his site reveals "billions of eyes. All watching the same thing at the same time. One big happy family"; the Tribe/family unit made of communicative bodies that *Hackers* encourages and *Firewall* aims to protect is lost to the root immoral nature of the Internet and its users.

From this, the torture moves away from Mulvey's visual scolophilia and, instead follows what Foucault flags as punishment practices common in the eighteenth century, in particular *supplice* (*Discipline and Punish*, 33). This type of corporal punishment is distinguished by the calculated degrees ("quantity, intensity, duration of pain") of pain created by the "rules" of the torture (34); *supplice* is carefully created and measured, just as Reilly's correlates exact viewership to a certain set amount of pain on the victim is, underlining the need for a spectacular public torture and execution (34). The essential aspect of this mode of punishment is that "it pinned the public torture on to the crime itself; it established from one to the other a series of decipherable relations… 'symbolic' torture in which the forms of execution referred to the nature of the crime" (44–45). From this sensational perspective, the men Reilly captures deserve to be punished very publicly, online with a viewership of (potentially) hundreds of millions, because they publicly exploited the death of another (his father); the symbolic expansion/inclusion of the audience to include the Internet user/watcher exponentially spreads the murderous action among the same "watchers" that enjoyed his father's death. While the online viewer him/herself is not punished, the film rather caustically portrays the Internet as a place in which the avatar, the BwO, is treated instead as a body without an organism, dematerialized, completely virtual and therefore completely unreal; the purposeful disintegration/decay of the physical body is meant to show how little value the Internet's users have for such an entity (and identity), and how much the Internet dehumanizes and disembodies/disembowels its occupants.

The "look back" in the film then appropriately shifts from the gaze/inclusion of the camera to the gaze/inclusion of the computer screen. As the first victim (Cliff Fleming) is tormented, there are multiple shots of Reilly's hands typing intercut with intimidating shots of a camera, presumably the one being used to stream, capturing the torture but then also shot so that it "looks back" directly at the audience; this conflates Reilly's display of torture online (his typing, one "murder weapon") with the act of watching it (the camera that simultaneously captures while gazing directly at the [accomplice] audience, the other murder weapons). The camera's "look back," like Reilly's elaborate traps, is a passively violent one, capturing (watching) and retransmitting without emotion, like the Internet user/audience (figure 5.2).

But, the movie's Internet users do not even connect the crime to the punishment and instead revel in the pure spectacle of it. This

Figure 5.2 The Internet Killer (Joseph Cross) works with his digital audience to torture his victim (*Untraceable*, 2008)

active but ignorant participation is underscored by the live chat function down the side of the site that has commentary, under usernames such as Nancyschima and Samysays, such as "see if you can get a torrent of this," "y isn't he moving?????" and "fucking idiots. hes fucking dead can't you fucking see" (all [*sic*]). The screen, with its unique gaze back upon the audience as the final visual of the movie, holds the same gazing menace as the camera filming/broadcasting the torture. Too, the grammatical and spelling mistakes point to the fear of the "immature" Internet user, too powerful and too stunted, as explored in chapter 4's discussion of cyberphobia in *War Games*. The reveal of Owen Reilly, a digital native who is proclaimed a technological genius and a psychopathic super-user of the Internet, only cements this argument, showcasing a vision of how mastery of this new Web 2.0, especially in young users, will lead to deviance and violence. With this, any trust between the centralized policing assemblages (the super-user Marsh, the FBI) and Internet users in a possibly healthy synopticon, is gone, undermined by the community-less and disconnected Internet technologies that inevitably produce the sadistic nature of its (infected) users.

In both *feardotcom* and *Untraceable*, the specter of the voyeuristic film spectator, watching only for the spectacle of escapism, is combined with same cynical portrayal of the voyeuristic Web 2.0 user until the two entities are inseparable. Turner echoes this sentiment, combining our discussion of surveillance, writing "films that address the practice of surveillance or use of surveillance technologies in their narratives do so as an opportunity to celebrate the spectacle elements" (94), seducing the viewer with "the pixilated cool of both watching and

being watched" (121). In particular, the focus on the technology in the films offers a "contaminated spectacle" wherein "the act of looking on at a remarkable phenomena—the grotesque, the forbidden, the outrageous, the unarrived future—all become lethal wonders— visuality run amok" (100). Speaking in response to John Ellis, Turner cynically argues this creates a moviegoer that is naturally voyeuristic and obsessed with a gaze that "implies the irreducible distance between the looker and the thing seen" (109). Through this lens, the film audience encourages sensationalized versions of their own technologies, fetishizing the satellite zoom-ins of *Enemy of the State* (an over-hyperactive version of Deleuze and Guattari's map [chapter 2]) and the slick live-streaming of *Untraceable*, and obsessing over both the visual product and the process of being made visible. In many ways, this attitude is rooted in Guy Debord's work in *The Society of the Spectacle* or T. W. Adorno and Max Horkheimer's theory on mass media, wherein the theorists attack mass culture as a capitalistic industry that pacifies and controls an audience into submission, "[making] adults into eleven-year-olds" (Adorno, 59). Coming out of a Second World War that leaned heavily on the mass technological production and distribution of hateful propaganda, they were more than correct to be suspicious of mass technologies; likewise, Christian Metz's dismissal of the cinema-fetishist of the 1970s was a deliberate reaction to a film industry moving away from the *auteur* and into an increasingly special effects and tent pole/blockbuster driven model (explored further in chapter 3). However, to cast the movie viewer as privileging "looking" above all else, to the point of unwitting immersion into spectacle, is to ignore Vivian Sobchack's cinesthete, an audience member who recognizes that "vision is only one modality of [his/her] lived body's access to the world and only one means of making the world of objects and others sensible" (*Carnal Thoughts*, 64). Building off her essential work in *The Address of the Eye*, this means acknowledging the materiality of sitting in a seat as well as the muscles tenses and the changes in breath that correspond to the engagement with film; more importantly, the cinesthete bridges the gap between watching an event ("as-is-real") and being present ("real") at an event (73). To Sobchack, movie viewers are "*systematically*...embodied and conscious subjects who both 'have' and 'make' sense *simultaneously*" that creates "a reflexive and protective action that attests to the literal body's reciprocal and reversible relation to the figures on the screen," an "experience that is carnally as well as consciously meaningful" (75, author's italics; 79). This results in "an embodied intelligence that opens our eyes far beyond their discrete capacity for vision and opens

the film far beyond its visible containment by the screen, and opens language to a reflexive knowledge of its carnal origins and limits" (84). For such a movie viewer, film is a deeply emotional and physical experience that engages a full sensorium beyond a simple and all-encompassing visual consumption.[9]

We should start casting the machinic audience in the same type of multisensual mold as Sobchack's cinesthete. In many ways, Turner's and Gumpert and Drucker's theoretical approaches are not aligned with how a contemporary machinic audience engages with their filmic documents. The Internet is a mass-scale cultural interface, reaching far more people than a movie could hope to, and its amorphous form and personalized contents have trained its users to engage very differently than a film audience of 20 years ago might. To dismiss those users/viewers as unable to parse out "real" and "as-if-real," as *Untraceable* does, or with the same "immature" complaint Adorno voices, takes the humanist out of the posthumanist. It pessimistically promotes a viewer/user that is passive in his/her participation, one that is focused on "gazing" with the eye as the primary mode of interpretation, that doesn't reflect the material and multisensual presence a machinic audience/Web 2.0 user in virtuality possesses. A Web 2.0 user does not just look at the Internet; similarly, the Internet does not just "look back," as it does at the end of *Untraceable*. As Allison Muri forcefully writes in "Of Shit and Soul," "[if] we are going to be talking about the human body in cultural studies of the interface of body and technology ... we need to emphasize that human consciousness is inalienably enmeshed with its corporeality, with the everyday actualities of its flesh" (77). To visit a webpage is to participate in a virtual space that is far more multisensory and embodied than *feardotcom* or *Untraceable* give credit to: the user does not teleport into an encompassing Baudrillardian simulation, lost completely inside that cyberspace; instead, that user is well aware of the pressure of fingers typing and the sounds those keys make, the smells coming in through their window or drifting from the kitchen or, as Muri says, the need to shit. This is especially true of a Web 2.0 user, extended into virtuality, who is web browsing or Tweeting from any number of diverse geographical places (on a sidewalk, in a food court, etc). These users are embodied and in constant contact with other comparable users (touching, listening and looking back), all operating in dense networks that are both physical and virtual. While this does create the opportunity for looking, for recording, and for surveillance, it also provides the opportunity to sensually interact with a rich community. When the Web 2.0 user then enters the theater, they do

not abandon this understanding of the world: rather the movie slides into his/her already established modes of interaction. A critic's focus on the dark theater that superficially isolates and demands a passive gaze brushes aside a digitally literate machinic audience (chapter 3), that understands and considers as part of his/her understanding of the filmic document how a film is constructed, how an actress or actor plays their part, how a special effect is made, etc. More, the machinic audience is the embodied cinesethetic audience, a self-aware audience, possessing a higher tolerance for multisensory moviegoing experiences, and would expect to see narratives and characters that espouse and uphold the same values; we might even imagine, in the near future, a separate theater for those who want Wi-Fi and a smartphone as a second, complimentary screen. For this type of audience, movies then exist in both the theater but also within the same hyper-connected virtuality as the rest of the Web 2.0 Internet and its users. A portable Web 2.0 and its devices have moved "watching" and "using" out from under Birkerts's mesh and into the elastic (embodied) simultaneously digital and physical worlds.

If the Internet user is no longer imprisoned by the Internet's mesh but instead empowered by the extreme connectivity of it, the surveillance assemblages are no longer overpowering. Foucault explains that the body is immersed in a "political technology of the body," a technology that is "diffuse, rarely formulated in continuous, systematic discourse" and, if wielded correctly, resists being localized in "a particular type of institution or state apparatus" (25–26). Even Mathiesen's synopticon, under the changes of a Web 2.0 environment is, as Aaron Doyle argues, too specific and "quite dismissive of the liberating potential of the internet" (294). Doyle argues, the contemporary Internet engages resistance through its potential "two-way medium," rather than the one-way medium of television, and promotes a horizontal sharing on a mass scale of users (billions) that act as a space for non-hegemonic voices and politics to safely emerge (295); this horizontal/rhizomatic nature encourages user-assemblages that are potentially tolerant and/or adept at self-policing. We can then consider the individual body as a specific site of "private" subjectivity that, when extended by their Web 2.0 technologies in embodied virtuality, is active and potentially ethical if encouraged by the right role models, such as Spiderman in this chapter's conclusion. Such a model would resist localization and begin to recognize and harness the power that comes with full BwOs-organism unity, and, in combination with other such users/assemblages, could encourage deep wells of digital creativity, safety, and connectivity.

Conclusion: The Amazing Spiderman on The Web

De Landa outlines his concept of "meshworks" in *A Thousand Years of Non-Linear History* as the collection of BwOs, dependent on "connectivity," that work to destratify and restratify the relationship between the BwOs' organism(s) along with all the other "nonorganic" BwOs connected in a biological or social network. These networks are governed by a flow of intensities that are in contact with "attractors," "patterns of stability" or "periodic behavior," that control the relationships of the network. With this meshwork concept in mind, we might begin to imagine a policing force that isn't strictly military (as it is in chapter 4) or surveillant, but rather a system capable of harnessing the constant flux (or De Landian "flows") a dense network of users in an embodied virtuality need; unlike Birkerts's singular enmeshed user, a "meshwork-generating machine" like a collection of Web 2.0 users could be a social network "capable of acting as enforcement mechanisms for the transmission of norms" (De Landa, 260–265). It is then important to note that the films in this chapter have focused on authority figures attempting to use the Internet to control and/or take care of the Internet and its users. They are figures who struggle, via panoptic or synoptic methods, against the contaminated mesh of the Internet; yet, none present a particularly positive model for a film audience as to how a younger generation of Internet users in a dense meshwork might best utilize the technology to safely navigate and police their physical and virtual spaces.

The Amazing Spiderman, a reboot of the Sam Rami–directed *Spiderman* trilogy, presents its hero, high school student Peter Parker (Andrew Garfield), as a digital native who undramatically uses the Internet. His relationship with the Internet is already ingrained and normalized and so, when he is confronted with a problem, he uses the technologies that the machinic audience would: he uses Bing. com to look up information on his father's relationship with Dr. Curt Connors (Rhys Ifans) and later to find out information on spider bites. As well, he is not a millionaire like Tony Stark or Bruce Wayne, but rather (lower) middle class, linking less fantastically to the average Internet user; as such, his only "gadgets" are his web shooters. These web shooters, a move away from the biological ones of the first three *Spiderman* movies, are a technological prosthesis that mirrors the cell phone he uses, even in costume, throughout the movie, generating an augmented assemblage that facilitates his tremendous digital and, in particular, physical mobility. Unlike Stark and Wayne, Spiderman is defined by how materially embodied he is; his flexibility and speed

are his greatest powers and allow him to traverse the city without the need of a vehicle (Iron Man suit or Batmobile). The movie conflates the digital prosthesis of his cell phone with his web shooters as the audience is given repeated instances of webslinging through Peter Parker's first person perspective. His first webslinging in his new costume begins with the camera looking out through his eyes, thrusting the machinic audience into Parker's webslinging with the same first person perspective of *Strange Day*'s Youtube-like SQUIDs, immersed in wearable space and impossibly fast and agile over the city, a humanized hyperlink and a hyperlinked human.[10]

All the while, Parker possesses the same hacker engineer skills of a Stark or Wayne with the same ethical responsibility to use his powers for combating evil, yet with a greater reliance and acknowledgment of the community around him: he is only able to make his way to Oscorp in the final fight scene because the other inhabitants of the city help him by setting up cranes he can swing from; likewise, it is his cooperation with the police force, specifically Captain Stacey (Dennis Leary) that allows him to defeat the Lizard and return the infected citizens to normal. Where *feardotcom* and *Untraceable* end with the "infected" Internet user still "ill" and at large, *The Amazing Spiderman* ends with a salvaging (and redemptive) cure of both Dr. Connors and the (Internet using) citizens of New York. Unenhanced by a governmental assemblage or capitalistic wealth, Spiderman/Peter Parker is one assemblage in a collection of assemblages: he is not part of a superteam (like Ironman's role in The Avengers), or a lone wolf with the occasional Robin, but rather a hero integrated into his densely populated physical and digital meshworks, working in tandem with the other citizens as one large policing force. It is this connective and embodied model that the Web 2.0 user might hope for and emulate, a user that is both on the Web and uses webs interchangeably.

Chapter 6

Don't Shoot the (Instant) Messenger: The Efficient Virtual Body Learns

Introduction: The Impossible Finality of Digital Property

When Milo Hoffamn (Ryan Phillipe) first meets Gary Winston (Tim Robbins) in *Antitrust* (Dir. Peter Howitt, 2001), he immediately comments on a "digital canvas" on the wall of Winston's office that changes copies of paintings with each person's entry into the room. Winston, a Steve Jobs–style billionaire, is unbothered by Walter Benjamin's statement that a copy of an art work loses its "unique existence in a particular place...that bears the mark of history to which the work has been subject" (103); instead, Winston casts aside any "authenticity" or "aura" (the "here and now of the artwork" [ibid., 103]), stripping out the ritual of the work and instead replacing it with its exhibition (ibid., 106). Nearly 70 years after Benjamin was writing, Winston's digital canvas encompasses a process familiar to the digital native who is constantly sharing one digital "copy" of many different types of documents (textual, pictorial, video, etc., not just art work), retrieved from a server and brought back to his/her devices, that, once downloaded, s/he can then redistribute or display themselves. Van der Weel summarizes this by explaining "the digital document has, as it were, a built-in copying press, which manufactures a copy for any potential reader" (151). Yet, as David R. Koepsell's in *The Ontology of Cyberspace* (2000) states, "the only differences between digitally encoded and expressed information, and that is which is encoded and expressed in analog form are difference in degree. It is *easier* to reproduce and transmit digital expressions. This does not mean that digital and analog expressions are different in *kind*" (87, author's italics). As such, the sheer difference of scale (degree) exponentially exaggerates Benjamin's careful theorizing of

public/mass consumption via copies (119): this participation amplifies an Internet-engaged mass audience (in contrast to Benjamin's unnetworked, consumed and "concentrating" audience), an audience that instead "[absorbs] the work of art into themselves. Their waves lap around it; they encompass it with their tide" (119). If these digital versions are not any lesser, as Koepsell argues, they are potentially absorbed/engaged with in a far more powerful and populated participation than Benjamin could even fathom. As the head of NURV, Winston appears to embrace that extremely dense participation as he creates a interconnected software system of satellites and networks called Synapse (remarkably close to a Web 2.0 Internet), which aims to link individuals through whatever Internet portal (phone, computer, television) they have access to. Through Synapse, every screen becomes a potential digital canvass, shifting information, art included, in reaction to each individual user.

However, *Antitrust* complicates the main tension underneath Benjamin's essay by asking how free to move across the Internet's dense networks, from node to node, should information be. Hoffman's former partner Teddy Chin (Yee Jee Tso) wants the software he creates to be "open source," casting Winston as an unethical, greedy gatekeeper; as he tells Milo, "human knowledge belongs to the world" and people like Winston hoard their knowledge (software, code) in overprotective, selfish ways. Winston, in contrast, is nowhere near as humanistic as Chin, asking, "How many people that you share your discoveries with will be altruistic and how many will make a fortune off your generosity?" When Milo explains that he wants his small web start-up, Skullblockers, to follow the idealism Teddy puts forth, Winston counters "It's a cutthroat business we're in Milo. It's only a matter of time before someone 'borrows' your technology and improves it. And makes a billion dollars on it." Winston attempts to enlighten Hoffman to his "adult" worldview, a perspective deeply rooted in the capitalistic mode of creating and maintaining property/product, digital and/or analog. Much of Winston's understanding of knowledge and intellectual property Marshall McLuhan would trace back to ethics instilled in Literate Man. For McLuhan, Literate Man, borne of the printing press, consumed and produced knowledge and his/her documents with the fragmenting and alienating eye as his/her primary sensory organ; the eye, for Literate Man, separates the reader/writer from the rest of the world and encourages an extreme visual focus that sacrifices her/his other four senses. From this, the writer/artist, acting in extreme personal/sensual isolation and immersed in what Benjamin calls contemplation (120), treats her/his work as the

product of his/her uninfluenced and innate mind (or soul or consciousness) alone: the work that a writer (or artist or programmer) creates, as a sole and completed product of his/her own, is therefore his/her own property. Applying this to the Internet, Christopher M. Kelly's impressive *Two Bits*, explains that such attitudes are rooted in the belief of an achievable "finality" of a document, a stable and complete version (code, art, literature) that allows the author (or copyright holder, Winston) to hold and control that document as property (11, 270); this "finality" resists the mass access and "modifiability" (11), the borrowing and improving, of open source and free software programs (source codes). This argument around ownership of knowledge and ideas is expressed repeatedly throughout *Antitrust*: It is one thing for Winston to display digital copies of artwork he likes, but his own "final" product, the Synapse code, is his company's, and, by proxy, his property. Though Winston is McLuhan's Retribalized Man, his adherence to the older modes of Literate Man's privacy and isolation (and therefore property) does not reflect a generation of Digital Native Internet users, like Hoffman or Chin, that is far more comfortable with Benjamin's notion that documents were moving toward "[works] reproduced [that become] the reproduction of a work designed for reproducibility" (Benjamin, 106). Hoffman and Chin, as Digital Natives, are beyond the initial Retribalizing of the electric telegraph and radio and therefore deeply invested in a McLuhan's theory of a communal and simultaneous (pre-Literate) Tribal understanding of knowledge production, reproduction, and maintenance. Such a Tribal/oral worldview creates a community (virtual and/or physical), acting in a multisensory acoustic space, that has a responsibility to maintain (remember), reproduce (speak), and modify each document and piece of knowledge. In a digital setting, the very reproducible nature of the mass digitized and networked documents demands that those documents (and knowledge within) be consumed (and stored and modified) communally, and trying to force a strict (final/unified) optical means upon them is ignoring the documents' strengths and goals. McLuhan, and Benjamin to some extent, anticipate what Milad Doueihi in *Digital Cultures* calls a "digital divide" between different modes of literacy where an older generation carries over "conceptual structures that frame [their] understanding of emerging technologies and new paradigms of behavior" that no longer suit the technology and literacies being used (13).[1]

As *Antitrust* progresses, Hoffman learns about the increasingly violent means Winston employs to preserve his Synapse property (including killing Chin for a piece of code he needs) and must then

resort to hacking Winston's own systems as an expression/defense
of his Digital Native ethics. While the figure of Winston is overdra-
matized in his murderous tactics, Hoffman's hacking is akin to the
heroic hacking of chapter 4 and presented along the same lines as
recent examples like Aaron Swartz's hacking of JSTOR ("The Brilliant
Life and Tragic Death of Aaron Swartz") or Wikileaks' release of
international secret documents and memos. While the public has
shown sympathy and even admiration for such figures, "hacking,"
as evidenced by *Surrogates* (chapter 2) and *Untraceable* (chapter 5),
is still seen in much the same ways as Stirling describes in the early
1990s where "the term 'hacking' is routinely used...by almost all
law enforcement officials with any public interested in computer fraud
and abuse. American police describe almost any crime committed
with, by, through, or against a computer as hacking" (53). Stirling,
echoing Sontag (chapter 1), says these types of hackers are seen as
"'sick,' as *computer addicts* unable to control their irresponsible, com-
pulsive behavior" (55, italics authors). In a number of films leading
up to *Antitrust*, Winston's "adult," attitude toward computer use
and digital property causes great friction with those operating under
Hoffman's ideals of "white-hat" hacking, manifesting in Young cri-
tique of a hysteric "cyberphobia." Young sees this phobia as a product
of the "hacker myth" that "computers offer unearned and uncontrol-
lable power over the real world to irresponsible subjects" (28): David
Lightman, the teenage protagonist of *War Games*, nearly causes
World War III because of his hacking abilities; the teenage Dade's
crimes, listed in the early scenes of *Hackers*, are also vilified by his
sentencing judge as "destructive and antisocial"; in *The Lawnmower
Man*, a "mentally immature" Jobe Smith gains God-like powers then
goes on a killing spree. Bunched in the first two eras of Internet use,
each film, though the scrim of cyberphobia, reinforces that comput-
ers, and the Internet, creates users that are dangerously improved and
then driven mad by that digital access to knowledge and power; by
wielding the technology, the Internet user becomes an unchecked
hazardous and immoral force.

 Antitrust, released in 2001, starts to push back against this cyber-
phobia and exposes the negative representations Young flags as gen-
erating an unrealistic "moral panic...derived from the demonization
of hackers being out of proportion to the threat" (Thomas, 600);
instead, this type of hacker/user exposes the shifting value systems
attached to the extremely new "cyberspace" that Koepsell outlines
and Winston is terrified of. Thomas adds "imposing familiar concepts
on new behaviors [occurs] in ways in which legal concepts such as

'burglary', trespassing' or 'theft'...[become] opaque, even absurd, when applied to cyberspace" (601). The Literate Man's ontology that Winston embodies, Koepsell states, applies a too simple Platonic metaphysics to cyberspace and, as such, ignores how "cyberspatial objects fit into a categorization of other experiential objects" (23); employing Heim's (Introduction) and Winston's ontology "conflates *information* with *expression*" and "form with function" (ibid., 86, author's italics) and stigmatizes the use and creation of digital copies by overemphasizing the content over the form of a document "just because it is transmitted and reproduced so easily" (87). Rather, Koepsell stresses, computers (hardware and software) are a means of displaying information (just as a book is [93]); while the information/document is material in that it must be physically stored on a device somewhere, information on the Internet, as code and markup that manifests through interfaces, is flexible and modifiable by its nature. Space and information on the Internet, by being part of a (public) network of networks, demands copying and large-scale distribution that naturally leads to reinterpretation and reimagining on a mass scale.

A moviegoing audience can be excused for their confusion: while a young Internet user like Owen Reilly from *Untraceable* is distanced by a cyberphobia, many of the films discussed above further muddle their treatments of the Internet by also expressing distrust in the surveilling "adult" corporations that are greedily profiting from the Internet user. In *The Lawnmower Man 2: Beyond Cyberspace*, a significantly smarter version of Jobe (Matt Frewer) is supported by a massive corporation hell-bent on controlling the Internet via the mysterious Chiron Chip. Likewise, in *The Net*, Gregg Microsystem's CEO and mastermind Jeff Gregg (Gerald Berns) is demonized as a perpetrator of personal/home computer invasion, using his "security" software Gatekeeper to hack into and infect millions of users. Further, The Plague (Fisher Stevens), working as an employee of Ellingson Mineral Company in *Hackers*, uses his Da Vinci virus as a means to try and extort millions of dollars from the American government. In *Antitrust*, Winston is willing to manipulate Milo's "girlfriend" Alice Poulson (Claire Forlani) into pretending to love him for six-plus years to protect his corporate interests. In these films, while young users are too immature to handle the Internet responsibly, adults are too corruptible to be put in charge.

In the same way we wondered what the positive models for a policing force of a Web 2.0 world might be (chapter 5), the conflicting value systems given by cinematic cultural interfaces, especially in the

early years of the public Internet, are incredibly problematic. Benjamin could just as easily be writing about the Internet when he writes "*the presentation of film is incomparably the more significant of today, since it provides the equipment-free aspect of reality they are entitled to demand from a work of art, and does so precisely on the basis of the most intensive interpenetration of reality with equipment*" (116, author's italics). "Entitled" is a key word: what ethics of Internet use, reflected in both (physical/virtual) form and content, should a machinic audience "demand" of their movies? The broader strokes of *Antitrust* provide a useful entry point: if information on the Internet is produced to be reproduced and consumed on a mass scale, then Milo is a good role model; he releases Winston's Synapse source code to the world at the end of the film, affirming his Digital Native ideals. Yet, his use of the Internet, though through familiar interfaces, lacks the embodied and dense networking of a Web 2.0-using machinic audience. As discussed earlier, films such as *Avatar* (chapter 3), *The Amazing Spiderman* (chapter 5) and *TRON: Legacy* (chapter 2) present useful metaphorical reflections of an embodied Web 2.0 user, but none are grappling with the smaller-scale exchanges and issues around digital information, knowledge, and documents that an "average" Internet user would be asked to engage with in 2014. This becomes especially important when we remember that the contemporary movie audience is also an Internet using assemblage. By shrinking our focus to the individual Internet user/viewer and how s/he might begin to understand personal property and how s/he experiences his/her memories and the documents (including movies) around memories, we might begin to illuminate some of the more specific concerns or freedoms that arise from a digital space populated by replicas. In particular, we are interested in examining how an Internet user, steeped in reproductions designed for reproducibility and encouraged by films like *The Matrix*, *Johnny Mnemonic*, and both versions of *Total Recall* (1990; 2012), might come to his/her cultural and personal knowledge, memory, and identity.

Downloading as Learning

Writing at the roughly the same time as McLuhan, Jacques Ellul's *The Technological Society* (1964) defines "technique" as "the *totality of methods of rationally arrived at and having absolutely efficiency* (for a given state of development) in *every* field of human activity" (xxv, author's italics). He argued that technique is already "absorbed into man's psychology" to the point where humans cannot separate

themselves or their actions from it (23). He was careful not to simply conflate the technological or the mechanical into technique and to stress that the concept is distinctive to the specific society and era it inhabits; more, it is important to consider the concept as a mode of thinking, a construction of individual and social action that penetrates all objects and citizens (3–6). Though writing in the earliest stages of computing (and before the Internet), he lays the concerned foundation contemporary critiques of the Internet echo: "technique will assimilate everything to the machine; the ideal for which each technique strives the mechanization of everything it encounters" (12); such a mechanization has little tolerance for divergence as "the multiplicity of means is reduced to one: the most efficient" (21). This reduction is fine so long as there is a "social equilibrium" and technique "[does] not outstrip the slow evolution of man himself" (72). Yet when technique does begin to evolve faster (through, for example, the conduits of the exponentially more sophisticated and networked computers of the last 50 years) it encourages a society to cast aside "aesthetic preoccupations," and instead focus on "purely technical considerations" that ultimately run "counter to the human factor" (74); more, these "automatisms which become hereditary...are integrated into each new form of the technology," always evolving forward with Darwinian strength (14).[2] Jean-François Lyotard's work in *The Postmodern Condition* (1979) updated Ellul's concerns by articulating that the main effects of efficiency, what he calls a "logic of maximum performance," constructs a society whose elements are "commensurable and that the whole is determinable" simply by managing the "input/output matrices" of feedback/information available to decision makers (xxiv). He expands: "[computers] follow a principle, and it is the principle of optimal performance: maximum output...and minimizing input...Technology is therefore a game pertaining not to the true, the just, or the beautiful, etc., but to efficiency: a technical 'move' is 'good' when it does better and/or expresses less energy than another" (44). From this perspective, humans are significantly less productive than computers, as they are weighed down by all sorts of other considerations (beauty, justice), and are therefore forced to become like computers in order to survive.

In echo of De Landa's robot historian from this text's Introduction, Nicholas Carr in "Is Google Making Us Stupid" points out that "when the mechanical clock arrived, people began thinking of their brains as operating 'like clockwork.' Today, in the age of software, we have come to think of them as operating 'like computers'" (para. 18). As Carr argues, the operating metaphor for technique moves from

overt and observable gears/cogs to electronic and "invisible" pulses that manifest through complex interfaces; the treatment of knowledge transforms from physical process (seeing gears turn) to an intangibly/invisibly fashioned end-product (what the electronic pulses produce). Carr argues that the user is recreating his/her brain as a hyper-efficient computer, a brain fashioned with technique at the forefront that then produces knowledge and documents in similar hyper-efficient modes. In his 1991 book *The Inhuman*, Lyotard describes the computer-saturated world as "disturbing," not because of the virtual simulations Baudrillard is suspicious of, but because of "the importance of the *bit*, the unit of information" that resists "sensibility and the imagination" (34, author's italics). From his view, "the bit" flattens knowledge and reduces it to externalized tiny units of data "assembled into systems following a set of possibilities (a 'menu') under the control of a programmer" (35); such units demand that "any piece of data becomes useful (exploitable, operational) once it is translated into information" (50). With knowledge becoming externalized into bits (in computer databases then displayed via Internet interfaces), the barriers around "internal" knowledge (what Literate Man values in a physical book and/or the private thoughts in one's mind) are greatly reduced and, in turn, made public. From this, Luke Tredinnick sees computers and digital technologies as decentralizing authority (from the mind or the book or Winston's corporate property) and, in turn, proliferating it widely, all the while generating "a general disintermediation of knowledge creation" (102).

H. G. Wells's notion of a "World Encyclopaedia" put forth in his 1937 lectures (and collected in *World Brain*) and Vannevar Bush's "memex" offer early conceptual models of this public/communal knowledge but De Landa, in the final section of *A Thousand Years of Nonlinear History* (in reference to Howard Rheingold's *The Virtual Community*) says that some of the earliest examples show up in the early BBS Usenet, a "many-to-many" structure "in which geographically dispersed communities emerged as computerized communications, originally intended for technical (scientific or military) communication were transformed into a variety of different forms of *conversation*" (252, italics author). Rather than transferring information and knowledge one-on-one (Literate Man's hyper localized reader-book or person-person), Usenet was a harbinger of the now normative Web 2.0 world, with Wikipedia as an obvious example, wherein the digital native is very comfortable coming to knowledge as one assemblage inside a massively collective conversation/exchange with other user assemblages. Even in the shift from early web design,

beginning in metaphors of the body then moving toward an "urbanized" Web 2.0 (chapter 2), we can see that instead of the finality or aura associated with Literate Man's knowledge creation (one person's isolated thought from one's person's soul/mind), a digital native is used to multiparticipant, hyper-connected collage, or "bricolage" (Tredinnick, 103), as a way of producing and maintaining knowledge. Within this environment, the clash between Winston and Hoffman in *Antitrust* is one of authorship; yet, authorship on a Web 2.0 Internet, as Doueihi points out, is always dual and bilingual, a combination of the software/programmer/coder's work (language) and the user's own content they are putting within that code, a type of cooperation that is a far cry from Literate Man's singular isolated producer of knowledge (28–29). As Tredinnick states, when a user adds to a space like Wikipedia, guided by a user-designer–friendly CMS, "the reproduction of digital objects occurs through copying the instructions for creating them" (83) rather than generating the digital object entirely from scratch; an entry on Wikipedia is produced within a structure that acknowledges and takes great advantage of its reproducibility via the "built-in copying press" of its code. With this externalized and easily accessible wealth of communal knowledge, producing and consuming knowledge turns from memorizing and manipulating stable, finite formulas or facts internally (in the private, individual brain in combination with one's own experiences), to learning how to access and retrieve from (and correct or add to) the external and communal systems in which the facts and formulas are being held.

While a Web 2.0 environment makes it relatively easy to create and distribute documents, that ease leads to an extreme oversaturation of potential pieces of knowledge, hundreds of lifetimes worth of documents, into a virtual ecosystem that expands, with every user addition, exponentially every second. To efficiently sort through this tremendous glut requires, again, a submission to technique that manifests in the reduction of units of knowledge to bits that is Lyotard's exact fear: in order to manage an overwhelming amount of documents efficiently, those documents must be reduced to their smallest forms, compressed in both in the device that accesses it and the (coded) form that it takes, but also into oversimplified key words and phrases. The contemporary means of doing this is the search engine. Alexander Halavais's *Search Engine Society* is an excellent technical explanation of algorithms and search engines that outlines many of the more immediate and technical concerns with using search engines as the main form of knowledge access, but doesn't point clearly enough to what information, guided by technique and dependent on a search engine,

becomes. When a user types "What is Abe Lincoln's birthday?" into Google's maw, the results are not answers to that question (Google itself does not "know" the answer), but rather a sorting of available/ external, already constructed, documents into what Google's algorithm thinks would be the best answer. For a simple question with a stable answer, this is efficient and convenient. However, asking Google "What are the themes of 'Rime of the Ancient Mariner?'" or "Should the death penalty be legal?" exposes the limits of a search engine's "answers." In order for knowledge to be sorted effectively and quickly it needs to be, as Lyotard stated earlier, commensurable and finite; Ellul, in an echo of Kelly's "finality," writes that technique demands that "every procedure implies a single specific result" (75). De Landa would liken the process to a "universalizing" of knowledge similar to Johnson's work on a singular dictionary of the English language in the late nineteenth century that aimed for a "correct" and "reputable" (stable and finite) treatment of language (*A Thousand Years*, 234). Similarly, the "homogenizing force" De Landa identifies is mirrored in the shift to code, or reducing to bits, that the Internet and its machine interfaces require: information that is not coded correctly simply doesn't display and, as such, that information must be (digitally) readable by a machine in order for it to be accessible. What Google does with complex ideas (ethics of punishment, the thematic concerns of a poem) is break the query itself down into its smallest units, commensurable bits stored in its bot-gathered databases, and calculates, via a complex and shifting algorithm, what it thinks the "best" (external) available answers are. This simplification runs the very real danger of the unreflective Internet user being trained to not expect to "think" or "consider" or "solve," but rather to depend upon Google's algorithmic answer. But, more troublingly, producing knowledge specifically for efficient machines (search engines) to algorithmically read and sort forces that knowledge toward the language (a homogenizing of vocabulary) that the machine best organizes/ identifies, not necessarily the language that best and most clearly expresses or argues. More, the machine then treats the knowledge as a stable, finite piece of data, manipulatable but uninterpretable, stripping an argumentative stance or rhetoric from the document.

So, is the brain, enhanced by a search engine and the extreme access to digital documents, a place of experiential interpretation or is it simply a depersonalized storage space? For all the idealistic democratizing of knowledge the Internet might encourage, the same muddling identified in the introduction of this chapter takes place in a number of films around these topics of learning and knowledge on

the Internet. *Johnny Mnemonic* treats all information equally and its titular protagonist as a walking USB key who is simply a transport vessel complete with "wet-wired brain implants." Johnny's brain is partitioned so that parts of it can be used as straight hardware: he is seen early in the movie upgrading from 80 to 160 gigabytes by inserting a cable into a headphone-like jack in his skull; this process is not just a simple expansion but mediated by a piece of software, establishing Johnny's brain as far more machine/computer than biological. The plot of the movie is propelled by Johnny's corrupted download from a client and his need to get the information hacked out of its encrypted state in his head; his brain then is a computer, overstuffed beyond its hardware's capabilities. Within *Johnny Mnemonic*, knowledge is pure data, treated as a finite object with strict measurable values, that is simply deposited or withdrawn when needed; Johnny's courier brain is no longer the Romantic site of identity, but just a piece of limited hardware.

It follows along the lines that if information can be wet-wired into the human brain as pure data (as it is in *Johnny Mnemonic*), then surely a technology that could then translate that data into a learned experience that the brain could interface with, stripped of the messy and time-consuming process of embodied experience, would be the most efficient.[3] While Johnny chooses to not access the data he has in his brain for his own purposes, a number of films, understanding knowledge in much the same static and commensurable modes, entertain the fantasy of accessing the hardware of the brain so that a human is able to learn by downloading digital documents/software into the brain. In his summary of the predictions other scientists were making about the year 2000, Ellul flags the notions that "knowledge will be accumulated in 'electronic banks' and transmitted directly to the human nervous system by means of coded electronic messages...there will be no need of attention or effort. What is needed will pass directly from the machine to the brain without going through consciousness" (432). In such an environment, Lyotard adds, "learning is translated into quantities of information" as mediated specifically by computer technology (*The Postmodern Condition*, 4). The 1969 version of *The Computer Wore Tennis Shoes*, although it does focus on nonnetworked computers, displays the thrills of digital automatic learning. Far more magical than scientific, Dexter (Kurt Russell) has his brain turned into, literally, a computer: after the transformation, an inspecting doctor looks through Dexter's eyes and sees the blinking lights of a mainframe computer, bereft of any biological material. Dexter, extremely popular, tours the country as an "intellectual freak"

able to hyperefficiently consume and recall information, a humanized technique. More interestingly though, he acquires the ability to speak any language, with the proper accent and inflection, as part of his accident; such a demonstration showcases skills beyond the input-output of strict memorization or calculation. *The Matrix* (1999) is a better example of networked automatic learning as Neo is trained by Tank (Marcus Chong) via a series of software programs. The brain is treated as a hardware device with a controlling operating system (OS) that can switch through various programs ("Jump," "Operations Programs," "Combat training," "Sparring"); when Neo "learns" (a term both Neo and Tank use), it takes approximately three seconds of twitching, at which point he emerges from the program with an orgasmic breathlessness. The interface that Tank tracks Neo's brain activity through is a visual display of what is being learned (a body doing Kung-Fu) with the icon of a human brain filling from top to bottom (figure 6.1).

The brain as fillable storage moves humans much closer to hard drive than reasoning problem solver. The fact that Neo is able to digitally "know" (learn) Kung-fu encourages a viewing audience to shift away from the model of embodied gradual procedural learning to the fantasy of near-instantaneous acquisition of skills.

Again, a network of increasingly powerful computers used to access stable facts, formulas, etc. seems relatively harmless, if not astounding, when done with user awareness. However, externalizing the learning process into those same networked computers is potentially problematic. Superficially, films such as *The Computer Wore Tennis Shoes* and *The Matrix*, by treating the process of learning as an external process coded into bits, make that process the same sort of finite and stable

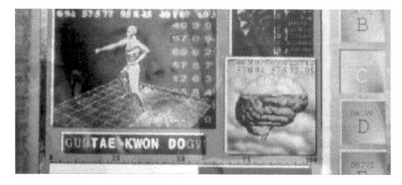

Figure 6.1 Neo's (Keanu Reeves) brain learns Tae Kwon Do automatically in *The Matrix* (1999)

product that Winston sees his software as. The implication is that Tank doesn't use different programs for different users, but rather there is one program that works for every user, one stable version of "Kung-Fu" or "Jujitsu." From such a perspective it is a reproducible product, a reducible and singular program created by one source (individual or team), and, as such, can be treated as property. This world is a lot like *Johnny Mnemonic*'s in which, as the film's opening text-crawl explains, information/data is the most important currency. If information and/or data is currency, then larger corporations or governments, not the individual user, would likely control access; if "learning" a task could theoretically be owned, then it makes the most sense that those with the largest amount of resources (hardware, software, money) would control that learning. While 2014 is a ways away from The Sprawl of *Johnny Mnemonic* or the apocalyptic earth of *The Matrix*, this model manifests in a gated "privatization of knowledge" that creates "a 'digital divide' between information 'haves' and 'have-nots'" that Nicholas Joint sees as very present in contemporary digital spaces (**660**). It is this digital divide, resulting from Literate and Retribalized Man's residual values around privacy/ isolation in opposition to the Digital Native's expectations of communality and simultaneity, that results in many of the instances of "hacking" explored throughout the whole of this text.

As a bridging solution, Deleuze, discussing Foucault, explains knowledge as "defined by the combinations of visible and articulable that are unique to each stratum or historical formulation...that is to say knowledge exists only according to widely varying 'thresholds' which impose particular layers, splits and directions" (*Foucault*, 44). To "load up" a human brain with the complex programs of automatic learning is to reduce a human in the same way a search engine's algorithm reduces an abstract question (and that question's layers and splits) and casts the Internet user assemblage along the same lines as the problematic postbiological (what Lyotard calls a potential "binary ghost" [*Inhuman*, 17]). In the same way, the postbiological reduces human identity to a stable and reproducible version of a self as bits, automatic learning ignores the essential material component, the blending of organism(s) with its multiple BwOs in a spectrum of experiences (thresholds) or Nietzschean Returns, that defines how the posthuman navigates the world. Lyotard too argues that learning and knowledge is extremely multifaceted, "a question of competence that goes beyond the simple determination and application of the criterion of truth, extending to the determination and application of criteria of efficiency (technical qualification), of justice and/or happiness (ethical wisdom), of the beauty of a sound or colour

(auditory and visual sensibility)" (ibid., 18). When Lyotard states that humans are "already technological devices" and compares the components of a human to the components of a machine ("its equipment for absorbing data" or "storage capacity"), he does so to differentiate the human as "recursive" in that it processes information "above and beyond raw data" (ibid., 12); he later adds that "each human body doesn't stop changing in its mass and has real and exact unity only through difference" (ibid., 40). A human then "is a living organism that is not only complex, but, so to speak, replex" (ibid., 12). Being "replex" or "recursive" is to acknowledge the Deleuzian Repetition (chapter 3) that is essential to forming and re-forming a unified organism/BwOs relationship. Applying this to an Internet-using machinic audience, learning in a Web 2.0 world is a necessarily embodied and abstract experience that requires the organism as much as it relies on its BwOs (avatars).

If taken at its simplest form, the automatic learning in *The Matrix* seems to fall into the trap of the disembodied postbiological. However, while *The Matrix* does portray automatic learning as exciting/heroic, Neo's survival (and resurrection) is not based on the knowledge that he "learned" via Tank's programs, but rather, as previously discussed in chapter 4, through the embodied experience of being in love with Trinity. Within the film, what ultimately defeats the Agents is that the abstraction of love, like "justice" or "happiness," cannot be reduced and replicated as bits. More, Neo does train and learn, over a period of time, concepts that are not immediately present in the programs he downloads: this is similar to De Landa's description of Usenet in which knowledge is gained by a communal interaction (Neo and Morpheus in a training program, for example) that flows with degrees of intensity rather than stability (*A Thousand Years*, 254). The transfer of knowledge in *The Matrix* is not instantaneous but rather falls into a replexive progression in which Neo, physically (organism), but most obviously virtually (avatar, BwO), gets gradually stronger. The fact that he is immersed more fully in his Matrix avatar (BwO) self is problematic but perhaps not as much so if we consider how closely Lyotard ties knowledge and learning to the internal process of memory. Lyotard highlights the human consciousness's "ability to gather and retain, at least potentially, in a single 'presence,' a certain number of distinct moments" (*The Inhuman*, 60). While he does acknowledge that digital technologies make memory "less dependent on conditions of life on earth" (ibid., 60), ultimately, knowledge and learning depend on memory which then depends on narrative, "a technical apparatus giving people the means to store, order and retrieve units

of information," adding "more precisely, narratives are like temporal
filters whose function is to transform the emotive charge linked to
the event into sequences of units of information capable of giving rise
to something like meaning" but distinctly "bound to the historical
and geographical context in which they operate" (ibid., 63). Lyotard's
use of "narrative," as both a larger societal assemblage and as personal
memory (initially established in *The Postmodern Condition* [pages
18–21]), echoes Hayles. She defines posthuman by asserting that nar-
rative, as constructed "with its chronological thrust, polymorphous
digressions, located actions, and personified agents," is essential
in that it structures the posthuman around "the negotiations that
took place between particular people at particular times and places"
(*HWBPh*, 22). Rather than the steady beam of information present
in the finality of automatic learning, narrative recognizes knowl-
edge (and the learning thereof) as a shifting personal landscape of
information, distinct to each person and in constant flux. This then
requires the replexive use and reuse of memory (personal narrative) as
a way of establishing a digressive and polymorphous sense of identity.
Significantly, in *The Computer Wore Tennis Shoes*, it is not Dexter who
is responsible for the triumphant climax but rather his friend Schuyler
(Michael McGreevey) who tracks through his own non-augmented
brain and answers the final trivia question correctly based on his past
experiences, remembering it was "the place where my uncle owns the
dry-cleaning store"; this implies that knowledge and learning in digi-
tal form resists the pure reduction into pure bits and instead requires
cooperation with an embodied personal history.

Yet, cinema, as an external and (potentially) populous document,
can be a substitute or replication of both a group's and/or an indi-
vidual's memories. In combination, the increasing digitization of the
machinic audience's world is transforming the narratives formed and
maintained in both the internal memory of an Internet using movie
audience member and the externalized networks and devices the user is
storing/retrieving/composing their memory-objects/documents (pic-
tures, videos, text, etc.) within. With this, films like *Johnny Mnemonic*,
Strange Days, and *Untraceable* bring to light the shifting narratives
and narrative constructions that come with dual digital memories.

The Machinic Audience's Dual "Memories"

Robert Bruygone in "Memory, History and Digital Imagery" defines
the traditional sense of memory, which he contrasts to an objec-
tive History, as "an individual relation to the past, a bodily, physical

relation to an actual experience that is significant enough to inform and colour the subjectivity of the rememberer" (225). This definition builds off *Remembering* (1932) in which Frederic Bartlett theorizes that "traces" of events are left behind in the memory and are recalled through an stimulus (mental and/or physical) that "re-excites" that trace or group of traces (198); he adds "each trace retains its essential individuality, and remembering, in the ideal case, is simple re-excitation, or pure reproduction" (198). The reproduction of a bodily experience, biologically designed for reproduction, is inter-related, he argues, to all the other traces hosted in an individual's brain, that then combine existing memory with incoming sensory input, "constantly developing, affected by every bit of incoming sensational experience of a given kind" (201); the "Introduction" to *Save As...Digital Memories* summarizes Bartlett's work as "the introduction of the past into the present to produce a 'reactivated' site of consciousness" (2). Viktor Mayer-Schönberger agrees, as he breaks human memory down even further into different types of human memory (17–20), ultimately explaining "we don't simply recall an event but *reconstruct* it" (122, author's italics). The subjectivity of the rememberer is created and re-created, as an assemblage of reconstructed events that exist in the dense interconnections of the brain, parallel to the embodied narrative Lyotard and Hayles point toward. Yet, as Mayer-Schönberger text thoroughly establishes, a digital native's understanding of this reconstruction is very different, heavily mediated and increasingly externalized (28); expanding, the cultural interfaces of cinema and the Internet normalize the notion that a machinic audience doesn't necessarily have to be immediately bodily present in order to participate in the remembering of an event.

Movies have long been a form of communal and cultural memory, preserving events and/or figures to be consumed on a potentially simultaneous, mass scale; in much the same way a book or web page externalizes, movies have the power to make lived events exist well beyond geographic or chronologic constraints, granting the ability to watch and re-watch outside the lived experiences of those involved. Speaking of *Schindler's List* (Dir. Steven Speilberg, 1993), Paul Grainge clarifies that, on a macroscale, film can draw out "the multiple facets of cultural memory as lived in history and experienced through the auspices of twentieth-century media" (6). With this, cinema has the power to both preserve and create memories, personal and mass: Alison Lansberg, in "Prosthetic Memory: the ethics and politics of memory in an age of mass culture," writes that cinema made possible "an unprecedented circulation of images and

narratives about the past" (146), resulting in what she calls "prosthetic memories," which move past geographical specificity and the need to "reinforce and naturalize a group's identity"; instead, the movie audience is thrust into "collective horizons of experience" (149) in which the individual viewer can have "an intimate relationship to memories of events through which one did not live" (148). Early cinema theorists, like Bazin (chapter 3), working from a model of cinema deeply indebted to the realism of photography, would view earlier analog film-formed prosthetic memories as deeply humanized, with the camera a direct analogy for the eye and the actors in front of that eye were always "real" humans. Bernardo Bertolucci, says that this view of cinema centers around the notion that to access "the language through which reality expresses itself…you have to first put your camera in front of reality, because cinema is made of reality" (as cited by Robert Burgoyne, 220). However, in 2014, instead of these memories being based in a "humanized" filmic world and/or Bertolucci's sense of "reality," prosthetic memories, by nature mediated "through [the] cultural, political and social worlds of the individual" as well as the medium of film, produce subjectivities which are deliberately and self-consciously not "natural" and therefore "not premised on some count of authenticity" (Lansberg, "Prosthetic Memory: The Ethics…" 151). As discussed in chapter 3, the machinic audience, a savvy and self-conscious spectator, is very comfortable with a digital cinema that, to paraphrase D. N. Rodowick, casts aside the materiality of film (celluloid, "weight on reels and cores" (*The Virtual Life of Films*, 13) and replaces it with the computational nature of translating machine language (code) into a pictorial form or what Lev Manovich might call "synthetic realism" (*The Language of New Media*, 174). With this, the machinic audience is trained, via the cultural interfaces of both digital cinema and the Internet, to accept and analyze narratives as constructs with a knowing eye toward the "invisible effects," the synthetic blending of live actors and locations with digital footage or the filter of an Instagram photo, that are so present in digital cinema and contemporary Internet use (Manovich, 260). With this, the prosthetic memory created by cinema, along with the digital prothetic memory of the Internet, moves away from "the traditional sense of origins, domination and lived duration" and instead lays bare "the collapse of the clear-cut distinctions between the natural and manufactured worlds" (Burgoyne, 228). This prosthetic narrative, or external personal memory, then, whether at the larger scale of a popular movie or at a smaller scale in a Facebook post of vacation pictures, is made with mediation and overt alteration at the forefront.

This does not demean either of these modes: as Burgoyne argues, "film appears to have acquired, more than ever, the mantle of meaningfulness, authenticity with relation to the past—not necessarily of accuracy or fidelity to the record, but of meaningfulness understood in terms of emotional and affective truth" (223); similarly, this "emotional certitude" can most definitely be present in the current Web 2.0 culture of externalized memory when made prosthetic into social networks and/or the digital devices we bind to ourselves. The fact that we are sharing these personal narratives in such a wide and open manner not only creates a cultural memory that is networked and public, but, as Andrew Hoskins explains, generates a "mediatisation of memory," one in which the user is well aware that the memories are going to be reconstructed as public documents that then "feeds back to affirm and/or develop these modes and routines" of memory and narrative (29). In the same way the prosthetic memory of films are created with a deliberate attempt to acknowledge a prospective audience, the Web 2.0 user creates their own narratives with the same self awareness of a "visible past" (30). In fact, as demonstrated by films like *Strange Days* and *Untraceable*, the digital native might in fact construct their externalized memories mirroring the very familiar techniques and structures of cinema that Manovich pointed out in this text's Introduction. Then, the form of cinema, as one culturally dominant force, combines with the Internet, likewise dominant, to produce an audience that values narrative and memory, cultural and personal, entirely different than the generation before. This in turn remolds how a machinic audience, through the compilation of their narrative memories and bodily stimulus, constructs a replexive sense of his/her self-identity.

As previously discussed in chapter 3, the emotional response to *Avatar* by a large number of its viewers speaks to its articulation of Burgoyne's affective truth. Within *Avatar*, prosthetic memory manifests in the Tree of Souls and the Tree of Voices, two sites that stand as the clearest connections the Na'vi have to their spiritual centre, Eywa. Neytiri takes Jake to the spot just after the ceremony that makes Jake part of the Omaticaya clan and explains that the Tree of Voices, with its long, cable-like branches, grants access via connection with the Na'vi's queue. By plugging into the Tree of Voices, the Na'vi are able to communicate with each other and nature as one large entity, using it as the central linking hub of Pandora (figure 6.2).

Such a connection also allows the Na'vi, when they've died, to "upload" their experiences into the biological network of Pandora. The site houses all the collected "voices" (narratives) of the Na'vi

Figure 6.2 Jake Sully (Sam Worthington) plugs into his world via his queue in *Avatar* (2009)

ancestor. Here, the audience is encouraged to view the externalizing of memories, accessed through a biological/technological mediation, as a sacred ability, one that brings a user closer to the memories and narratives of the past (Eywa). This is not that different than a family leaving up a Facebook profile left up after the user dies (or the long-running Virtual Memory Garden at http://www.virtualmemori-algarden.net; Kaleem, "Death On Facebook"): the act of externalizing that person (photos, videos, messages) and also keeping it as a site of interaction where other users can view and post messages, speaks to the wish to keep the narratives and memories of that person (digitally) preserved. Memory, then, is not just private, in the way knowledge is treated by Literate Man, but rather collective and external and, most interestingly, ongoing and adaptable. The fact that the Tree of Souls and the Tree of Voices are linked so closely to the cultural identity of the clan encourages the machinic audiences to, first, upload parts of their memories or embodied narratives and, second, allow those to be accessed on a large mass scale, beyond geography or lived duration, as a place of intergenerational learning and strength. This impulse is what social networks or a space like Youtube thrive on, a cultural memory that combines its many personal voices/narratives into a shifting, forever growing, poly-vocal entity, hopefully reflecting in the healthy BwOs-organism relationships argued for earlier in this text.

In contrast, *Untraceable* argues that the this externalizing of memories does not create the spiritual wholeness *Avatar* envisions but

rather allows a user to voyeuristically gaze in at others without any consideration for the personal and embodied narratives of other user assemblages. The two films stand in stark contrast in terms of genre: *Avatar* is a science fiction epic and *Untraceable* is a realistic detective drama. However, the verisimilitude of the technology used by the characters in *Untraceable* makes the film a potentially stronger, more literal, and directly familiar rhetorical document. Like *Firewall* and *The Net*, *Untraceable* makes clear that uploading personal information does not further help define the user's self but instead opens him/ her to the horrors of a murderous stranger. Initially, Owen Reilly is motivated by an Internet audience that watched and re-watched a Youtube-style video of his father's suicide. In response, his horrific torture live-streams present the view of digital prosthetic memory that casts the Internet as a decontextualized, and therefore dehumanized (nonnarrative), space of passive voyeurism. Again, *Untraceable* evokes Literate Man's fear of the commensurable and fragmented nature of the Internet as a technology: there is no possible way to explain or upload a person's (private) self and, as such, anything that is exposed is incomplete and an inaccurate representation of the person; there-fore, the prosthetic memories of the Internet are deliberate spectacle and not memories or narratives at all. The Internet user, whether creator or viewer, makes no attempt to construct or preserve personal and/or cultural narrative as the Na'vi's sense of conversation at the Tree of Voices portrays; rather, the externalized digital prosthetic memories are a database of information (bits) to be manipulated and devoured unemotionally. The documents that are created on these self-aware "mediatised" spaces are done only for consumption, not self-expression/creation, and the viewing user consumes them as a product stripped of any sense of humanized narrative. There is no possible machinic audience in this scenario; any memories/narratives created and/or maintained by the BwO are hollow and immoral.

The fears around the externalizing of memory that *Untraceable* upholds speak to the generational values that are rooted in our previous chapters' discussions of Debord's and Adorno's suspicion of mass consumption of cultural objects. If invested in Benjamin's "contemplation" and Literate Man's "finality," then it is easy to see movies as too easily digested and discarded spectacular documents and webspaces as dehumanized data, much as automatic learning and Ellul's algorithmic technique construes knowledge (and mem-ory) as hyperefficient and commensurable bits. In fact, movies like *Blade Runner* (Dir. Ridley Scott, 1982) and the first *Total Recall* present pre-popular Internet versions of digital prosthetic memory as

terrifyingly malleable and unstable.[4] Within both films, the audience is encouraged to consider digital memory as static (commensurable collections of bits to be implanted and extracted). As such, the characters within the films are tormented and confused: the replicants of *Blade Runner*, in particular Rachael (Sean Young), are undone by their downloaded false memories, made miserable by their lack of anchor in the subjective narrative personal (non-digital) memory provides; likewise, Douglas Quaid (Arnold Schwarzenegger) struggles throughout the entire movie to reconcile the "old" version of himself, corrupt and largely unfeeling, with the new sympathetic version of himself he finds once his original memories are purged and replaced.[5] Updated versions of these models of digital prosthetic memory like *Eternal Sunshine of the Spotless Mind* (Dir. Michel Gondry, 2004) and *Inception* (Dir. Christopher Nolan, 2010) present similar, more technologically complex, repetitions of how the digitizing of the human brain makes that brain (and the identity therein) susceptible and chaotic. *Strange Days*, though not dealing explicitly with the Internet but released in 1995 and creating Web 2.0-like documents (chapter 5), treats memory in much the same way *Total Recall* does, in that Lenny sells "wire-trips," the memories of other people. Wire-trips can be reexperienced via SQUIDS but in a more interactive and immersive narrative document than the purchasable memories of *Total Recall*. Similarly to *Untraceable*, wire-trips are destructive and deviant, akin to narcotics as evidenced by Lenny's addictive re-living of his relationship with ex-girlfriend Faith (Lansberg, "Ethics and Politics," 144). *Strange Days'* reduction of an individual's complex experience into the replicable bits, with a direct focus on their mediatised nature, represents the human experience of engaging with digital prosthetic memories to passively ingest the lives of others, "[preventing] individuals from acting in the present, from being productive, politically engaged members of society" (ibid., 144). *Johnny Mnemonic* specifically reflects the Internet user's struggles to maintain/create self-identity through her/his digital and networked prosthetic memories. Johnny, a regular Internet user, explains that he had to "dump a chunk of long term memory" in order to make room within his brain for the wet-wire implants that allow him to be a courier. In effect, he sacrifices all memory of his childhood, leaving him with decontextualized "residual traces" and effectively destroying anything that Literate Man might use (family, geography, personal experiences) as a way of defining a self; he is then anonymous, as reflected by his name (John) and only the title of his job as a surname. It is only after his heroics and the purging of the data in his brain that he regains his childhood

memories (a seventh birthday party). From this, the movie argues that a user can choose to have a digital memory or a human memory, but not both; this perspective encourages a moviegoing audience to unite any self identity within one stable, most likely biological, version of the self.

It is correct that a passive moviegoing audience or Internet user that engages movies and cyberspace with an unhealthy immersiveness (like the "lost" VR user from our Introduction) could cause a deep and incurable rift between his/her dual digital memories; if not careful, the "invisible effects" of Manovich's digital cinema becomes mirrored and amplified by what Hayles explains as the invisible computer code/language ("technological nonconscious") where, "as the technological nonconscious expands, the sedimented routines and habits joining human behavior to the technological infrastructure continue to operate outside the realm of human awareness" ("Traumas of Code," 157). However, we can't or shouldn't assume that the average machinic audience user/viewer is passive. Increasingly, the machinic audience, whether interfacing with cinema or the Internet, is increasingly self-aware, making visible those very "invisible" effects; if such an active user/audience is aware of his/her usage then the formation of self identity, through the dual memories of the technological and biological, becomes healthy and expansive. Lansberg sees the rhetorical construction of a passive Internet user as especially reflective of early views of the Internet wherein its "new technologies might atomize, rather than politicise individuals" (156). However, as a potential creator of prosthetic memories, she expands that the Internet, "because of its fundamental interactivity...engages the individual body" and, as the Internet becomes more complex, it might become a "mass cultural mechanism" capable of great communal power (specifically politically and ethically) (156). Her focus on the individual body within a mass group is key to understanding that posthuman narrative (and memory) must be, in part, always individually embodied, and that the bodiless-versions of memory in *Blade Runner*, *Total Recall*, and *Strange Days* are problematic because they construct memory in the same mode as the postbiological constructs the self or automatic learning constructs knowledge: as commensurable, manipulatable bits. The memories within *Blade Runner* and the first *Total Recall* are too literally prosthetic: they are clumsily attached, externalized limbs that are not reflective of the immensely reciprocal nature between the user and the technology (Internet and cinema) used to create and store that narrative. With this symbiotic biological-technological complexity in mind, Lansberg argues that

by their very nature "prosthetic memories cannot be owned exclusively," and have "meanings [that] can never be completely stabilized" (151). Though clumsy, the end of *Johnny Mnemonic* underlines this: Johnny is able to regain his personal memory and, in doing so, the proprietary data Johnny is carrying in his head, the evil corporation Pharma-Kon's cure for the black shakes, is released to the Lo-Tek's networks, turning the cure (previously the company's property) from private to public.

More metaphoric and complex than Johnny, the Na'vi are an extremely popular (and potentially positive) updated model of the active, communal memory-making machinic audience. Such an audience is also an active Internet user, that, if encouraged toward a rigorous self-awareness and caution toward the immediate *present* (and not the "rear view" perspective McLuhan fears) is the healthy posthuman Hayles envisions. Such a posthuman figure acknowledges that the replexive Repetitions with his/her many BwOs are generating resonate personal (memories) narratives dependent on the digital and the physical. The machinic audience's combined dual memories are equally important: the biological (organism) stores, retrieves but also replexively adapts, and is reflective of the embodied experience while also constantly evolving; the machine memory, imbedded in the technological devices symbiotically attached to the biological and extended by a user's BwOs, similarly stores and retrieves, but also expands beyond the internal (potentially isolated) biological into a dense and communal (public) network of networks. A self-aware balance of the "un-reconstructed facts" of externalized "bits" (Mayer-Schönberger, 106) with the contextual and embodied biological, combines to potentially create powerful prosthetic memories. Further, as Lansberg argues "because prosthetic memories enable individuals to have a personal connection to an event they did not live through, to see through another's eyes [they] have the capacity to make possible alliances across racial, class, and other chasms of difference" (156); from this, she adds, speaking about the first *Total Recall*, "memories are less about authenticating the past, than about generating possible courses of action in the future" (Prosthetic Memory," 183). The prosthetic memory, whether created/maintained through digital cinema or the Internet, may be one aspect of the full BwO-organism assemblage that would resemble the probe-head Deleuze and Guattari see as such an essential and resistive force (chapter 3). This optimistic and humanistic approach, an ethics based on "a recognition of difference" (ibid., 187), demands that we consider the individual user in mass technologies (cinema and the Internet) and do our best to recognize

each BwO as a self-fashioned snapshot of self-expression and identity
that is balanced by the user's other BwOs as well as by the embod-
ied organism(s). The narrative and memories essential to shaping and
reshaping this unity, though perhaps amplified in terms of distribu-
tion and immediacy by digital technology, is healthy and potent.

Conclusion: The Future of Total and Perfect Recall

The rebooted *Total Recall* restates many of the same concerns as the
original version: the rejection of "an authentic, or more authentic, self
underneath the layers of identity" that Lansberg sees in the first is
still present ("Total Recall," 181); too, Hauser's identity is still frac-
tured from his body, undermining "the assumption that a particular
memory has a rightful owner, a proper body to adhere to" (ibid., 183).
The reboot, however, is a movie far more comfortable with the dual
digital memories of the machinic audience in both its form and con-
tent. As a mode of digital cinema, the movie utilizes the lens flare
throughout, drawing attention to its own artifice. The machinic audi-
ence would also recognize the large digital cities not as sets but rather
digital constructions; and also, though using "real" actors/actresses,
those actors/actresses are often in a "fake" rendered environment with
other nonhuman actors (robotic/digital Synths as soldiers). The film
makes little effort to hide this, often revelling in its impossible (digi-
tally crafted) hyperreal in the same way *Avatar* does.

The digitally prosthetic cinematic form combines with its protago-
nist to give a central figure, especially when compared to the original
movie, that is navigating his posthuman narrative more complexly.
The updated film pinpoints this intricacy in the way it shows much
more flexibility toward its characters' faces: faces, traditionally a place
of stable identity, are molded with the same fluidity of a machinic
audience's digital avatar(s), slippery and quickly re-constructible (in
conversation with chapter 3). When the rebooted movie has Hauser
try to sneak through security under another identity, the first
Total Recall uses an obviously prosthetic (physical) head, while the
Wiseman-directed version makes Hauser's facial transformation via
a collar that generates a digital image/mask over his face. This digi-
tal overlay is not physically obscuring the face, but is very similar to
the machinic audience's slipping into the many different BwOs they
replexively cycle through daily. While the original film has Arnold
Schwarzenegger playing both versions of Hauser, the reboot casts two
separate actors. The "original" Hauser is played by Ethan Hawke[6]
while the post-memory wipe Quaid/Hauser, brought back to Earth

after "complete reconstructive surgery," is played by Collin Farrell. Again, the dual (physical) faces of Hauser, and the ease in which the character slips between them, reflects how the posthuman recognizes identity not so completely in the physical versions of themselves, but can identify the self through the assemblage of physical/organism in contact with the mental and virtual versions of themselves as well. As further evidence of this, the two versions of Hauser, housed in a single biological body but separated by the erasure of memory, are able to talk to each other through a digital-only, pre-memory–wipe version of Hauser. This speaks to the movie's reflection of embodied memory in which the digital version is only one aspect of the old version of Hauser but one that is always tethered to the "new" version of himself/Quaid. This hinges on memory, which the movie treats as halfway between *Johnny Mnemonic*'s and *Avatar*'s approaches: Hauser is said to be carrying a "kill-code" ("black box") in his brain in much the same way Johnny carries the cure for the Black-Shakes; however, Hauser is not forced to choose between his two memories and is able to hold both his personal memory and this externalized kill code (though literally internal) as a block of data in his brain. This is reflective of the machinic audience's interactions with the Internet as a blend of externalized (commensurable) fact and embodied experience, memory that is both sensual and factual, not a binary, but rather a combination.

This is best expressed by Quaid/Hauser's trek to find "the key" in his apartment. Early in the film, he tells Harry (Bokeem Woodbine) that he "always wanted to learn to play piano." However, "learning" is not treated with the same slipperiness as memory nor does he simply implant the capacity to play piano into his mind as Neo might. Instead, the ability is buried within his contextual personal narrative. After he is forced to escape to his old apartment, he is told by Charles Hammond (Dylan Scott Smith) that he needs to find the key. Frustrated, he sits at the piano and, slowly, begins to play, picking up momentum until he is performing beautifully smooth. He is stopped when he hits a key and, instead of a note, it makes a "thunking" noise, revealing itself as the clue he needed: the interactive uploaded Hauser from the past. It is here that the machinic audience's dual memory is most clear: Quaid/Hauser is at once an externalized (postbioloigcal) "copy," yet also a copy (prosthetic memory) capable of interactive flexibility, not merely a perfect reproduction. Too, access to that copy is dependent on his bodily remembering of how to play the piano and his physical interaction with this analog object (not a computer). When the digital version of Hauser says "somewhere inside of you,

you're still me," he points to the Deleuzian Repetitions inherent in a contemporary Internet user's identity, one that requires the sensual bodily memory/narrative (playing the piano) in combination with the digital.

Quaid/Hauser's struggles with his own identity are in line with the necessary and historical "trauma" that takes place, McLuhan argues, when transitioning from one value system to another. Mayer-Schönberger, in conversation with Togelius and boyd, states that the current generation of digital natives may in fact make a "cognitive readjustment," an evolution that grants a multigenerational adaptation, though painful, to the new digital narrative/memory technologies (154); in time, the machinic audience, with a specific eye toward personal narrative as a digital reproduction designed for reproduction, will recognize their own assemblages of identity as normalized and powerful. Mayer-Schönberger's argument for a necessary forgetting (or deleting) within the "perfect" finality of digital memory is already part of this process because the physical organism is a crucial part of posthuman narrative: the replexive process of (cultural and personal) memory involves a re-construction or re-re-construction and, in that, additions and deletions, repetitions and differences, not perfection. As with a Facebook post, the machinic audience is bathed in the basic reproductions-of-reproductions enabled by a digital cinema but still knows that, as Rodowick writes, it's impossible to replicate the viewing experience itself (20), a sentiment that reiterates Sobchack's embodied cinesthete moviegoer (chapter 5) and the posthuman's dependence on recursive narrative. The active interpretation of a movie is an important part of the machinic audience's navigation through her/his identity; when we acknowledge that the contemporary moviegoing audience are Internet users, then we might, as Burgoyne imagines, generate a future culture in which "the distinction between fact and fiction presented in the media will no longer matter because a whole new genre of visual history, or history as vision, will have emerged" (234). This "history as vision" is constructed knowing that, for the machinic audience, movies look like Internet narrative documents and Internet narrative documents look like movies and both inform each other in encouraging how the individual might engage with his/her virtual and physical worlds and bodies. Rather than perfectly reproducing an experience (as with automatic learning) or embalming a document by overemphasizing its finality (as Winston does), we should consider Mayer-Schönberger's potential solution of "perfect contextualization," a more holistic (and "inefficient") recreation of the ecology of memory/narrative that

reconstructs what is in a document/experience in complete relationship with where and how a document/experience was generated. This ecology, metaphorically created in Pandora's jungles and Quaid/Hauser's piano, eschews the potentially overwhelming nature of Ellul's technique and instead attempts, using the Internet's and digital cinema's prosthetic memories, to repeat, rather than exactly reproduce, how a embodied and unified assemblage-user comes to experience the past and the present.

Chapter 7

The Reel/Real Internet: Beyond Genre and the Often Vulnerable Virtual Family

Introduction: The Internet beyond Science Fiction

In many ways, *Disclosure* was a decade ahead of its time, a precursor to the films of the mid-2000s in how it depicts characters using the Internet without overtly drawing attention to the technology. In both *The Net* and *Hackers*, the Internet acts almost as an overt character or force; in contrast, within *Disclosure* the Internet is one part of the film's "realistic" narrative world. The heart of the movie is the workplace politics and sexual dynamics between Tom Sanders and his old girlfriend Meredith Johnson; the movie takes place at the tech firm DigiCom but it could have just as easily have been at an advertising agency or law firm. As many companies in the early 1990s did, DigiCom and its employees use the Internet (email specifically) as both a way of communicating and as a space to organize and preserve information and data. When the film opens with the floating "e" of Internet Explorer, it showcases an email interface that is awkward (it looks more like a static picture than an interactive program), but it is far from the strange and unrealistic hyper-color screens of *Hackers;* similarly, the Internet users of the film, such as the Sanders' young daughter Eliza (Faryn Einhorn) or Sanders himself, are not the super-users present in *The Net* or *Sneakers*, but rather a reasonable reflection of how an average user of that era would actually interact with cyberspace. Though Eliza does use email in the family's private home, for most users up until the millennial saturation of faster Internet connections (with better and expanded network infrastructure) and cheaper hardware, the Internet was a place accessed at work

or at larger institutions;[1] getting on the Internet, though becoming increasingly common, was still reasonably difficult for a large percentage of users. While treated semi-glamorously (these are movie stars as users after all) and representing a home-use that was likely beyond most of its audience, *Disclosure* initially presents the Internet as a normalized function of the family home and workspace, as a technology that resides in the background in the same way a phone on the kitchen counter or a television in the living room might.

This stands in fairly stark opposition to most other Internet-engaged movies from the 1990s that cast the technology as in either the realm of advanced super-users (the aforementioned *Hackers, The Net, Sneakers*, as well as *War Games*) or within the more metaphoric constructions of science fiction (SF), like *The Lawnmower Man, Johnny Mnemonic*, and *TRON*. The SF version of the Internet, most often hinging on a VR interface, integrated or exaggerated the overly fantastical/futuristic elements of the Internet, pushing the films far away from the attempted verisimilitude of *Disclosure* and instead casting the Internet as impossible to understand or control by an "average" user. Likewise, *Virtuality* and *Strange Days* both distance their audiences from the Internet by setting their SF worlds and Internet-like documents into an unfamiliar and hostile future, depicting the Internet as an inevitable virus or addiction: the post-biological construction of SID 6.7 is a warning toward the pure virtual user; the addictive SQUIDS of *Strange Days* are a signpost toward the onrushing narcotic digital immersion and voyeurism. As well, while *The Matrix* and *The Thirteenth Floor* encourage a semi-embodied and heroic version of the Internet user, both also advance the technology into the future and further abstract it by removing it from any audience-familiar interfaces, focusing on the immersive and potentially active avatars (BwOs) the technology *could* create; the "plugging in" that takes place in both movies problematizes the embodied user (full BwO and organism unity), potentially over-romanticizing the avatar (chapter 3). Though chapter 4 discussed the increased cooperation between user–Internet in movies post-Y2K, the residual apprehension of a SF-Internet as an antagonistic machine-controlled/caused apocalypse can be further illustrated by the treatment of Skynet in the three *Terminator* films. In *The Terminator* (Dir. James Cameron, 1984) and *Terminator 2: Judgement Day* (Dir. James Cameron, 1991), Skynet is a computerized defense network that gains sentience and proceeds to exterminate humanity. However, little attention is paid to Skynet itself: instead, the two (pre-Second Era) movies focus more on the cyborgs of the future; as such, Skynet is more reflective of the concerns around intelligent

machines and advancing AI than the increasingly ubiquitous Internet. While *Terminator 3: Rise of the Machines* (Dir. Jonathan Mostow, 2003) does center mainly on the battle between the two Terminators (played by Arnold Schwarzenegger and Kristanna Loken), Skynet is transformed into a specifically Internet-empowered horror, reflective of the ten years since Moasic's launch (and the release of *Judgement Day*) and the interpenetration of the technology into an average user's life by 2003. While the Internet itself isn't the villain, the network of networks allows Skynet to spread virally and globally until it eventually highjacks the necessary military hardware to cause a nuclear holocaust at the end of the film. As John Connors (Nick Stahl) narrates in the movie-ending voice-over:

> By the time Skynet became self-aware it had spread into millions of computer servers across the planet. Ordinary computers in office buildings, dorm rooms; everywhere. It was software in cyberspace. There was no system core; it could not be shut down... Judgment Day, the day the human race was almost destroyed by the weapons they'd built to protect themselves.

While the film echoes the fear of the vulnerable military Internet as shown in *War Games*, the real focus is on how cyberspace and "ordinary computers" enabled the infection and eventual destruction of humankind. Unable to separate the "ordinary computers" and the Internet from its SF setting of cyborgs and sentient computers, *Terminator 3* exemplifies the first two eras of Internet engaged films: Internet technologies were a (often spectacular) diegetic prototype that marked the technology as dramatically futuristic, rather than grounded and present-reflective. This is not to say that the technology in the films didn't mirror (or encourage) certain relationships between Internet-user (like the one formed through web browser [chapter 2]), but that the movies more often than not construct the Internet as part of (science) fictive universe beyond a non-dramatic or "average" or "ordinary" usage.

If the Internet was viewed as inherently SF, then *Disclosure*'s oddly common classification as part of the genre makes some sense, but demands a more in-depth look at the SF genre itself, especially if, as Susan Sontag explains, SF films "can be looked at as thematically central allegory, replete with standard modern attitudes" that reflect "the most profound dilemmas of the contemporary situation" ("The Imagination of Disaster," 111–112). In *Screening Space*, Vivian Sobchack struggles to pinpoint "science fiction" exactly (pulling

quotes from a wide range of other experts on pages 18–20), but does usefully characterize the SF villain as "less personalized [than the horror film], [with] less of an interior presence...usually we are given only form, physical attributes; the Creature of science fiction distinctly lacks a psyche...it remains, always, a thing" (32). She adds that the externalized nature of the Creature in SF creates a more "diluted and less immediate fear of what we may yet become" (39). This Creature is then combined with a colder and calculated ("objective") scientific viewpoint in which "the magical and miraculous [of the horror film] become—simply—the empirically explainable" (55). Through this, we can see Sobchack's expansion in her 1988 second edition of *Screening Space* (just pre-Second Era Internet) anticipating the inclusion of the Internet in the genre of SF, in which she argues that "the popularization and pervasiveness of electronic technology" is a change away from the cold calculated nature of empiricism to a reimagined "experience of space and time as expansive and inclusive. It has recast the human being into a myriad of visible and active simulacra" (229). She echoes chapter 6's discussion of Lyotard when she explains "the digital 'bit' has fragmented our experience and representation of space...the character of electronic dispersal has dislocated our experience and sense of 'place'" (232); this dislocation leads to bodies that "have become pervasively re-cognized as cultural, commodified objects...a 'self' always (re)produced and projected as an image available to others" (237). Through this lens, the Internet-as-Creature ("The Net") in early Internet-engaged films is an exterior "thing" without psyche or body, amorphous and always/never present, that lurks everywhere but is embodied precisely nowhere. More, as a depersonalized, man-made, and materially independent/shifty technology (the Internet can be on any screen, computer, server, and "inside" any user), there is an empirical quality to the Internet-as-Creature, making the scope and invasiveness present in the films all the more frightening. Susan Sontag would view the Internet user in these films as similar to the scientist of SF films: a mixture of "satanist and savior...admiration and fear," adding "[the user's] sphere of influence is no longer local...[it] is planetary and cosmic," a user that uses the technology beyond its means ("pushing it too far" like Lightman in *War Games*, Dade in *Hackers*, even Neo in *The Matrix*) and, because of that, is both dangerous and marvelous ("The Imagination of Disaster," 106). The Internet-as-Creature and the Scientist-as-User in early Internet-era films represented the anxieties and dilemmas surrounding this "(re)production" (made for reproduction) of a mediated Self: this genre-specific Creature served as a vehicle to express the fears

around shifts in self-identity and technological extensions of the body, the traumas brought about by generational shifts, to a user-audience that more and more identified themselves as the Repetitive assemblages of assemblages (BwOs and organisms) that came about from their interactions with a network of networks.

Further, Rick Altman's division of semantic elements ("common traits, attitudes, characters, shots, locations, sets") from syntactic elements ("definitions which play up certain constitutive relationships between undesignated and variable placeholders") as a means of explaining film genre, situates the Internet as one of the key variables in negotiating a new "site" in 1980s/1990s SF ("A Semantic/Syntactic Approach to Film Genre," 10–13). Sobchack's anticipation of the representation of the Internet in SF movies is an example of what Altman argues arises when "an already existing syntax adopts a new set of semantic elements" (12). We've discussed some of the syntactic elements in the previous paragraph (on-screen user-technology relationships and interfaces), but it is important to note that it is the interaction of the semantic elements that produce the syntactic elements. The Internet was a marker of SF grounded in its semantic or "primary" manifestation of the computer-object (monitor, keyboard, giant server, etc.), what Sontag flags as part of the "technological view . . . things, objects, machinery," that are clues to the identification of SF and are an evolutionary form of the 1960s' concerns around "man's ability to be turned into a machine" (105, 110).[2] Like the iconography of the spaceship or robot that Sobchack ruminates on in her second chapter (68), the computer, and the Internet by extension, is enough within the previously discussed films of this chapter to make them SF, often regardless of the other elements in play (the syntactic workplace or gender relationships in *Disclosure*, for example). In combination with the computer, we should point to representations of VR environments along with the hyperlink "zoom-down-a-cable into the machinery/computer" effect as further "visual functions," or repeated "*types* of images," that establish the "look" and "feel" of a movie specific to the SF genre in the first two Internet eras (*Screening Space*, 87, author's italics). Using Christian Metz's thoughts in "'Trucage' and the Film," we would further add that the VR sequences common in early-Internet films like *The Lawnmower Man* and *Johnny Mnemonic*, are visible *trucage* ("fakery" or "deceit"). *Trucage* is not "special effects" nor the "punctuation" of film (transitionary wipes or fades), but rather manipulations that affect the "realism" of the movie (a stuntman or multiple exposures are two examples Metz uses). Understanding that the VR sequence is a type of "cinematographic

trucage" (662, author's italics) and a way of expressing interface with the Internet, creates a visual function attached to the semantic computer. We would also include shots where the camera "enters" into the computer and lingers on the computer chips and electronic pulses (as it does in *The Net* and *Hackers)* as a similar, though less dramatic, version of this; the "zooming-down-a-cable" shot (or the similar "hyperspace" shot with many bits "flying" by the camera as it transitions through cyberspace) discussed as a representation of the hyperlink at various points in this text (chapter 2 in particular), is read similarly, even when it is slightly more metaphorical as it is when the audience travels down the metallic throat of Neo in *The Matrix.* From this, the semantic icon of the computer in combination with these two visible functions became near overwhelming markers of the SF genre in the 1990s.

From this, *Disclosure* was likely flagged as SF[3] despite the film's focal themes of family fracture and workplace sexual harassment, because of a six-minute scene at the climax of the film where Sanders and Johnson have a final showdown within the cybernetic space of The Corridor software. The sequence is quite jarring compared to the rest of the film: aside from a very brief (and non-immersive) dem-onstration of The Corridor near the halfway point of the film, almost all emphasis is placed on the characters' actions in the "real world"; suddenly thrusting them into a virtual space as a means of "solving" the plot is very out of place. Putting aside its perplexing combining of VR with the Internet, the film struggles in this six-minute stretch to make a distinction between the "real world" technology present in the rest of the film that is similar to what its audience might have found in their own offices (e.g., email) and technology advanced well beyond the audience's world (e.g., the VR Corridor that depends on goggles and gloves as interface).[4] This scene, despite its brevity in comparison to the 128 minute runtime of the movie, overwhelms any other syntactic elements and the demonstrates how just the inclusion of the Internet in many movies pre-Y2K moved a film away from a viewing based in verisimilitude or naturalism and into the realm of SF.

Yet, by the late 1990s, an exponential increase in Internet users and online content had taken place and a large pool of the moviego-ing audience was using the technology for any number of mundane purposes. That most Internet-engaged films of the time chose to steer away from a "realistic" depiction of Internet use makes *You've Got Mail* (1998), like *Disclosure*, a strange outlier of its time. As discussed in far more detail later in this chapter, Joe Fox (Tom Hanks) and Kathleen Kelly (Meg Ryan) use the Internet in their homes, like Eliza, casually

and without incident. Granted, the movie makes the Internet distantly romantic with its overt focus on the technology (from the title of the film through the machinations leading to the eventual coupling of the protagonists); still, it presents "real" people using the Internet in "real" or "average" situations with an eye toward verisimilitude that the Internet-as-SF in the other 1990s films discussed lack. *You've Got Mail* is a toe-dip into a cinematic representation of the Internet that would eventually take hold most strongly in the mid-2000s onward wherein films like *Me and You and Everyone We Know* and *The Social Network* mirror the Internet's comfortable interpenetration into the machinic audience's habits and interactions. Using *Terminator 3* as a potential endpoint, the Internet was no longer a consistent element of the SF genre. The semantic icon of the computer did not necessarily link to the anxieties of "made into machine": characters simply used computers as integrated social and knowledge devices. Similarly, the visible *trucage* of VR scenes, "a series of disquieting or 'impossible' events which nonetheless unfold before [the audience] in the guise of eventlike appearances" (Metz, 667), were either removed entirely or blended into invisible *trucage*, generating virtual spaces in which "[the spectator] could not explain how [the space] is produced nor at exactly which point in the filmic text it intervenes... [a space that is] impossible to localize, but the existence of which is beyond doubt and even creates one of the major interests in the film" (ibid., 664). Previously, an audience member could tell when a character in a movie was using the Internet because the boundaries of the virtual space were deliberately visible; now, the machinic audience, though aware that such a space exists, cannot separate it from the other filmic elements of the movie. More, the visible function of the "zoom-down-the-cable" shot is no longer needed to signal a user "entering" (using) the Internet: a character simply turns on their phone or laptop and types. While contemporary SF films like *TRON: Legacy* and *Avatar* are still engaging with the Internet, a vastly increasing number of "non-SF" films portray the Internet with the same casualness as the machinic audience uses the technology outside the theater, where characters, in a narrative world similar to their audiences', google terms on screen, use an instant message service or, as is *Friend with Benefits* (Dir. Will Gluck, 2011), casually utilize the whole range of Web 2.0 technologies without drawing attention to the technology itself. This increase illustrates how the machinic audience has integrated the technology into their life; to reflect the "real" world of 2014 in film, a filmmaker must have his/her characters draped in the (nonintrusive) virtuality of the contemporary Internet.

Even with this shift toward a cinematic naturalizing of the Internet, the Internet is still often portrayed as a harbinger of the destruction of the private and familial values that Retribalized Man inherited from Literate Man. As Sontag argues, "science fiction films are not about science. They are about disaster" (101): while contemporary films have moved to include the Internet as part of their "realistic" background, naturalistic films that choose to foreground their Internet engagement often hold onto their own SF roots in that they are about the potential disasters the technology will bring to the familial unit. Like *The Net* and *Hackers, Disclosure* opens with the Internet in the home; throughout the film, it is Saunders' association with the Internet, via his workplace, that leads him to his alleged sexual harassment of Johnson and to the subsequent reveal of his sexual activities to his wife, very nearly leading to the couple's divorce. This is reflective of the shift in Tribes that the Internet brought about: for Literate and Retribalized Man, the most dense and meaningful interactions would most likely have been within the Tribe of his/her family, with "satellite tribes" being defined largely by language and geographical proximity; the interactive, more democratic, and instantaneous nature of the Internet makes it so that the digital native interacts in a much wider variety and greater number of tribes. Sobchack would say this is in line with the shift in 1980s–1990s SF: earlier films like *Star Wars—Episode IV* (Dir. George Lucas, 1977) or *Close Encounters of the Third Kind* (Dir. Steven Spielberg, 1977) yearn for "a thoroughly domestic space and domesticated technology" (Sobchack, 229). The films invested in the naturalistic portrayal of Internet use are still often steeped in a Literate Man's fear that such a technology, and its move away from the familial tribe and the domestic, is terrifying. Part of this is in part due to the increasingly externalization and Hoskin's "mediatisation" of "private" (internal) narrative and memory that chapter 6 (and Sobchack [235]) points to: the previous generations have a deep investment in familial narratives as a main way of forming a self-identity (a surname and all the history that comes with it), whereas the machinic audience's slippery avatars do not demand that rooted historicism. In some cases this is constructed as positive: the two rival booksellers in *You've Got Mail* have family-owned businesses that have been passed down to the protagonists and are the cause of the animosity between the two; yet the anonymous nature of the Internet allows these schisms to be overcome. However, even in the more contemporary *Untraceable* and *Trust* (2010) discussed later in this chapter, the horror of the user "losing" him/herself in the Internet is that they also lose his/her own sense of familial ties

and become dangerously vulnerable, with the potentially anonymous nature of the technology being especially horrifying.

The comparison between Johnson and Sanders' wife Susan (Caroline Goodall) best exemplifies the Internet's destructive powers: the Internet empowers Johnson to be a childless/husbandless villainous sexpot while the wife, despite being a distant third party, is the most affected. This female focus then trickles into the whole family unit. Similarly, a number of Internet-engaged films target females as the most susceptible (and/or ignorant) to the dangers of the Internet. It is Kathleen in *You've Got Mail* who is blinded to "NY152"/Fox's real identity; it is the daughter, Annie (Liana Liberato), in *Trust*, who is seduced online, then raped; it is Jennifer Marsh in *Untraceable* that has her own daughter and mother targeted, in her own private home, by Owen Reilly; Stanfield's wife and family in *Firewall* are repeatedly tormented by their captures, with his wife the particular focus of physical and mental abuse; this is to say nothing of Angela Bennett's (*The Net*) and Terry Munroe's (*Ghost in the Machine*) previously discussed tortures. Once the Internet has gained access to the private home of these films, the "realistic" disaster the Internet brings is then very often female-focused, using that feminine force as leverage to fracturing the entire familial unit.

The Vulnerable Women of *You've Got Mail* and *Trust*

The reviews and what little scholarship on *Disclosure* there is tends to focus on its gender dynamics, with Sanders as the focal point around which all the other female characters and the discussion/fears around the growing influence of female sexuality in the workplace revolve.[5] While there are the strong female character of Catherine Alvarez (Roma Maffia) and Stephanie Kaplan (Rosemary Forsyth) set in place to balance Sanders and his boss Bob Garvin (Donald Sutherland), most responses to the film center on Meredith Johnson and the casting of Demi Moore. Johnson is overtly sexual, overtly manipulative and, by the end of the film, incompetent and evil. More interestingly though, she has no husband or family. She is a vixen outside comforting (domestic) familial structures and all the more dangerous for it; it is her blatant (feminine) assertiveness, outside of mother/daughter roles, that makes her the villain. More, as Rajani Sudan states, "[the] 'innovations' Johnson embodies—feminist advances in the corporate workplace, a new vision of technological 'freedom'—are deliberately cast as underserved or, frankly, utterly disruptive" (122). Expanding this idea of "disruption," it is especially key that she is the

only character, aside from Sanders, that is seen "inside" The Corridor software. In the aforementioned scene, when Sanders enters into the database, his avatar is a near-exact mirror image of his physical self, only slightly pixelated; too, his movements through the 3-D environment are smooth and fluid. When Johnson logs in moments after, the film underscores her access with discordant horror music. More, when she approaches, her avatar is a green wireframe of a generic body with a static picture of her face pasted overtop the head; her monstrous lumber toward Sanders is done without moving any part of her body, as if she is a statue being pulled on a dolly (figure 7.1). While she is a much savvier user than Sanders, her grotesque digital representation, versus Sanders' near perfect avatar, argues that her expert use of the technology and her manipulation and deletion of files makes her monstrous. Speaking about Michael Crichton's novel (on which the film is based) in a manner that definitively overlaps with the film, Camille Nurka rightly explains "[virtual] bodies ... become metaphors of 'real' bodies. The body as fetish-secret: signified as lack and reproduced in code" (165). The fact that she is established as an overtly sexual vixen, a "fetish-secret," and then is the only female to use The

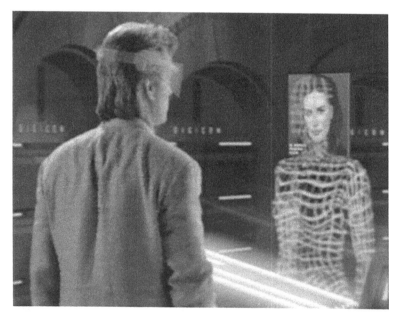

Figure 7.1 The monstrous avatar of Meredith Johnson (Demi Moore) advances on Tom Sanders (Michael Douglas) in *Disclosure* (1994)

Corridor/Internet associates her with many of the same fears around pornography/deviant sexuality attached to the Internet (reproduced code) discussed in chapter 1. With Johnson as the focus, Internet use isn't sexy, it's sexual. Even if she is a villain, Johnson's super-use of the Internet and subsequent punishment/firing are not a far leap from the trials endured by other movie versions of female super-users (Bennett in *The Net*; Denise Stone (Amelia Curtis) in *feardotcom*), characters who are also without strong familial ties. Jennifer Marsh in *Untraceable* is only slightly different: she has to send both her own daughter and mother away, and it is this break from family, and her maternal role, that is needed in order to defeat Reilly; however, she too is punished as she loses one of her best friends (Griffin) and is herself tortured and almost killed. This punishment of female super-users is in direct opposition to the liberating potential that Haraway explains in her "Cyborg Manifesto": instead of the Internet as a space in which the female can reimage herself outside paternal norms of domesticity and traditional femininity, the female super-user is a monster and/ or a victim. Even a positive super-user like Kate Libby/Acid Burn in *Hackers* stands as an "exceptional smurfette," her value, and uniqueness, defined by being as "good" as the male super-user.[6] More often than not, the male super-user is portrayed as a potential heroic hacker while the rare female super-user of the Internet is viewed as an especially dangerous blend of technical savvy and female sexuality. Such a mix might lead to a dominance over men in both the virtual and physical realms and therefore the female super-user, like Johnson, is castigated for her skills.

By comparison, the "average" female Internet user is commonly constructed as passive but also disciplined with the same severity as a female super-user, a trend very present in the character of Kathleen Kelly in *You've Got Mail*. Within the film, the VR interface of The Corridor is gone and replaced with a far more bodily integrated and personal version of the Internet. *You've Got Mail* opens with a faux-desktop GUI that morphs into the eventual world of the film: the audience enters into the computer where, soundtracked by the sunny "The Puppy Song," a virtual New York City is displayed and zoomed in on via mouse click. The environment is far more mixed than in *Disclosure* as the (virtual) cursor interacting with the document/ virtual city on the screen is combined with the (physical) sounds of modems beeping and, clearly, someone typing. When the audience stops in front of a blocky-computerized apartment, the cursor clicks and the virtual city transitions by wiping into Kelly's "real" apartment: the "virtual" and the "real" blend seamlessly, the exterior

typing and modem sounds mixing with the internal computerized space, presenting the audience with a version of user-Internet interaction that is quite close to the contemporary Web 2.0 world. Noting that Kelly's use is five years or so advanced past the average audience member's home-use and hardware, she uses her laptop in her private home at the start of the movie, integrating her computer and her email discussions with NYC152/Fox into her morning routine and establishing the technology as normalized (and essential) to her everyday life. Yet, this normalization initially ignores the domestic and familial stability of *Disclosure*: though both Kelly and Fox are unmarried, they are in relationships (Kelly with Frank Navasky [Greg Kinnear], Fox with Patricia Eden [Parker Posey]) and so their flirting and intimacy via the Internet is not that far removed from the Sanders–Johnson tension in *Disclosure*. While the Sanders–Johnson relationship nearly destroys the Sanders family-unit, neither Kelly nor Fox see their behavior as particularly deviant or destructive. There is a slight worry from Kelly as she asks "Is it infidelity if you're involved with somebody on email?" However, Christina Plutzker (Heather Burns) assures her that so long as there is no cybersex, the relationship is safe; from this, Kelly is able to dismiss the relationship as "confusing," "out of hand," then "nothing," and finally "harmless." Instead, the nostalgia for a domesticated (monogamous) home and technology is replaced, as Aimée Morrison in "Newfangled Computers and Old-Fashioned Romantic Comedy" describes, with a nostalgia for a personal and intimate capitalism. The family-unit, and the nostalgia for its nuclear unity, is instead encapsulated by the bookstores that each character is in charge of: each bookstore is an inherited business (Kelly from her mother, Fox from his father) and in line with the sort of familial narrative that Literate Man and Retribalized Man would value. Of course, the two competing bookstores cause Kelly and Fox to begin the film hating each other, a conflict that continues even after Fox's store has put Kelly's tiny Shop around the Corner out of business.

However, online, where neither knows who the other is in "real life," the two are very close; they start each email to each other with "Dear Friend," sharing personal and internal thoughts/feelings and then anxiously awaiting the other's reply. Kelly retells how they met online in a speech typical of two characters' first meeting in a romantic comedy: "The day I turned thirty I wandered into the Over Thirty Room for a joke, sort of, and he was there, and we started chatting…Books. Music. How much we both love New York," all this despite the fact that "we don't talk about anything personal. We

made a rule about that. I don't know his name, what he does or exactly where he lives." This anonymous conversation, where both protagonists' avatars and interactions are relatively devoid of identifying markers ("personal details"), is an essential part of the two characters' love story. In fact, each protagonist is shown being far more honest, with both themselves ("authentic self knowledge") and each other online (Morrison, 49). This "cautious optimist assessment of the here-and-now" that Morrison sees in the film is established by the characters' repeated use of the word "personal" to describe their online relationships (43), and by their private/leisure use of the Internet (rather than Marsh's and Bennett's professional use). In aiming to "humanize the future," Morrison adds, the film argues "[electronic] mail and instant messaging technologies are shown not to destroy the fabric of traditional community and interpersonal relations. Rather, they enable characters to be truer to themselves and to relate to each other more authentically" (55). Still, this changed value system wherein email is the gateway to authenticity is overtly constructed and the films asks the audience to recognize themselves in Fox's and Kelly's carefully edited online conversations and avatars. Repeatedly, both characters write and rewrite their messages to the other, casting the authenticity of their online dialogue not as the ability to think and respond spontaneously/messily, but, through careful composition, the ability to construct a particular BwO with crystallized perfection. While Retribalized Man might find this a fabricated and "fake" Self, the film argues that Internet technologies are the best mode through which a person might reflect on him/herself before articulating and exchanging his/her intimate thoughts. Further, as Navasky breaks up with Kelly, he asks if there's someone else and she replies, thinking of NYC152, "No, but there is the dream of someone else." The "dream" here is the avatar (a BwO) of Fox; while "dreams" have the connotation of impossibility or fantasy, here Kelly associates the "dream" avatar with the achievable perfection she is in daily conversation with; to her, NYC152 is not a wispy creature but a substantial potential partner and confidant.

This is true within the film so long as both parties are allowed to keep their avatar and its construction as private and anonymous as s/he chooses. However, an uneven power dynamic develops once Fox finds out that Shopgirl is Kelly. This eventuality is hinted at in the beginning of the film: the camera tracks into Kelly's home through the window with the same slow and snaking intrusion that introduces Bennett in *The Net*; the audience then follows the camera through the domesticated apartment before resting on Kelly's sleeping face.

While the cheery music is cuing the audience to feel at ease, the fact that Kelly vulnerably/ignorantly sleeps while the Internet/camera comes into her home immediately establishes her as passive. The audience's introduction to Fox has none of the ambling camera, nor is he shown, as Kelly is, patiently waiting as the modem dials into his email. Instead, Fox is established with a cut to the interior of his apartment as he walks through his morning routine. This binary between passive/assertive user along gender lines is amplified later in the film when Fox, as NYC152, goes to meet Kelly, as Shopgirl, in a coffee shop; he arrives after her, sees Shopgirl's "true" identity, and, after a brief conversation in which he keeps his own avatar secret, abandons her. He then talks with Shopgirl online, continuing to carry on a separate relationship with her via NYC152 while he and Kelly gain a slow friendship in "real life." Up until the end of the film, Fox pretends the pact of anonymity still exists, all the while asserting a superiority of knowledge, manipulating Kelly; he is effectively playing two parts while Kelly is kept passively in the dark. While balance between the two is supposed to be restored by the eventual reveal that Fox is NYC152 at the end of the film, the fact that he is allowed to keep a knowing and powerful grip on his own identity before revealing himself on his own terms is troubling, presenting the average female user, exampled by the exposed Kelly, as vulnerable and then, with her approval of Fox's manipulations, accepting of that uneven dynamic.

The film's reviews and sparse scholarship voice no such concerns. Leger Grindon's "Introduction" in *The Hollywood Romantic Comedy* makes it clear how closely the film fits within the genre conventions of the romantic comedy wherein Kelly is "the innocent" and Fox "the scoundrel," and therefore Fox's digital "schemes and disguises" are just a part of the convention of the "masquerade" that is essential to the genre (16). Perhaps because the film fits so snuggly within the "master plot" of the romantic comedy, the audience is constantly aware that Kelly is "protected from harm" and in no real danger (ibid., 2–11); such an audience is able to look past Fox's maneuverings as part and parcel of the fantastical and fated machines, laptops and the Internet included, destined to bring the two together. *Trust*, by comparison, is a much more serious film that expresses the parental concerns that come with a child's immersion into a Web 2.0 Internet environment. While the film was a box office disappointment, garnering just $120 thousand on a budget of $4 million, its very positive reviews after its Toronto Film Festival release make it worth noting.[7] As discussed throughout this text, the fears around children and the Internet is repeated throughout Internet-engaged films; however,

Trust is unique in its focus on the young daughter of the Cameron family, Annie. Largely through the casting of Meg Ryan, Kelly is constructed as adorable in her flighty innocence/naivety; more, she is a small business–owning adult, capable of mature decisions and able to deal with the adult world of sex and romance. Annie, on the other hand, is made extremely vulnerable because of her teenage naivety and innocence. While she is shown to be an intelligent and popular high school student, her willingness to accept Charlie/chRleeCA's shifting explanations of his identity in their private, online conversations (from a high school student to a 20-year-old college wrestler to a 25–year-old to, when she physically meets him at a mall, a man into middle age) is treacherously ignorant. While the bulk of the film does grapple with the complexity of her unawareness, the Web 2.0 female teen is shown to be constantly plugged in, constantly accessible, and therefore especially open to the danger of a "fake" stranger-user. While anonymity is seen as a powerful tool of connection in the adult world of *You've Got Mail*, the slippery avatar is treated with much the same terror and indignation as the alleged plethora of pornography on the mid-1990s Internet was (chapter 1). Charlie/chRleeCA encapsulates this fear, especially considering he is never caught, and therefore, unlike (the female) Meredith Johnson, the audience receives no sense of justice or retribution. The end-credits sequence shows Charlie/chRleeCA at a fair with his own family, interacting behind a devious facade of normalcy, implying to the exiting movie audience that Charlie, and the many others like him, are still searching for prey online, with their eyes set specifically on young females. In particular, the scene in which Annie is raped showcases the dangers of adult digital manipulations in a young Internet-user's world: to begin, the scene is set in a hotel room, a representative generic and nondescript space that stands in direct opposition to the intimate/personal domestic home. The hotel room is a distrustful metaphor for virtual space, a limbo-like "non-space" that is for momentary occupation and deviant/criminal behavior. Dressed only in the lingerie that Charlie bought her, Annie's obvious discomfort as a fully clothed Charlie strokes her arm is then connected to the mediatisation of a Web 2.0 Internet as the viewpoint shifts so that the audience is looking through a hidden camera; the audience can only see Charlie and Annie's torsos, stripping them of their faces and "personal details." The audience retains this perspective as we hear Annie repeatedly tell Charlie "No" and to "Wait." However, Charlie overpowers her, obscured from the camera, anonymous, at all times. From this, the Internet is not only a place for anonymous predators to hunt, but

a place in which that predatory user is then, through his mediated nature, going to continue his abuse by watching and re-watching the digital document before potentially distributing it across the expansive networks that hide him.

Once the scene is done, the movie transitions immediately to the Cameron family dinner table, only with Annie's frantic "Y aren't u calling me back?!" superimposed over top of the family's chatter; Annie grips her smartphone, devastated and distant. Despite the horrors of her rape, she still clings to the technology in a deeply personal way, using it, at least initially, as the main way of making sense of her trauma. Both *You've Got Mail* and *Trust* make their Internet-connected female susceptible because of their extremely personal and integrated relationship with the Internet, a relationship best shown through the films' use of voice-overs and text-overlays. *You've Got Mail* is distinct in the way it shows both Fox and, more so, Kelly reading their own emails and online conversations in a voice-over (so Fox hears Kelly reading the email she sent and vise versa) while the characters continue to navigate the world, away from their computer. Morrison states that this suggests "conversation and interiority at one and the same time" and that "there is an intimacy in hearing the other's voice 'speak' the text" as they maneuver un-tethered from their computers. The fact that neither character is consistently shown sitting in front of the computer while they "read" their email is a break from movies, like the earlier films previously mentioned in this chapter, where characters were shown in "real-time" at their computers interacting with chat boxes or email programs. Instead, the email document blends in with the world (a precursor to Hansen's wearable space [chapter 3]), carried with each character as they walk down New York streets or wander his/her apartment. More, the conversation/voice-overs are internal: when the characters sit down to read their emails, they don't do so aloud, as the characters of *The Net* and *Hackers* often do; they are also not transported into the Internet as the user is in the *The Matrix* or *The Thirteenth Floor*. Rather the characters process the language and emotion internally, as one part of their embodied experiences. This cinematic treatment of the Internet encourages its audience to see the Internet as a blended part of their own worlds, a background feature that does not intrude, but rather works in tandem with the BwOs and organism; such a treatment is linked and materially/actively embodied in the "real"/physical world. For Kelly, however, this deeply ingrained personal and embodied treatment does not allow her the distance to separate or analyze the other avatars (NYC152) she interacts with. Because of this intimate/integrated closeness, she does not see the

digital manipulations that ultimately lead to the uneven power dynamics between herself and Fox. While Fox can juggle between BwOs and organism, even deliberately separate the two, Kelly is fairly inept at it, unable to fully control her BwOs or organism, and, as such, is placed is a lesser position of power.

Trust transforms *You've Got Mail's* voice-over into text projected overtop of the action in the scene; the text conversations between Annie and Charlie/chRleeCA are overlaid above the other characters talking and acting. Here, Kelly and Fox's "intimate voice" is unvocalized, presented instead as static and depersonalized text, devoid of human attachment or the vocal/emotional performance that a voice-over gives; the fact that it lays overtop of the rest of the world is consciously intrusive, a too powerful voice that threatens to overtake the whole narrative and the characters within (figure 7.2).

The technique's obvious artifice creates the Web 2.0 texting-conversations as a jarring visible *trucage*, a deep break from an otherwise deliberately realistic film. This pessimistic portrayal of a Web 2.0 Internet is defined by its intrusive, overwhelming, nature; Annie, as a female Web 2.0 user, is unable to either prevent the violence of its intrusion nor carefully/intelligently engage with it. Unlike Kelly, who is shown typing full emails in complete sentences, Annie communicates through the same "text-speak" of the Internet-voyeurs in *Untraceable* (chapter 5), a language repeatedly dismissed by Retribalized and Literate man as inarticulate and juvenile.[8] In *Trust*, the cyberphobia rooted in male immaturity that structures *War Games* and *Hackers* is substituted for a sexual immaturity that manifests in Annie's rape, as well as her insistence after the event that Charlie/chRleeCA loves her.

Figure 7.2 Annie (Liana Liberato) texts with Charlie/chRLeeCA. Their text conversation intrudes overtop of the scene (*Trust*, 2010)

Unlike Dade or Lightman, Annie does not possess enough technical skill to offset her unawareness and immaturity; she instead overlaps with Marsh's young daughter, who accepts spyware from the killer Reilly in the form of a horse-riding video game, in that both daughters, because of their naivety and lack of Internet prowess, invite strangers into their (domestic) computers, and therefore infect and rupture the family unit. The parents of *Trust* most clearly represent the traumatized family unit: a large portion of the movie is spent with Annie's parents (played by Catherine Keener and Clive Owen) dealing with the assault on their daughter, as each struggles with their daughter's decision to first establish her secret relationship, then meet with him in person. As Retribalized members, neither parent understands the depth and intensity of their digital native daughter's online relationships and their confusion, especially Will's, drives the family toward implosion. The Cameron family is brought back together at the end of the film only after Annie is able to see how Charlie had used the Internet to seduce at least two other young girls; once Annie is able to accept that the Internet, and its population of evasively unidentifiable avatars, is a place of danger, the familial tribe is able to reunite. The implication at the end of the film is that, while Annie is still an immature and susceptible Internet user, her inclusion back into the familial tribe, a tribe now reestablished as the most important and intense, provides enough protection to ward off any corrupt avatar.

This ending echoes that of *Disclosure*, as, after Kaplan has been promoted, Sanders returns to his computer to check his email and finds a digital copy of a drawing from his daughter. The message reads: "Daddy we miss you" and is signed "A family." Much like *You've Got Mail* and *Trust*, it is only after the Internet, populated by vixens, serial killers, rapists, and/or business-destroyers, are banished or revealed, that the family can come together and protect, perhaps even "cure" its vulnerable female members.

The Mature Digital Natives of *You and Me and Everyone We Know*

In the same way we speculated that *Surrogates* was lacking a depiction of a healthy unity that the machinic audience could identify with (chapter 3), we might say *Trust* suffers from the same affliction. Like *Firewall*, the film is rooted too deeply in older value systems, and is near-hysterical in its treatment of the avatar; in turn, it leverages the "young and innocent" Annie too far beyond a machinic audience's engagement. Like our earlier discussions of *Untraceable*

and *feardotcom* (chapter 5), it is an adult movie with adult (parental) concerns and treats the "immature" machinic audience's abilities to navigate/integrate the Internet responsibly with overwhelming doubt. In opposition, though metaphoric in their SF construction (and problematic in their own rights), the Na'vi (Tribes) are given a heroic framing that encourages a digital native to look at his/her own embodied virtuality as a means to establish meaningful and expansive Tribal (familial and otherwise), networks of like-minded comrades, virtual and physical. The positive construction that *Avatar* houses its Tribes of digital/physical members inside of it is a large part of what engages the machinic audience in the film.

Still, *Avatar* is a SF film that does not depict what an "average" user-Internet interaction might look like, and therefore needs to be complimented by other films that do reflect how the mechanic audience actually engages with their cyberspace(s). If we use *Terminator 3* as a rough marker signalling the end of the SF-of-the-Internet, we could use *Me and You and Everyone We Know* (*MYEK*, 2005) as the starting point of a more positive and complex naturalistic, cinematic depiction of the Internet. Admittedly, it is not exactly "popular" cinema; however, its limited release was extremely well received by critics as the film won the *Caméra D'or* and was lauded by Roger Ebert as the fifth best movie of the 2000s (para. 19). The film is fairly upfront about its quest to explore Internet-user relationships: Nancy Herrington (Tracy Wright), as the curator of a contemporary art museum looking for new material, asks her assistant, "Could this have been made in any era or only now?...What does this tell us about digital culture?" Her version of that digital culture reminds us of *The Net*, as she argues, "email wouldn't exist if it weren't for AIDS. Fear of contamination. Fear of bodily fluids." Herrington's negativity around the distance and sterility of the Internet is set within the confines of an art museum: in it, pictures of emails are hung as "digital culture," a strange, taxidermied version of what it means to digitally communicate. From this, the film examines how, outside of a formalized institution (like Herrington's art gallery), the Internet acts as a profound rhizomatic force for its users, a force that also becomes a modeling form for how the characters choose to interact with each other when away from their computers. The average users portrayed in the *MYEK*, regardless of age, act in their "real" lives as if they still were online; how they talk with and engage with each other is surrounded by the same notions of "fantasy" as Kelly's "dream" of NYC152. However, the characters in *MYEK* are self-aware users of the Internet that navigate and appreciate its virtual, unreal spaces; the

fantasy worlds within the film are deeply personal and unique but also acknowledged (or exposed) as the dreams of wishful narrative. The Youtube-style videos that protagonist Christine Jesperson (Miranda July) creates are not the voyeuristic SQUIDS of *Strange Days* but instead personal conversations where she looks into the camera, face in full view, and addresses the audience watching; unlike Charlie's hidden camera in *Trust*, the camera/Internet here is a conduit to other people, one that enables a self-aware document where both audience and author of the video are tied together in intimate dialogue, a Web 2.0 version of "Dear Friend." When there is the hint of sexual perversity, as when Andrew (Brad William Henke) is goaded into posting semi-anonymous graphically (though cliched) erotic messages on his window to the teenage Heather (Natasha Slayton) and Rebecca (Najarra Townsend), he hides in terror when the girls go to confront him in person. He, and the girls, healthily differentiate between fantasy and reality; posting anonymous Internet(-like) messages is fine because all users recognize the content for what it is: a fantasy that neither party is particularly invested in actually doing in "real life."

Unlike Annie, Rebecca and Heather are in direct control of their sexuality, semi-taunting Andrew into shame and directing their own oral sex experiments with Peter Swersey (Miles Thompson). Such curiosity and sexuality is not demonized, but portrayed as a necessary step toward growing up. In fact, the children using the Internet in *MYEK* are shown to be remarkably mature, more than able to deal with the complex ideas surrounding relationships on the Internet as well as the larger adult world of divorce, marriage, sex, etc. Outside the Internet, this can be encapsulated by Sylvie's (Carlie Westerman) hope chest that she fills with towel sets and various kitchen appliance, which she explains will be her future wedding dowry for her imagined husband. Within the Internet, six-year-old Robby begins an online sexual relationship in a chat room where he asks an anonymous woman if she wants to "poop back and forth forever." The simplistic language he uses, a cartoonishly graphic suggestion, echoes Andrew's; too, when we are shown his composing the messages, he does so by copy and pasting from earlier portions of the conversation, echoing the same slow, deliberate but obvious composition Fox and Kelly use in writing to each other. Even at six, he is shown to understand how to use and communicate in a startlingly complex manner on the Internet. When he does physically meet the other user, it turns out to be Herrington. While this does fit in with the previously discussed patterns of the average female users being almost dangerously

ignorant, her being "fooled" has more to do with her over-sanitized understanding of the Internet than a lack of digital knowledge/savviness. Unlike the other characters of the film, Herrington tries to make her fantasy, her "dream" relationship with Robby's avatar, into reality, confusing the two and is therefore exposed as a more naive user of the technology. Still, the film gives their meeting a striking tenderness: Robby reaches up and pushes the hair from her face and Herrington lightly kisses him before walking away. Despite Robby being very young, he still understands Herrington, via the Internet, in some basic human way. Herrington's discovery is not met with humiliation or violence, but rather with a sadness that leads to an understanding of the Internet's strengths (and weaknesses) that is then reflected in her art gallery's exhibit at the end of the film. As perhaps the last to realize it, she comes to see the technology as the film's audience does, as a potential conduit to human connection, an intimate and familiar place in which "everyone we know" exists tethered to every other person they know (and don't know), a broadening of Tribe to a much wider and (post)humanistic lens.

Conclusion: *The Social Network* and the Troubled Saviour of the Future

Me and You and Everyone We Know gets its title from a dialogue between Peter and Robby in which Peter explains that the picture he is "drawing" on the computer with punctuation marks is actually "people seen from above": the "." is a person walking; the "," is a person lying down; the ";" is a "person standing up next to a person lying down." Peter then explains, pointing to two particular punctuation marks that "This is me. And you. And everyone we know." Peter's reduction of the world's population into simplistic (and seemingly homogenized) punctuation marks seems, at first, to agree with critiques of how the Internet creates Bauldrillard clones. Yet, his ability to signal out individuals in that crowd points to a way in which an Internet user might start to identify a self online in relation to the other online BwOs a user, and other users, possess. Within Facebook, for example, each user is constrained by the same basic template; however, within that template, the user curates multisensual documents and contexts that articulate a specific and personalized set of selves. Within Facebook, each occupant of the population is simultaneously a massive group (network) of hyper-connected Tribes while also an individual and unique user. Further, even in Facebook's treatment/ transformation of the word "friend," the user can see the need to

establish the same simultaneous micro-macro scales Peter points toward: a Facebook "friend" can be both a small part of the larger sea of users, a punctuation mark in a giant sea of unfamiliar or globally distant marks, but could also be a literal family member, a single comma different from all other similar looking marks. Branding all users as "friends" is both inaccurate and understated, but also encourages the user to look more positively at other Internet users that surround them in that space, an echo of the *YMEK*'s humanist impulses. It is fitting then that *The Social Network* works so hard to distinguish what exactly the Web 2.0 era means for the younger members of its Tribes of "friends" and, further, what heroes and/or (new) familial units that might arise from its networks. While *Avatar* and *TRON: Legacy* provided allegorical modes of representing these Tribes, *The Social Network* aims to show how these Tribes have come together in the very world the machinic audience populates.

Like *Disclosure*, *The Social Network* claims to be based on "real life" events and takes great care to realistically mirror Internet usage, both advanced and "average," within the five-year time frame (2004–2009) of its narrative. It is not just a naturalistic film: the two lawsuits that the film uses as its framing device create a stable, nonfiction anchor to the world outside the movie, acting as a series of precise chronological landmarks that allow its audience to keep track of exactly where well-known, "real-life" figures (Zuckerberg, Parker) were, and when, down to the day, the events in the movie take place. Unlike the earlier made-for-television *Pirates of Silicon Valley* (Dir. Martyn Burke, 1999) or *Takedown* (alternately *Track Down*; Dir. Joe Chappelle, 2000), *The Social Network*'s Oscar recognition, alongside its box office success, underline its importance to the larger zeitgeist and how important its nonfiction narrative and specific mythmaking around Internet technologies was to the machinic audience.[9] *The Social Network* effectively captures one of the machinic audience's origin stories, using a very familiar technology (Facebook) alongside an enigmatic (trickster/Prometheus) Mark Zuckerberg (Jesse Eisenberg), to structure a mythic version of how the machinic audience watching came to the very technology in front (and inside) of them.

Far from the Internet-as-SF, the movie's commitment to "real life" generates a pseudo-biopic, but a biopic where the exact subject in examination is in question. Steve Neale, paraphrasing Custen's *Bio/Pics*, outlines that, at its core, a biopic is "one that depicts the life of historical person, past or present" (60). While biopics have to adapt themselves to the particular aesthetics of its era of filmmaking, there are consistent conventions of the genre that overlap with *The Social*

Network that include: beginning *in medias res* (62); the inclusion/ reliance on trial scenes (63–64); and, quoting Custen, "the hero's antagonist relationships with members of a given community...[in which] the hero is attempting to reformulate the boundaries of a given community" (as quoted, 72, 63). Neale expands the last point to include those morally ambiguous figures "who are willing to ignore or destroy the rules and the boundaries of communities as well as those who wish to reformulate them" (64). With all this in mind, because he is the protagonist of the film and founder of Facebook, it is tempting to view Zuckerberg as the biopic's subject. After all, he is the awkward and often abrasive genius that is at the forefront of the re-construction and antagonism of his (virtual and physical) communities' boundaries, whether it be on a small scale at Harvard or on the larger scales of the American court systems or even the Internet itself. The movie constructs Zuckerberg, the "youngest billionaire in the world," as an updated version of Bill Gates or Steve Jobs, as the larger-than-life, combative (and self-righteously singular) creator/inventor of Facebook's transformative technology. His story is half Greek myth, half Self Made Man: after stealing from the rich Winklevoss twins (the Greek gods, played by Armie Hammer) and giving Web 2.0 to the masses, the hacker Prometheus Zuckerberg must defend his successful product/property and his extraordinary vision.

It is strange, however, to think of a biopic focusing on such a short, intense, period of time and covering a figure still so incredibly young. Part of this is reflective of the (very recent) history of the Internet: the "dotcom bubble" bursting in the early 2000 was echoed by the immensely quick rise and fall of technologies like Myspace or Napster; the urgency in capturing the narrative of Facebook, as it is at its most important to its audience, makes sense. Yet, if Zuckerberg is the focus, the traditional model of family unit is nearly completely forgotten: in contrast to a contemporary esteemed biopic like *Ray* (Dir. Taylor Hackford, 2004), the film never shows any of Zuckerberg's childhood or other family members (mother or father), nor does it take much time to contextualize his experiences leading up to the audience's introduction to him at Harvard in 2004. He is therefore unique, unlike Dade or Sam Flynn or David Lightman, in that the other young men (hackers) of the Internet are enclosed by traditional family units.[10] Instead, Zuckerberg's kin is replaced by his cofounder Eduardo (Andrew Garfield), Sean Parker (Justin Timberlake) and, once he moves to California, a house/team of coders who are helping to scale up Facebook's software and networks. His most influential

tribes are defined by technological overlaps not blood or familial history, and are a direct reflection of how the technology he creates is encouraging that same communal value/Tribe system in its users: unlike *You've Got Mail* or *Trust*, where the characters are most often by themselves staring at the screens, *The Social Network* repeatedly shows a crowd around whatever screen the Internet is on. In this, the machinic audience can see the ripples of an embodied and (virtually and physically) networked posthuman, one that is physically and virtually communal: the users of the Internet in the film often use the Internet with each other, in dorm rooms (as the early scenes of the creation of "facemash" show), or bedrooms, or the coding house in California.

From this perspective, it is more useful to look past Zuckerberg as the subject of the movie and instead focus on how the film is about the "birth" and "life" of Facebook itself. The technology itself becomes the force pushing at the boundaries of its communities, its exponential growth underlining a clear sea change in how the Internet, and the BwOs/organisms that populate it, have shifted from the user-to-user contact of very early FTP file transfers, to an ever-increasingly dense network of networks (groups of Facebook Groups) that aims to connect everyone. Reexamining *You've Got Mail*'s voice-over and *Trust*'s text overlays, both films present the mechanics of the Internet quite similarly to *War Games,* wherein a single user contacts another single user and carries on an intimate conversation (or file transfer) with that individual user: Fox only reads Kelly's emails and vise versa; Annie almost exclusively reads Charlie's private online messages. The Internet represented in this way, though breaking free of Birkerts' mesh, is still a long way from the communal experience of *The Social Network*'s Web 2.0. First, as Sean Parker explains in the film, echoing chapter 5's discussion of the digital panopticon and synopticon, "private behavior is a relic of a time gone by." While the individual/private transfers of email to email (or phone to phone) are still very common, the movie highlights how Facebook encourages (demands) that everyone is public and always looking at everyone else in much larger, more communal conversations than the emails Kelly and Fox share. Yet, this is not the terrifying anonymity of Charlie/chRleeCA: within this Tribal network of networks, Facebook is invested in having the "real" identity of its user attached to his/her BwO as a distinct and intimate portrait (version) of that user, a portrait that is then one in a crowded web of other intimate user portraits. Second, as Zuckerberg begins to take the initial steps toward creating/coding Facebook in his dorm early in the film, as a typical Web 2.0 posthuman, he narrates what he

is doing in physical and virtual space: he catalogues his hacking on his livejournal, a detailed and technical online document that is the publicly open model of discussion that Facebook would later normalize; simultaneously, seated at his computer, the film provides a stream-of-consciousness voice-over of Zuckerberg reading/typing his posts while also in physical interaction with his dorm mates. Not only is the way in which a self-identity is established/expressed communal, but the process of coming to knowledge (i.e., how to collect pictures and put together "facemash") is also a multiuser experience: Zuckerberg is shown talking with his dorm mates about facemash's problems and it is Eduardo's "key ingredient," his chess-player ranking algorithm, that pulls the project together. While *The Matrix* shows digital information beamed/hyperlinked into the user's head (not unlike Fox's/Kelly's private online conversations), *The Social Network* melds both the physical and virtual users/communities and therefore showcases knowledge being generated in a trial-and-error, collective method/space. Finally, when the group finishes, one student asks "Who are you going to send it to?" to which Zuckerberg replies "Just a couple of people. The question is: who are they going to send it to?" This immediate acknowledgment of the Internet's communal base, and the exponential spread of any information or BwO within those networks, explains why there is no intimate familial contextualization for Zuckerberg: instead, *The Social Network* is a narrative about the Tribal (Facebook) groups, the many parents and gigantic extended family, that publicly birthed and raised Facebook.

More, all of the young characters involved and the modern Trent Reznor score (like the *Hackers'* soundtrack) signal to the audience that the film is a narrative about and for digital natives. However, while the law-suit/courtroom-esque structure provides the aforementioned true-life stability to the film, it also sets its "family squabbles" inside the same "adult" capitalistic worlds of *You've Got Mail* and *Antitrust*. If *You've Got Mail* is built around a nostalgic capitalism, *The Social Network* struggles with how (or if) the hacker ideals that Zuckerberg and Facebook begins with can translate into a global digital market that skips over traditional barriers of locality and language. *You've Got Mail* is somewhat quaint in that it is blindsided by Amazon's arrival mere years later, an event that would greatly contribute to the eventual closure of both small bookstores and larger chains (like Fox's Books, which is a near direct parallel to Borders);[11] while *You've Got Mail* acknowledges the Internet as a potentially positive and personal space, it completely ignores how it might transform the capitalistic world it sets itself in, perhaps partly

because both Fox and Kelly's products are physical objects (books). However, *The Social Network* showcases the same messy sense of digital ownership explored in chapter 6, wherein the product is essentially a no-thing or non-object, a set of scripts run on servers and displayed via a browser or app. The movie's lawsuits wrestle with the same sense of "hereditary" ownership Fox and Kelly's businesses are rooted in, yet the "families" involved are no longer purely biological and the bloodlines are no longer tracked by simply tracing backward. The Winklevoss twins are an updated version of *Antitrust*'s Winston, figures who still define the notion of property by the "original act" that brings it to the surface. Zuckerberg is the exact person Winston fears in that he holds none of these more traditional sentiments; instead, he upholds the communal collage of public knowledge and editing/re-(re-)writing as the essential form of digital creativity (and therefore property). As he argues "A guy who builds a nice chair doesn't owe money to everyone who ever has built a chair, okay? They came to me with an idea, I had a better one." Zuckerberg articulates the generational traumas of a Web 2.0, oversaturated informational world, where "inspiration" is not borne from an individual mind but rather from contact with others in physical and virtual networks: for Zuckerberg, the concept the Winklevoss twins provided is merely the initial spark, the basic raw material, to build a larger, more complicated product; to single out that raw material as more important, or even separate from, the process or (digital/physical) ecosystem/"family" responsible for its creation is impossible.

Still, we end the film with Zuckerberg himself claiming ownership and power ("I invented Facebook"), with the same hubris-packed defiance of Winston, ultimately subsuming his initial hacker ideals to betray Eduardo. It is this twist that shapes the strange digital landscape contemporary Web 2.0 users and technologies occupy. The all important founding narrative of the American Dream is in the foreground of *The Social Network*, but that myth is built on a capitalistic/materialistic base that is in contrast to the ethics behind the technology that is enabling Facebook. In the same way, chapter 4 of this text explored how the remilitarization of the Internet is a very real hazard for Internet users, the capitalistic reconstructions of the Internet are equally as threatening. Currently, the many discussions around "net neutrality" and whether the Internet should be "tiered," or how much an Internet provider can restrict a user's monthly download/upload limit, are battles that affect the machinic audience profoundly;[12] similarly, the increasing consolidation of who owns/controls the server spaces and basic physical infrastructure of

the Internet is becoming ever more problematic. Like chapter 6's discussion of *Antitrust*, the real tension of *The Social Network* then is how the machinic audience will find some balance between their capitalist and open-source impulses (or even whether they care to). Though Facebook has expanded to a giant global company with public stock offerings, it relies entirely on their networks of networked users providing terabytes upon terabytes of personal content. This conflicted oscillation between personal user and global corporation is then embodied by the film's version of Zuckerberg who is at once a role-model to a new generation of users while also a figurehead of the (Literate/Retribalized) capitalistic system constructed to make money off the Internet users' interactions.

The film ends with Marylin Delpy (Rashida Jones) reminding "creation myths need a devil." If the machinic audience is supposed to look up to him in some way, the devilish portrait is not particularly flattering: even though he insists he's "not a bad guy," he is an alienating and condescending figure pulled simultaneously and increasingly further into his own mind and his computers. The dispassionate way he disposes of Eduardo casts him in the same calculating and inhuman mold as the computers he uses and depends on. It is important then that the film ends with a gesture that restores some (post) humanity to him. Delpy corrects him by saying his mistake was not "blogging" but blogging while he was "drunk and stupid and angry," highlighting an experience likely familiar to the machinic audience. As such, the film ends with him as a lonely, rather than purposely isolated, figure. His "Friend Request" of ex-girlfriend Erica Albright (Rooney Mara) is a pseudo-apology and admission of guilt; his compulsive refresh of the page deconstructs his mythic status and instead establishes him as part of the machinic audience, reaching out in one of the more intimate ways he knows, digitally.

Conclusion

As I finished this text over the second half of 2013, I was reminded of the immense speed at which contemporary digital change takes place. Just as I felt I was starting to get a solid idea about how a robot historian might start to contextualize the cinematic and/or digital cultural interfaces being presented, a new event or movie would shift that dynamic. Edward Snowden's revelation of how deep and global the NSA's surveillant capacities and impulses demands more expansion beyond its brief mention in chapter 5. Too, following Facebook's public stock offer in 2012 (Gelles, "Facebook's IPO Value: $104B; Higher-than-Expected Starting Price"), Twitter released an IPO of their own (Rusli et al., "Twitter IPO Plan: Contrast Facebook"), forcing me to reconsider my thoughts on *The Social Network* (chapter 8) and begin to analyze, in more depth, the commodification of privacy and personal information on the Internet touched on in chapter 5. All the while, I felt that Internet-enabled hardware advances, like the releases of Google Glass's developer kits ("Google unveils app development kit for Glass") and the Oculus Rift (Prebble, "Virtual reality? Yes, and a world of wonder thanks to the Oculus Rift"), not to mention the looming (normalizing of) wearable computing exampled initially by smart watches ("Watch this space; Wearable computing") and the launch of the next generation of video game consoles (the Xbox One; Seitz, "Microsoft releases Xbox One in grand fashion") and the Playstation 4 (Poulisse, "Playstation 4 release kicks off console wars"), warranted more commentary as (possible) diegetic prototypes of the Internet. Still, for me, all these events culminate in the assurance that Hayles's biological–technological posthuman is the increasingly obvious cultural force.

This assurance was only further solidified by a number of movies that came out (or that I became aware of) that further complicate the arguments made in this text. I found that *lol* (Dir. Lisa Azuelos, 2012) and *The Internship* (Dir. Shawn Levy, 2013) would be useful

additions to chapter 7's discussion of the Internet as a necessary part of a machinic audience's cinematic worlds; *Her* (Dir. Spike Jonze, 2013) is also a further (and excellent) example of this. The Steve Jobs biopic *Jobs* (Dir. Joshua Michael Stern, 2013) provides an interesting bridge between the older generations of Internet users (Digital Immigrants, home computer users) and Digital Natives most familiar with Apple's portable Internet-enabled devices. I would also pair *The Fifth Estate* (Dir. Bill Condon, 2013.) with *Jobs* as a way of bridging between chapter 7's "naturalized" cinematic Internet and chapter 4's remilitarized Internet: while writing this book, I have only become more afraid of the potentially uneven power dynamics between individual users and larger infrastructure machines (corporate, military especially); *The Fifth Estate* does well to explain the tensions inherent in hacking, and how that resistive force is a problematic blend of transparency and lawlessness that encapsulates a number of the mainstream constructions of the 2014 Internet. I also found there was a whole other chapter to be written (planned, but cut out of this text) on the cinematic use of networked videogames and the Internet, specifically as it relates to *Ender's Game* (Dir. Gavin Hood, 2013). The film's use of child soldiers, unknowingly enhanced by digital spaces (synthetic realism) and "tricked" by what they think is a simulation of war, was fascinating. This illusion/trickery becomes especially important as more militaries turn to video games as a way of "training" civilians (potential soldiers) and enlisted soldiers alike (a practice becoming more mainstream with games like the *Call of Duty* series, the *Battlefield* series, but more interestingly the many evolutions of *America's Army* in the twenty-first century). I found, as well, that "man-in-the-middle" soldiers (chapter 4) were becoming messier and more technologically overt: while *Pacific Rim* (Dir. Guillermo del Toro, 2013) evolves Iron Man's simple cyborg forward, *Elysium*'s (Dir. Neill Blomkamp, 2013) and *Edge of Tomorrow*'s (Dir. Doug Liman, 2014) soldiers are regressing toward the 1980s "future" terminators, obvious biology–technology hybrids, constructed as grotesque and encaged (enmeshed). As diegetic prototypes of future human–Internet assemblages, they encourage their audiences to view the necessary blending of biology and technology as a desperate, restrictive, and overtly inhuman combination.

In short, my attempts to be a robot historian that kept up with the (virtual) heterotopia of the Internet failed simply because it was an impossible task to begin with. Instead, I was reminded that this text needs to have a Repetitive approach similar to the one chapter 3 proposes in reaction to an Internet user's organism(s)–full BwO unity.

My future hope is to add to this text in some way, but I suspect that the more frequent and detailed analysis will spring from other writing assemblages (robot historians) that will act and react to the world's important events and movies. Again, the very speed of change involved in the Internet necessitates a network of robot historians, all working and weaving together to sort and analyze the information and documents emerging from such a space. I suspect that the machinic audience I propose in this text will recognize itself and add its thoughts accordingly. Even still, the concept of the machinic audience that I had imagined when I began writing this text has changed, partly due to the events and movies mentioned above, but partly through my own thinking on the subject. As I made clear in the Introduction, there needs to be more expansion on the different racial, geographical, gender, and class-based perspectives of what is, as constructed in this text, a fairly homogenous group of Internet-using movie-viewers. The other hurdle I found was attempting to separate generations of value systems while not falling into the generalizing trap of age divisions. The machinic audience isn't divided by year of birth, but according to willing engagement with the Internet: a 50 year old could just as easily embrace being a member of the machinic audience as much as a 12 year old could reject it. While I might be willing to concede that it would be easier for a Digital Native to embrace being part of a machinic audience, I think that the more useful thinking I did on the subject had to do with how much residual Literate (and Retribalized) values remained and how much will remain in generations going forward.

So what might the future of the Internet look like? I suspect that Internet interfaces will become increasingly more internal, perhaps to the point of disappearing, relatively quickly; I semi-joke at the conclusion of chapter 2 that it won't be long until we're born internally digital, biologically evolved to include the Internet. While this is fanciful, I do think the (software, but mostly hardware) barriers between technological–biological will go away. This becomes especially important as wireless computing has doubled (Chen, "U.S. Mobile Internet Traffic Nearly Doubled This Year") and the ability to move throughout a physical world tethered to a virtuality and wearable space has become increasingly normal and sought after. With this, the population of Internet-enabled robots, drones in particular, will only increase: we're starting to see the edges of it problematically exampled by an increase in their military use ("Drones: 21st century war"), as well as an expansion in their corporate implementation (Amazon.com [Streitfeld, "Amazon plan: Delivery by drone"]; realty

companies [Hu, "Still Unconvinced, Home buyer?"]). Lastly, the potential near-future of quantum computing has made the outskirts of the postbiological a reality. The immense, almost incomprehensible, gap between binary and quantum computing (in combination with nanotechnology advancements and the shrinking of the Uncanny Valley) could bring about the sort of digital-only user that Moravec and Kuzweil imagine (Prigg, "Russian Billionaire Reveals Real-Life 'Avatar' Plan"). All of these predictions will make it essential to form stronger and more self-aware bonds with overt robots and the Internet at large, and to be especially judicious in examining their present (not past) use in hopes of best utilizing their effects. The most useful portions of McLuhan's theories have to do with his insistence that a "rear-view" perspective is foolhardy. An Internet user must examine her/his world and the technologies (and intellectual habits that arise from those technologies) as they are now in hopes of going forward with the best symbiotic relationship possible. In the same way that Walter Ong says oral cultures have all but disappeared ("Some Psychodynamics of Orality," 31–57), Literate Man, despite the dominant echoes of his/her value system, is nearing extinction. I am optimistic that the coming generations can incorporate the many useful elements of a Literate Man's (and Retribalized) value system into her/his own perspectives and navigations of the world. With a self-awareness and posthumanist impulse, the oncoming future users of the Internet will go forward into an incredibly fast-changing culture, making movies that reflect and resonate with their own particular values, with the tools and ethics necessary to create an engaged and livable world.

Notes

Introduction: The Robot Historian and the Internet

1. Manuel Castells's *Internet Galaxy* and Lev Manovich's *The Language of New Media* both provide very useful historical outlines of the Internet up to the point of their publications. Castells relies on Janet Abbate's *Inventing the Internet* (MIT Press, 2000) and John Naughton's *A Brief History of the Future* (Overlook, 2001). I also use Johnny Ryan's *A History of the Internet and the Digital Future* (New York: ReaktionBook, 2010) as well as J. P. Moschovitis et al.'s *History of the Internet: Chronology, 1843 to the Present* (Denver: ABC-CLIO, 1999).

2. A robot historian in 2050 might look back at 2014 as the end of Web 2.0 and the beginning of a Wearable Computing and Internet of Everything Era brought on by technologies such as Google Glass, the Pebble Watch, the Oculus Rift (not to mention the specter of a possible future quantum computer).

3. While I use the key McLuhan texts, *The Medium Is the Massage* (Random House, 1967) and *Understanding Media* (Sphere Books, 1967), my clearest comprehension of the concepts comes from an interview he did with *Playboy* in 1969, found in *Understanding Me: Lectures and Interviews.* (Toronto: McClelland & Stewart, 2003).

4. The "Y2K bug" lying in wait was the domino effect of older computer systems being date programmed with only two digits, instead of four (the "19" prefix implied) to indicate the year; therefore, a computer with this bug would go from "99" back down to "00" and the computer would think it was January 1, 1900. This "crisis" passed, though only after a time-exhaustive "checking and rewriting of millions of lines of computer code and the scrapping and replacement of equipment worth billions of dollars" (John Quiggin, "The Y2K scare: Causes, Costs and Cures," accessed July 18, 2013, http://www.uq.edu.au/economics/johnquiggin/JournalArticles05/QuigginAJPA05Y2K.pdf, 47).

5. For further explanations of the technical aspects of Web 2.0, see Felicia Wu Song's "Theorizing Web 2.0," *Information, Communication &*

Society 13.2 (2010), specifically pages 260–263, as well as Sam Murugesan's "Understanding Web 2.0," *IT Pro* (July/August 2007).

6. "The Internet of Everything" (or "The Internet of Things") is a relatively new concept, brought about by increasingly smaller/more powerful microchips and the proliferation of smartphones, pointing to the idea that nonnetworked objects (lamps, coffeemakers, etc.) can be "made" digital and plugged into the Internet. "Welcome to the Programmable World" by Bill Wasik (*Wired*, April 2013) imagines "smart homes," but also concerts in which a user's phone automatically pairs him/her with like-minded dates or allows a server to find him/her on a crowded dance floor with drinks via GPS.

7. De Landa rightly notes that Deleuze uses "assemblage" in a number of different ways depending on whether he is writing by himself or with Guattari. Like De Landa, I use the Deleuze's more "open" definition "while trying to capture the content of the second one through the distinction between the material and expressive components of an assemblage. Different assemblages have 'control knobs' of more or less homogeneity/heterogeneity: quantifying the degree of homo or hetero of the components, or the degree to which the assemblage's identity is rigid or flexibly determined" in Manuel De Landa, *Deleuze: History and Science* (New York: Atropos Press, 2010), 72–73. This allows an assemblage to be more "full" (or "cancerous" or "empty") than others, therefore expressing more or less unified or intense organism(s)-BwOs relationships.

1 The Cables under, in, and around Our Homes: "The Net" as Viral Suburban Intruder

1. Taken from Richard E. Drake's literature review in "Potential Health Hazards of Pornography Consumption as Viewed by Psychiatric Nurses." Original articles are: D. Zillman, "Effects of Prolonged Consumption of Pornography," in *Pornography: Research Advances and Policy Considerations*, ed. D. Zillman and J. Bryant (Hillsdale, NJ: Erlbaum, 1989), 127–157; D. Zillman and J. Bryant, "Effects of Massive Exposure to Pornography," in *Pornography and Sexual Aggression*, ed. N. M. Malamuth and E. Donnerstein (Orlando, FL: Academic, 1984), 115–138; E. Donnerstein, "Pornography: Its Effect on Violence against Women," in *Pornography and Sexual Aggression*, ed. N. M. Malamuth and E. Donnerstein (New York: Academic Press, 1984), 53–81; N. M. Malamuth, "Debriefing Effectiveness Following Exposure to Pornographic Rape Depictions," *Journal of Sex Research* 20 (1984): 1–13.

2. The General Society Survey didn't start publishing information on its respondents' Internet usage until 2000. In 2000, 87 percent of respondents claimed to have not visited a pornography site in the previous 30 days; by 2004, that number was up to 91.5 percent.

3. Neil Munroe's article "The Web's Pornicopia" is a strong history of the Child Online Protection Act and does very well to track shifting reactions from both government officials and users of the Internet. It is a fascinating explanation of how the government was trying to create a walled-off version of the Internet to save children from "obscenity" while still attempting to maintain a digital arena of free speech.

4. Rimm's work was later disproved by a number of sources but not before *Time*'s Elmer-DeWitt only worsened the initial panic of Rimm's report by conflating a number of his statistics to get to the "83.5%" of the Internet that the *Times* article reported as pornography. Donna L. Hoffman and Thomas P. Novak were the most vocal opponents. Jim Thomas's "When Cyberresearch Goes Awry: The Ethics of the Rimm 'Cyberporn' Study," *Information Society* 12 (2) (April 1996): 189–198, is an excellent summary of the details.

5. As mentioned in the Introduction, Turkle's *The Second Self* and *Life on the Screen* are both excellent texts in describing how users of that time interacted with their computers and how their identities were shaped by them.

6. While *Hackers* did not make nearly as much box office money ($7.5 million) as *The Net* in its original release, its best-selling soundtrack and cult status nearly 20 years later speaks to its influence and my included discussion of the film. All box office statistics were gathered from the individual films' boxofficemojo.com webpages.

2 The Evolution of the Web Browser: The Global Village Outgrown

1. The ability for multiple users to inhabit the digital space at once as separate agents moves the Tron software toward an initial (somewhat primitive) understanding of the Internet. If the Internet is a network of networked devices and users, then the original TRON can be seen as a very simple, early form of the Internet (a LAN party perhaps).

Similarly, *The Thirteenth Floor* appears to be a piece of nonnetworked software wherein one user at a time uses the world and the other entities are nonplayable characters (NPCs). However, the revelation that the initial world of the film is in fact a simulation that multiple users are interacting within at once points us toward it as a reflection of the Internet.

2. The remnants of this can be seen with Apple's iPhone touch-based interface (first released in 2007) in which "swiping" or "pinching" have essentially similar effects, regardless of the application.

3. This discussion of evolution and "legacy" is carried further with an in-depth discussion of *Avatar* and the machinic audience in chapter 3.

4. Jeff Flynn has actually undergone what Moravec predicts/advocates when outlining the postbiological, yet feels it necessary to sacrifice himself at the end. Alternatively, Quorra is a creature who opts to live

in the "real" rather than the digital ephemera, and, as such, would perhaps speak to a machine's/avatar's need/compulsion to "become" human.

5. I owe a deep debt to Candra Gill and her presentation "Tony Stark Doesn't Use Keyboards: Interaction Design in Blockbuster Movies" at the 2013 PCA/ACA conference in Washington, DC. Her excellent discussion of interfaces in contemporary films (in particular *Minority Report* and *Iron Man*) were very exciting and informative, and did much to add to my thinking here. Further, she was extremely generous in sending me a list of books to consider, many of which show up in this chapter.

To build on the comment about films effecting user/technology interface, Christina Brown's piece "How '*Minority Report*' Trapped Us In a World of Bad Interfaces" (http://www.theawl.com/2013/02/how-minority-report-trapped-us-in-a-world-of-bad-interfaces) details the reciprocal (and frustrating) attempts to have "real" interfaces mirror those imagined cinematic diegetic prototypes and how *Minority Report* in particular has influenced the interfaces of users ten years later.

3 *Avatar* in the Uncanny Valley: The Na'vi and Us, the Machinic Audience

1. Sadly, years later, Chamberlain admitted to "editing" the work of Racter, though claiming to not add any material but rather shape the poems. Further discussion of Racter by its author can be found at http://www.atariarchives.org/deli/write_about_itself.php.

2. It should be noted that Cameron's auteur status and previous track record with exceptionally successful films such as *Terminator* (1984), *Aliens* (1986), and *Titanic* (1997) must be factored into considering the film's success. While this is undeniably true, the twelve year gap between *Titanic* and *Avatar* suggests that it is the film's technological breakthroughs that drew a younger, contemporary audience that might not be familiar with his previous films. All box office figures come from the films' boxofficemojo.com pages

3. While the doppelgangers in both *Surrogates* and *Avatar* are not, by Coleman's definition, avatars, I would argue both films use surrogates-avatars as allegorical devices to explore the expanding (and increasingly physical) reality of an audience member's relationship to her/his digital avatars.

4. Cameron discusses the years he had to wait for the filming, editing, and projecting technology to catch up with his vision in many interviews and magazine profiles, including Joshua Davies's "James Cameron's New 3-D Epic Could Change Film Forever," *Wired*, accessed May 31, 2013, http://www.wired.com/magazine/2009/11/ff_avatar_cameron/all/ (2009); Brent Dunham, ed., *James Cameron: Interviews* (Jackson: University Press of Mississippi, 2012) among many others.

5. Ellen Grabier was on the Northeast MLA panel with me in 2010 when I first gave a version of this chapter.
6. For more detailed descriptions on how the technology works, see also Jenna Ng's "Seeing Movement: On Motion Capture Animation and James Cameron's Avatar," *Animation* 7.3 (November 2012) or Davies's "James Cameron's New 3-D Epic."
7. While I was unable to use Amanda LeBlanc's "Making Love, Making Violence Avatar-Style: Hyperreal Connection and Deconstructive Identification," in *Simulation in Media and Culture*, edited by Robin DeRosa (New York: Lexington Books, 2011) in this chapter, it influenced my thinking about Baudrillard's theories as enacted within *Avatar*.

4 Hacking against the Apocalypse: Tony Stark and the Remilitarized Internet

1. In writing this chapter I also considered Todd Standage's *The Turk* (New York: Walker, 2002); David Levy's *Chess and Computers* (Potomac, MD: Computer Science Press, 1976); and David Levy, ed., *Computer Chess Compendium* (London: B. T. Batsford, 1988). I am also indebted to Andrew Hodges's fantastic biography of Alan Turing (*The Enigma* [London: Vintage Books, 1983]).
2. Nate Silver's book *The Signal and the Noise* (New York: Penguin Press, 2012) details Kasparov's battle with Deep Blue in more depth.
3. I remember here *Blade Runner* (1982), the first two *Terminator* films (1984; 1991), and *I, Robot* (2004). These movies are more focused on intelligent robots (AI) rather than the Internet and therefore I don't discuss them at length.
4. Many other writers have noted that Neo uses a hollowed out copy of Baudrillard's *Simulacra and Simulation* as a hiding space for discs and money in *The Matrix*. The directors are obviously (and perhaps negatively) acknowledging the blurred lines between reality/simulation that a computer network generates as explored further in chapter 3 of this text.
5. While I also considered Slavoj Žižek's *Welcome to the Desert of the Real* (New York: Verso, 2002) and Paul Virilo's *Strategy of Deception*, trans. Chris Turner (New York: Verso, 2000), the most useful connections here were drawn from Baudrillard's *The Gulf War did not take place* (Bloomington: Indiana University Press, 1991) wherein he describes the dangers surrounding a modern warfare made unreal by the distance of spectacular television coverage and increasingly disembodied combat. The war games De Landa describes are just slightly more literal simulations.
6. Lawrence H. Suid in *Guts and Glory* (Lexington: University of Kentucky Press, 2002) highlights the ending sequence in which Lightman effectively gets the acting soldier to stand down as particularly egregiously unrealistic (446–452). In fact, he points out that the computer would

have no access to any computer network and especially not to telephone lines (451).

7. There are other more recent (and potentially healthy) fictional postbiological figures to draw on, like Zoe Graystone (Alessandra Torresani) from the television series *Caprica* (Syfy, Universal Cable Productions, 2009–2010).

8. Foucault, Baudrillard, and Deleuze and Guattari all point to the example of a capitalistic machine of labor as a site where civilians act in similar manners to a military machines. Within that capitalistic machine, Deleuze points to computers as a technology "whose passive danger is jamming and whose active one is piracy and the introduction of viruses" ("Postscript on the Societies of Control," 6). Deleuze and Guattari clarify this slightly in *What is Philosophy*, linking a negative portrayal of computers to the conceptual theft of capitalism and, in particular, advertising (10); this seems to imply then that there are other potentially positive, noncapitalistic modes to use the technologies of the Internet and computers.

9. In an alternate ending to the film ("Alternate Ending #1" on the *Swordfish* Blu-ray DVD), Stanley empties the bank account, save for $500, before Gabriel and Ginger can access the money, and distributes the cash to various charities.

10. Peter Krapp, "Terror and Play, or What Was Hacktivism?" *Grey Room* 21 (Fall 2005): 70–93; Eric Schmitt, David E. Sanger, and Charlie Savage, "Mining of Data is Called Crucial to Fight Terror." *New York Times*, June 8, 2013; David E Sanger and Thom Shanker, "Broad Powers seen for Obama in Cyberstrikes." *New York Times*, February 4, 2013.

11. Michelle Maltais, "Iran Nuke-Site Virus Came from U.S." *The Charleston Gazette*, June 2, 2012; James Hider, "Computer Virus that Halted Iran's Nuclear Plans 'Devised by US and Israeli Experts,'" *Times*, January 17, 2011; Choe Sang-Hun. "Cyberattacks Shut Down Web Sites in Korea," *New York Times*, June 26, 2013; "South Korea Blames North for 'Cyber Attacks,'" *Asian News International*, July 17, 2013; "North Korea Party Paper Denies South's 'Cyber Terrorism' Allegations," *BBC Monitoring Asia Pacific*, August 16, 2011; Jackie Calmes and Lee M. Steven, "Obama and Xi Tackle Cybersecurity as Talks Begin in California," *New York Times*, June 8, 2013; Peter Krapp, "Terror and Play," 72.

12. The FCS program was cancelled in 2009; however, the American Army has continued it under a new name, the Army Brigade Combat Team Modernization (http://www.defense.gov/releases/release.aspx?releaseid=12763).

13. Candra Gill's "Tony Stark Doesn't Use Keyboards: Interaction Design in Blockbuster Movies" at the 2013 PCA/ACA conference in Washington, DC, sparked the idea of Stark as hacker and how he was removed from the civilian hacker ethic.

14. As per boxofficemojo.com, *Iron Man* generated $318 million and *Iron Man 2* made $312 million in the United States.

5 With a Great Data Plan Comes Great Responsibility: The Enmeshed Web 2.0 Internet User

1. David H. Rothman describes the cheapest model, the Tandy 1500 HD, as "a six-pound notebook [which] offers a 1.44-megabyte floppy drive. The 20-megabyte hard drive stores about 10,000 pages, and the NEC V-20 chip runs at 10 megahertz. RAM is 640K. Price is $1,999"; the most expensive laptop, "The Outbound weighs nine pounds and costs $2,999 with a 1.44-megabyte floppy or $3,999 with a 40-megabyte hard drive." (*Money Magazine*, October 1, 1990, http://money.cnn.com/magazines/moneymag/moneymag _archive/1990/10/01/86115/index.htm, accessed July 19, 2013).
2. Information from "PDAs & Smartphones," *Encyclopedia of Products & Industries—Manufacturing*, edited by Patricia J. Bungert and Arsen J. Darnay, vol. 2. Detroit: Gale, 2008. 751–757.
3. Stephen Rex Brown, "'Everyone' is target of NSA, Snowden says," *New York Daily News*, July 9, 2013, 10; Pete Yost, "NSA Leaker Snowden Charged with Espionage," *Charleston Gazette*, June 22, 2013: A1.
4. Deleuze does not, in this essay, dismiss all computers and their users, but rather computers used within capitalistic assemblages that track users in order to exploit and monitor them. I do think he leaves open the possibility of using computers positively as each individual becomes aware of the effects and presence of these assemblages and is therefore able to use it as a tool of resistance and self identity (Gilles Deleuze and Félix Guattari, *What Is Philosophy?* [New York: Columbia University Press, 1996]).
5. Interestingly, the only person that overtly uses the Internet is Brill, who hacks into the NSA databases through a familiar GUI web browser.
6. David Lyons does an excellent job explaining and expanding Oscar Gundy's concept of the "panoptic sort" and its ramifications in *Surveillance Studies: An Overview* (Malden, MA: Polity Press, 2007, 41–43).
7. A good snapshot of the kind and price of digital cameras available in 2002: http://www.digitalcamerawarehouse.com.au/category8_1 .htm (accessed July 19, 2013). Most built-in smartphone cameras in 2013 are more technologically advanced, especially in terms of hard drive size and video capabilities (e.g., http://www.apple.com/ca /iphone/specs.html, accessed July 19, 2013).
8. *Firewall*, on the strength of its lead Harrison Ford, only brought in $82 million on a budget of $50 million; *The Blair Witch Project* and its more overtly mediated style of filmmaking brought just under $250 million. All figures via boxofficemojo.com.

9. In 2004, Sobchack is actually quite skeptical of the smaller screens of computers and how embodied an Internet user is ("The Scene of the Screen," in *Carnal Thoughts: Embodiment and Moving Image Culture* [Berkeley: University of California Press, 2004]). She advocates strongly for an increased awareness of technological bodily presences: "devaluing the physically lived body and the concrete materiality of the world, the dominant cultural 'presence' suggests that—if we do not take care—we are all in danger of becoming merely ghosts in the machine" (162).

10. The Blu-ray version of *The Amazing Spiderman* works in conjunction with a "Second Screen App" (increasingly common), allowing a user to use his/her tablet computer, synced to specific parts of the movie, to explore further production notes, interviews from the cast, storyboards, etc., engaging multiple senses and literacies at once in an experience the Digital Native might find engaging.

6 Don't Shoot the (Instant) Messenger: The Efficient Virtual Body Learns

1. While I don't specifically use them, I found Marcus Boon's *In Praise of Copying* (Cambridge, MA: Harvard University Press, 2012); Lawrence Lessig's *Free Culture* (New York: Penguin Books, 2004); and Simon Reynolds' *Retromania* (New York: Faber and Faber, 2011) very helpful.

2. Viktor Mayer-Schönberger's *delete* provides strong statistics and context around the amplification of computer hardware capabilities and usage (on pages 52 and 62–63 specifically). Recalling Hayles's discussions of the Macy Conferences and chapter 4 of this text, Ellul would argue these particular increases have only normalized a world where all is dependent on "feedback" (14) and that humans are cut "out of the loop," resulting in "the human being [as] no longer in any sense the agent of choice" (80).

3. Early research into "perceptual" or "automatic" learning shows that the human brain, via "fMRI Neurofeedback" may be capable of such feats, as it could potentially "acquire new learning, skills or memory, or possibly to restore skills or knowledge…without one's awareness of what is learned or memorized" (Takeo Watanabe et al., "Perceptual Learning Incepted by Decoded fMRI Neurofeedback Without Stimulus Presentation." *Science* 334.6061 [December 9, 2011]: 1413–1415).

4. Incredibly, like automatic learning, this is not complete science fiction: as Nick Blinton in the *New York Times* article "Computer Brain Interfaces Making Big Leaps" reports, "[researchers] from the Riken-M.I.T. Center for Neural Circuit Genetics at the Massachusetts Institute of Technology took us closer to this science-fiction world of brain tweaking last week when they said they were able to create a false memory in a mouse" (August 4, 2013, http://bits.blogs.nytimes

.com/2013/08/04/disruptions-rather-than-time-computers-might
-become-panacea-to-hurt/?_r=0. Retrieved August 14, 2013).
5. Because *Total Recall* and *Blade Runner* don't really reflect Internet
 usage, I didn't go very far in-depth with my analysis. I did how-
 ever enjoy Alison Lansberg's *Prosthetic Memory: The Transformation
 of American Remembrance in the Age of Mass Culture* (New York:
 Columbia University Press, 2004) and found it useful in forming the
 arguments of this chapter.
6. I'm speaking here of the Blu-Ray "Extended Director's Cut"; in the
 original theatrical release, Farrell plays both Quaid and Hauser.

7 The Reel/Real Internet: Beyond Genre and the Often Vulnerable Virtual Family

1. We discussed (private) home computer and Internet presence in the
 Introduction and chapter 1, but Aimée Morrison adds "Internet users,
 of the late 1990s were far more likely to access the web from work or
 home and were again far more likely to use desktop machines than
 the elegant laptops [the] characters are depicted favouring" (50).
2. This is similar to Baudrillard's treatment of the computer in *The
 System of Objects* (discussed further in chapter 4 of this text).
3. The correction has mostly been made as amazon.com lists *Disclosure*
 under "Mystery and Suspense"; imdb.com lists it as a "Drama" or
 "Thriller."
4. The filmmakers were very aware of this though: the film's director
 Levinson's production notes speak to this: the VR "does not show the
 technology as it is currently available, but rather, a version of what is
 expected of that technology in the future." Neil Spisak adds that the
 actual computers at the workspaces of DigiCom "add a definite tex-
 ture to the movie ... We researched what exists now and what it means
 to be 'advanced' and where the technology will be five years from
 now" (http://www.levinson.com/bl/disclosure/prod.htm, accessed
 September 17, 2013).
5. The film's page at rottentomatoes.com (accessed September 17, 2013);
 Sara Jane Finlay and Natlie Fenton's "'If You've Got a Vagina and an
 Attitude, that's a Deadly Combination': Sex and Heterosexuality in *Basic
 Instinct, Body of Evidence and Disclosure*," *Sexualities* 8.1 (February 2005):
 49–74; Rajani Sudan's "Technophalla," *Camera Obscura* (May 1997).
6. The term "exceptional smurfette" came to me from a respondent
 in the Q & A period at the 2013 PCA/ACA conference. Further
 explored/defined in Ekaterina Sedia's "Another Word: The
 Exceptional Smurfette, or Being One of the Guys as a Superpower,"
 Clarkesworld Magazine, July 2012.
7. The film shows a 78 percent score at its rottentomatoes.com page
 (accessed September 17, 2013). The much more popular documen-
 tary *Catfish* was released within months of the film.

8. Sven Birkerts, in the previously discussed "Into the Electronic Millennium" very pointedly describes one of the morbid symptoms of "the protoelectric era" was the "erosion of language," which he characterized not just as the loss of the ability to spell and punctuate correctly but also to articulate complex ideas due to a stunted vocabulary.

9. *The Social Network* won three Oscars and was nominated for a number of other awards during 2011/12 (imdb.com); the film made nearly 225 million dollars worldwide on a production budget of 40 million dollars (boxofficemojo.com).

10. Fitting with this chapter's previous discussion, women that are present in the film are reduced to "crazy" girlfriend (Christy, played by Brenda Song) or tech groupies (an argument explored further in "Friendship Pending" by Susanna Nelson [*Screen Education* 61 (2011): 8–15]).

11. Ben Baeder, "In Wake of Borders Closings, Future of Local Bookstores in Doubt," *Whittier Daily News*, February 26, 2011; Robert Dominguez, "Story of Borders about to End on Chapter 11," *New York Daily News*, July 19, 2011, 26.

12. Chang, Richard, and Kim Dixon, "Lawmaker Plans Bill on Web Neutrality," *eWeek* November 14, 2008; Roy Mark, "Net Neutrality Debate Still on," *eWeek* December 1, 2008; A more negative approach by John Hayward, "Net Neutrality for Dummies," *Human Events* 68.15 (April 30, 2012): 14.

Works Cited

Adorno, T. W. "Culture Industry Reconsidered." In *Audience Studies Reader*. Ed. Will Brooker and Deborah Jermyn. New York, Routledge, 2003. 55–60.

Altman, Rick. "A Semantic/Syntactic Approach to Film Genre." *Cinema Journal* 23.3 (1984): 6–18.

Altman, Rick. *Film/Genre*. London: BFI Publishing, 1999.

Amsden, David. "The Brilliant Life and Tragic Death of Aaron Swartz." *Rolling Stone*. February 28, 2013.

Apple Computer, Inc. *Macintosh Human Interface Guidelines*. New York: Addison-Wesley, 1992.

Baecker, Ronald M., and William A. S. Buxton. *Reading in Human-Computer Interaction: A Multidisciplinary Approach*. New York: Morgan Kaufmann, 1987.

Baran, Paul. "On Distributed Communications." Accessed December 12, 2013. http://web.archive.org/web/20101228070851/http://www.rand.org/about/history/baran-list.html.

Barnett, P. C. "Reviving Cyberpunk: (Re)Constructing the Subject and Mapping Cyberspace in the Wachowski Brother's Film *The Matrix*." *Extrapolation* 41.4 (2000): 359–374.

Bartlett, Frederic. *Remembering*. Cambridge: Cambridge University Press, 1995.

Baudrillard, Jean. "The Ecstasy of Communication." In *The Anti-Aesthetic: Essays on Postmodern Culture*. Ed. Hal Foster. New York: New Press, 2002. 126–134.

Baudrillard, Jean. *Simulacra and Simulation*. Translated by Sheila Faria Glaser. Ann Arbor: University of Michigan Press, 1994.

Baudrillard, Jean. *The System of Objects*. New York: Vintage, 2005.

Bazin, André. "The Ontology of the Photographic Image." In *The Film Theory Reader: Debates and Arguments*. Ed. Marc Furstenau. New York: Routledge, 2010.

Benjamin. Walter "The Work of Art in the Age of Its Technological Reproduction: Second Version." In *Selected Writings*. Ed. Howard Eiland and Michael W. Jennings. Cambridge, MA: Harvard University Press, 2004.

Bennet-Smith, Meredith. "Steubenville High School Students Joke about Rape in Video Leaked by Anonymous." *Huffington Post.* Accessed December 22, 2013. http://www.huffingtonpost.com/2013/01/02/steubenville-high-school-joke-rape-targeted-anonymous-video_n_2398479.html.

Bentham, Jeremy. *Panopticon Writings.* London: Verso, 1995.

Bertolucci, Bernardo. "Interview with Bernardo Bertolucci." *Bertolucci, Bernardo Interviews.* As cited in Bruygone, Robert. "Memory, History and Digital Imagery in Contemporary Film." In *Memory and Popular Film.* Ed. Paul Grainge. New York: Manchester University Press, 2003. 220–236.

Beuka, Robert. *Suburbia Nation.* New York: Palgrave Macmillan, 2004.

Birkerts, Sven. "Into the Electronic Millennium." *Boston Review.* October 1991. Accessed July 20, 2013. http://new.bostonreview.net/BR16.5/birkerts.html.

Birkerts, Sven. *Guttenberg Elegies.* Winchester, MA: Faber and Faber, 1994.

Blum, Andrew. *Tubes: A Journey to the Center of the Internet.* New York: Ecco, 2012.

Bök, Christian. "The Piecemeal Bard Is Deconstructed: Notes Towards a Potential Robopoetics." *Object 10: Cyberpoetics,* Winter 2002. Accessed May 30, 2013. http://www.ubu.com/papers/object/03_bok.pdf.

Bolt, Richard A. *The Human Interface: Where People and Computers Meet.* New York: Lifetime Learning, 1984.

Bowden, Mark. *Worm: The First Digital World War.* New York: Atlantic Monthly Press, 2011.

boyd, danah. "The Advantages of Amnesia" (Jessica Winters). *Boston Globe.* September 23, 2007. As cited in Mayer-Schönberger, Viktor. *delete.* Princeton: Princeton University Press, 2009. 154.

Brachman, Jarret. "Internet as Emirate: Al-Qaeda's Pragmatic use of the Virtual Jihad." *The Officer.* 81.10 (December 2005): 95–8.

Braidotti, Rosi. *The Posthuman.* Cambridge, UK: Polity Press, 2013.

Brandon, Karen. "Cyber Survivalists Fear Year 2000 Means Apocalypse." *The Ottawa Citizen.* August 5, 1998.

Brians, Ella. "The 'Virtual' Body and the Strange Persistence of the Flesh: Deleuze, Cyberspace and the Posthuman." In *Deleuze and the Body.* Ed. Laura Guillaume and Joe Hughes. Edinburgh: Edinburgh University Press, 2011.

Broom, Jack. "Rooting for the Human." *Seattle Times.* February 15, 1996.

Brophy-Warren, Jamin. "4chan: The Site to See for Viral Ideas; 4chan Is Known for Spreading Web Trends; Now, Its Founder Speaks Out." *Wall Street Journal.* July 11, 2008.

Brown, William. "Avatar: Stereoscopic Cinema, Gaseous Perception and Darkness." *Animation* 7.3 (November 2012): 259–271.

Brown, William. "Man Without a Movie Camera—Movies Without Men." *Film Theory and Contemporary Hollywood Movies.* Ed. Warren Buckland. New York: Routledge, 2009. 66–86.

Brunner, John. *The Shockwave Rider.* New York: Del Rey, 1977.

Bruygone, Robert. "Memory, History and Digital Imagery in Contemporary Film." In *Memory and Popular Film*. Ed. Paul Grainge. New York: Manchester University Press, 2003. 220–236.

Bush, Vannevar. "As We May Think." *The Atlantic*. July 1, 1945. Accessed August 15, 2013. http://www.theatlantic.com/magazine/archive/1945/07/as-we-may-think/303881/.

Byrne, Deirdre. "The Messiah Versus Collective Consciousness in the Matrix Triology." *English Studies in Africa* 48.2 (January 2005): 61–74.

Cameron, James. "James Cameron, Director." Interview with Charlie Rose. February 17, 2010. Accessed May 5, 2013. http://www.charlierose.com/view/interview/10866.

Campbell, Bradley, and Matt Snyders. "Craigslist Declassified." *The Village Voice*. May 12, 2009.

Carr, Nicholas. "Is Google Making Us Stupid?" *The Atlantic*. July/August 2008. Accessed August 15, 2013. http://www.theatlantic.com/magazine/archive/2008/07/is-google-making-us-stupid/306868/.

Casilli, Antonio A. "A History of Virulence: The Body and Computer Culture in the 1980s." *Body & Society* 16.4 (December 2010): 1–31.

Castells, Manuel. *The Internet Galaxy: Reflections on the Internet, Business, and Society*. Toronto: Oxford University Press, 2001.

Chambers, John. "The Internet of Everything: Let's Get This Right." *Wired*. Accessed May 3, 2013. http://www.wired.com/opinion/2012/12/the-internet-of-everything-lets-get-this-right/.

Chen, Brian X. "U.S. Mobile Internet Traffic Nearly Doubled This Year." *New York Times*. Accessed December 27, 2013. http://bits.blogs.nytimes.com/2013/12/23/u-s-mobile-internet-traffic-nearly-doubled-this-year/?_r=0.

Clarke, Roger. "Information Technology and Dataveillance." *Communications of the ACM* 31.5 (1988): 498–512.

Cohen, David. "Digital Proves Problematic." *Variety*. April 20, 2007. Accessed August 15, 2013. http://variety.com/2007/film/news/digital-proves-problematic-1117963533/.

Coleman, Beth. *Hello Avatar: Rise of the Networked Generation*. Cambridge, MA: MIT Press, 2011.

"Communications Decency Act." 1996. Accessed December 29, 2013. http://transition.fcc.gov/Reports/tcom1996.txt.

Connolly, P. J. "A Return to Echelon." *Infoworld*. 23.25. June 18, 2001. 76.

Cook, Richard, Alan Johnston, and Cecilia Heyes. "Self-Recognition of Avatar Motion: How Do I Know It's Me." *Proceedings of the Royal Society B: Biological Sciences* (February 2012): 669–674.

Custen, Geroge F. *Bio/Pics: How Hollywood Constructed Public History*. New Brunswick, NJ: Rutgers University Press, 1992.

Davies, Joshua. "James Cameron's New 3-D Epic Could Change Film Forever." *Wired*. Accessed May 31, 2013. http://www.wired.com/magazine/2009/11/ff_avatar_cameron/all/.

Davis, Michele E., and Jan A. Phillips. *Learning PHP & MySQL*. Cambridge: O'Reilly, 2006.

Debord, Guy. *Society of the Spectacle*. 1967. Detroit: Black and Red, 1970.

De Hertogh Steven, Stijn Viaene, and Guido Dedene. *Communications of the ACM* 54.3 (March 2011): 124–130.

De Landa, Manuel. *A New Philosophy of Society: Assemblage Theory and Social Complexity*. London: Continuum, 2006.

De Landa, Manuel. *A Thousand Years of Nonlinear History*. New York: Swerve Editions, 2000.

De Landa, Manuel. *Deleuze: History and Science*. New York: Atropos Press, 2010.

De Landa, Manuel. *Intensive Science and Virtual Philosophy*. New York: Continuum, 2002.

De Landa, Manuel. *War in the Age of Intelligent Machines*. New York: Zone, 1991.

Deleuze, Gilles. *Cinema 1: The Movement-Image*. Translated by Hugh Tomlinson and Barbara Habberjam. Chicago: University of Minnesota Press, 1986.

Deleuze, Gilles. *Cinema 2: The Time-Image*. Translated by Hugh Tomlinson and Robert Galeta. Chicago: University of Minnesota Press, 1989.

Deleuze, Gilles. *Foucault*. Translated by Seán Hand. London: Continuum, 2006.

Deleuze, Gilles. *The Logic of Sense*. London: Continuum, 1969.

Deleuze, Gilles. "Postscript on the Societies of Control." *October* 59 (Winter 1992): 3–7.

Deleuze, Gilles. *Difference and Repetition*. Translated by Paul Patton. New York: Columbia University Press, 1994.

Deleuze, Gilles, and Félix Guattari. *Anti-Oedipus: Capitalism and Schizophrenia*. New York: Penguin Books, 1977.

Deleuze, Gilles, and Félix Guattari. *A Thousand Plateaus*. Translated by Brian Massumi. Minneapolis: University of Minnesota, 1987.

Deleuze, Gilles, and Félix Guattari. *What Is Philosophy?* New York: Columbia University Press, 1996.

Denzin, Norman K. *The Cinematic Society: The Voyeur's Gaze*. Thousand Oaks, CA: Sage, 1995.

Doueihi, Milad. *Digital Cultures*. Cambridge, MA: Harvard University Press, 2011.

Doyle, Aaron. "Revisiting the Synopticon: Reconsidering Mathiesen's 'The Viewer Society' in the Age of Web 2.0." *Theoretical Criminology* 15.3 (2011): 283–299.

Dixon, Wheeler Winston. *It Looks at You*. Albany: State University of New York Press, 1995.

Dragunoiu, Dana. "Neo's Kantian Choice: *The Matrix Reloaded* and the Limits of the Posthuman." *Mosaic: A Journal for the Interdisciplinary Study of Literature* 40.4 (2007): 51–67.

Drake, Richard E. "Potential Health Hazards of Pornography Consumption as Viewed by Psychiatric Nurses." *Archives of Psychiatric Nursing* 8.2 (April 1994): 101–106.

"Drones." *The Charleston Gazette*. December 03, 2012.

Ebert, Roger. "The Best Films of The Decade." *Rogerebert.com*. December 30, 2009. Accessed August 17, 2013. http://www.rogerebert.com/rogers-journal/the-best-films-of-the-decade.

"Electronic Commerce Interest Group." Accessed December 20, 2013. http://www.w3.org/ECommerce/.

Elmer-Dewitt, Philip, and Hannah Bloch. "On a Screen Near You: Cyberporn." *Time* 146.1 (1995): 38.

Ellul, Jacques. *The Technological Society*. Translated by Robert K. Merton. New York: Alfred A. Knopf, 1964.

Farrell, Greg. "FBI Cyber Sleuths Capture Alleged Silk Road Internet Crime Boss." *Sunday Phoenix*. October 20, 2013.

Father Knows Best. Created by Ed James. Performed by Robert Young, Jane Wyatt. October 3, 1954–May 23, 1960. TV series.

Featherstone, Mike. "In Pursuit of the Postmodern: An Introduction." *Theory, Culture and Society* 2.3 (June 1988): 195–215. As cited in Thomas, Jim. "The Moral Ambiguity of Social Control in Cyberspace: A Retro-Assessment of the 'Golden Age' of Hacking." *New Media and Society* 7.5 (October 2005): 599–624.

Filiol, Eric. *Computer Viruses: From Theory to Applications*. Berlin: Springer, 2005.

Foucault, Michel. *Discipline and Punish*. Translated by Alan Sheridan. New York: Vintage Books, 1995.

Foucault, Michel. "Of Other Spaces: Utopias and Heterotopias." In *Rethinking Architecture: A Reader in Cultural Theory*. Ed. Neil Leach. New York: Routledge, 1997. 330–336.

Foucault, Michel. "Prisons et asiles dans le mécanisme du pouvoir." *Dits et Ecrits11*. Paris: Gallimard. 1994. 523–4. Translated by Clare O'Farrell. Accessed December 20, 2013. http://www.michel-foucault.com/quote/2004q.html.

Frank, Arthur. "The Body's Problems with Illness." In *The Body Reader*. Ed. Lisa Jean Moore and Mary Kosut. New York: New York University Press, 2010. 31–47.

Freud, Sigmund. "The Uncanny." In *The Uncanny*. Translated by David McLintock. New York: Penguin Books, 2003.

Gelles, Jeff. "Facebook's IPO Value: $104B; Higher-than-Expected Starting Price; Rush Marked by Questions." *Philadelphia Inquirer*. May 18, 2012. A1

Gibson, William. *Neuromancer*. New York: Ace Books, 1984.

Gillespie, Tarlteon. "The Stories Digital Tools Tell." In *New Media: Theories and Practices of Digitextuality*. Ed. Anna Everett and John T. Caldwell. New York: Routledge, 2003.

"Google Unveils App Development Kit for Glass." *Asian News International.* November 20, 2013.

Grabier, Ellen. *I See You: The Shifting Paradigms of James Cameron's Avatar.* Jefferson, NC: McFarland, 2012. Kindle Edition.

Gray, Chris Hables. *Cyborg Citizen: Politics in the Posthuman Age.* New York: Routledge, 2002.

Grindon, Leger. *The Hollywood Romantic Comedy.* Oxford: Wiley-Blackwell, 2011.

Governor, James, Dion Hinchcliffe, and Duane Nickull. *Web 2.0 Architectures.* Sebastopol, CA: O'Reilly Media, 2009.

Grainge, Paul. "Introduction." In *Memory and Popular Film.* Ed. Paul Grainge. New York: Manchester University Press, 2003. 1–20.

Grigoriadis, Vanessa. "4chan's Chaos Theory." *Vanity Fair.* April 2011. Accessed July 20, 2013. http://www.vanityfair.com/business/features /2011/04/4chan-201104.

Grossman, Lev. "Person of the Year: You." *Time.* December 2007. 38.

Gumpert, Gary, and Suan J. Drucker. "Public Boundaries: Privacy and Surveillance in a Technological World." *Communication Quarterly* 49.2 (2001): 115–129.

Haggerty, Kevin D. "Tear Down the Walls." In *Theorizing Surveillance: The Panopticon and Beyond.* Ed. David Lyon. Cullompton, Devon: Willan, 2006. 23–45.

Halavais, Alexander. *Search Engine Society.* Cambridge, MA: Polity Press, 2009.

Hansen, Mark B. N. *Bodies in Code: Interfaces with Digital Media.* New York and London: Routledge, 2006.

Hansen, Mark D. "The Year 2000: Apocalypse Soon." *Professional safety* 44.2 (1999): 37–41.

Haraway, Donna J. *Simians, Cyborgs, and Women: The Reinvention of Nature.* New York: Routledge, 1991.

Harris, Richard, and Peter Larkham. "Suburban Foundation, Form and Function." In *Changing Suburbs: Foundation, Form, and Function.* Ed. Richard Harris and Peter Larkham. New York: Routledge, 1999.

Hayles, N. Katherine. *How We Became Posthuman.* Chicago: University of Chicago Press, 1999.

Hayles, N. Katherine. *My Mother Was a Computer: Digital Subjects and Literary Texts.* Chicago: University of Chicago Press, 2005.

Hayles, N. Katherine. "Traumas of Code." *Critical Inquiry* 33.1 (Autumn 2006): 136–157.

Hayles, N. Katherine. "Waking Up to the Surveillance Society." *Surveillance and Society* 6.3 (2009): 313–316.

Heim, Michael. *The Metaphysics of Virtual Reality.* New York: Oxford University Press, 1993. As cited in Muri, Allison. "Of Shit and Soul: Tropes of Cybernetic Disembodiment in Contemporary Culture." *Body and Society* 9.3 (2003): 73–92.

Herbrechter, Stefan. *Posthumanism: A Critical Analysis.* New York: Bloomsbury, 2013.

4444444444444

44444444444444

44444444444444



Hoskins, Andrew. "The Mediatisation of Memory." In *Save As...Digital Memories*. Ed. Joanne Garde-Hansen, Andrew Hoskins, and Anna Reading. New York: Palgrave Macmillan, 2009. 1–26.

Hruska, Jan. *Computer Viruses and Anti-Virus Warfare*. New York; Ellis Horwood. 1990.

Hu, Winnie. "Still Unconvinced, Home Buyer? Maybe a Drone Camera Will Create Some Buzz." *New York Times*. December 24, 2013.

Hulsbus, Monica. "Viral Bodies, Virtual Practices."*Convergence: The International Journal of Research into New Media Technologies* 7.3 (September 2001): 18–27.

"Interview with Jean-Claude Carriere." *Conversations about the End of Time*. Ed. Catherine David and Frederic Lenoir. London: Penguin. New edition. 2000.

"Introduction." In *Save As...Digital Memories*. Ed. Joanne Garde-Hansen, Andrew Hoskins, and Anna Reading. New York: Palgrave Macmillan, 2009. 1–26.

Jameson, Fredric. *Postmodernism, Or, the Cultural Logic of Late Capitalism*. Durham, NC: Duke University Press, 1990.

Johnson, Trevor. "Final Fantasy: The Spirits Within." *Time Out*. Accessed May 31, 2013. http://www.timeout.com/london/film/final-fantasy-the -spirits-within.

Joint, Nicholas. "Digital Information and the 'Privatisation of Knowledge.'" *Library Review* 56.8 (January 2007): 659–665.

Jones, Brian. "New Technology in AVATAR—Performance Capture, Fusion Camera System, and Simul-Cam." *Avatarblog*. Accessed May 31, 2013. http://avatarblog.typepad.com/avatar-blog/2010/05/new-technology -in-avatar-performance-capture-fusion-camera-system-and-simulcam. html.

Kaleem, Jaweed. "Death On Facebook Now Common As 'Dead Profiles' Create Vast Virtual Cemetery." Accessed December 23, 2013. http:// www.huffingtonpost.com/2012/12/07/death-facebook-dead-profiles _n_2245397.html.

Kelly, Christopher M. *Two Bits*. Durham, NC: Duke University Press, 2008.

Kidder, Tracy. *The Soul of a New Machine*. New York: Back Bay Books, 1981.

Kirby, David. "The Future is Now: Diegetic Prototypes and the Role of Popular Films in Generating Real-world Technological Development." *Social Studies of Science* 40.1 (February 2010): 41–70.

Knafo, D., and Feiner, K. "Film Review Essay Blue Velvet: David Lynch's Primal Scene." *International Journal of Psychoanalysis* 8 (2002): 1445–1451.

Koepsell, David R. *The Ontology of Cyberspace: Law, Philosophy, and the Future of Intellectual Property*. New York: Open Court, 2000.

Krapp, Peter. "Terror and Play, or What Was Hacktivism?" *Grey Room* 21 (Fall 2005): 70–93.

Krotoski, Aleks. "Meet the Cyber Radicals using the Net to Change the World: Christopher 'Moot' Poole 4chan." *The Observer*. November 28, 2010.

Kunzru, Hari. "You are Cyborg." *Wired*. February 5, 1997. Accessed May 30, 2013. http://www.wired.com/wired/archive/5.02/ffharaway.html.

Kurzweil, Ray. *The Age of Intelligent Machines*. Cambridge, MA: MIT Press, 1990.

Kurzweil, Ray. *The Age of Spiritual Machines: When Computers Exceed Human Intelligence*. New York: Viking, 1999.

Lakoff, George, and Mark Johnson. *Metaphors We Live By*. Chicago: University of Chicago Press, 2003. Kindle edition.

Lansberg, Alison. "Prosthetic Memory: *Blade Runner* and *Total Recall*." *Body and Society 1.3*. (November 1995): 175–189.

Lansberg, Alison. "Prosthetic Memory: The Ethics and Politics of Memory in an Age of Mass Culture." In *Memory and Popular Film*. Ed. Paul Grainge. New York: Manchester University Press, 2003. 144–161.

Laurel, Brenda. *Computers as Theatre*. New York: Addison-Wesley, 1992.

Lee, Christina. "Lock and Load(up): The Action Body in *The Matrix*. *Continuum* 19.4 (December 2005): 559–569.

Levy, Steven. *Hackers: Heroes of the Computer Revolution*. New York: Dell, 1984.

Lunenfeld, Peter. "Space Invaders: Thoughts on Technology and the Production of Culture." In *New Media: Theories and Practices of Digitextuality*. Ed. Anna Everett and John T. Caldwell. New York: Routledge, 2003. 63–74.

Lynch, Robert. "Kasparov Falters, Deep Blue Prevails." *MIDRANGE Systems*. May 30, 1997.

Lyon, David. "Surveillance, Power and Everyday Life." In *Emerging Digital Spaces in Contemporary Society*. Ed. Phillip Kalantzis-Cope and Karim Gherab-Martin. New York: Palgrave, 2011. 107–120.

Lyon, David. *The Electronic Eye*. Minneapolis: University of Minnesota, 1994.

Lyotard, Jean-François. *The Postmodern Condition*. Translated by Geoffrey Bennington and Brian Massumi. Minneapolis: University of Minnesota Press, 1979.

Lyotard, Jean-François. *The Inhuman*. Translated by Geoffrey Bennington and Rachel Bowlby. Stanford: Stanford University Press, 1992.

Macklin, William R. "Deep Blue Engendered Latent Fear, Loathing Of Machines." *Seattle Times*. February 19, 1996.

Mamber, Stephen. "Narrative Mapping." In *New Media: Theories and Practices of Digitextuality*. Ed. Anna Everett and John T. Caldwell. New York: Routledge, 2003.

Mann, Katrina. "'You're Next!': Postwar Hegemony Besieged in Invasion of the Body Snatchers (1956)." *Cinema Journal* 44.1 (December 2004): 49–68.

Manovich, Lev. *The Language of New Media*. Cambridge, MA: MIT Press, 2001.

Manovich, Lev. "The Poetics of Augmented Space." In *New Media: Theories and Practices of Digitextuality*. Ed. Anna Everett and John T. Caldwell. New York: Routledge, 2003.

Manovich, Lev. "What is Digital Cinema." Accessed May 31, 2013. http://www.manovich.net/TEXT/digital-cinema.html.

Martin, Ralph G. "Life in the New Suburbia." In *Suburbia: The American Dream and Dilemma*. Ed. Philip C. Dolce. Garden City, NY: Anchor Books, 1976.

Marx, Gary T. "Electric Eye in the Sky: Some Reflections on the New Surveillance and Popular Culture." In *Computers, Surveillance, and Privacy*. Ed. David Lyon and Elia Zureik. Minneapolis: University of Minnesota Press, 1996.

Mathiesen, Thomas. "The Viewer Society: Michel Foucault's 'Panopticon' Revisited." *Theoretical Criminology* 1.2 (1997): 215–234.

Mayer-Schönberger, Viktor. *delete*. Princeton: Princeton University Press, 2009.

McLuhan, Marshall. "*Playboy* Interview." In *Understanding Me: Lectures and Interviews*. Ed. Stephanie McLuhan and David Staines. Toronto: McClelland and Stewart, 2003.

"mesh, n. (and adj.)." *OED Online*. June 2013. Oxford University Press. Accessed July 20, 2013. http://www.oed.com.ezproxy.lib.ryerson.ca/view/Entry/116958rskey=9AtoDx&result=1&isAdvanced=false.

Metz, Christian. "The Imaginary Signifier." In *Film and Theory: An Anthology*. Ed. Robert Stam and Toby Miller. Malden, MA: Blackwell, 2000. 408–436.

Metz, Christian. "'Trucage' and the Film." *Critical Inquiry* 3.4 (1977): 657–675.

Moravec, Hans P. *Mind Children: The Future of Robot and Human Intelligence*. Cambridge, MA: Harvard University Press, 1988.

Mori, Masahiro. "The Uncanny Valley." *http://spectrum.ieee.org*. Accessed May 31, 2013. http://spectrum.ieee.org/automaton/robotics/humanoids/the-uncanny-valley.

Morrison, Aimée. "Newfangled Computers and Old-Fashioned Romantic Comedy." *Canadian Journal of Film Studies* 19.1 (2010): 41–58.

Moschovitis, Christos J. P. et al. *History of the Internet: Chronology, 1843 to the Present*. Denver: ABC-CLIO, 1999.

Mulrooney, Jonathan. "The Sadness of Avatar." *Wordsworth Circle* 42.3 (Summer 2011): 201.

Munro, Neil. "The Web's Pornocopia." *National Journal* 31.1 (1999): 38.

Mulvey, Laura. "Visual Pleasure and Narrative Cinema." In *Audience Studies Reader*. Ed. Will Brooker and Deborah Jermyn. New York: Routledge, 2003. 133–143.

Muri, Allison. "Of Shit and the Soul: Tropes of Cybernetic Disembodiment in Contemporary Culture." *Body and Society* 9.3 (2003): 73–92.

Murugesan, Sam. "Understanding Web 2.0." *IT Pro* (July/August 2007): 34–71.

Neale, Steve. *Genre and Hollywood*. New York: Taylor and Francis, 2005.

Nelson, Susanna. "Friendship Pending." *Screen Education* 61 (2011): 8–15.

Ng, Jenna. "Seeing Movement: On Motion Capture Animation and James Cameron's Avatar." *Animation* 7.3 (November 2012): 273–286.

Nilsson, Harry. "The Puppy Song." *You've Got Mail Soundtrack*. Atlantic, 1998.

Norman, Donald A. *Emotional Design*. New York: Basic Books, 2004.

Norman, Donald A. *The Design of Everyday Things*. Originally published: *The Psychology of Everyday Things*. New York: Basic Books, 2002, c1988.

Nurka, Camille. "Exposing Power in Michael Crichton's *Disclosure*." *Continuum*. 16.2 (June 2002). 157–167.

Ong, Walter. "Some Psychodynamics of Orality." *Orality and Literacy*. New York: Routledge, 2002. 31–57.

Perlroth, Nicole. "Luring Young Web Warriors is a U.S. Priority: It's also a Game." *New York Times*. March 25, 2013.

Pence, Jeffery. "Postcinema/Postmemory." In *Memory and Popular Film*. Ed. Paul Grainge. New York: Manchester University Press, 2003. 237–256.

Piazza, Joe. "Audiences Experience 'Avatar' Blues." Accessed May 31, 2013. http://www.cnn.com/2010/SHOWBIZ/Movies/01/11/avatar.movie.blues/index.html.

Pierson, Michele. "No longer State-of-the-Art: Crafting a Future for CGI." *Wide Angle* 21.1 (January 1999): 29–47.

Pietrobrono, Sheenagh. "Scale and the Digital: The Miniaturizing of Global Knowledge." *International Journal of Cultural Studies* 15.2 (March 2012): 101–116.

Plato. "Allegory of the Cave." In *The Republic of Plato*. Translated by Francis Macdonald Cornford. New York: Oxford University Press, 1945.

Plato. *Phaedrus*. Translated by Christopher Rowe. New York: Penguin Books, 2005.

Posner, Michael. " Deep Blue Stuns Kasparov." *Globe and Mail*. February 10, 1996.

Poulisse, Adam. "Playstation 4 Release Kicks Off Console Wars." *San Gabriel Valley Tribune*. November 16, 2013.

Prebble, Lucy. "Tech Monthly: The Gaming Column: Virtual Reality? Yes, and a World of Wonder Thanks to the Oculus Rift." *The Observer*. November 10, 2013. 37.

Prensky, Marc. "Digital Natives, Digital Immigrants Part 1." *On the Horizon* 9.5 (2001): 1–6.

Prigg, Mark. "Russian Billionaire Reveals Real-Life 'Avatar' Plan—and Says He Will Upload His Brain to a Hologram and Become Immortal by 2045." *DailyMail*. Accessed December 27, 2013. http://www.dailymail.co.uk/sciencetech/article-2322703/Want-live-forever-Russian-billionaire-reveals-real-life-avatar-plan-says-upload-brain-hologram-immortal-2045.html.

Purse, Lisa. "Digital Heroes in Contemporary Cinema: Exertion, Identification and the Virtual Action Body." *Film Criticism* 32.1 (Fall 2007): 5–25.

Purse, Lisa. *Digital Imaging in Popular Cinema*. Edinburgh: Edinburgh University Press, 2013.

Quiggin, John. "The Y2K Scare: Causes, Costs and Cures." Accessed July 18, 2013. http://www.uq.edu.au/economics/johnquiggin/JournalArticles05/QuigginAJPA05Y2K.pdf.

Racter. *The Policeman's Beard is Half-Constructed.* Ed. William Chamberlain. New York: Warner Books, 1984.

Raskin, Jef. *The Humane Interface.* Don Mills, ON: Addison-Wesley, 2000.

Reed, Rex. "Rage against the Keyboard." *The NY Observer.* November 15, 2004. 22.

Reznor, Trent, and Atticus Ross. *The Social Network.* Audio CD. Null Corporation, 2010.

Rheingold, Howard. *Tools for Thought: The People and Ideas behind the Next Computer Revolution.* New York: Computer Book Division/Simon and Schuster, 1985.

Rheingold, Howard. *The Virtual Community.* Reading, MA: Addison-Wesley, 1993.

Rheingold, Howard. *Virtual Reality.* New York: Simon and Schuster, 1991.

Rimm, Marty. "Marketing Pornography on the Information Superhighway: A Survey of 917,410 Images, Descriptions, Short Stories, and Animations Downloaded 8.5 Million Times by Consumers in over 2000 Cities in Forty Countries, Provinces, and Territories." *Georgetown Law Journal* 83 (1994–1995).

Robert T., Mike Little, and Jared W. Smith. *Building Online Communities with Drupal, phpBB, and Wordpress.* New York: Apress, 2006.

Roderick, Ian. "Putting the Post-Human in the Loop: Future Combat Systems and Post-Disciplinary Training." *Journal for Cultural Research* 12.4 (October 2008): 301–316

Rodowick, D. N. *The Digital Life of Film.* Cambridge, MA: Harvard University Press, 2007.

Rombes, Nicholas. *Cinema in the Digital Age.* London and New York: Wallflower Press, 2009.

Rosen, Elizabeth K. *Apocalyptic Transformation: Apocalypse and the Postmodern Imagination.* Lanham, MD, and Toronto: Lexington Books, 2008.

Rubinstein, Richard, and Harry M. Hersh. *The Human Factor: Designing Computer Systems for People.* New York: Digital Press, 1984.

Rusli, Evelyn M., Telis Demos, and Yoree Koh. "Twitter IPO Plan: Contrast Facebook." *Wall Street Journal.* September 14, 2013.

Ryan, Johnny. *A History of the Internet and The Digital Future.* New York: ReaktionBook, 2010.

Scott-Card, Orson. *Ender's Game.* New York: Tor Science Fiction, 1985.

Seitz, Patrick. "Microsoft Releases Xbox One in Grand Fashion." *Investor's Business Daily.* November 22, 2013.

Seyama, Jun'ichiro, and Ruth S. Nagayama. "Probing the Uncanny Valley with the Eye Size Aftereffect." *Presence* 18.5 (October 2009): 321–339.

Sobchack, Vivian Carol. *Carnal Thoughts: Embodiment and Moving Image Culture.* Berkeley: University of California Press, 2004.

Sobchack, Vivian. *Screening Space: The American Science Fiction Film.* New Brunswick, NJ: Rutgers University Press, 1997.

Sobchack, Vivian Carol. *The Address of the Eye.* Princeton, NJ: Princeton University Press, 1992.

Sontag, Susan. *Illness and Metaphor and AIDS and Its Metaphors.* New York: Doubleday, 1988.

Sontag, Susan. "The Imagination of Disaster." In *The Science Fiction Film Reader.* Ed. Gregg Rickman. New York: Limelight Editions, 2004.

Stephenson, Neal. *Snow Crash.* New York: Spectra, 1992.

Sterling, Bruce. *The Hacker Crackdown: Law and Disorder on the Electronic Frontier.* 1st ed. New York: Bantam, 1992.

Stone, Jon R. "Apocalyptic Fiction: Revelatory Elements within Post-war American Films." In *Reel Revelations: Apocalypse and Film.* Ed. John Walliss and Lee Quinby. Sheffiel, England: Phoenix Press, 2010. 54–74.

Streitfeld, David. "Amazon Plan: Delivery by Drone." *International New York Times.* December 3, 2013. 16.

Sudan, Rajani. "Technophalla." *Camera Obscura.* May 1997. 105–128.

Telotte, J. P. "The Tremulous Public Body: Robots, Change, and the Science Fiction Film." *Journal of Popular Film and Television* 19.1 (1991): 14–23.

The Donna Reed Show. Performed by Donna Reed, Carl Betz, Shelley Fabares. September 24, 1958–March 19, 1966. TV series.

The Computer Matching and Privacy Protection Act. International Revenue Service. Accessed July 20, 2013. http://www.irs.gov/irm/part11/irm _11-003-039.html.

The Privacy Act of 1974. National Archive. Accessed July 20, 2013. http:// www.archives.gov/about/laws/privacy-act-1974.html.

Toffler, Alvin. *Future Shock.* New York; Bantam, 1970.

Togelius, Julian. Comment on Slashdot. May 10, 2007. As cited in Mayer-Schönberger, Viktor. *delete.* Princeton: Princeton University Press, 2009. 154.

Thomas, Jim. "The Moral Ambiguity of Social Control in Cyberspace: A Retro-Assessment of the 'Golden Age' of Hacking." *New Media and Society* 7.5 (October 2005): 599–624.

Tredinnick, Luke. *Digital Information Culture.* Oxford, UK: Chandos, 2008.

Turkle, Sherry. *Life on the Screen: Identity in the Age of the Internet.* New York: Simon and Schuster, 1995.

Turkle, Sherry. *The Second Self: Computer and the Human Spirit.* New York: Simon and Schuster, 1984.

Turner, John S. "Collapsing the Interior/Exterior Distinction." *Wide Angle* 20.4 (1998): 93–123.

United States. *Homeland Security Act of 2002.* 107th Congress. Washington: GPO, 2002. Accessed July 20, 2013. http://www.dhs.gov/xlibrary/assets /hr_5005_enr.pdf.

United States. General Social Survey: Pornography; Feelings about Pornography Laws. TRENDS Porn Law: Table A. General Social Survey. Accessed February 21, 2013. http://www3.norc.org/GSS+Website/.

United States. United States Census Bureau: People and Households; Computer and Internet Uses Main. Publications about Computer and Internet Use: Table A. Level of Access and Use of Computers 1984, 1989

and 1993. United States Census Bureau. Accessed February 12, 2013. http://www.census.gov/.

Urbanski, Heather. *Plagues, Apocalypses and Bug-Eyed Monsters: How Speculative Fiction Shows Us Our Nightmares.* Jefferson, NC: McFarland, 2006.

Van der Weel, Adriaan. *Changing our Textual Minds.* New York: Manchester University Press, 2011.

VanDyk, John K, and Matt Westgate. *Pro Drupal Development.* New York: Apress, 2007.

Various Artists. *Hackers Soundtrack.* Edeltone, 1996.

Venditti, Robert. *The Surrogates.* New York: Top Shelf Productions, 2006.

Villapaz, Luke. "World Wide Web Public Anniversary: 20 Years Since the Technology behind the Web Was Released into Public Domain." *International Business Times.* April 30, 2013. Accessed July 18, 2013. http://www.ibtimes.com/world-wide-web-public- anniversary-20-years-technology-behind-web-was-released-public-domain-1226341.

"Watch this Space: Wearable Computing." *The Economist.* Jan. 26, 2013. 58.

Wells, H. G. "World Encyclopaedia." *World Brain.* Accessed August 15, 2013. http://www.ics.uci.edu/~vid/Readings/Wells_World_Brain.pdf.

White, Richard. "Lyotard and Posthuman Possibilities." *Philosophy Today* 50.2 (Summer 2006): 183.

Wu Song, Felicia. "Theorizing Web 2.0." *Information, Communication and Society* 13.2 (2010): 249–275.

Young, Paul. "The Negative Reinvention of Cinema: Late Hollywood in the Early Digital Age." *Convergence: The International Journal of Research into New Media Technologies* 5.2 (June 1999): 24–50.

Yourdon, Edward, and Jennifer Yourdon. *Time Bomb 2000!: What the Year 2000 Computer Crisis Means to You!* Upper Saddle River, NJ: Prentice Hall, 1998.

Zetlin, Minda. *The Computer Time Bomb: How to Keep the Century Date Change from Killing Your Organization.* New York: American Management Association, 1998.

Žižek, Slavoj. "Cyberspace, or, The Unbearable Closure of Being." In *The Plague of Fantasies.* New York: Verso. 1997.

Žižek, Slavoj. *Organs Without Bodies: On Deleuze and Consequences.* New York: Routledge, 2004.

Films Cited

A Clockwork Orange. Dir. Stanley Kubrick. Warner Bros., 1971.

The Amazing Spiderman. Dir. Marc Webb. Columbia Pictures, 2012.

American Pie. Dir. Paul Weitz. Universal Pictures, 1999.

Antitrust. Dir. Peter Howitt. Metro-Goldwyn-Mayer, 2000.

Avatar. Dir. James Cameron. 20th Century Fox, 2009.

Blade Runner. Dir. Ridley Scott. Warner Bros., 1982.

The Blair Witch Project. Dir. Eduardo Sánchez & and Daniel Myrick. Artisan Entertainment, 1999.

The Blob. Dir. Irvin Yeaworth. Paramount Pictures, 1958.

Blowup. Dir. Michelangelo Antonioni. MGM Premier Productions, 1966.

Blue Velvet. Dir. David Lynch. Paramount Pictures, 1986.

Catfish. Dir. Henry Joost and Ariel Schulman. Universal Pictures, 2010.

Close Encounters of the Third Kind. Dir. Steven Spielberg. Columbia Pictures, 1977.

The Computer Wore Tennis Shoes. Dir. Robert Butler. Walt Disney Productions, 1969.

The Conversation. Dir. Francis Ford Coppola. Paramount Pictures, 1974.

The Core. Dir. Jon Amiel. Paramount Pictures, 2003.

The Dark Knight. Dir. Christopher Nolan. Warner Bros., 2008.

Disclosure. Dir. Barry Levinson. Warner Bros., 1994.

Edge of Tomorrow. Dir. Doug Liman. Warner Bros., 2014.

Elysium. Dir. Neill Blomkamp. TriStar Pictures, 2013.

Ender's Game. Dir. Gavin Hood. Summit Entertainment, 2013.

Enemy of the State. Dir. Tony Scott. Buena Vista Pictures, 1998.

Eternal Sunshine of the Spotless Mind. Dir. Michel Gondry. Focus Features, 2004.

feardotcom. Dir. William Malone. Warner Bros., 2002.

The Fifth Estate. Dir. Bill Condon. Walt Disney Studios, 2013.

Final Fantasy: The Spirits Within. Dir. Hironobu Sakaguchi and Motonori Sakakibara. Columbia Pictures, 2001.

Firewall. Dir. Richard Loncraine. Warner Bros., 2006.

The Fly. Dir. Kurt Neumann. 20th Century Fox, 1958.

Freaks. Dir. Tod Browning. MGM, 1932.

Friend with Benefits. Dir. Will Gluck. Screen Gems, 2011.

Ghost in the Machine. Dir. Rachel Talalay. 20th Century Fox, 1993.

The Girl with the Dragon Tattoo. Dir. David Fincher. Metro-Goldwyn-Mayer Columbia Pictures, 2011.

Hackers. Dir. Iain Softley. United Artists, 1995.

Her. Dir. Spike Jonze. Annapurna Pictures, 2013.

Hulk. Dir. Ang Lee. Universal Pictures, 2003.

Inception. Dir. Christopher Nolan. Warner Bros., 2010.

The Internship. Dir. Shawn Levy. 20th Century Fox, 2013.

Invasion of the Body Snatchers. Dir. Don Seigel. Allied Artists, 1956.

Iron Man. Dir. Jon Favreau. Paramount Pictures, 2008.

Iron Man 2. Dir. Jon Favreau. Paramount Pictures, 2010.

Iron Man 3. Dir. Shane Black. Walt Disney Studios Motion Pictures, 2013.

Jobs. Dir. Joshua Michael Stern. Open Road Films, 2013.

Johnny Mnemonic. Dir. Robert Longo. TriStar Pictures, 1995.

The Lawnmower Man. Dir. Brett Leonard. New Line Cinema, 1992.

The Lawnmower Man 2: Beyond Cyberspace. Dir. Farhad Mann. New Line Cinema, 1996.

lol. Dir. Lisa Azuelos. Double Feature Films, 2012.

The Matrix. Dir. Andy Wachowski and Lana Wachowski. Warner Bros., 1999.
The Matrix Reloaded. Dir. Andy Wachowski and Lana Wachowski. Warner Bros., 2003.
The Matrix Revolution. Dir. Andy Wachowski and Lana Wachowski. Warner Bros., 2003.
Me and You and Everyone We Know. Dir. Miranda July. IFC Films, 2006.
Minority Report. Dir. Steven Spielberg. 20th Century Fox, 2002.
The Net. Dir. Irwin Winkler. Columbia Pictures, 1995.
Pacific Rim. Dir. Guillermo del Toro. Warner Bros., 2013.
Pirates of Silicon Valley. Dir. Martyn Burke. Turner Network Television, 1999.
Pleasantville. Dir. Gary Ross. New Line Cinema, 1998.
Polar Express. Dir. Robert Zemeckis. Warner Bros., 2004.
The Postman. Dir. Kevin Costner. Tig Productions, 1997.
Ray. Dir. Taylor Hackford. Universal Studios, 2004.
The Ring. Dir. Gore Verbinski. DreamWorks Pictures, 2002.
Schindler's List. Dir. Steven Spielberg. Universal Pictures, 1993.
Sneakers. Dir. Phil Alden Robinson. Universal Studios, 1992.
The Social Network. Dir. David Fincher. Columbia Pictures, 2010.
Spiderman. Dir. Sam Rami. Columbia Pictures, 2002.
Spiderman 2. Dir. Sam Rami. Columbia Pictures, 2004.
Spiderman 3. Dir. Sam Rami. Columbia Pictures, 2007.
Spy Kids 3-D. Dir. Robert Rodriquez. Dimension Films, 2003.
Star Wars Episode IV: A New Hope. Dir. George Lucas. 20th Century Fox, 1977.
Strange Days. Dir. Kathryn Bigelow. 20th Century Fox, 1995.
Surrogates. Dir. Jonathan Mostiw. Touchstone, 2009.
Swordfish. Dir. Dominic Sena. Warner Bros., 2001.
Takedown. Dir. Joe Chappelle. Dimension Films, 2000.
Terminator 2: Judgement Day. Dir. James Cameron. TriStar Pictures, 1991.
Terminator 3: Rise of the Machines. Dir. Jonathan Mostow. Warner Bros., 2003.
The Terminator. Dir. James Cameron. Orion Pictures, 1984
The Thirteenth Floor. Dir. Josef Rusnack. Columbia Pictures, 1999.
Total Recall. Dir. Paul Verhoeven. TriStar Pictures, 1990.
Total Recall. Dir. Len Wiseman. Columbia Pictures, 2012.
TRON. Dir. Steven Lisberger. Walt Disney Pictures, 1982.
TRON: Legacy. Dir. Joseph Kosinski. Walt Disney Pictures, 2010.
Trust. Dir. David Schwimmer. Millennium Films, 2010.
Untraceable. Dir. Gregory Hoblit. Lakeshore Entertainment, 2008.
Virtuosity. Dir. Brett Leonard. Universal Pictures, 1995.
War Games. Dir. John Badham. MGM Entertainment, 1983.
You've Got Mail. Dir. Nora Ephron. Warner Bros., 1998.

Index

GPSR Compliance
The European Union's (EU) General Product Safety Regulation (GPSR) is a set
of rules that requires consumer products to be safe and our obligations to
ensure this.

If you have any concerns about our products, you can contact us on

ProductSafety@springernature.com

In case Publisher is established outside the EU, the EU authorized
representative is:

Springer Nature Customer Service Center GmbH
Europaplatz 3
69115 Heidelberg, Germany

www.ingramcontent.com/pod-product-compliance
Lightning Source LLC
Chambersburg PA
CBHW070939050326
40689CB00014B/3273

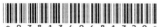

*9 7 8 1 3 4 9 4 8 1 7 2 9 *